THE NEW SMITHSONIAN BOOK OF COMIC-BOOK STORIES

THE NEW SMITHSONIAN BOOK OF COMIC-BOOK STORIES

from **Crumb** to **Clowes**

Edited by Bob Callahan

SMITHSONIAN BOOKS

WASHINGTON

This book is published in partnership with The New College Press, "The Nation's Alternative College Press,"

New College of California, San Francisco, California

Permissions: Wendy Ervin

Research: Rory Root

Production editor: Robert A. Poarch

Copy editor: Mary Christian

Designer: Kate McConnell

Library of Congress Cataloging-in-Publication Data

The new Smithsonian book of comic-book stories : from Crumb to Clowes / edited by Bob Callahan.

 p. cm.

 Includes bibliographical references.

 ISBN 1-58834-183-6 (alk. paper)

 1. Comic books, strips, etc.—United States. I. Callahan, Bob.

 PN6726.N48 2004

 741.5'0973—dc22 2004048245

British Library Cataloguing-in-Publication Data available

Manufactured in China

10 09 08 07 06 05 04 1 2 3 4 5

♾ The paper used in this publication meets the minimum requirements of the American National Standard for

Information Sciences—Permanence of Paper for Printed Library Materials ANSI Z39.48–1984.

For Paul T. Callahan,
and a couple of boxes of Classic Comics, a long long time ago

ACKNOWLEDGMENTS

The New Smithsonian Book of Comic-Book Stories continues the survey first begun by Michael Barrier and Martin Williams in the *First Smithsonian Book of Comic-Book Comics*, copublished by Smithsonian Institution Press and Harry N. Abrams in 1981. Five years later the same publishers also released *The Smithsonian Collection of Newspaper Comics*, edited by my friend and teacher, Bill Blackbeard, and Martin Williams. These two books are widely considered to be the best standard historical anthologies in the field.

One must be aware that this collection is only a representative sampling of the hundreds of great stories that have been written in this medium over the past fifty years. For a better reading of the full scope of this accomplishment, consult For Further Reading in the back of this volume.

Among the creators of this art form, I would like to pay particular tribute to the great Will Eisner, the only American cartoonist whose work is featured in both the first and this new Smithsonian volume. This is not merely homage to a great man: It is a recognition that the autobiographical comics Eisner created in recent years speak just as clearly to the center of current concerns as his first work epitomized what was fine and elegant about the forties and early fifties, when The Spirit first prevailed. Will Eisner is the Duke Ellington of the comic book form.

In presenting this book, I would like to acknowledge my debt to my co-editors on this project, Rory Root and Comic Relief in Berkeley, and Wendy Ervin at New College of California in San Francisco. To Rory I owe a huge thanks for many beneficial conversations when first discussing the arc of this collection, and an even greater debt for turning his great comic book store into a lending library for me to explore new, rare, and even out-of-print works by the authors whose stories can be found in this book.

To Wendy Ervin I send much love and thanks for sharing with me the amazing mountain of paperwork that goes into a collection of this nature. This book simply could not have been built in the same time and scope without Wendy's endlessly friendly, professional, and entirely welcome contribution. As all the artists who worked directly with Wendy would, I am sure, agree: This Wendy woman is a charm.

In the end, this book was created in association with the publishing arm of New College of California, the New College Press, a relatively recent undertaking that promises many more projects in the field of popular and working-class literature and culture. Thanks in particular go to students and colleagues Martin Hamilton, David Meltzer, Danny Cassidy, Micah Ballard, Suzanne Kleid, Travis Myles, Tonya Meeks, Kimberly Ross, Bobby Lavery, and Peter Gabel at New College. I also thank the staff at Comic Relief: Todd Martinez, Stephen Gresch, Mark Haven Britt (Mark) "The Stikman," Geoff Vasille, Shawn Saler, Jim Friel, Jenn Yin, and their pal, Dave Nee.

At the Smithsonian I would like to acknowledge my editor, Scott Mahler, who believed in this volume from the first moment I outlined it to him, and who stood by me and this book through a couple of unplanned lung operations with a kindness and courtesy for which I shall always be grateful.

Ultimately of course this book belongs to its contributors. Thanks in particular to Art Spiegelman, Spain Rodriguez, Justin Green, Melinda Gebbie, Alan Moore, Chris Ware, Ben Katchor, Gary Panter, Lynda Barry, and Neil Gaiman for their special insights, kind words, and various forms of encouragement during the editorial process.

Two of my favorite American cultural institutions are the Smithsonian Institution and the comic book. In my father's name—as he was the one who took me to the Smithsonian for my first and only visit, and he was also the one to give me my first funny book—I feel honored to have helped keep an old and enduring relationship alive with this new collection.

Thanks, finally, always and especially, to Eileen and David, whose love has sustained me through a very challenging year.

NO MORE YIELDING BUT A DREAM

Bob Callahan

An Imp Shall Lead Them from the Darkness

The current era in American comic-book history swung boldly into place one brilliant San Francisco morning in the late 1960s when an odd-looking man, straight out of *Mutt and Jeff,* began to sell his own self-published comic book, *Zap Comix,* from inside a baby carriage while perambulating through the Haight-Ashbury district of San Francisco. The artist's name was Robert Crumb, and the Haight was then the psychedelic center of the cosmos. Crumb captured the moment—or, perhaps better yet, as he would later never tire of complaining, a moment had captured him. It would not be long before Mr. Crumb became the perfect alienated poster boy for a brand new people's art form called the "underground" comic book.

The comic book itself was only about thirty years old when Crumb came along and rearranged it. The format first came to life in the 1930s, when the larger newspapers found a cheap way to repackage their most popular daily serials inside these new pulp pages. And yet, the real break-through did not take place until 1938, when a couple of Jewish American high school students from Cleveland, Jerry Siegel and Joe Shuster, began to create for this new medium a series of adventure stories based on a new American Zeus folk hero character who they first choose to call Superman. Superman and his compatriot superheroes would provide America with a new pop art secular religion for years to come.

According to no less an authority than Will Eisner, the creator of both The Spirit and *A Contract with God,* there was an important strategic element to the invention of Superman. At a time when, across the Atlantic, a monster by the name of Adolph Hitler was attempting to breed a new race of actual supermen, these Cleveland kids created a counter-army of red, white, and blue super-heroes ready to give Herr Hitler a run for his money. Indeed, by the early 1940s these new super-

heroes—these Golem, as they might be called in the Jewish tradition—were fighting the Nazis and the

Japanese on the front covers of a thousand different comic books read by millions of young

Americans at war, or heading to war, in Europe and the Pacific.

There was a powerful magic at work here; yet the comics had often danced to the silent music of hidden archetypes and archaic tribal rituals in the past. What made this moment different was the sobriety of the task. Over the years, the comics more often responded to the spirit of disorder—to the divine virtues Sedition, Anarchy, and Mischievous—than to the need to put anybody's house back in order. As a rule it had been Puck, not some well-meaning new Boy Scout character like Superman, who presided over the world of comedy.

And so it would be for these new comic books as well. The first Superman story appeared in *Action Comics* #1 in 1938. Less than two years later, the first anti-Superman arrived more than willing to overturn the apple cart. The new guy's name was Scribbly; and, as created by Sheldon Mayer, he stumbled across the pages of *All American Comics* for the first time in 1940. Overweight, stuffed into a decidedly un-color-coordinated superhero costume, and wearing an upside-down kitchen pan or a beer basin for a helmet, Scribbly was clearly old Puck reasserting himself again.

When, in the next year, 1941, an actual subversive genius by the name of Jack Cole published his first Plastic Man story in the pages of *Police Comics* #1, Puck was back in business big time. Indeed, by the end of the decade, when the next generation of superheroes finally came along, there was a geniality about their mission, a beguiling charm, which made the first Captain Marvel stories— as written by Otto Binder and drawn by C. C. Beck—one of the most beautifully nuanced hero fantasies ever to appear in this form.

And yet, the comics had other major coming-of-age problems to deal with. For one, few readers appreciated the sophisticated play going on inside the best books being created for the medium. For most readers then—and for too many today—the comics were matter-of-factly considered a literature created simply for kids.

Today, of course, things have changed somewhat. Today excerpts from some of the more serious comics can be found in established scholarly anthologies such as the *Norton Book of*

Postmodern Literature. Art Spiegelman's *Maus* won a Pulitzer Prize in 1992. Indeed, how these changes have come about is an important underlying theme for this collection. A gathering of sometimes strange but always enjoyable stories, this book is also a historical survey.

Following the chronology addressed in the first *Smithsonian Book of Comic-Book Comics,* this story begins in the early 1950s with the example of one of Robert Crumb's greatest teachers, Harvey Kurtzman. For most of the writers and artists in this anthology, Kurtzman remains the most important figure in the history of the modern comic book. As most of the people whose work appears in this anthology would be quick to tell you, when it comes to editing, writing, and illustrating brilliant comic books, Harvey Kurtzman's work has not been surpassed. He remains the father of the contemporary world of the comic.

Kurtzman and the Code

Harvey Kurtzman's contribution to comics—both the knowing, street-smart realism that stood behind his pioneering antiwar stories for both *Two-Fisted Tales* and *Frontline Combat* and the sheer brilliance of the send-ups and parodies that made *Mad* magazine the most celebrated comic of all time— have been well documented in *Smithsonian Book of Comic-Book Comics.* As the history of those comics ran headlong into the America of Joseph McCarthy, Kurtzman's contribution would remain the last great achievement to occur in comics before the institution of the Comics Code Authority in 1954. With the arrival of the code, the first great era of comic book came to a sudden and violent close. In the fall of 1954, with articles appearing almost every day in the press connecting crime comics to juvenile delinquency, and under direct pressure from the politicians in the nation's capital, the major comic publishers of the time gathered together to dumb down their product even further to avoid the levels of realism that Kurtzman and others had begun to introduce into the comic book.

To comply with the spirit and the letter of the code, participating comic books were now required to display a prominent seal on its front cover indicating that their book had been "Approved by the Comics Code Authority." This seal would only be awarded if the book presented crime in a way

so as "not to create sympathy for the criminal. . . . Policeman, judges, government officials, and respected institutions shall never be presented in such a way as to create disrespect for established authority," the code directed. From now on, the realistic depiction of horror, terror, or war was also taboo, and the code even instituted vocabulary restrictions: "Profanity, obscenity, smut, vulgarity, or words or symbols which have acquired undesirable meanings are forbidden." And the code had much to say about sex, and marriage, and the home. Divorce shall never be treated humorously, illicit sex shall never even be implied, and most importantly of all, "respect for parents, the moral code, and for honorable behavior shall always be fostered."

Although even he would have disagreed with some aspects of the code, the main anti-comic book propagandist in America at the time was a New York psychiatrist by the name of Frederic Wertham. Wertham had been a senior psychiatrist in New York City hospitals from 1932 until 1952, when he conducted a regular series of mental hygiene seminars at Bellevue. Somewhere along the line, Wertham (born Werthemier in Germany in 1895) came to believe that crime and horror comic books were the real cause of juvenile delinquency in America. For Wertham, the actual criminals were the comic book publishers, and something had to be done about them in order to stop the tidal wave of gore and bloodshed flooding through good old Blackboard Jungle, USA.

According to Wertham, the comics were also gleefully spreading the joys of communism and homosexuality wherever they went. Wonder Woman, for example, was clearly a lesbian. And Batman and Robin? Well Robin, in particular, seemed to bother Wertham a great deal. "He is buoyant with energy and devoted to nothing on earth or in interplanetary space as much as to Bruce Wayne," Wertham writes. "He often stands with his legs spread, his genital region discreetly evident."

Now all of this might have been considered great fun, of course, if Wertham and the code hadn't managed to virtually shut down comics for the next ten years.

Indeed, in October 1954, the very month the Comic Code Authority was introduced, Kurtzman published the headline "Comics Go Underground" across the bottom of the cover of that month's issue of *Mad*. And, of course, that is exactly what happened. It was twelve years, however, before open, smart, and adventurous comics surfaced again.

Robin Goodfellow's Revenge

In 1963 Robert Crumb wrote Harvey Kurtzman a fan letter. After leaving *Mad*, Kurtzman began to edit a new magazine called *Help*. Crumb wrote to encourage him to continue the good work. Two years later Crumb published his own gag cartoons in Kurtzman's magazine, and so would future underground pioneers Jay Lynch, Skip Williamson, and Gilbert Shelton.

1965 would be the year of the great turning. Not only had a few of the early underground notables met in the pages of Kurtzman's new magazine, but innovations in offset printing technology made it possible for artists to print their own small tabloid newspaper runs for a couple hundred dollars. By the end of that year alternative newspapers such as the *Los Angeles Free Press*, the *Berkeley Barb*, the *San Francisco Oracle*, the *Chicago Seed*, *Detroit's Fifth Estate*, and New York's *East Village Other* threw open their doors to certain new and radical perspectives in art and politics. The counterculture began to come alive in these pages.

Then there was the small question of drugs. It was no coincidence that 1965 was also the year when LSD and certain other hallucinogenic drugs first began to circulate widely in certain American urban centers. Acid, for example, had begun to circulate through the bloodstreams of the very same men and women who were proclaiming—in an often loud and insane manner—the birth of this new counterculture in the pages of these new alternative newspapers. "Rebels on Drugs." It both was, and was not more than a great new "B" movie.

Overwhelmed from his first experiences with LSD, Crumb sought refuge in Chicago. Yet the effects of the drug persisted in his brain. "The whole time, while in this fuzzy state of mind," he wrote, "the separation, the barrier betwixt the conscious and the subconscious was broken open somehow. A grotesque kaleidoscope, a tawdry carnival of disassociated images kept sputtering to the surface, especially if I was sitting and staring, which I often was."

And in just such a state of fuzz, an entire family of new psychedelic comic-book characters was born. "What a boon to my art!" Crumb declared. "It was during that fuzzy period that I recorded in my sketchbook all the main characters I would be using in comics for the next ten years:

Mr. Natural, Flakey Foont, Schuman the Human, the Snoid, Eggs Ackley, the Vulture Demonesses, Shabno the Shoe-Horn dog, this one, that one. It was a once-in-a-lifetime experience, like a religious vision that changes someone's life, but, in my case, it was the psychotic manifestation of some grimy part of America's collective unconsciousness."

Crumb was of course not the only brilliant young artist of his generation to use the pages of the underground newspapers as an inkblot for his subconscious, a canvas on which to scrawl every suppressed, repressed, and depressed image and idea. For an entire generation of whacked-out, hideously conflicted teenagers, the moment of reckoning was at hand.

In 1965 and 1966 New York's Lower East Side was a mecca for these young artists and illustrators. By 1967, San Francisco was a new home for this extraordinary countercultural movement. By the end of that year it seemed every young poet with a rhyme or a pencil was buying a bus ticket from Anywhere-in-America to the town already billing itself as the new Electric Tibet.

The poet Robert Duncan mentioned a moment many years before when he had fallen down on his knees and prayed to God to send at least a few more poets to his beloved San Francisco. "By 1968," he later said, "I was down on my knees praying to God to please let them all go away!" By the end of 1967 Crumb had arrived in the Haight and was already putting together the first issue of *Zap Comix.* Still other artists were involved in creating new psychedelic music posters for rock ballrooms like the Fillmore and the Family Dog. Even more artists were involved cranking out regular issues of the *San Francisco Oracle*—immediately recognized for the beauty of its format and art—and the *Berkeley Barb*—better known still for its ability to raise holy hell from Selma, Alabama, to the jungles of Vietnam.

Crumb's *Zap Comix* was not the first underground comic book. In one way or another, strange new funny books of a kind by Rick Griffin, Frank Stack, and Joel Beck preceded *Zap* by a couple of years. Yet, in many circles Crumb's superior illustration skills preceded him. When the news was out that Crumb had now turned his main attentions to reviving the comic book, that simple fact became news from the East River to San Francisco Bay.

Zap Comix was actually printed by two Bay Area poets, Don Donahue and Charlie Plymell, on

a cheap offset East Bay printing press. The actual print run was either a thousand copies, if you ask Plymell, or close to five thousand copies, if you talk to Donahue. In either case, on February 25, 1968, Crumb, his wife, Dana; Donahue; Plymell; the now-famous baby carriage; and perhaps a few other friends went up and down Haight Street selling these new comic books, thoroughly corrupting the already disintegrating minds of their fellow hippies. Later that evening, Donahue recalls, "we threw a party to celebrate the birth of *Zap,* featuring a cake that Dana ordered with the *Zap* #1 cover reproduced in the icing."

For Bill Griffith, the creator of Zippy the Pinhead, the publication of *Zap* was the big moment. There were books before *Zap,* Griffith says, "but Crumb had the real big vision, the burning vision. Crumb reinvented the form. He took it over just as other people of his generation took over the direction of popular music at the same time."

Autobiographical Comics

Looking back at the underground comics today, it is easy to see how in those first years, in their endless cataloging of repressed or naughty or politically incorrect imagery, the undergrounds became at first the largely unwanted bastard child of the graphic arts. Yet, as the popularity of these books began to grow, a split developed between two very different camps of enthusiasts: those interested in these books as a gallery for weird graphic art and those who understood the new funnies as a bold new medium for storytelling. The first three or four years of this movement belonged to the graphic arts camp. In 1972 Justin Green, a Chicago artist of a combined Jewish and Catholic heritage, decided to take ye olde psychedelic boy on a brand-new narrative tour.

Green had published stories before, but 1972 was the year the Chicago-born and -bred artist finished writing and drawing the brilliant *Binky Brown Meets the Blessed Virgin Mary*—the comic medium's answer to James Joyce's *Portrait of the Artist as a Young Man.* With Binky, the undergrounds not only found their first bona fide storytelling masterpiece, they also found a fantasy-ridden, id-driven, yet ultimately autobiographical voice for the comic book that opened the door to new literary

possibilities that the medium is still exploring today.

Certainly watching Binky Brown come to life, panel by panel, in San Francisco back in 1971, Green's roommate at the time, the precocious young New York intellectual and cartoonist Art Spiegelman—whose own unusual life story was percolating in the back of his brain—knew something huge was happening right under his feet: "I'll never forget," Spiegelman later wrote, "seeing the unpublished pages of Binky Brown hanging from a clothes line stretched around the drawing table all through the living room and knowing I was seeing something new get born."

In the hands of many of these new storytelling masters—Green, Spain Rodriquez, Gilbert Shelton, Lee Mars, Kim Deitch, Melinda Gebbie, Carol Tyler, and later the unique and towering Harvey Pekar—the undergrounds discovered their own literary destiny.

The Gods Come Down from Olympus

In the early 1960s, under the spell of some of the same generation-altering influences that had helped to create the undergrounds in the first place, mainstream American comic books began to change as well. The author of many of these changes was Stan Lee, born Stanley Martin Lieber in 1922 in New York, the son of Jewish Romanian immigrants.

At the age of eighteen Stan Lee went to work for comics publisher Martin Goodman, whose empire had been launched the previous year with the publication of *Marvel Comics* #1. In time Lee would become Goodman's primary comic book editor. In the early 1960s he cocreated the new main line of Marvel superheroes—the Fantastic Four, Spider-Man, the X-Men, and so many others. Under Lee's direction Marvel would grow to become during that era the most popular comic book company in the world.

A Kennedy liberal and no fan of the Comic Code Authority, Lee brought his own unique irreverence and humor to this new generation of superheroes. As critic Frank Houston has already pointed out, Lee's godly superheroes did not descend from Mount Olympus; most of them seemed to come straight from the boroughs of New York. The Fantastic Four were strictly Midtown; Peter Parker

(Spider-Man) was from Queens; and the thoroughly psychedelic Dr. Strange had Greenwich Village written all over his midnight cape. Only the late-blooming Silver Surfer remained a decided "other." The Surfer had been lifted, it seems, straight from the pages of Albert Camus's existential Algiers.

More importantly, in their various insecurities and anger-management moments, Lee's heroes were deliberately and decisively every bit as neurotic and screwed-up as the average high school or college student who soon became the core audience for these new books. Published in 1961 and featuring the everyday experiences of what writer Jonathan Vankin later described as "a feuding dysfunctional family of physical freaks," the first issue of the *Fantastic Four* was a breakaway hit for Marvel. The next year Lee created the adventures of an erstwhile geek known as Spider-Man. Here Lee nailed the archetype right on its dizzying head. After all, what nerdy, sexually shy teenage boy couldn't identify with Peter Parker—at least before he was bitten by that radioactive spider. In some strange way Parker before the spider bite was a bit like Crumb before that magical first tab of acid. Hidden mythologies were at work here—parables of transformation—and Lee's unique way of mirroring these changes brought to his own company an unprecedented popularity.

Yet in terms of the medium itself, Lee's most telling accomplishment might well be found in the artists he chose as partners and active cocreators in these new character-driven adventures. Of the many great artists who drew for Marvel in this period, Steve Ditko, who drew the early Spider-Man, and Jim Steranko, who came along a few years later to draw Nick Fury and Captain America, stand out above most of the rest. Yet the greatest Marvel artist of them all was clearly Jack Kirby— the most popular action illustrator in the entire history of the medium. It was Kirby who coauthored many of the new titles with Lee. "Nobody drew a strip like Jack Kirby," Lee wrote in his autobiography: "[Kirby] was not only a great artist, he was also a great visual storyteller. I only had to say, 'Look, Jack, here's the story I want you to tell,' and he'd bring back the concept I had given him, but with the addition of countless imaginative elements of his own. . . . He knew just when to present a long shot or a close-up. He never drew a character that didn't look interesting or pose that wasn't dramatic. In virtually every one of his panels there was something to marvel at. There have always been artists who concentrate more on producing impressive illustrations than on visually telling a story in a clear,

compelling way. Jack wasn't one of them. As amazing as his artwork was, he also depicted a story that you could almost follow without reading the words." Rereading some of these titles today, it is enduringly clear that in their best books Stan Lee and Jack Kirby created magic together. In the 1960s Marvel had an important, transitional, liberalizing influence on the entire trade.

A Wolf Behowls the Moon

Born in Sweden in 1948, the son of two Holocaust survivors, and raised on the streets of New York, Art Spiegelman became during the next decade the most important comic-book artist of his era. In truth, he may have actually become one of the three or four most important comic artists of all time. Hooked on *Mad*—and later a colleague of Kurtzman and Will Eisner at New York's School of Visual Arts—Spiegelman has spent most of his creative life seditiously tweaking the arbitrary boundaries held to separate the worlds of highbrow and lowbrow art. With one foot in the world of bubble gum cards, and the other at the Museum of Modern Art, no one has ever played the high-low culture game more skillfully.

Even if he hadn't created *Maus*—arguably the greatest comic book ever written—Spiegelman still would have found a footnote in this history as the creator of the Garbage Pail Kids stickers for Topps Chewing Gum Company. Spiegelman went to work for Topps in 1966, the same year he began to sell his first psychedelic cartoons to the *Realist* and to certain minor men's magazines such as *Dude, Gent,* and *Nugget.*

In 1967 Spiegelman joined the caravan of aspiring young cartoonists on its way to San Francisco and soon found himself smack in the middle of that burgeoning scene. In San Francisco, with future Zippy the Pinhead creator Bill Griffith, he cofounded *Arcade* magazine, the best edited and most professionally produced comics magazine of its era.

And it was in San Francisco in 1972, influenced by his roommate Justin Green, that Art Spiegelman first created a short three-page comic book story called "Maus," which dealt with his father's tortured memories of life in Hitler's concentration camps. The next year Spiegelman pub-

lished a second short story, "Prisoner on the Hell Planet," from the same bank of memories. Although it would take years to complete this work—in a vastly different drawing style and in a far more emotionally nuanced manner—nevertheless, in the heart of underground San Francisco one of the comic's great masterpieces came to life.

Back in New York in 1977, Spiegelman married his new working partner, Francoise Mouly, a brilliant and beautiful French architecture student. It would be Francoise who would introduce Art to some of the sophisticated and mature comics being published in Europe. Before long these two artists combined their different histories and passions in a new international comics magazine called *Raw*.

With a new partner, Spiegelman was up to his old highbrow/lowbrow tricks once again. Producing a magazine the caliber of a European museum catalogue portfolio, then filling it with new stories by R. Crumb and some Punk Japanese artist doing her own slightly pornographic version of Daffy Duck, *Raw* instantly became one of the most wonderful and outrageous comic anthologies to appear since the first 1933 edition of *Funnies on Parade.*

As an added feature, each issue of *Raw* contained a stapled booklet with the latest chapter of Spiegelman's own ongoing work, *Maus*. In the history of comic-book publishing no one had ever raised the bar any higher. Indeed, when *Raw* finally came to an end and Spiegelman collected his Pulitzer Prize for *Maus,* few would deny that in the right hands, the once-lowly comic book rivaled film and the novel as a medium for sophisticated and literate narrative expression. On New York's Upper West Side, comics were now "hip," after all.

Last of the Red Hot Superheroes

An unusual account of one the worst crimes of the twentieth century, Spiegelman wrote *Maus* partly as a reaction to the sinister and treacherous tide of events of the 1980s. Within a year of the publication of the very first chapter, Archbishop Romero was assassinated in El Salvador; John Lennon was shot outside his apartment building in New York City; Bobby Sands went on a hunger strike in

Northern Ireland; the United States and Saudi Arabia began to fund Jihad Islamic extremists in Afghanistan; and Ronald Reagan was elected president of the United States. Born by the Cold War, America's noir decade had fully arrived.

Spiegelman was of course not the only brilliant writer and artist drawn to the open and new medium of the comics during those years. While working at DC Comics, the birthplace of the super-hero, it was fascinating to watch Frank Miller and Alan Moore introduce new noir decade realism into the old worlds of the costumed characters of the late thirties and early forties.

Born in Maryland in 1957, Miller was raised in Vermont and moved to New York City in his early twenties. Another child prodigy in a field that has generated its share, Miller was given one of Marvel Comics's legendary but then lagging franchises—the *Daredevil* comic book—and challenged to freshen its story line and revive its main characters. In the most significant borrowing from the films since Will Eisner first began to draw The Spirit, Miller turned in large part to the cinema of Francis Ford Coppola, Martin Scorsese, and Brian De Palma in order to make the old crime-fighting comic book majestic and compelling again. "I generally don't study comic books," Miller remarked in an interview with the *Comics Journal* in 1981. "I study movies. I've found that the Hitchcock/Truffaut book is the best book I've read on doing comics."

Based on this new visual vocabulary Miller was eventually hired by DC to take on Batman. the experiment quickly became a glorious success. What one finds in the very first pages of Miller's *Batman: The Dark Knight Returns* is an environment one part Berlin of the Weimar Republic, the other part New York under the weight of a plague. In critic Larry Rodman's words, a cocaine buzz drives most of the action in Miller's new Gotham. In a perfect rhythm of words and constantly size-shifting picture panels, Miller spins a dark tale worthy of James Ellroy, Robert Ferrigno, or George Pelecanos—or any of the recent masters of the hard-boiled detective tradition—a tradition begun with Dashiel Hammett and Raymond Chandler that has only grown nastier over time.

If Art Spiegelman reminded the world that *Maus* was German for "mouse," Frank Miller reminded us that, at first, Batman was a flying rat. You know you are living in a very special era when vermin have become the central icons of the age.

While Frank Miller's *Batman: The Dark Knight Returns* remains a perfect noir thriller of a comic book, and Art Spiegelman's *Maus* a powerfully disguised memoir, it is Alan Moore who created the medium's first convincing graphic novel. Alan Moore and Dave Gibbons's *Watchmen* is certainly one of the great novels ever written about the essential dynamics of the Cold War.

Born in Northampton, England, in 1953, Moore began to write his own comic strip stories as a teenager. By the time he was thirty he was already regarded as one of the finest comic-book writers in all of England. And so, in 1983 DC offered him the opportunity to rewrite the *Swamp Thing* in much the same way Marvel had invited Frank Miller to reinvent *Daredevil*. Moore's success with that project was phenomenal: within four years the book's sales climbed from 17,000 to 100,000 an issue. Moore's *Swamp Thing* became one of the most talked-about mainstream titles in all of comicdom. When DC decided to buy the old Charlton line of masked avenger and superhero comics, Moore let it be known that he wouldn't mind playing with some of those old characters as well; indeed—he might even have an idea or two for a few new characters of his own.

And so the door to the novel *Watchmen* swung open.

The story begins in the mid-1980s, as a group of masked avengers and minor superheroes from the thirties and forties are living in a state of forced retirement. Vigilantes—which is, after all, what most of these characters have always been—are no longer tolerated by what has become one of the world's most authoritarian governments. Richard Nixon is still alive and has repealed the Constitution. He has also decided to become president for life.

In the middle of the most heated era of the Cold War, with tensions heightened to the break-ing point, most of this old gang of superheroes have accepted retiremen—all except, at first, the truly insane Rorschach, a trench-coated private eye who might even have been a kind of Philip Marlowe if it weren't for the fact that something like a small atom bomb has gone off directly in the middle of his face. Rorschach is what some of the old crowd once called "rough duty." Yet, in many ways, he domi-nates *Watchmen* from page one.

As the novel begins Rorschach is looking for the killers responsible for the recent death of Edward Blake, known as The Comedian, a member of his old comic-book gang. In Alan Moore's hands, The Comedian has become an utterly fascinating and thoroughly postmodern character. The Comedian, it seems, began his career as a kind of Captain America figure. Eventually, however, he got balled up in so many nefarious Vietnam-era covert operations and CIA secret missions that he exploded into a savage killer of the kind, and survived to do the dirty work for the most powerful drug lords on our planet today.

Moore's understanding of this transformation is so keenly realized, so adept, that had the *Watchmen* merely been about Rorschach's search for The Comedian's killers his novel would have been a work of political intelligence of no small significance.

Moore, however, had even bigger designs in mind. There are a number of other fascinating yet relatively minor characters in the book, but the main story ultimately belongs to the mild and totally impersonal scientist Dr. Jonathan Osterman (who becomes the ultimate godlike superhero, Dr. Manhattan); and the Donald Trump–rich, JFK-pretty-boy millionaire Adrian Veidt (who transforms himself into the Egyptian pharaoh Ramses II, aka Ozymandias). It is in the contrast between Dr. Manhattan and Adrian Veidt that Moore addresses a central question that has stood behind the superhero tradition from the very beginning. If these new superhero comic-book characters are gods, then just what kind of gods are they? What kind of world have they created for the rest of us to live in?

In Moore's sublimely theosophical imagination, Adrian Veidt is God the Activist. Veidt is willing to destroy mankind to save mankind over and over again. Think of him, as you will, as a rich man's Ollie North. Dr. Manhattan, on the other hand, is the great god of benign indifference, content to stand outside the world and allow events to tick away without intervening, to the relentless rhythms of their own mysteriously maddening design. He is, in short, the watchman supreme. With Spiegelman and Miller, Moore had created one of the three truly towering comic-book works of this age.

An Enduring Dream

For many, but not all, a more modest era than the preceding decade—with an ocean of bad adolescent fiction now being marketed as the next great costumed or autobiographical graphic novel—the current age of comics has been distinguished by the half-lit dark and brooding noir fantasy stories

written by the amazing Neil Gaiman and deceptively savage, dysfunctional comedies created by Daniel Clowes and Chris Ware.

Born above his father's grocery store in Portchester, England, in 1960, Neil Gaiman was well on his way to a career writing new wave science fiction when he discovered the comic-book stories of Alan Moore. The work Gaiman has written since—particularly his epic *The Sandman*—is remarkable for the variety of seemingly incongruent tales held together by an implied but essential world of dreams with the capacity to play through many characters at a time in history, simultaneously. Dreams are not only the subject of Gaiman's work; they also provide his books with a narrative structure. The swirl of images that can logically or illogically arise from such an organizing principle represent something brand new for the comics.

Within a given *Sandman* collection, the stories might range from an African parable on the beginning of life at the edge of the Sahara, to an early evening performance of a new fairy play by Shakespeare on the foothills of England, to a thoroughly grim and impossible convention of serial killers held somewhere in the bleak dead heat of Noplaceville, America. Gaiman's stories do not end so much as they fold one into the other, effortlessly, like, deliberately enough, the relentless forwarding of a single continuous discontinuous dream.

While Neil Gaiman has done most of his great work for the mainstream publisher DC, Daniel Clowes and Chris Ware have been championed by the great alternative independent publisher, Fantagraphics.

Born in Chicago in 1961, Daniel Clowes's first great comic book was his six-volume *Lloyd Llewellyn* serial begun in 1986. In his first important work—a biting satire of some of the more thoroughly banal aspects of 1950s American consumer culture—Clowes took on the mantle of wiseguy

parodist and funnyman straight out of the world of *Mad* magazine and R. Crumb. Indeed it was Crumb who provided Fantagraphics, Clowes's publisher, with the blurb: "Dan Clowes is the R. Crumb of the 1990s."

In recent years Clowes has been working on what is now a twenty-three volume serial called *Eightball.* In each new issue the author's sense of comedy has grown richer, deeper, and more assured. A recent issue, *Eightball* #22 or *Ice Haven*, interlocks twenty-nine very short stories and represents an exploration into the novel form that could make the spirits of Charlie Brown, Lucy, and Vladimir Nabokov proud to know they influenced a work as mad, wonderful, and successful as this.

Clowes's most famous accomplishment has been the adventures of two brilliantly realized post-grunge young women, Enid and Rebecca, who are as familiar to most of us as two-thirds of the young women we see every day on the bus going to work at the local alternative book or record store. Working with Terry Zwigoff, director of the brilliant documentary *Crumb,* Clowes managed to link a series of Enid and Rebecca stories together into the movie *Ghost World.* Clowes and Zwigoff were nominated for an Academy Award for their screenplay for that film.

Chris Ware is the other truly great new comic-book artist of this decade. Born in Nebraska in 1967—his mother was a reporter and editor for the *Omaha World-Herald*—Ware published stories in Spiegelman and Mouly's *Raw* magazine while still an undergraduate the University of Texas at Austin. After graduating Ware moved to Chicago, where he began to develop the magic worlds he continues to create to this day. With an insistence on detail reminiscent of the pioneering work of Winsor McCay, since 1993 Ware has devoted his variously sized graphic works and comics largely to the heartbreaking adventures of Jimmy Corrigan, the Smartest Kid on Earth.

Other characters have appeared—Quimby the Mouse and, more recently, the promising Rusty Brown—but so far Ware is best known for his Jimmy Corrigan tales. Three years ago Jimmy's adventures were reprinted by Pantheon as a beautifully designed hardcover book that has become one of the most commercially successful hardcover comic books published since Art Spiegelman's *Maus.*

Still, as the gorgeous looking book, with its hundreds of pages, thousands of drawings, and countless intricate designs, sits on the coffee table in homes all over America, some people, including

Ware himself, have wondered how many readers actually get beyond the false assurance and inno-cence of the art to actually read the book's essential and surprising story lines. Those who do discov-er that beneath the strangely silent and at times curiously empty art panels, there is a river teeming with horror, dread, shame, and many other powerfully debilitating emotions cascading through Jimmy's world. It is in fact the tension created by these opposites—the distancing art style and the emotionally turbulent story lines—that creates the inner dynamics of Ware's remarkable art.

"I try to put as much emotion in the stories as I can," Ware has written. He explained: "People sometimes find the work dry and laborious. And it is—if you just look at it. It comes down to the prob-lem, or the advantage, of the comics. They're defined as separate from writing or visual art because they're simultaneously read and viewed. If the reader views the work, and does not read it, he or she is going to place too much emphasis on how it is drawn. I make my pictures look cold and dead because I believe that only you read them they come alive. . . . The closest analogy is with music notes on a paper. They're just marks, unless you understand music, can read them, and then it becomes music . . . inside your brain."

In the current decade, Gaiman, Clowes, and Ware have given the comics their leading edge. With most of the men and women in this collection still in the most active stages of their careers, the future of this exciting and eccentric medium is as promising as any of America's other vibrant and popular narrative arts.

...LLION OF THE "YOUTH CULTURE" WAS VERY SELF-CONSCI...
...ISTIC...

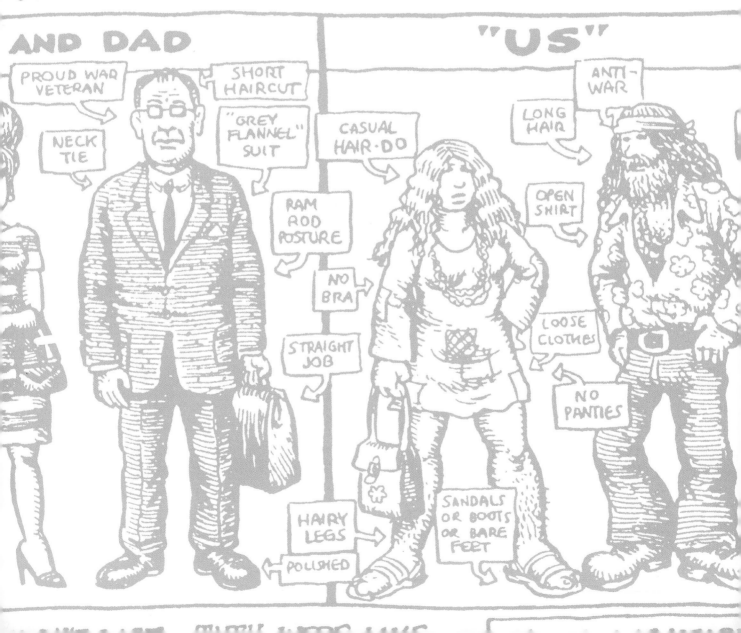

AND DAD

"US"

PROUD WAR VETERAN

SHORT HAIRCUT

ANTI-WAR

NECK TIE

"GREY FLANNEL" SUIT

CASUAL HAIR-DO

LONG HAIR

OPEN SHIRT

RAM ROD POSTURE

NO BRA

LOOSE CLOTHES

STRAIGHT JOB

NO PANTIES

HAIRY LEGS

SANDALS OR BOOTS OR BARE FEET

POLISHED

PART ONE
THE UNDERGROUNDS

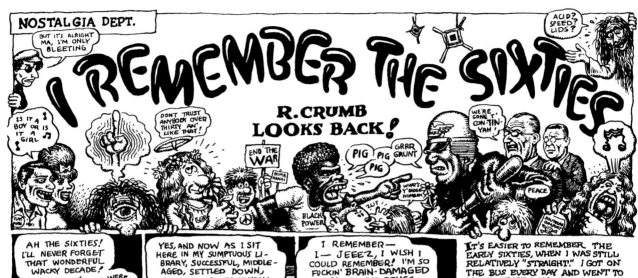
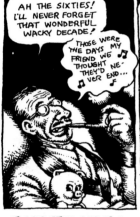
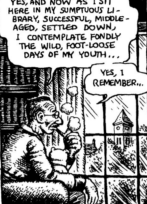

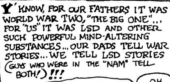
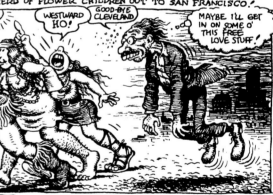

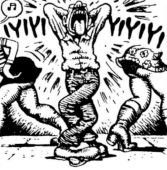

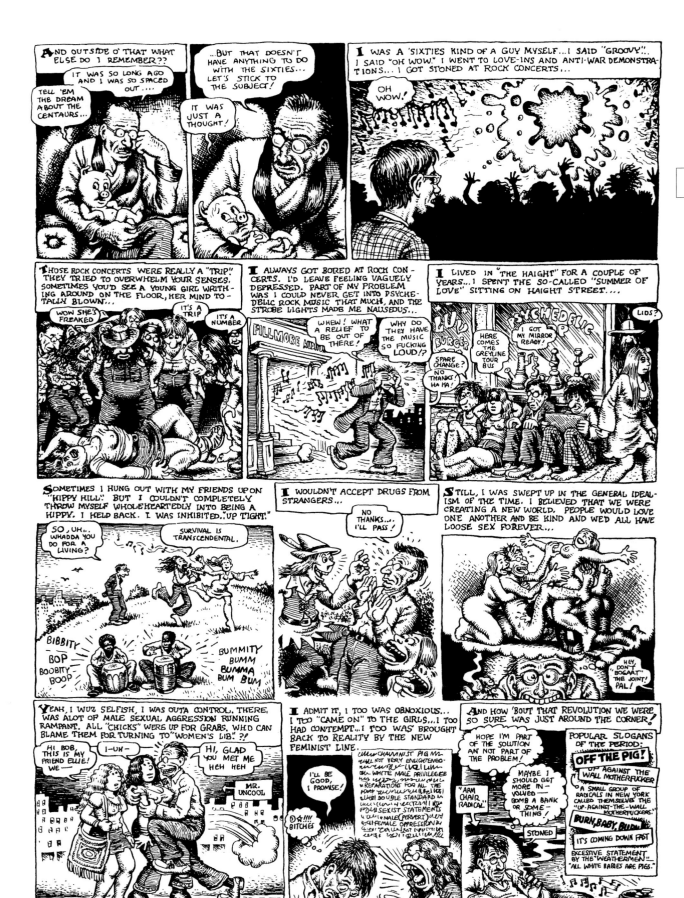

R. CRUMB

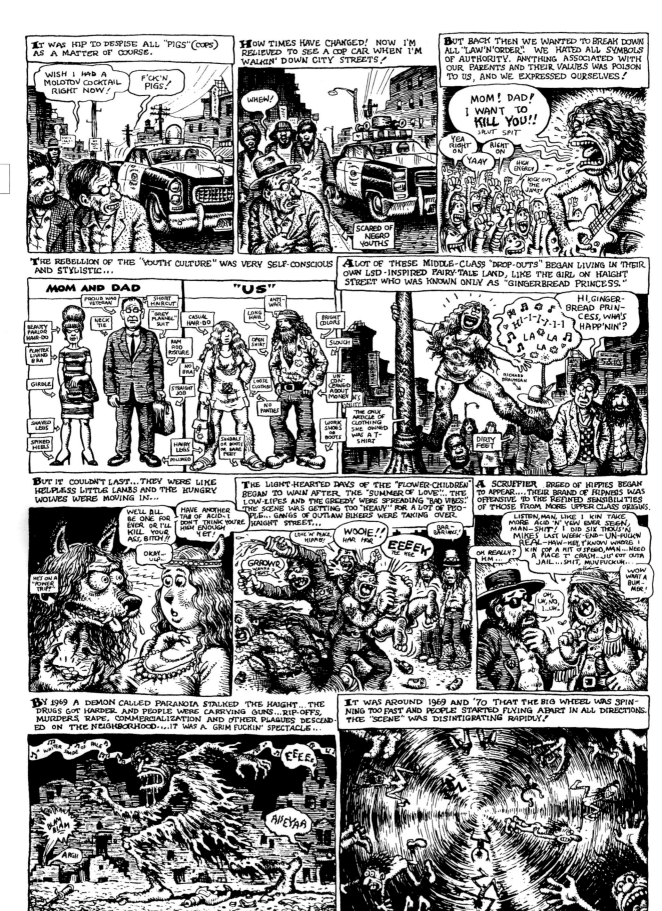

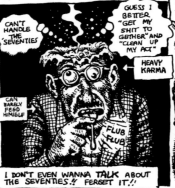

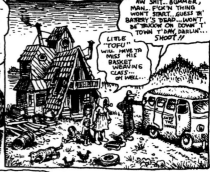

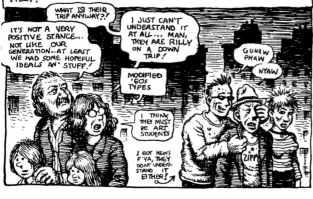

R. CRUMB

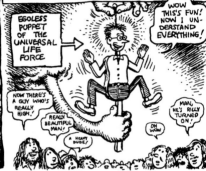
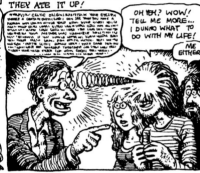

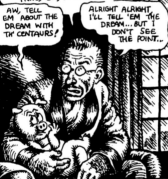
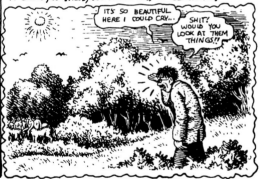
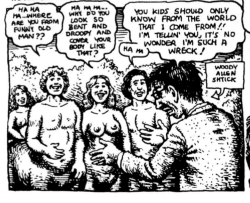
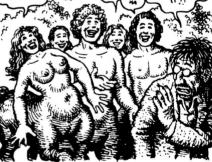
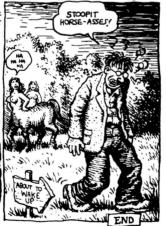

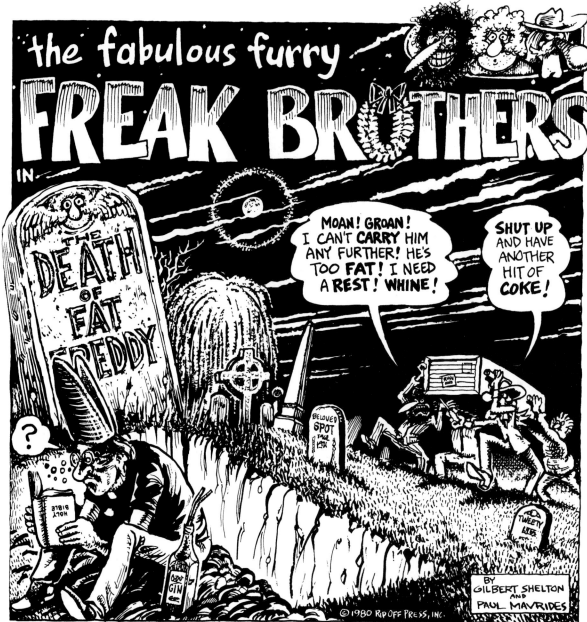

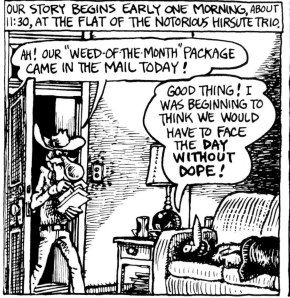

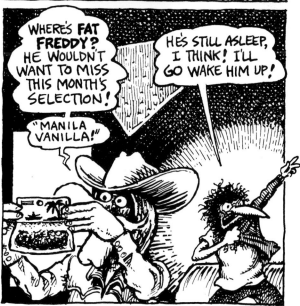

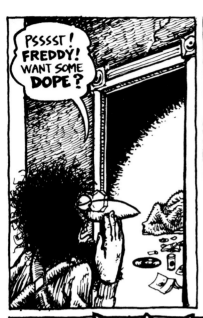

PSSSST! FREDDY! WANT SOME **DOPE**?

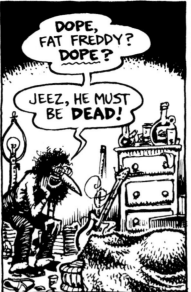

DOPE, FAT FREDDY? **DOPE**?

JEEZ, HE MUST BE **DEAD**!

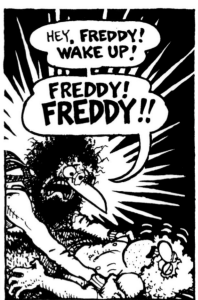

HEY, **FREDDY**! WAKE UP!

FREDDY! **FREDDY**!!

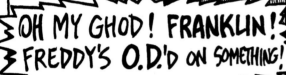

OH MY GHOD! FRANKLIN! FREDDY'S O.D.'D ON SOMETHING!

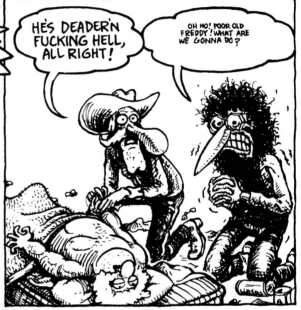

HE'S DEADER'N FUCKING HELL, ALL RIGHT!

OH NO! POOR OLD FREDDY! WHAT ARE WE GONNA DO?

LISTEN, WE CAN'T **REPORT** THIS OR ANYTHING! THE **COPS** WOULD WANT TO **SEARCH** TH' PLACE, DO AN **AUTOPSY**, DO ALL **KINDS** OF GOD DAMN THINGS!

WE'LL HAVE A **WAKE**! A **POTLATCH**! WE CAN **AUCTION OFF** ALL OF HIS, **THINGS** AND USE THE **MONEY** TO PAY FOR A **NICE, SECRET FUNERAL**!

HONK SNIF

FRANKLIN AND PHINEAS, WORKING WITH INTENSE VIGOR IN THE ATTEMPT TO REPRESS THEIR SHOCK AND GRIEF, ARE ABLE TO CLEAN UP FAT FREDDY'S ROOM IN ONLY SEVENTEEN HOURS.

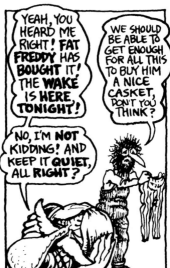

YEAH, YOU HEARD ME RIGHT! **FAT FREDDY** HAS **BOUGHT** IT! THE **WAKE** IS **HERE**, **TONIGHT**!

WE SHOULD BE ABLE TO GET ENOUGH FOR ALL THIS TO BUY HIM A NICE CASKET, DON'T YOU THINK?

NO, I'M **NOT** KIDDING! AND KEEP IT **QUIET**, ALL **RIGHT**?

THE FIRST GUESTS ARRIVE:

OH, FRANKLIN! IT'S SO **SAD**!

JESUS, PHINEAS, I DON'T KNOW WHAT TO **SAY**!

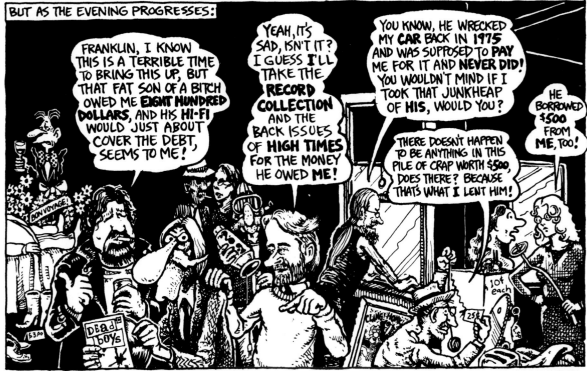

BUT AS THE EVENING PROGRESSES:

FRANKLIN, I KNOW THIS IS A TERRIBLE TIME TO BRING THIS UP, BUT THAT FAT SON OF A BITCH OWED ME **EIGHT HUNDRED DOLLARS**, AND HIS **HI-FI** WOULD JUST ABOUT COVER THE DEBT, SEEMS TO ME!

YEAH, IT'S SAD, ISN'T IT? I GUESS **I'LL** TAKE THE **RECORD COLLECTION** AND THE **BACK ISSUES** OF **HIGH TIMES** FOR THE MONEY HE OWED **ME**!

YOU KNOW, HE WRECKED MY **CAR** BACK IN **1975** AND WAS SUPPOSED TO **PAY** ME FOR IT AND **NEVER DID**! YOU WOULDN'T MIND IF I TOOK THAT JUNKHEAP OF **HIS**, WOULD YOU?

THERE DOESN'T HAPPEN TO BE ANYTHING IN THIS PILE OF CRAP WORTH $500, DOES THERE? BECAUSE THATS WHAT I LENT HIM!

HE BORROWED $500 FROM ME, TOO!

BON VOYAGE!

DEAD boys

10¢ each

25¢

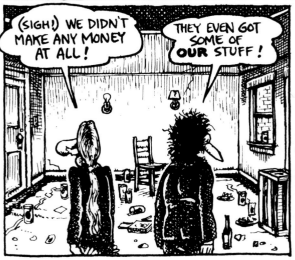

(SIGH!) WE DIDN'T MAKE ANY MONEY AT ALL!

THEY EVEN GOT SOME OF **OUR** STUFF!

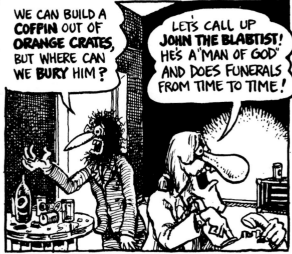

WE CAN BUILD A **COFFIN** OUT OF **ORANGE CRATES**, BUT WHERE CAN WE **BURY** HIM?

LET'S CALL UP **JOHN THE BLABTIST**! HE'S A "MAN OF GOD" AND DOES FUNERALS FROM TIME TO TIME!

SHELTON + MAVRIDES

RING RING RING RING

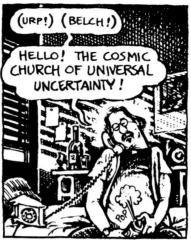

(URP!) (BELCH!)
HELLO! THE COSMIC CHURCH OF UNIVERSAL UNCERTAINTY!

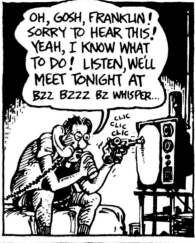

OH, GOSH, FRANKLIN! SORRY TO HEAR THIS! YEAH, I KNOW WHAT TO DO! LISTEN, WE'LL MEET TONIGHT AT BZZ BZZZ BZ WHISPER...
CLIC CLIC CLIC

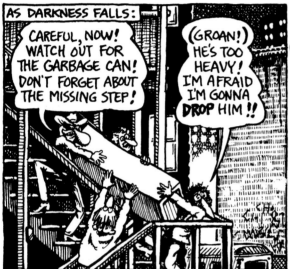

AS DARKNESS FALLS:
CAREFUL, NOW! WATCH OUT FOR THE GARBAGE CAN! DON'T FORGET ABOUT THE MISSING STEP!
(GROAN!) HE'S TOO HEAVY! I'M AFRAID I'M GONNA DROP HIM!!

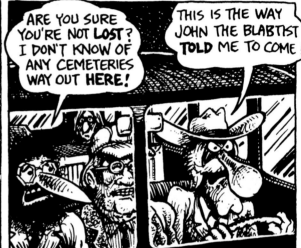

ARE YOU SURE YOU'RE NOT LOST? I DON'T KNOW OF ANY CEMETERIES WAY OUT HERE!
THIS IS THE WAY JOHN THE BLABTIST TOLD ME TO COME!

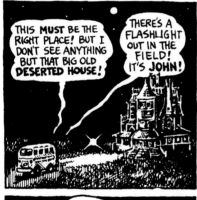

THIS MUST BE THE RIGHT PLACE! BUT I DON'T SEE ANYTHING BUT THAT BIG OLD DESERTED HOUSE!
THERE'S A FLASHLIGHT OUT IN THE FIELD! IT'S JOHN!

FOLLOW ME, YOU GUYS! IT'S AN OLD FAMILY BURIAL PLOT OUT BEHIND THIS OLD FARM!

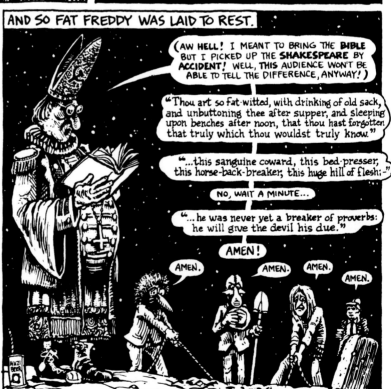

AND SO FAT FREDDY WAS LAID TO REST.

(AW HELL! I MEANT TO BRING THE BIBLE BUT I PICKED UP THE SHAKESPEARE BY ACCIDENT! WELL, THIS AUDIENCE WON'T BE ABLE TO TELL THE DIFFERENCE, ANYWAY!)

"Thou art so fat-witted, with drinking of old sack, and unbuttoning thee after supper, and sleeping upon benches after noon, that thou hast forgotten that truly which thou wouldst truly know."

"...this sanguine coward, this bed-presser, this horse-back-breaker, this huge hill of flesh;-"

NO, WAIT A MINUTE...

"...he was never yet a breaker of proverbs: he will give the devil his due."

AMEN!
AMEN. AMEN. AMEN. AMEN.

THE UNDERGROUNDS

29

A WEEK LATER, THE REMAINING FREAK BROTHERS ARE ALREADY BEGINNING TO FORGET THEIR TRAGIC LOSS.

SHIT! I'M BORED! WHAT'S FOR HUMOR?

WHY DON'T WE HAVE A **PICNIC** SOMEWHERE OUT IN THE **COUNTRY**?

AND SO ONCE AGAIN FRANKLIN AND PHINEAS (PLUS A FEW FRIENDS) HEAD TOWARD THE BURIAL PLOT.

HEY, THIS IS THE WAY OUT TO WHERE WE BURIED OLD WHAT'S-HIS-NAME, ISN'T IT?

I THINK SO! I'D RECOGNIZE THE PLACE IF I SAW IT!

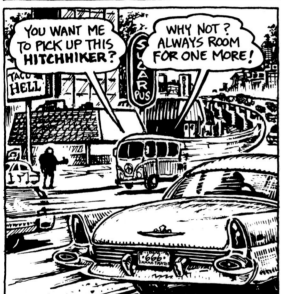

YOU WANT ME TO PICK UP THIS **HITCHHIKER**?

WHY NOT? ALWAYS ROOM FOR ONE MORE!

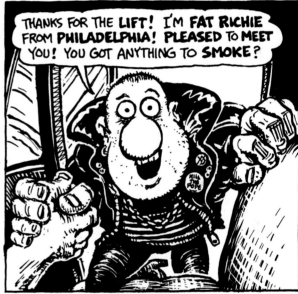

THANKS FOR THE **LIFT**! I'M **FAT RICHIE** FROM **PHILADELPHIA**! PLEASED TO MEET YOU! YOU GOT ANYTHING TO **SMOKE**?

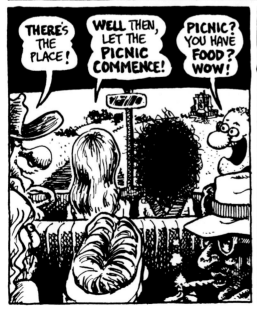

THERE'S THE PLACE!

WELL THEN, LET THE **PICNIC** COMMENCE!

PICNIC? YOU HAVE FOOD? WOW!

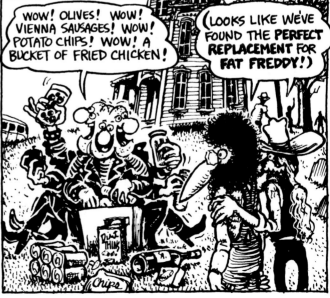

WOW! OLIVES! WOW! VIENNA SAUSAGES! WOW! POTATO CHIPS! WOW! A BUCKET OF FRIED CHICKEN!

(LOOKS LIKE WE'VE FOUND THE **PERFECT** REPLACEMENT FOR **FAT FREDDY**!)

SHELTON + MAVRIDES

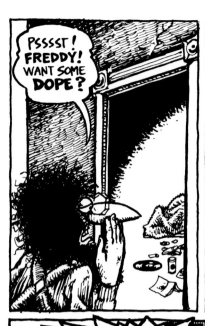

PSSSST! FREDDY! WANT SOME DOPE?

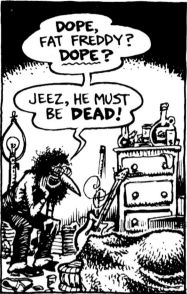

DOPE, FAT FREDDY? DOPE?

JEEZ, HE MUST BE DEAD!

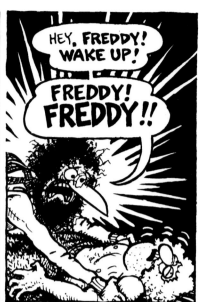

HEY, FREDDY! WAKE UP!

FREDDY! FREDDY!!

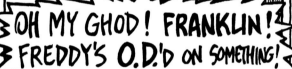

OH MY GHOD! FRANKLIN! FREDDY'S O.D.'D ON SOMETHING!

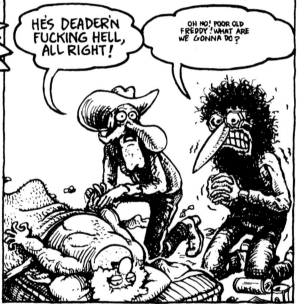

HE'S DEADER'N FUCKING HELL, ALL RIGHT!

OH NO! POOR OLD FREDDY! WHAT ARE WE GONNA DO?

LISTEN, WE CAN'T REPORT THIS OR ANYTHING! THE COPS WOULD WANT TO SEARCH TH' PLACE, DO AN AUTOPSY, DO ALL KINDS OF GOD DAMN THINGS!

WE'LL HAVE A WAKE! A POTLATCH! WE CAN AUCTION OFF ALL OF HIS, THINGS AND USE THE MONEY TO PAY FOR A NICE, SECRET FUNERAL!

HONK SNIF

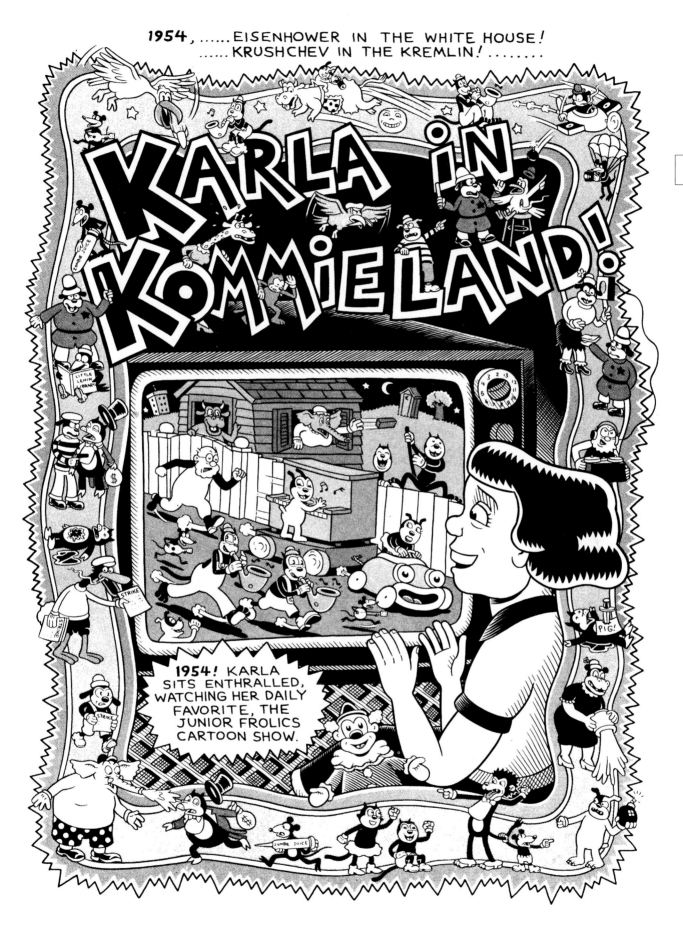

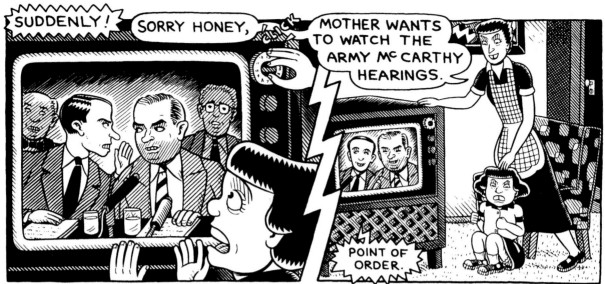

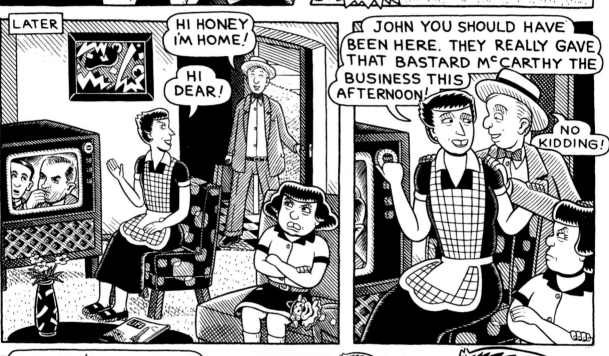

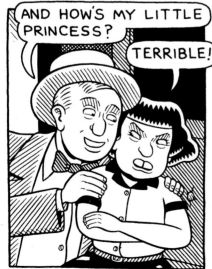

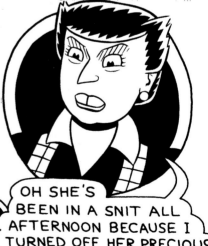

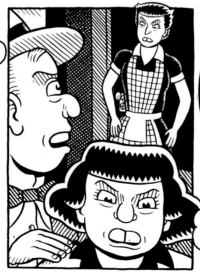

32

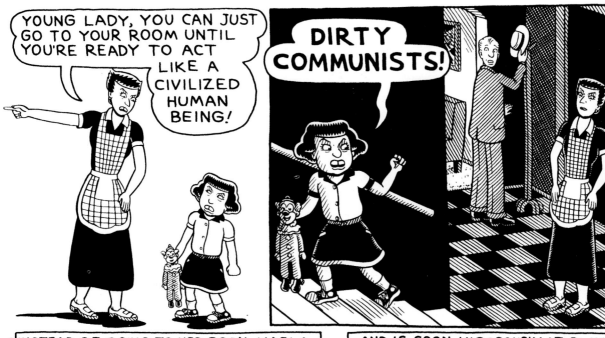

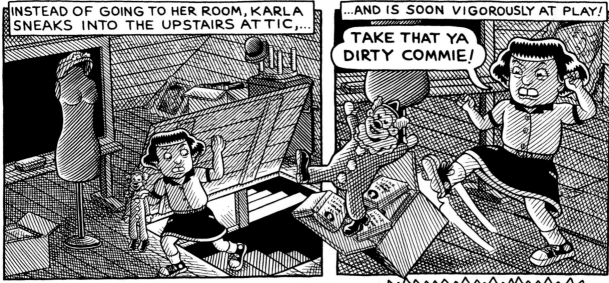

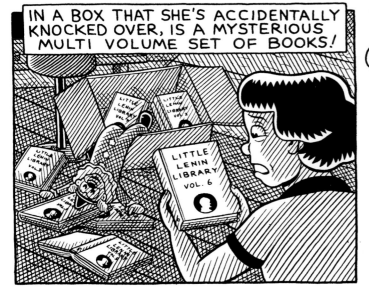

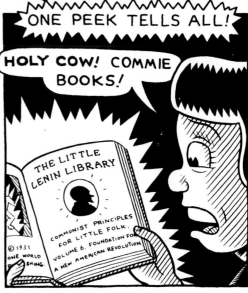

KIM DEITCH

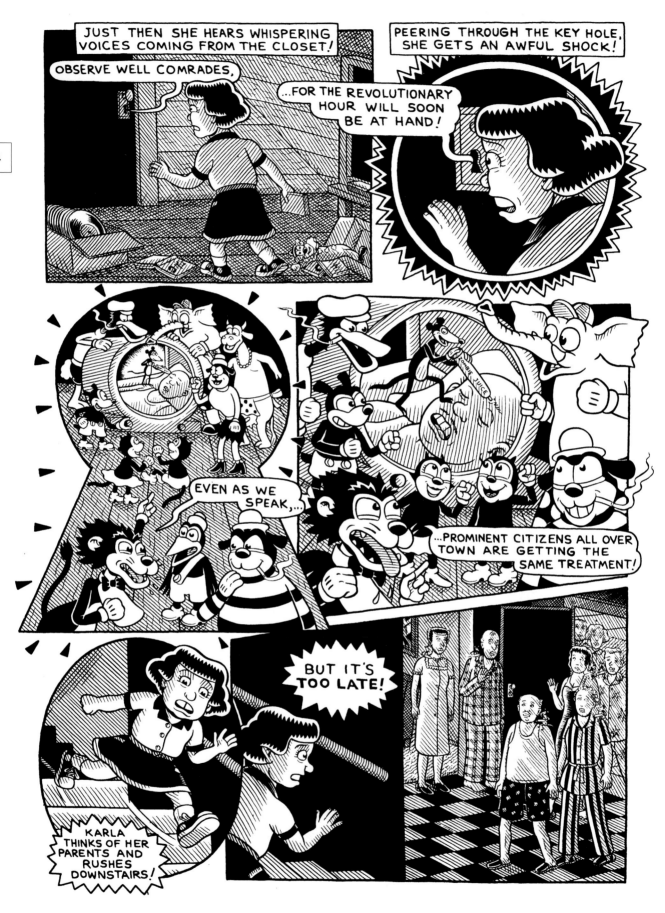

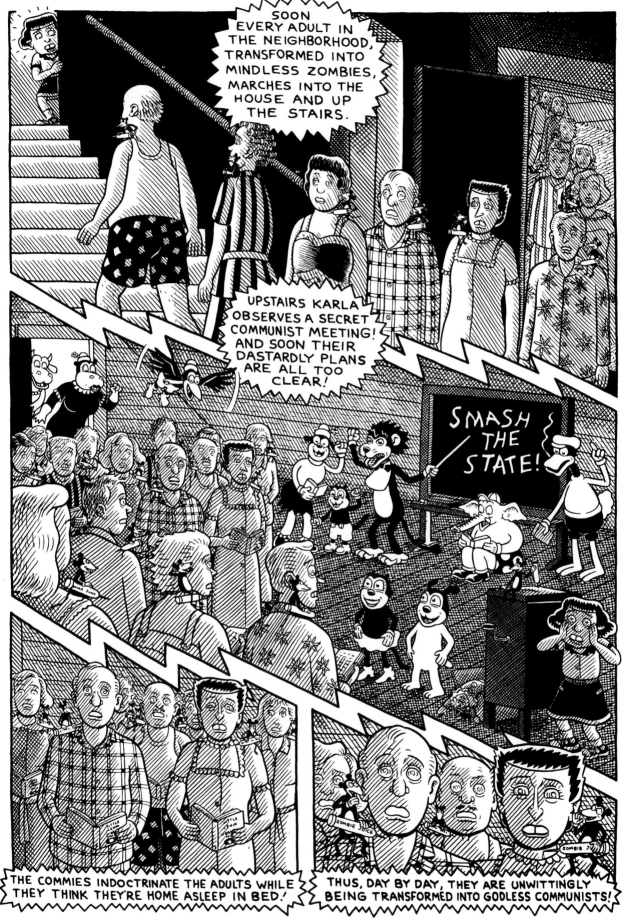

KIM DEITCH

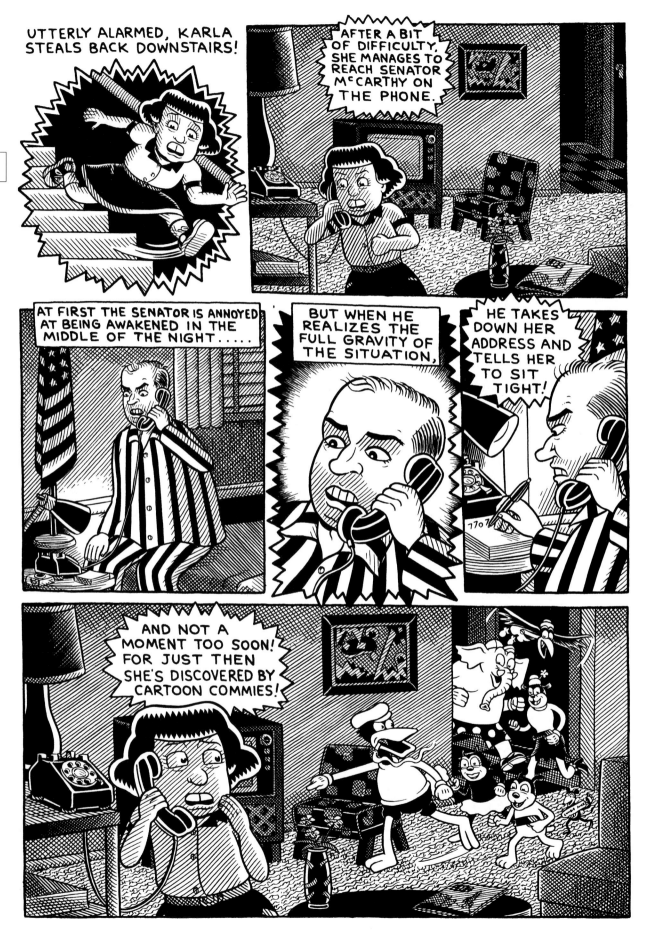

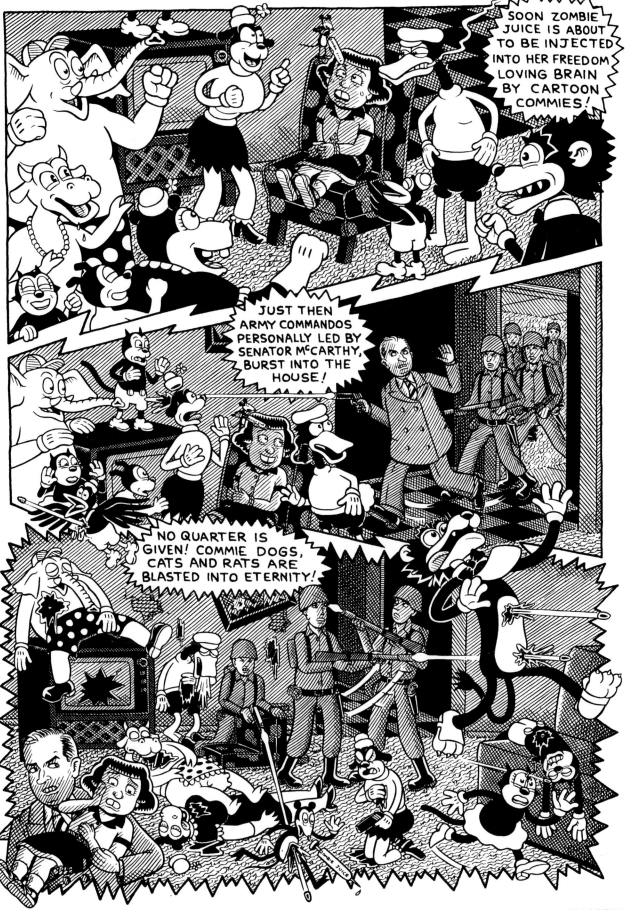

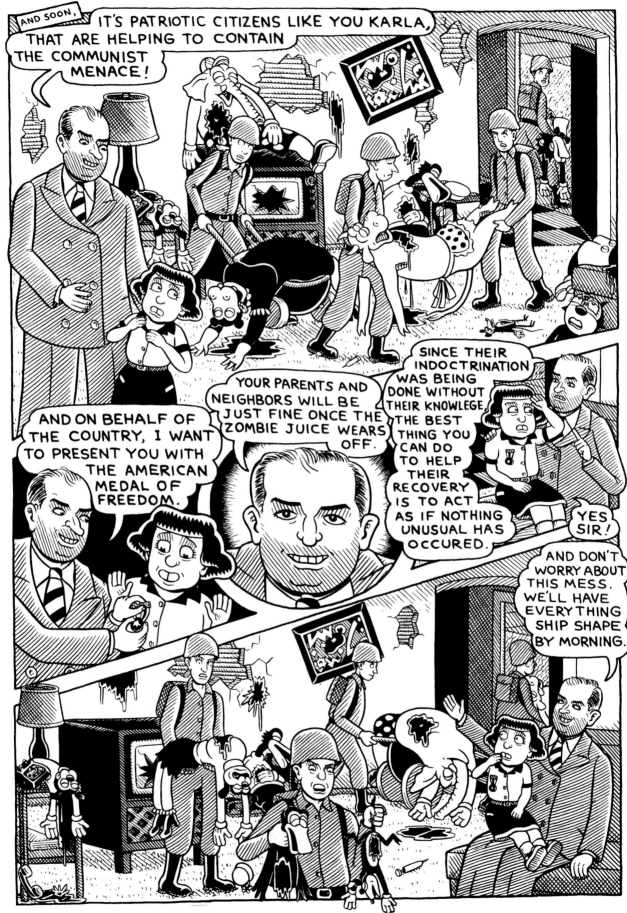

THE UNDERGROUNDS

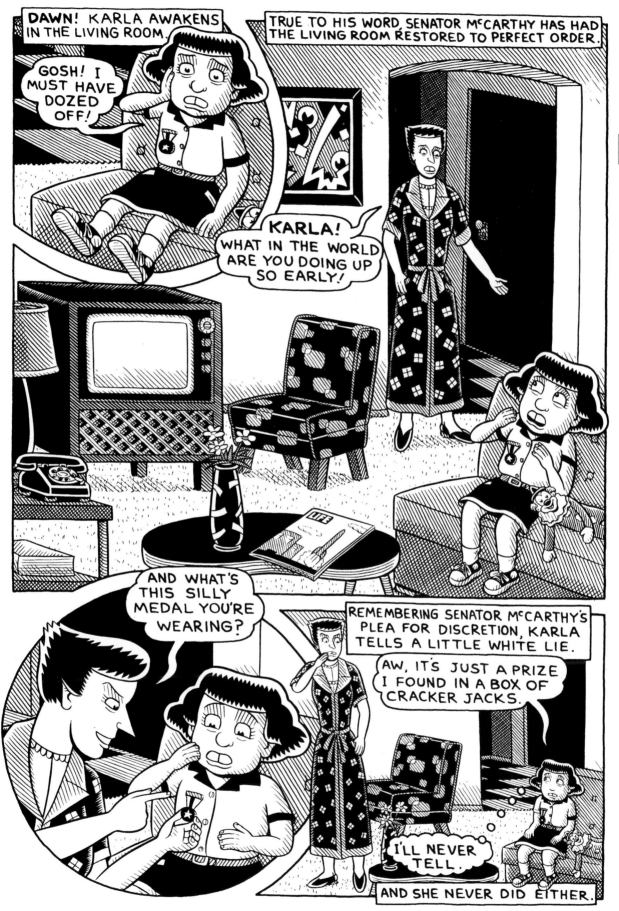

KIM DEITCH

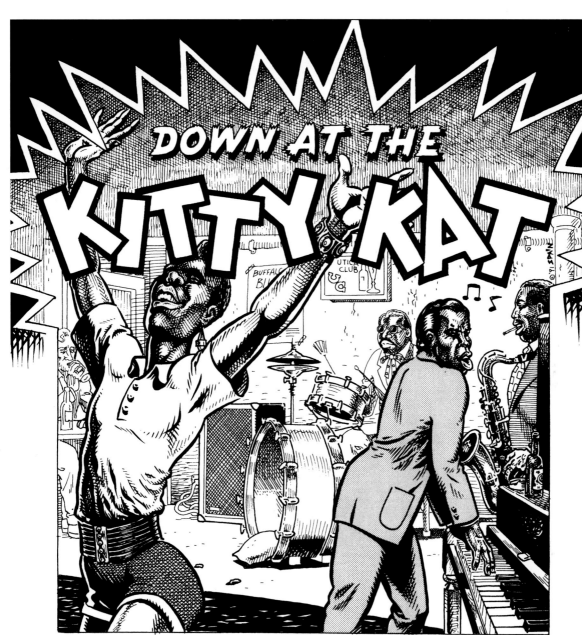

DOWN AT THE KITTY KAT

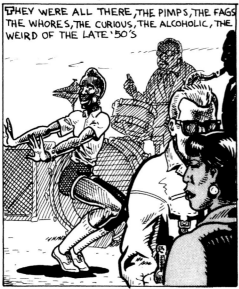

THEY WERE ALL THERE, THE PIMPS, THE FAGS THE WHORES, THE CURIOUS, THE ALCOHOLIC, THE WEIRD OF THE LATE '50'S

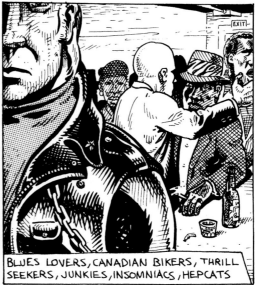

BLUES LOVERS, CANADIAN BIKERS, THRILL SEEKERS, JUNKIES, INSOMNIACS, HEPCATS

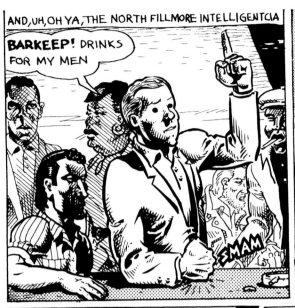

AND, UH, OH YA, THE NORTH FILLMORE INTELLIGENTCIA

BARKEEP! DRINKS FOR MY MEN

SMAM

HEY SPAIN, DON'T TAKE IT SO HARD

SNURF

SPAIN, SPAIN, SHE WAS WORTHLESS!

I KNOW SNF I KNOW

WELL I'M THE ONE THAT MADE YOU... I PICKED YOU OFF THE STREET...

AND IF YOU EVER LEAVE ME, YOU'LL BE BACK ON MICHIGAN STREET

AH AIN'T MAD AT YOU, WHY BE MAD AT ME AH AIN'T MAD AT YOU, WHY BE MAD AT ME

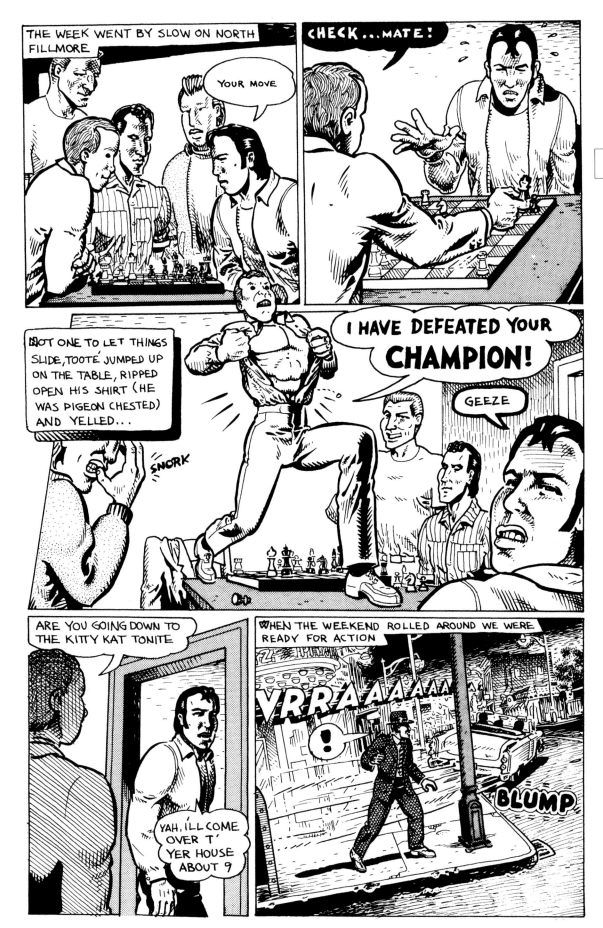

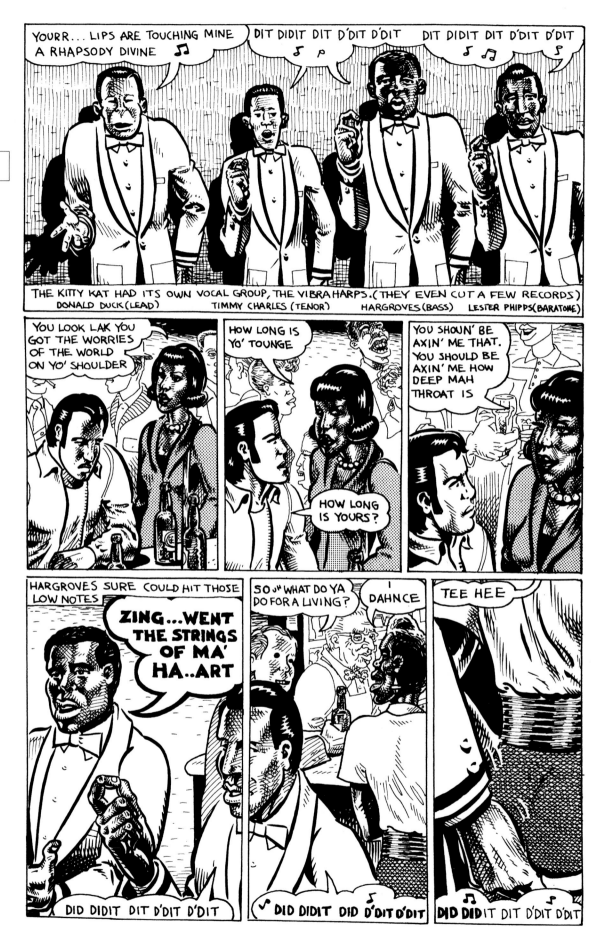

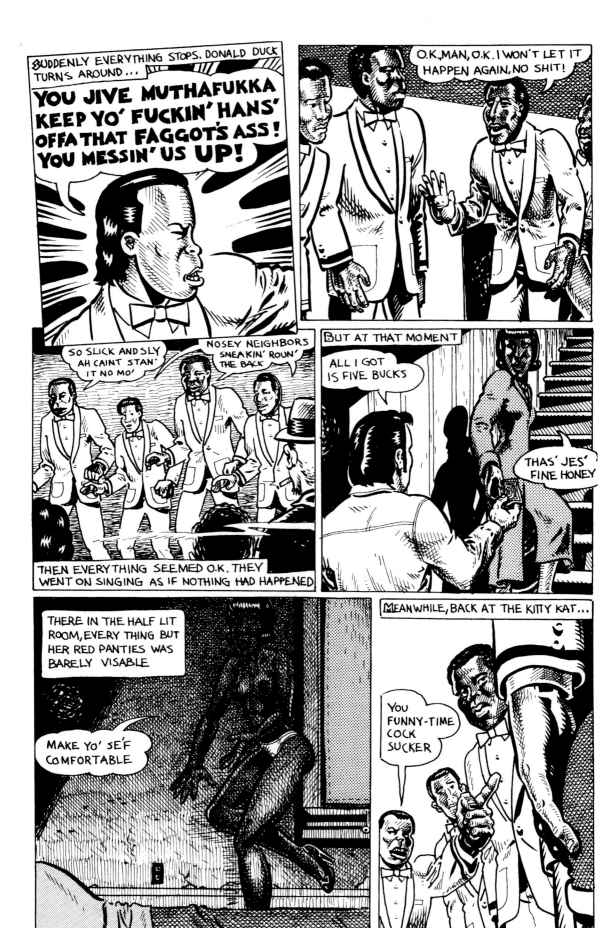

45

SPAIN

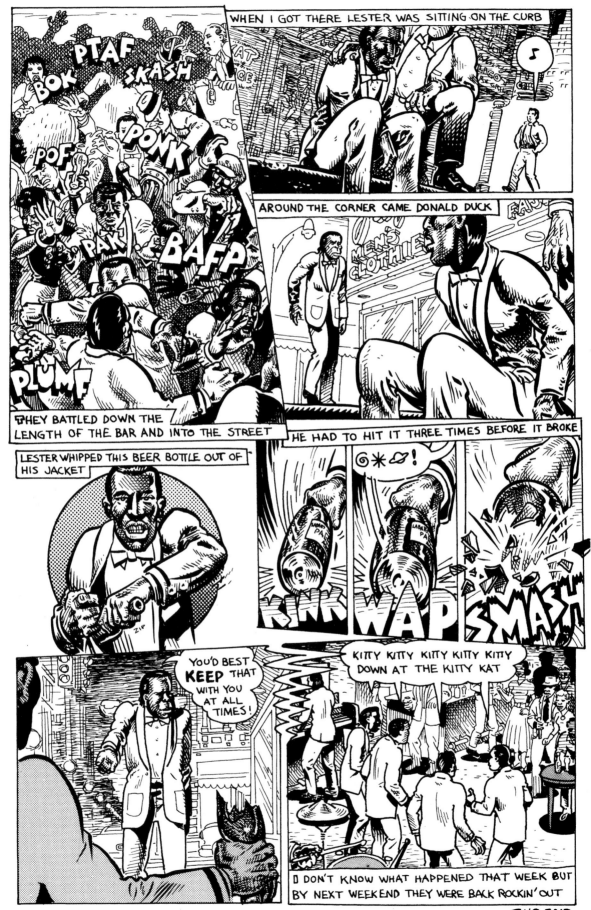

THE END

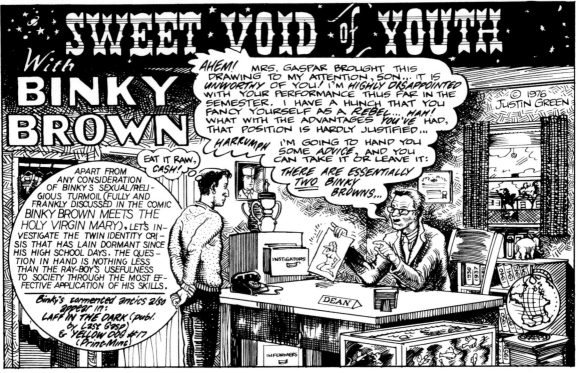

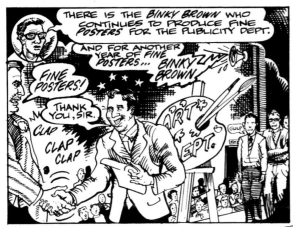
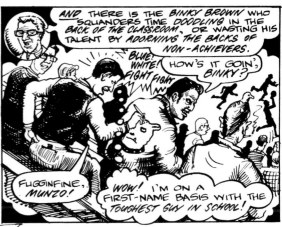

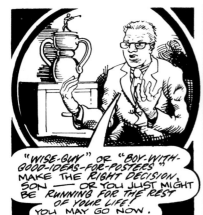
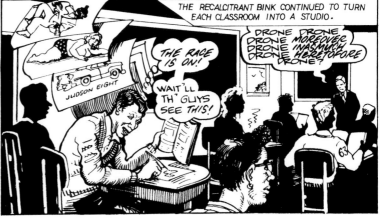

JUSTIN GREEN

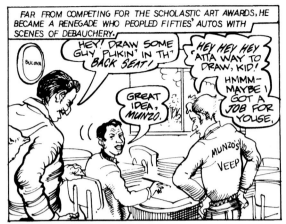

FAR FROM COMPETING FOR THE SCHOLASTIC ART AWARDS, HE BECAME A RENEGADE WHO PEOPLED FIFTIES' AUTOS WITH SCENES OF DEBAUCHERY.

HEY! DRAW SOME GUY PLUKIN' IN TH' BACK SEAT!

HEY HEY HEY ATTA WAY TO DRAW, KID!

GREAT IDEA, MUNZO.

HMMM— MAYBE I GOT A JOB FOR YOUSE.

MUNZO'S VEEP

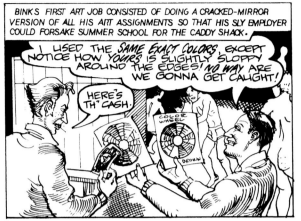

BINK'S FIRST ART JOB CONSISTED OF DOING A CRACKED-MIRROR VERSION OF ALL HIS ART ASSIGNMENTS SO THAT HIS SLY EMPLOYER COULD FORSAKE SUMMER SCHOOL FOR THE CADDY SHACK.

I USED THE SAME EXACT COLORS, EXCEPT NOTICE HOW YOURS IS SLIGHTLY SLOPPY AROUND THE EDGES! NO WAY ARE WE GONNA GET CAUGHT!

HERE'S TH' CASH.

COLOR WHEEL

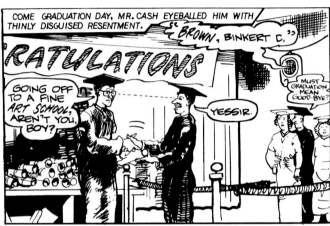

COME GRADUATION DAY, MR. CASH EYEBALLED HIM WITH THINLY DISGUISED RESENTMENT.

"BROWN, BINKERT C."

'RATULATIONS

GOING OFF TO A FINE ART SCHOOL, AREN'T YOU, BOY?

YESSIR.

MUST GRADUATION MEAN GOOD-BYE?

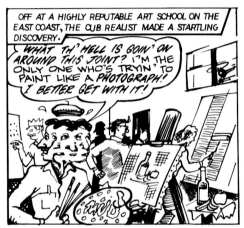

OFF AT A HIGHLY REPUTABLE ART SCHOOL ON THE EAST COAST, THE CUB REALIST MADE A STARTLING DISCOVERY.

WHAT TH' HELL IS GOIN' ON AROUND THIS JOINT? I'M THE ONLY ONE WHO'S TRYIN' TO PAINT LIKE A PHOTOGRAPH! I BETTER GET WITH IT!

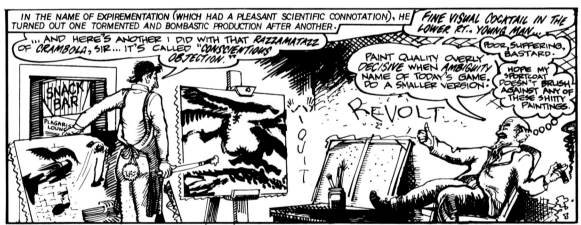

IN THE NAME OF EXPIREMENTATION (WHICH HAD A PLEASANT SCIENTIFIC CONNOTATION), HE TURNED OUT ONE TORMENTED AND BOMBASTIC PRODUCTION AFTER ANOTHER.

"...AND HERE'S ANOTHER I DID WITH THAT RAZZAMATAZZ OF CRAMBOLA, SIR... IT'S CALLED "CONSCIENTIOUS OBJECTION."

SNACK BAR

PLAGARIST LOUNGE

FINE VISUAL COCKTAIL IN THE LOWER RT., YOUNG MAN...

PAINT QUALITY OVERLY DECISIVE WHEN AMBIGUITY NAME OF TODAY'S GAME. DO A SMALLER VERSION.

POOR, SUFFERING, BASTARD.

HOPE MY SPORTCOAT DOESN'T BRUSH AGAINST ANY OF THESE SHITTY PAINTINGS.

REVOLT

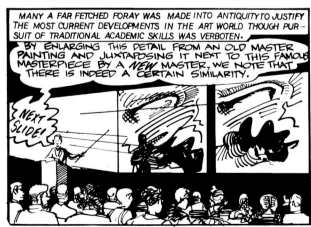

MANY A FAR FETCHED FORAY WAS MADE INTO ANTIQUITY TO JUSTIFY THE MOST CURRENT DEVELOPMENTS IN THE ART WORLD THOUGH PURSUIT OF TRADITIONAL ACADEMIC SKILLS WAS VERBOTEN.

BY ENLARGING THIS DETAIL FROM AN OLD MASTER PAINTING AND JUXTAPOSING IT NEXT TO THIS FAMOUS MASTERPIECE BY A NEW MASTER, WE NOTE THAT THERE IS INDEED A CERTAIN SIMILARITY.

NEXT SLIDE!

AND AS FOR CARTOONING, THE ONLY PROPER PLACE TO DO IT WAS "IN THE CLOSET."

SPIRIT OF MUNZO

48

BINKARINO WAS AMONG THE THOUSANDS OF SO-CALLED "BACHELORS OF FINE ART" WHO ISSUED FORTH FROM ACADEMIA IN SPRING, '68.

THE FORTUNATE BINK HAS LANDED A "TEACHING ASSISTANTSHIP" AT A BIG COLLEGE. SHORT ON FUNDS, THE ART DEPT. GIVES THE STILL-WET-BEHIND-THE-EARS BULLSHITTER 3 DIFFERENT SUBJECTS TO TEACH, SOLO!

McLUHANESQUE VISUAL COCKTAILS DEFLECT THOSE INQUIRIES WHICH SEEK MERE ELUCIDATION OF HISTORICAL MOTIVES. AHHHHH, AM I MAKING ANY SENSE?

SINCE 3 BONAFIDE TEACHERS WOULD HAVE COST AT LEAST 30 GRAND AND BINKY WAS PAID ONLY $3800 FOR HIS DAILY POSTURING, THE SCHOOL WAS SAVING A TIDY SUM. HOWEVER, HE WAS BEGINNING TO CRACK UNDER THE PRESSURE.

ONE DAY HE YIELDED TO A STRANGE IMPULSE WHICH WAS AN INSTANTANEOUS WAGER THAT IF A CLOWNING GESTURE OF DISGRACE WERE MADE TO THE STUDENTS THEN THEY WOULD TRY TO SEE THE BEST IN HIS MUDDLED INTENTIONS.

SNAKES! WHERE AM I? MY LIFE IS A MESS!

MR. BROWN! I DON'T BELIEVE YOU'RE STANDING ON YOUR HEAD!

JUST TO PROVE A POINT, PAM!

AND CALL ME "BINKY" WILL YOU

UNH

OH WOW.

I'LL GIVE HER AN "A".

IN TIME, THE ABANDONMENT OF THE TEACHING CAREER WAS LESS DISGRACEFUL AND IN THE GRAND SCHEME OF THINGS, A TRIFLING MATTER.

AFTER ALL, HE HAD TRIED MANY OTHER HATS ON ALONG THE WAY—SUCH AS THE... CABBIE'S CAP

6748! 6748! COME IN, 6748!

I'VE BEEN WAITIN' FER TH' TOW-TRUCK SINCE MIDNITE... I QUIT! TH' GAHDAMN CAB WILL BE IN FRONT OF TH' SHERATON...

BRAP!

OH NO Y'DON'T! BRAP!

BUS DRIVER'S BEANY (less pointed)

I'M TERRIBLY SORRY, MADAM, BUT YOU MUST HAVE LUNGED INTO THE BUS WHILET I WAS CLOSING THE DOOR.

YOCK! GAH! BLUH!

TUCKPOINTER'S TOPPER

HEY, TONY! WHAT TH' HECK IS "TUCKPOINTIN'"?

"TUCKPOINTIN'" IS FILLIN' IN DEM CEMENT CRACKS IN OL' BRICKS. SO WE STARTS WIT' TH' CHIMNEY. SO DON' STEP BACK TO AD-MIRE YER WORK, MISTER ARTIST.

BUT THERE WAS ONLY ONE HAT THAT SEEMED TO FIT COMFORTABLY.

TH' CARTOONIST'S VISOR!

I'LL BE A PROFESSIONAL WISE-GUY!

HEE HAW BITE DICK, MISTER VERN CASH!

HOUSEMOVER'S HEADPIECE

UNH! UNH! UNH!

SWING YOUR END UP, AND I'LL PIVOT AROUND!

JUSTIN GREEN

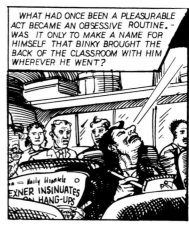
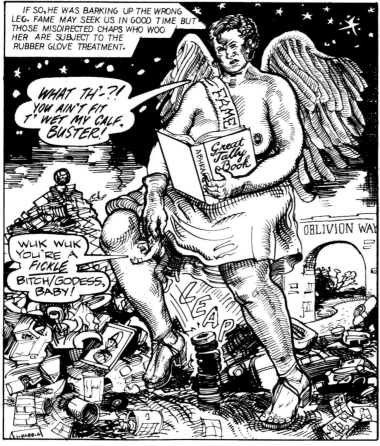
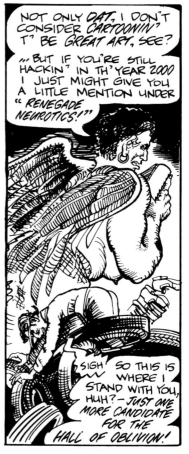

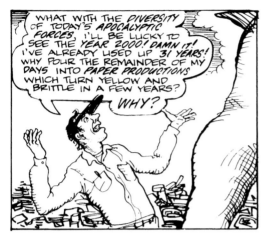

WHAT WITH THE *DIVERSITY* OF TODAY'S *APOCALYPTIC FORCES*, I'LL BE LUCKY TO SEE THE *YEAR 2000!* DAMN IT! I'VE ALREADY USED UP *31 YEARS!* WHY POUR THE REMAINDER OF MY DAYS INTO *PAPER PRODUCTIONS* WHICH TURN YELLOW AND BRITTLE IN A FEW YEARS?

WHY?

FOR THE *PAST 7 YEARS*, I'VE CONSIDERED *EVERY WAKING MOMENT* AND EVEN MY *DREAMS* AS POTENTIALLY VIABLE *CARTOONS* — SO MY LIFE HAS BECOME A RELENTLESS *COMIC STRIP!*

I WANNA GET OFFA THIS MERRY-GO-ROUND!

SPIN 75 45 Tilt

FORE!

GODDAMN FOOL WALKING IN THE MIDDLE OF THE FAIRWAY!!

BONK

PO-PO

53

68

57

63

BONUS

NO SOONER HAD THE MALCONTENT BINK DISCARDED HIS ONCE-REVERED HEADGEAR, A FLYING OBJECT LANDED ON HIS NOGGIN PROVOKING GREAT DISORIENTATION.

59

FLIP

LOOK— I'M IN THE MIDDLE OF THE *18TH HOLE*... I CAN'T STAND HERE AND *SHOOT THE BREEZE!*

SAY! AREN'T YOU MR. *VERN CASH* OF *RITZLAND PARK?*

TIME WAITS FOR NO MAN OR BOY. NEITHER DO I WHEN I'M *GOLFIN'!* STAND BACK!

DON'T YOU REMEMBER ME, *BINKY BROWN,* CLASS OF '63?

NATURE IS OVER-GENEROUS TO EACH GENERATION IN PROVIDING AN ABUNDANCE OF ARTISTS. IT IS SOCIETY'S ROLE TO HOLD IN CHECK THIS TENDENCY, WHICH IF LEFT UNOPPOSED WOULD RENDER THE FIELD UNTILLED AND THE CASH REGISTER UNTENDED. THE GEARING OF INHERENT ARTISTIC SKILLS TOWARDS THE MARKETPLACE SHOULD BEGIN IN HIGH SCHOOL; IT IS THE GUIDANCE COUNSELOR'S JOB TO ACQUAINT THE BUDDING ARTIST WITH THE DEMANDS OF SURVIVAL. THOUGH 15 YEARS LATER, BINKY FOLLOWED THE OLD DEAN'S ADVICE BY TAKING UP A CAREER IN SIGN-PAINTING.

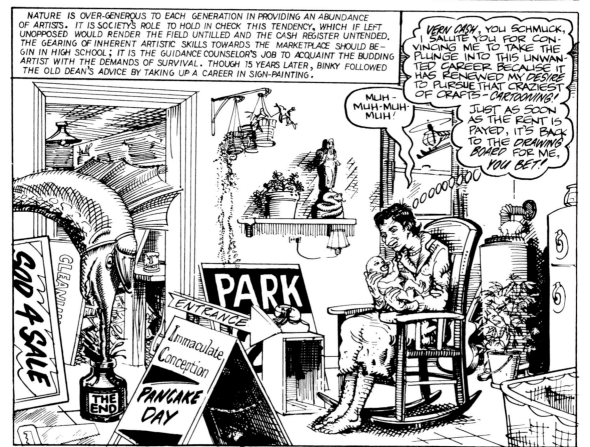

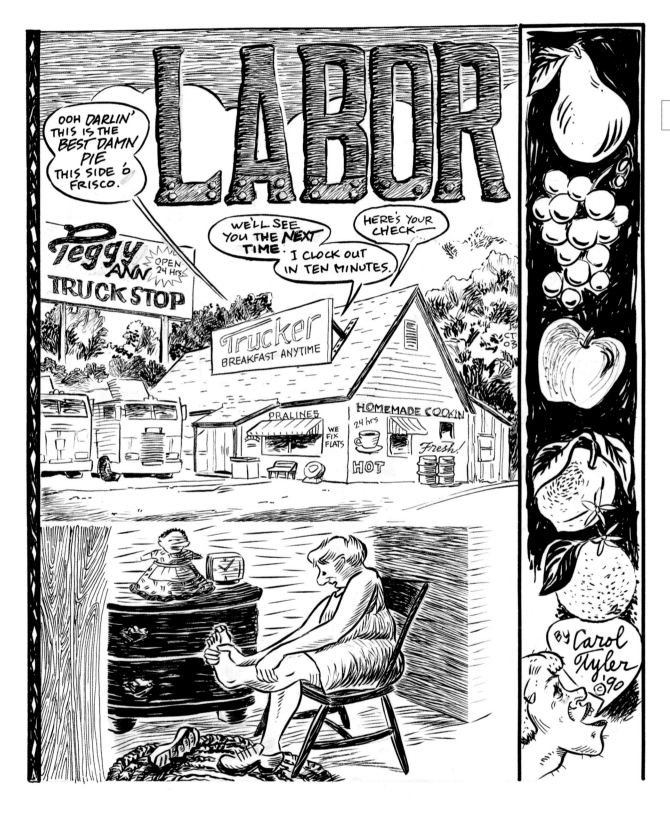

My Prayer

I THINK WE MAY AS WELL CHANGE THE SLOGAN ON OUR CURRENCY FROM "IN GOD WE TRUST" TO "T.G.I.F." (THANK GOD IT'S FRIDAY.) I MEAN, WHO ARE WE KIDDING?! **LABOR** IN THIS CULTURE IS JUST A VACUOUS EXCUSE TO GET TO THE WEEKEND. IT'S AN ATTITUDE THAT SUGGESTS THAT WHAT WE'RE DOIN' DURING THE WORK WEEK IS <u>NOT THE REAL THING</u>.

LOOK, HOWEVER AT THE FLIMSY HEM ON THAT "DESIGNER" GARMENT YOU PAID A FORTUNE FOR, OR SPEND HOURS TRYING TO UNRAVEL A CLERICAL ERROR YOU ARE BEING CHARGED FOR, AND IT BECOMES APPARENT. ... I WISH THAT PEOPLE WOULD REALIZE THAT ALTHO WE *HAVE* TO WORK TO SURVIVE, THE WORLD IS A BETTER PLACE WHEN THE STITCHES ARE SEWN CAREFULLY.

PTBBBB

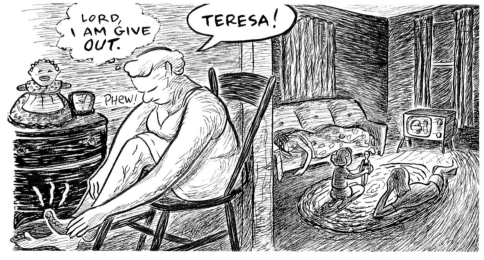

LORD, I AM GIVE OUT.

PHEW!

TERESA!

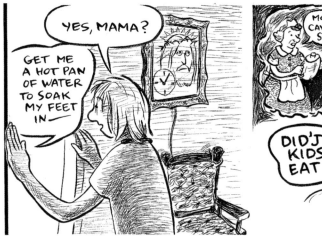

YES, MAMA?

GET ME A HOT PAN OF WATER TO SOAK MY FEET IN—

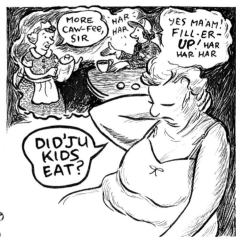

MORE CAW-FEE, SIR

HAR HAR

YES MA'AM! FILL-ER-UP! HAR HAR HAR

DID'JU KIDS EAT?

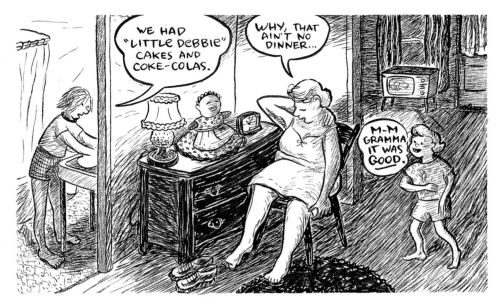

WE HAD "LITTLE DEBBIE" CAKES AND COKE-COLAS.

WHY, THAT AIN'T NO DINNER...

M-M GRAMMA IT WAS GOOD.

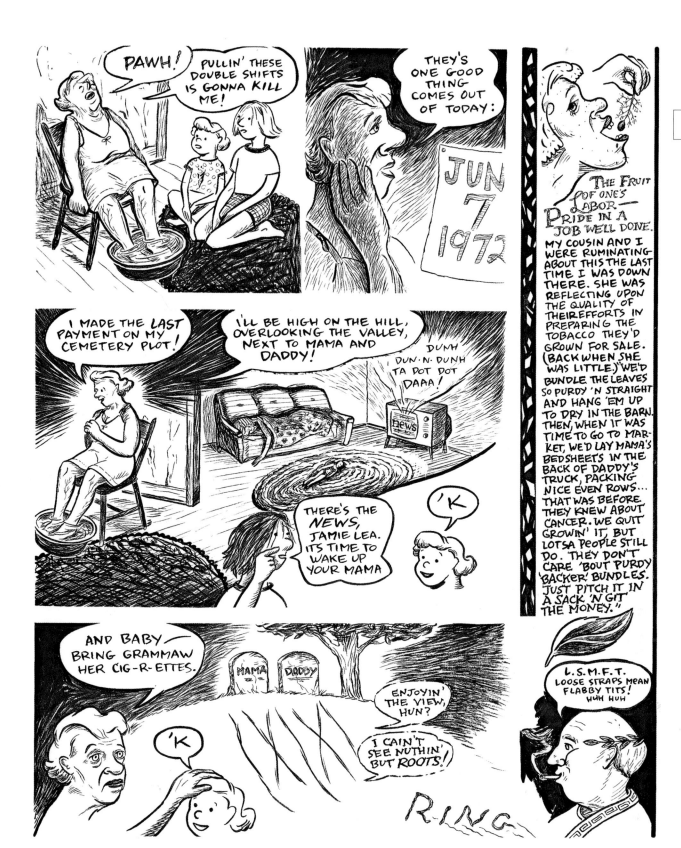

CAROL TYLER

56

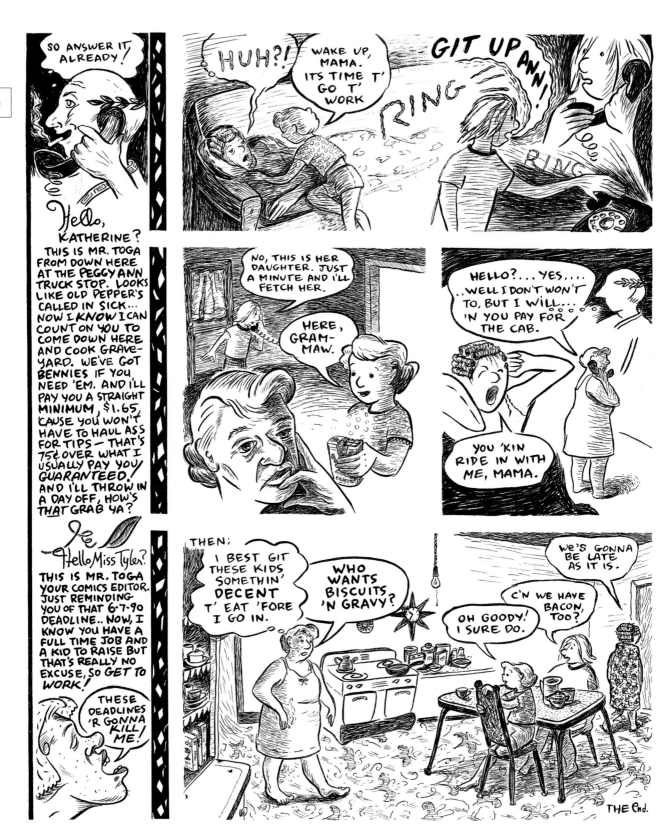

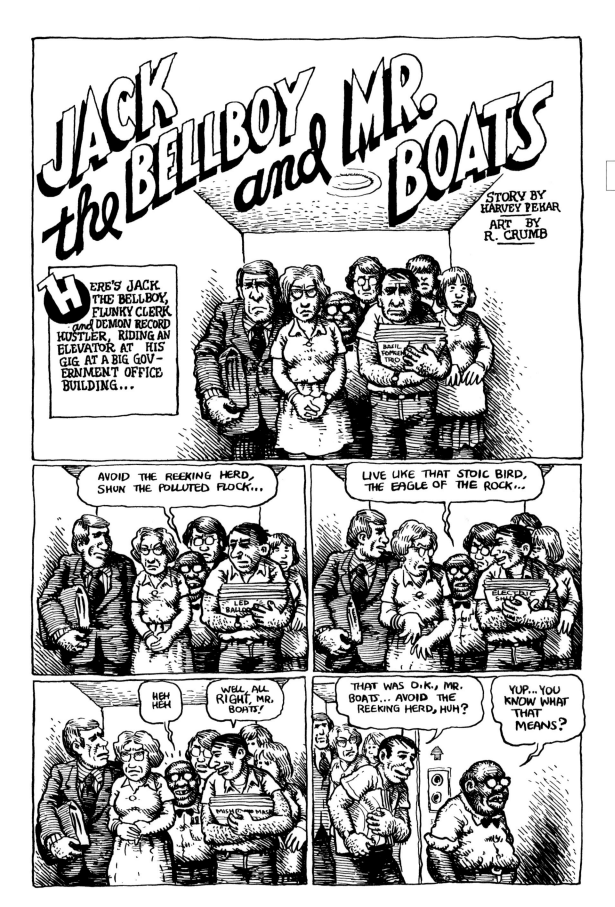

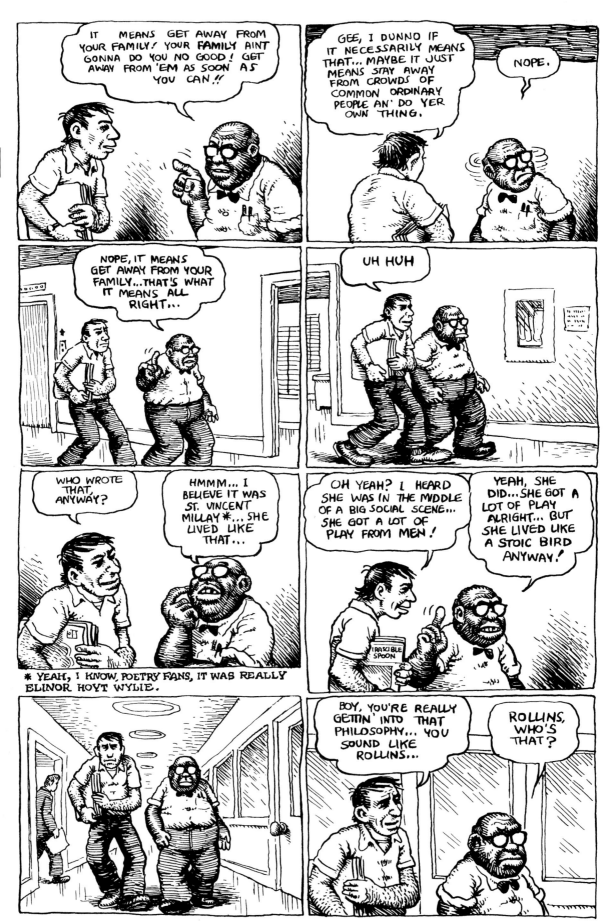

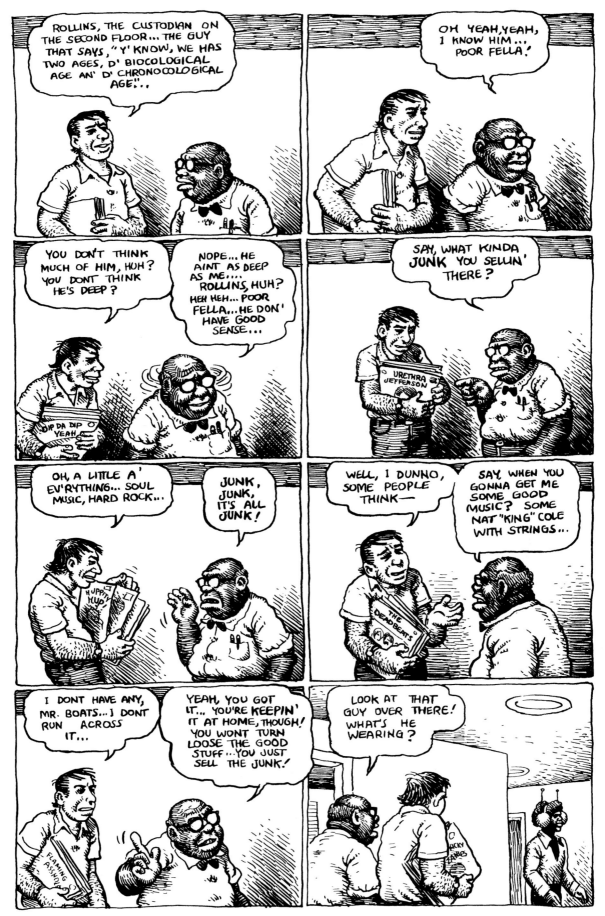

59

HARVEY PEKAR + R. CRUMB

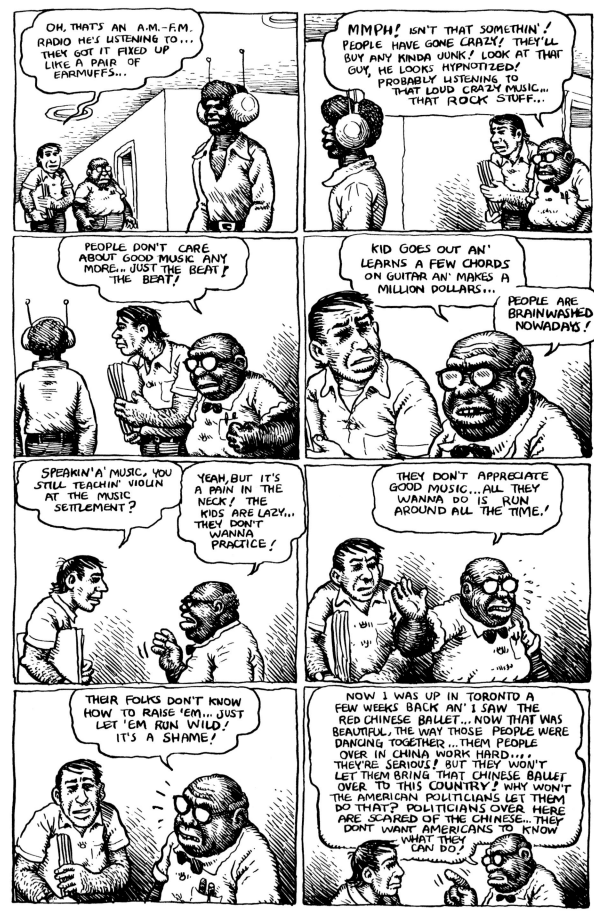

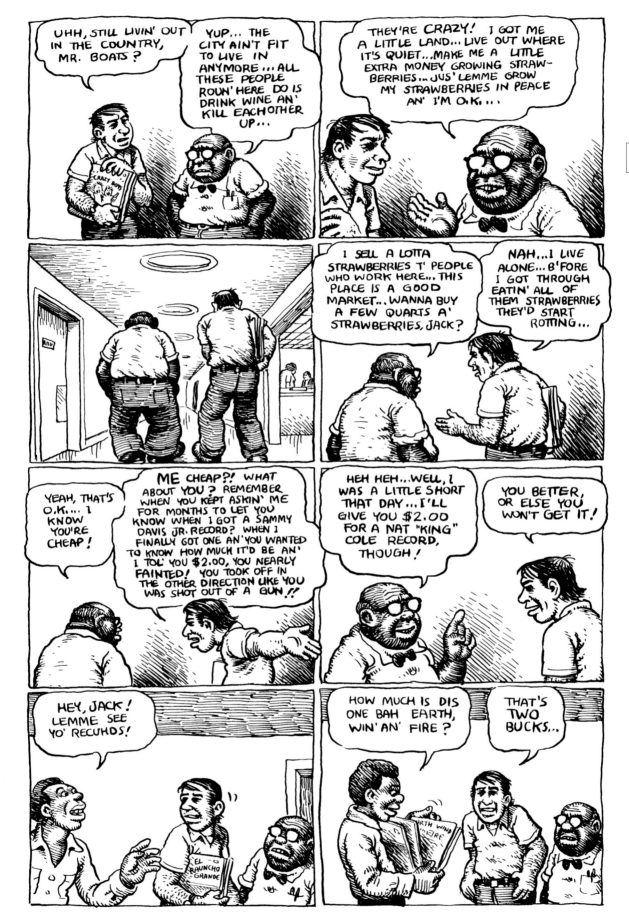

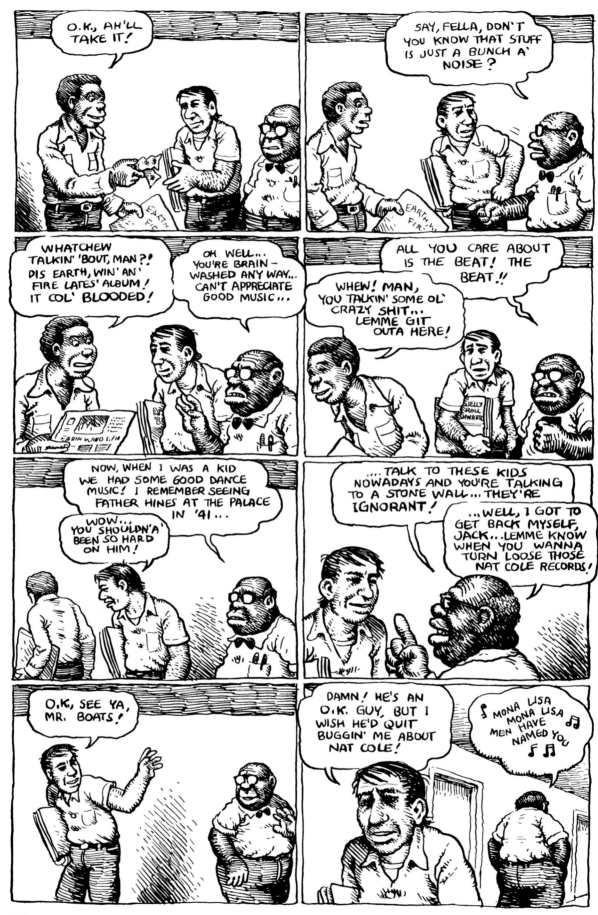

PART TWO
SILVER AGE OF SUPERHEROES

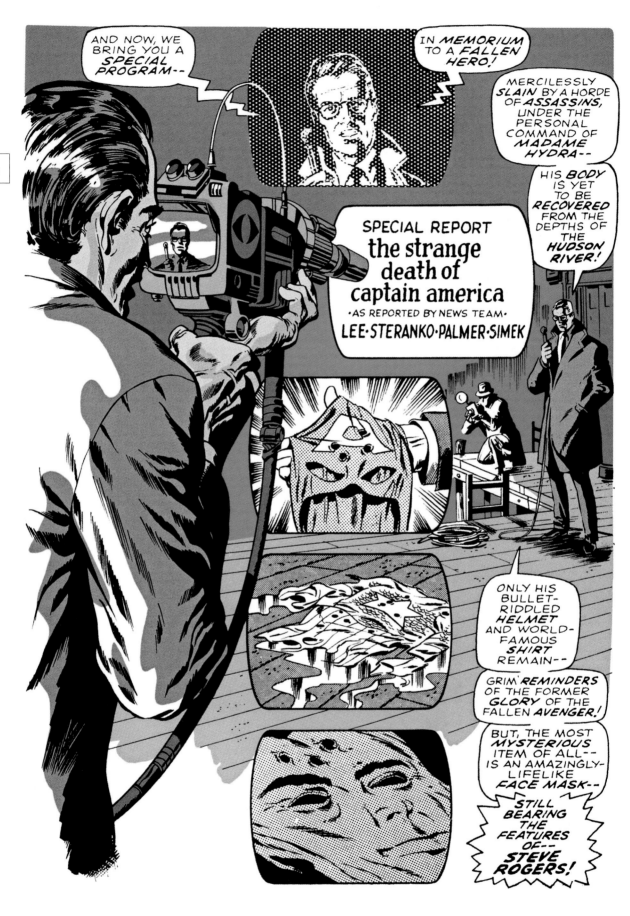

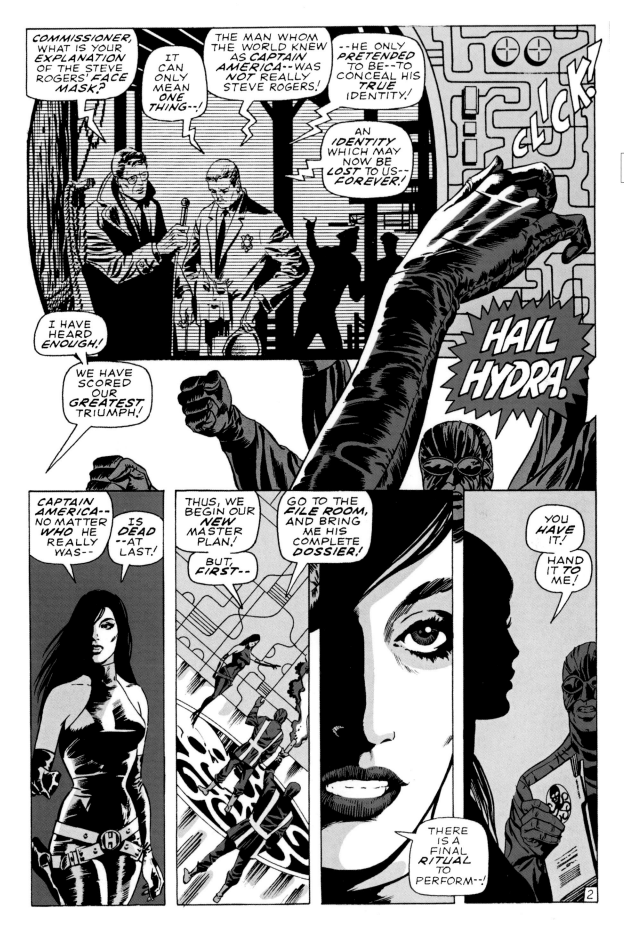

STAN LEE + JIM STERANKO

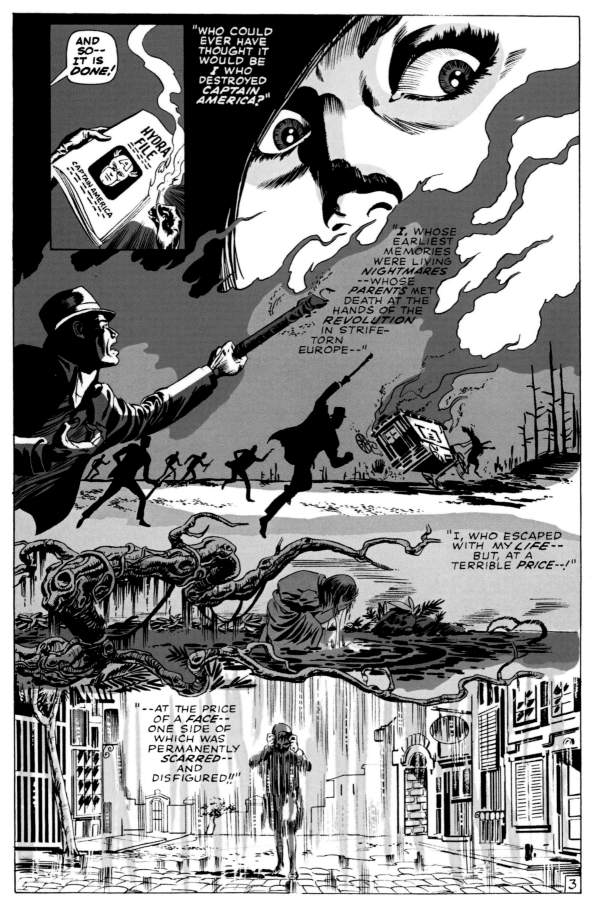

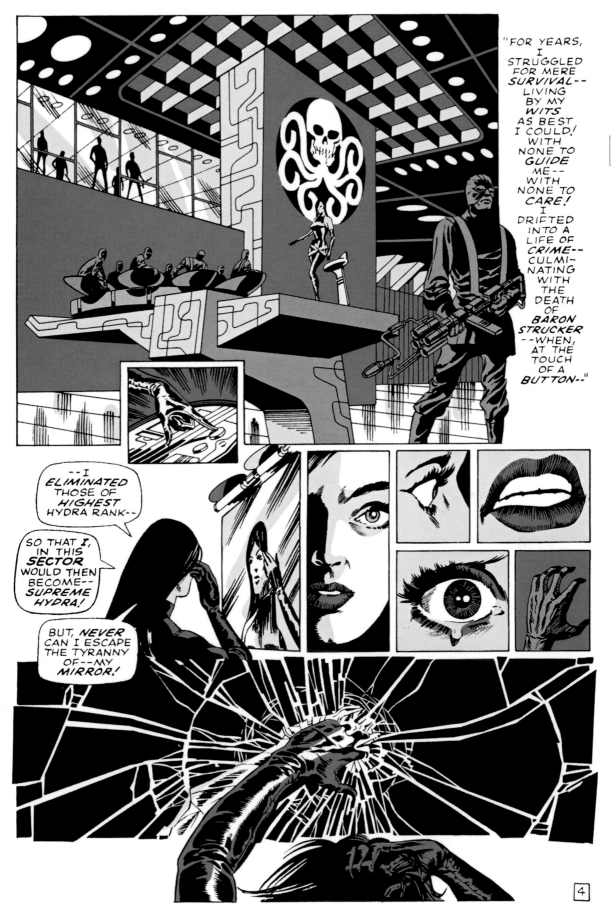

"FOR YEARS, I STRUGGLED FOR MERE SURVIVAL-- LIVING BY MY WITS AS BEST I COULD! WITH NONE TO GUIDE ME-- WITH NONE TO CARE! I DRIFTED INTO A LIFE OF CRIME-- CULMINATING WITH THE DEATH OF BARON STRUCKER --WHEN, AT THE TOUCH OF A BUTTON--"

--I ELIMINATED THOSE OF HIGHEST HYDRA RANK--

SO THAT I, IN THIS SECTOR WOULD THEN BECOME-- SUPREME HYDRA!

BUT, NEVER CAN I ESCAPE THE TYRANNY OF--MY MIRROR!

STAN LEE + JIM STERANKO

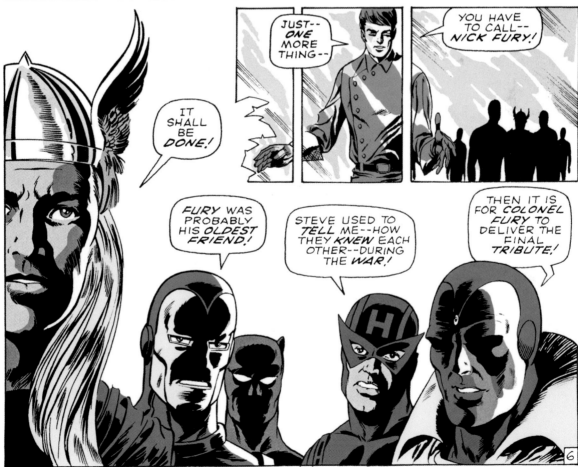

STAN LEE + JIM STERANKO

A SHORT TIME LATER, WITHIN THE AUSTERE CONFINES OF A MIDTOWN *FUNERAL PARLOR*--

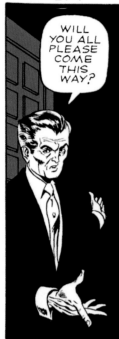

WILL YOU ALL PLEASE COME THIS WAY?

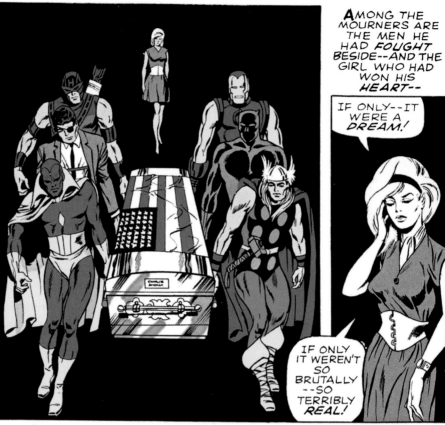

AMONG THE MOURNERS ARE THE MEN HE HAD *FOUGHT* BESIDE--AND THE GIRL WHO HAD WON HIS *HEART*--

IF ONLY--IT WERE A *DREAM!*

IF ONLY IT WEREN'T SO BRUTALLY --SO TERRIBLY *REAL!*

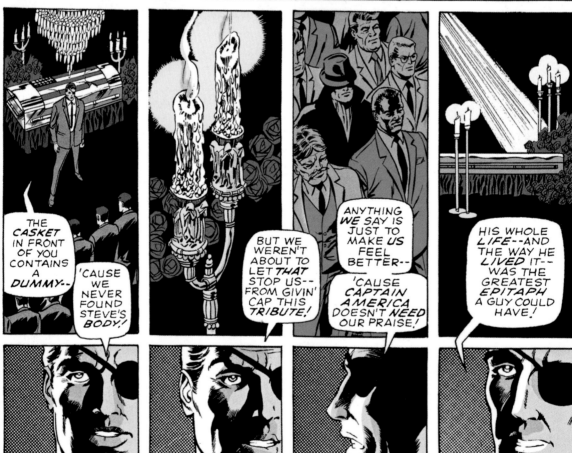

THE *CASKET* IN FRONT OF YOU CONTAINS A *DUMMY*--

'CAUSE WE NEVER FOUND STEVE'S *BODY!*

BUT WE WEREN'T ABOUT TO LET *THAT* STOP US-- FROM GIVIN' CAP THIS *TRIBUTE!*

ANYTHING *WE* SAY IS JUST TO MAKE *US* FEEL BETTER--

'CAUSE *CAPTAIN AMERICA* DOESN'T *NEED* OUR PRAISE!

HIS WHOLE *LIFE*--AND THE WAY HE *LIVED* IT-- WAS THE GREATEST *EPITAPH* A GUY COULD HAVE!

7

I'M NOT MUCH AT MAKIN' *SPEECHES*--

BUT IT DOESN'T *MATTER!*

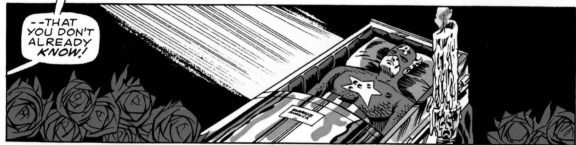

'CAUSE THERE'S NOTHIN' I CAN *SAY*--

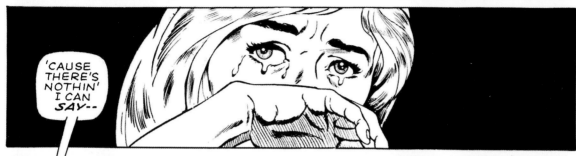

--THAT YOU DON'T ALREADY *KNOW!*

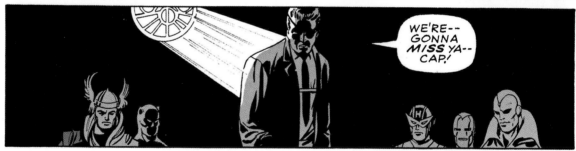

WE'RE-- GONNA *MISS* YA-- CAP!

MEANWHILE, AT THE AVENGERS MANSION, THERE IS *ANOTHER* WHO MISSES CAPTAIN AMERICA--

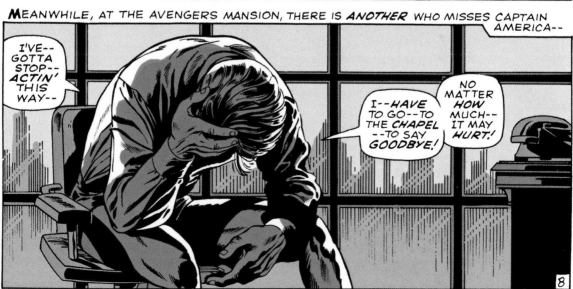

I'VE-- GOTTA STOP-- *ACTIN'* THIS WAY--

I--HAVE TO GO--TO THE *CHAPEL* --TO SAY *GOODBYE!*

NO MATTER *HOW* MUCH-- IT MAY *HURT!*

8

STAN LEE + JIM STERANKO

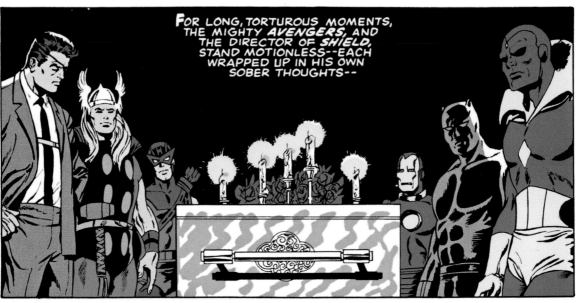

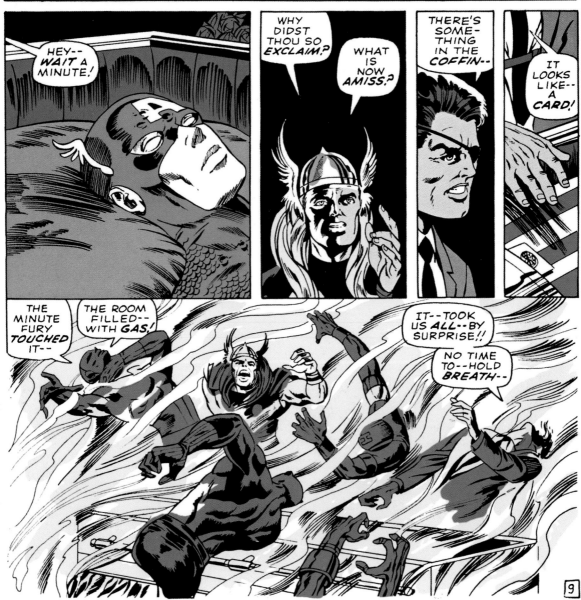

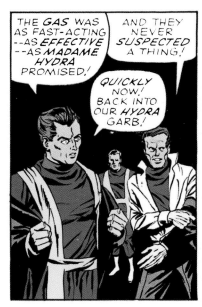

THE *GAS* WAS AS FAST-ACTING --AS *EFFECTIVE* --AS *MADAME HYDRA* PROMISED.!

AND THEY *NEVER* SUSPECTED A THING.!

QUICKLY *NOW!* BACK INTO OUR *HYDRA* GARB.!

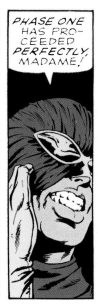

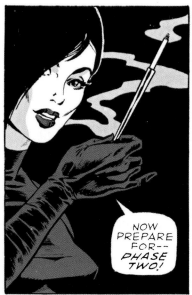

PHASE ONE HAS PRO-CEEDED *PERFECTLY,* MADAME.!

NOW PREPARE FOR-- *PHASE TWO!*

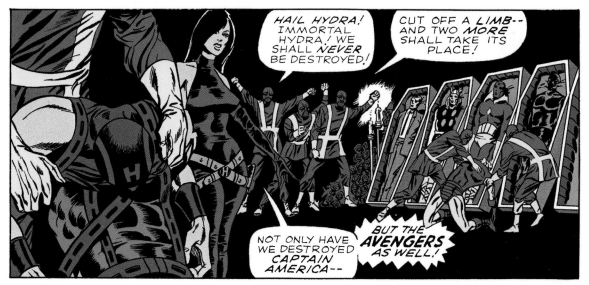

HAIL HYDRA! IMMORTAL *HYDRA!* WE SHALL *NEVER* BE DESTROYED.!

CUT OFF A *LIMB*-- AND TWO *MORE* SHALL TAKE ITS PLACE.!

NOT ONLY HAVE WE DESTROYED *CAPTAIN AMERICA*--

BUT THE AVENGERS AS WELL!

MEANWHILE, OUTSIDE--

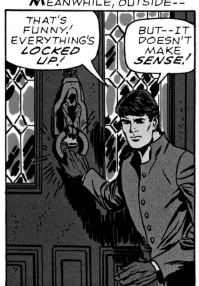

THAT'S *FUNNY!* EVERYTHING'S *LOCKED UP!*

BUT--IT DOESN'T MAKE *SENSE.!*

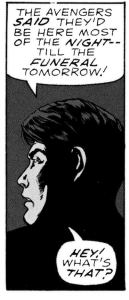

THE AVENGERS *SAID* THEY'D BE HERE MOST OF THE *NIGHT*-- TILL THE *FUNERAL* TOMORROW.!

HEY! WHAT'S *THAT?*

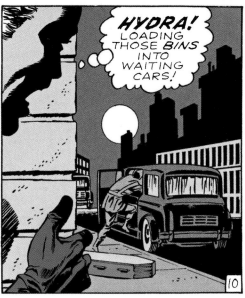

HYDRA! LOADING THOSE *BINS* INTO WAITING *CARS!*

10

I DUNNO WHAT IT *MEANS*--

BUT I KNOW I'VE GOTTA *FOLLOW* THEM!

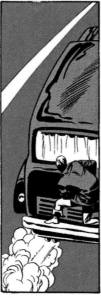

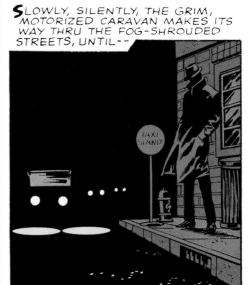

SLOWLY, SILENTLY, THE GRIM, MOTORIZED CARAVAN MAKES ITS WAY THRU THE FOG-SHROUDED STREETS, UNTIL--

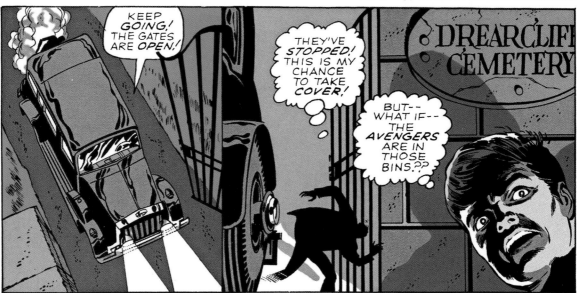

KEEP *GOING!* THE GATES ARE *OPEN!*

THEY'VE *STOPPED!* THIS IS MY CHANCE TO TAKE *COVER!*

BUT-- WHAT IF-- THE *AVENGERS* ARE IN THOSE BINS.??

DREARCLIFF CEMETERY

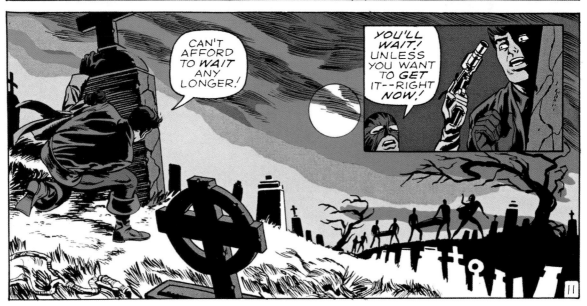

CAN'T AFFORD TO *WAIT* ANY LONGER!

YOU'LL WAIT! UNLESS YOU WANT TO *GET* IT--RIGHT *NOW!*

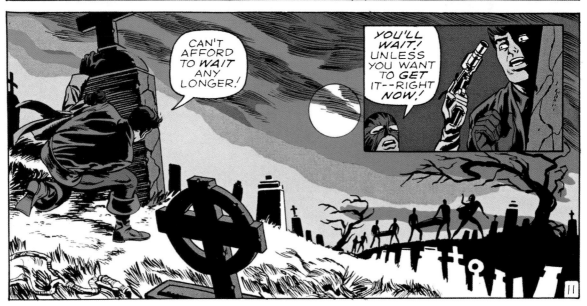

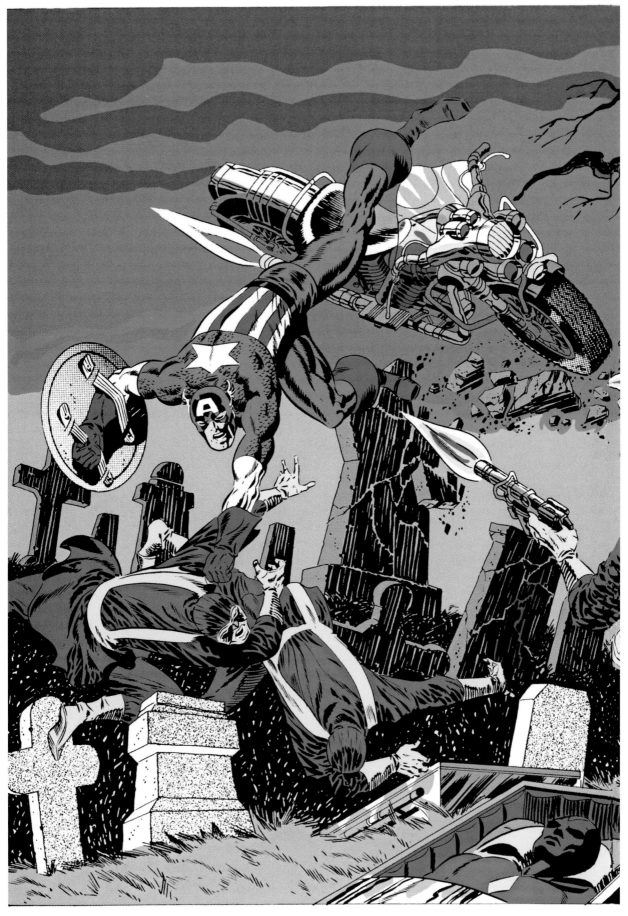

STAN LEE + JIM STERANKO

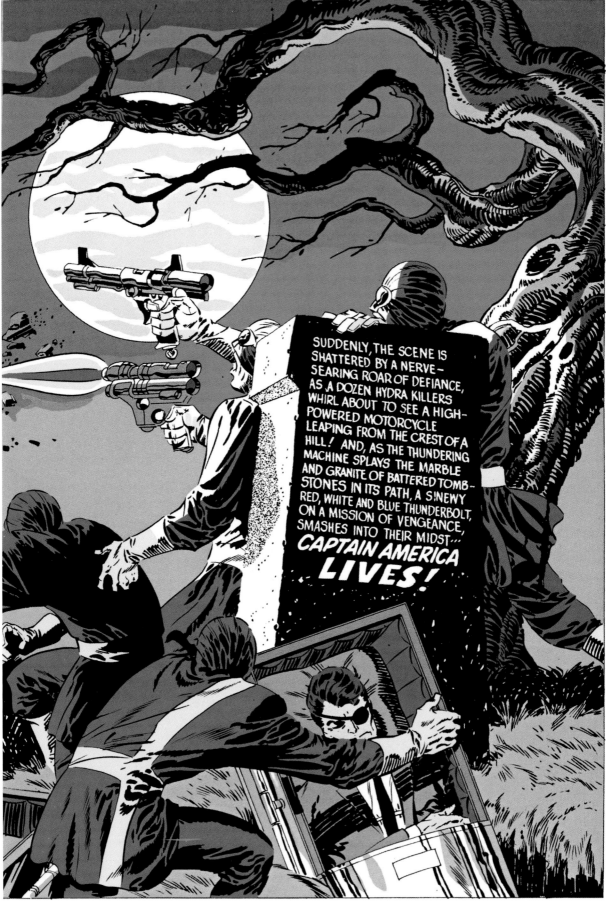

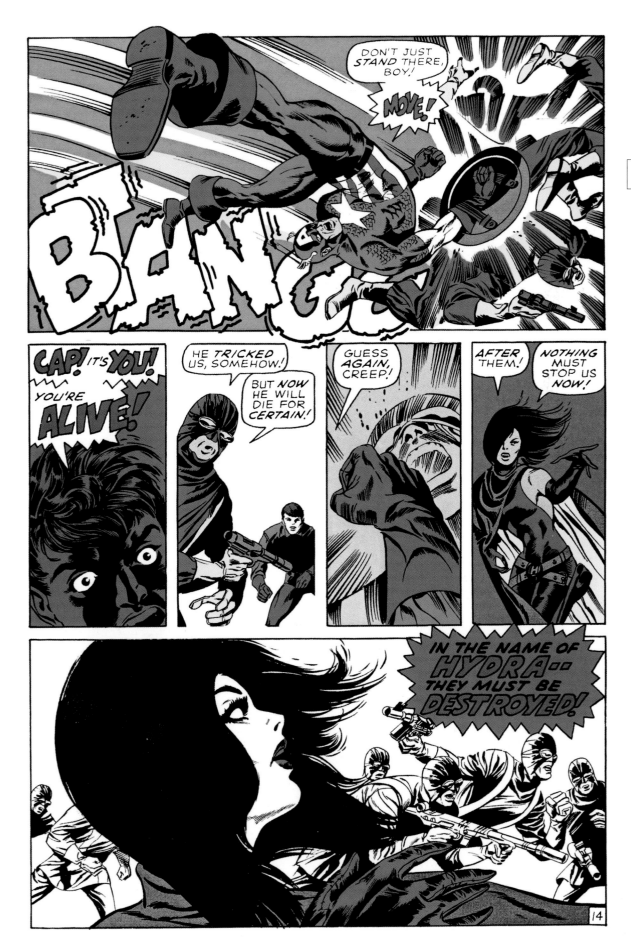

STAN LEE + JIM STERANKO

A *MAN* CAN BE DESTROYED! A *TEAM*, OR AN *ARMY* CAN BE DESTROYED! BUT, HOW DO YOU DESTROY AN *IDEAL*--A *DREAM?* HOW DO YOU DESTROY A LIVING *SYMBOL*--OR HIS INDOMITABLE *WILL*--HIS UNQUENCHABLE *SPIRIT?* PERHAPS *THESE* ARE THE THOUGHTS WHICH THUNDER WITHIN THE MURDEROUS *MINDS* OF THOSE WHO HAVE CHOSEN THE WAY OF *HYDRA*--OF THOSE WHO FACE THE *FIGHTING FURY* OF FREEDOM'S MOST FEAR-LESS *CHAMPION*--THE GALLANT, RED-WHITE-AND-BLUE-GARBED FIGURE WHO HAS BEEN A TOWERING SOURCE OF *INSPIRATION* TO LIBERTY-LOVERS EVERYWHERE! HOW CAN THE FEARSOME FORCES OF *EVIL* EVER HOPE TO DESTROY THE UNCONQUER-ABLE *CAPTAIN AMERICA?*

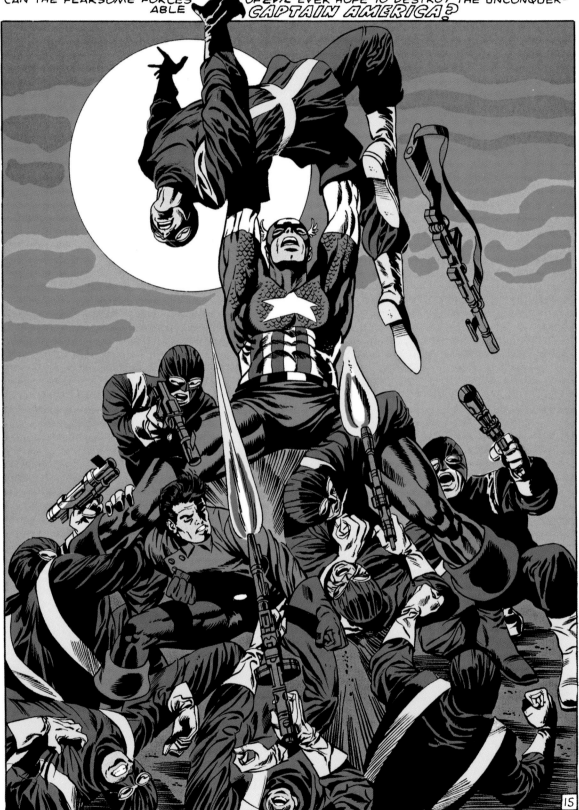

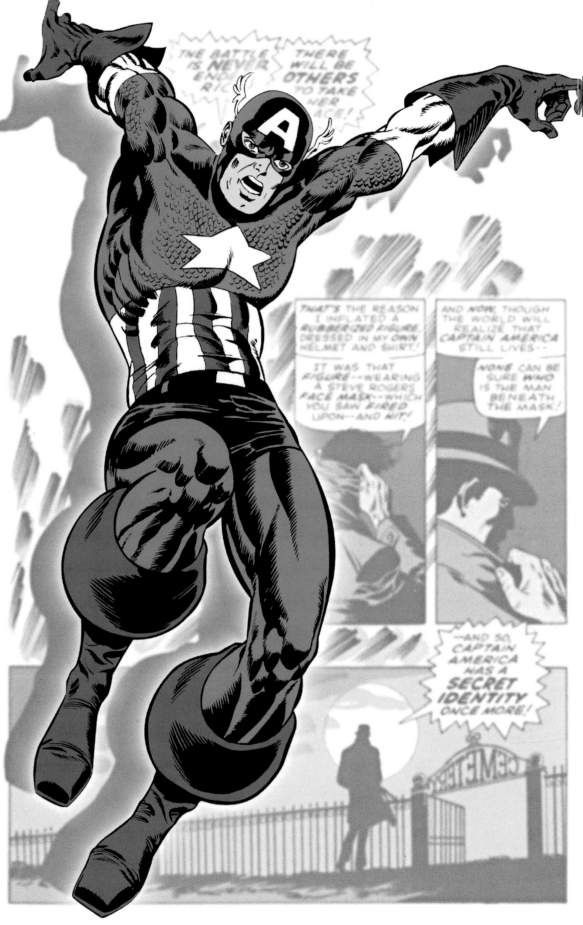

STAN LEE + JIM STERANKO

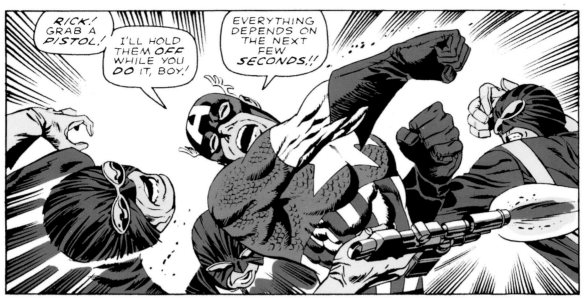

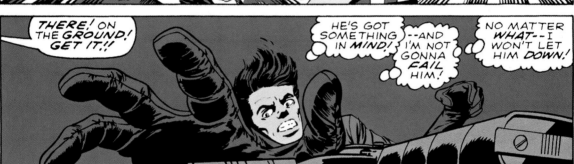

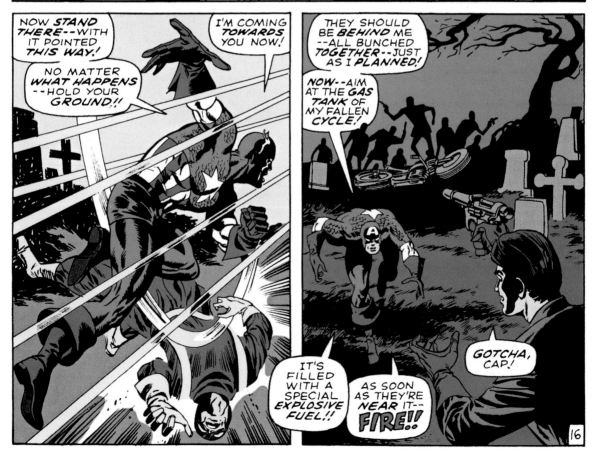

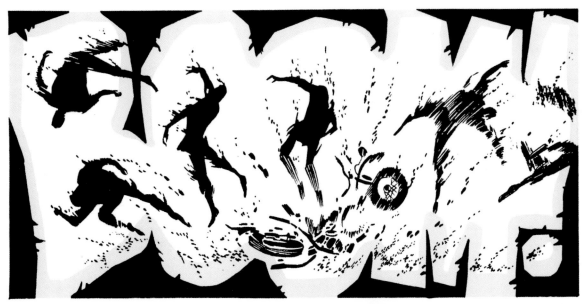

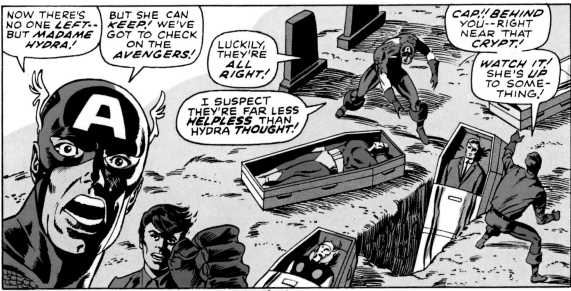

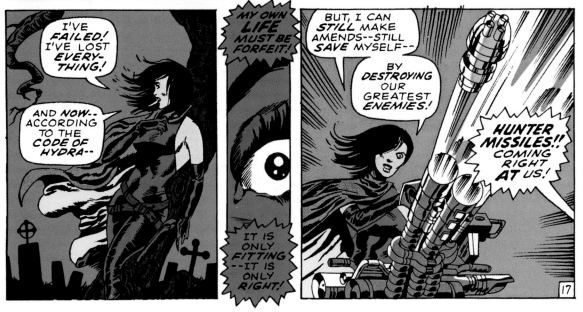

STAN LEE + JIM STERANKO

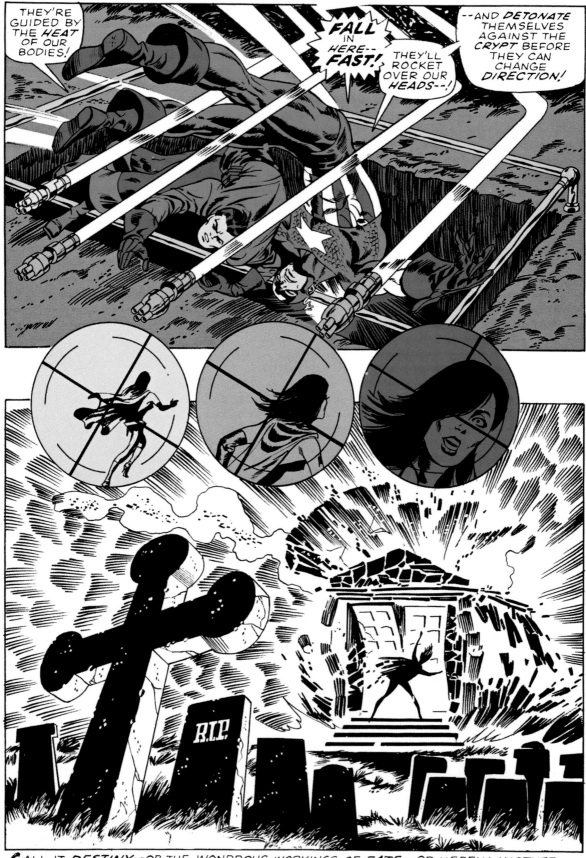

CALL IT DESTINY--OR THE WONDROUS WORKINGS OF FATE--OR MERELY ANOTHER OF LIFE'S INEXPLICABLE IRONIES...CALL IT WHAT YOU WILL--BUT, IN A MATTER OF SPLIT-SECONDS, SHE WHO HAD BEEN MADAME HYDRA REAPS THE GRIM HARVEST SHE HAD SO MERCILESSLY SOWN--!

18

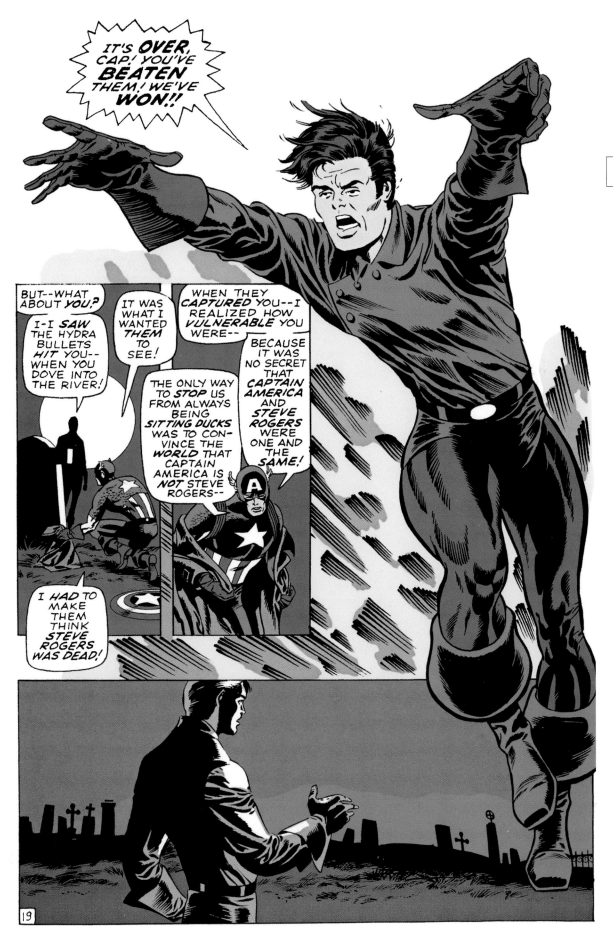

IT'S *OVER,* CAP.! YOU'VE *BEATEN* THEM.! WE'VE *WON!!*

83

BUT--WHAT ABOUT *YOU?*

I-I *SAW* THE HYDRA BULLETS *HIT* YOU-- WHEN YOU DOVE INTO THE RIVER!

IT WAS WHAT I WANTED *THEM* TO *SEE!*

WHEN THEY *CAPTURED* YOU--I REALIZED HOW *VULNERABLE* YOU WERE--

THE ONLY WAY TO *STOP* US FROM ALWAYS BEING *SITTING DUCKS* WAS TO CON-VINCE THE *WORLD* THAT CAPTAIN AMERICA IS *NOT* STEVE ROGERS--

BECAUSE IT WAS NO SECRET THAT *CAPTAIN AMERICA* AND *STEVE ROGERS* WERE ONE AND THE *SAME!*

I *HAD* TO MAKE THEM THINK *STEVE ROGERS* WAS DEAD!

19

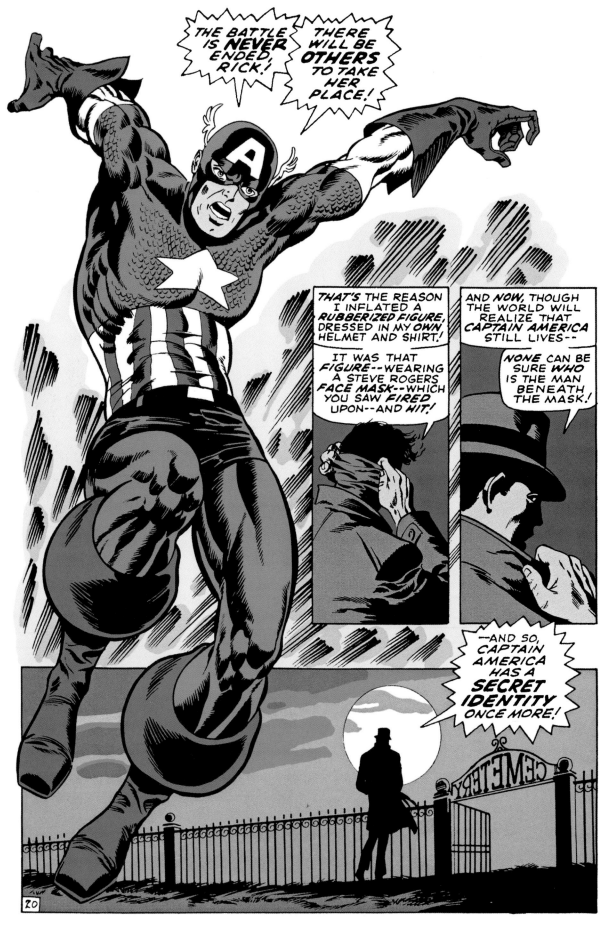

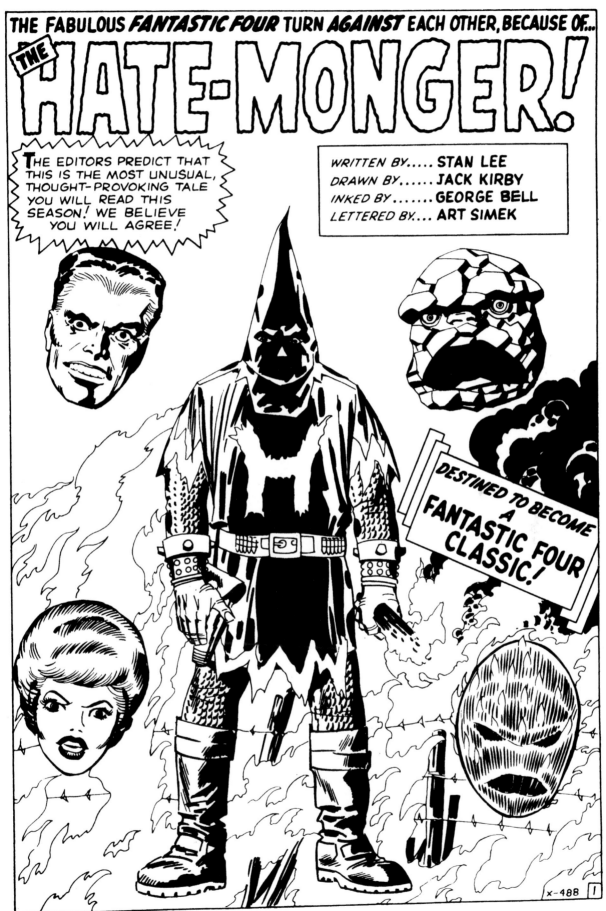

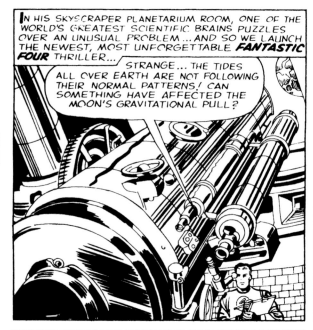

IN HIS SKYSCRAPER PLANETARIUM ROOM, ONE OF THE WORLD'S GREATEST SCIENTIFIC BRAINS PUZZLES OVER AN UNUSUAL PROBLEM...AND SO WE LAUNCH THE NEWEST, MOST UNFORGETTABLE *FANTASTIC FOUR* THRILLER...

STRANGE...THE TIDES ALL OVER EARTH ARE NOT FOLLOWING THEIR NORMAL PATTERNS! CAN SOMETHING HAVE AFFECTED THE MOON'S GRAVITATIONAL PULL?

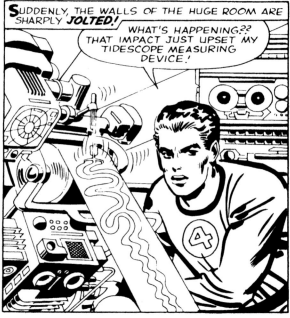

SUDDENLY, THE WALLS OF THE HUGE ROOM ARE SHARPLY *JOLTED!*

WHAT'S HAPPENING.?? THAT IMPACT JUST UPSET MY TIDESCOPE MEASURING DEVICE!

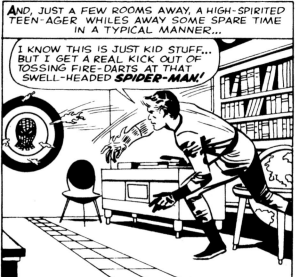

AND, JUST A FEW ROOMS AWAY, A HIGH-SPIRITED TEEN-AGER WHILES AWAY SOME SPARE TIME IN A TYPICAL MANNER...

I KNOW THIS IS JUST KID STUFF... BUT I GET A REAL KICK OUT OF TOSSING FIRE-DARTS AT THAT SWELL-HEADED *SPIDER-MAN!*

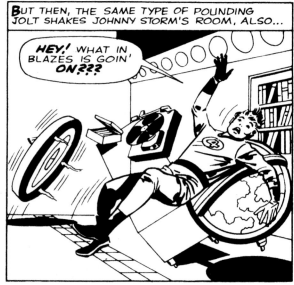

BUT THEN, THE SAME TYPE OF POUNDING JOLT SHAKES JOHNNY STORM'S ROOM, ALSO...

HEY! WHAT IN BLAZES IS GOIN' *ON.???*

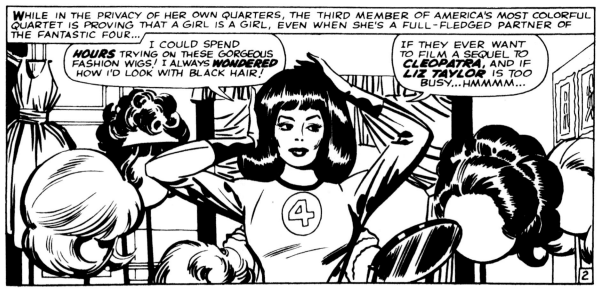

WHILE IN THE PRIVACY OF HER OWN QUARTERS, THE THIRD MEMBER OF AMERICA'S MOST COLORFUL QUARTET IS PROVING THAT A GIRL IS A GIRL, EVEN WHEN SHE'S A FULL-FLEDGED PARTNER OF THE FANTASTIC FOUR...

I COULD SPEND *HOURS* TRYING ON THESE GORGEOUS FASHION WIGS! I ALWAYS *WONDERED* HOW I'D LOOK WITH BLACK HAIR!

IF THEY EVER WANT TO FILM A SEQUEL TO *CLEOPATRA*, AND IF *LIZ TAYLOR* IS TOO BUSY...HMMMM...

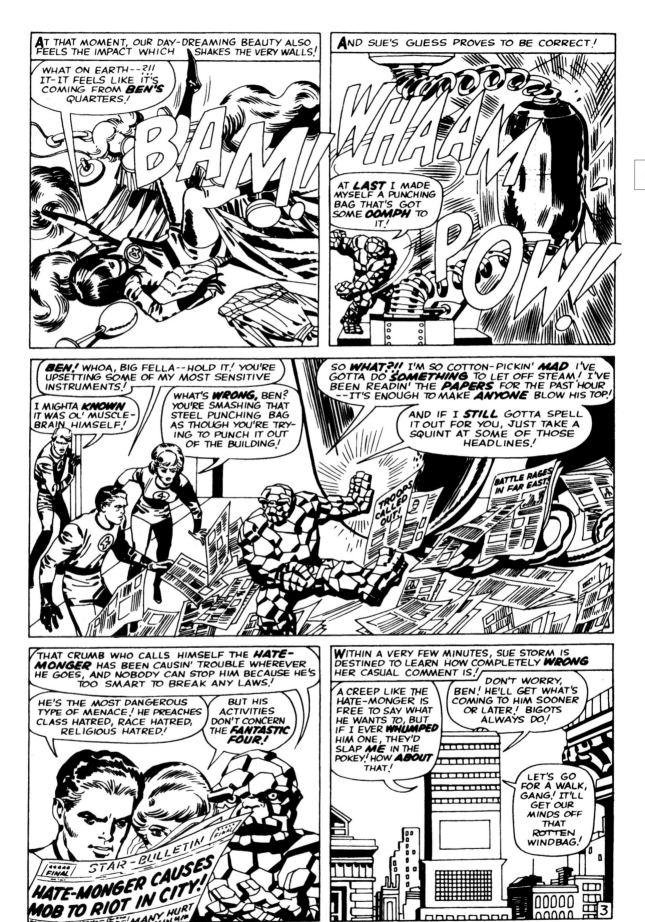

STAN LEE + JACK KIRBY

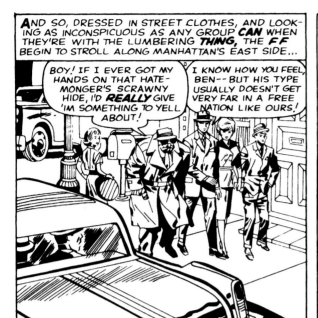

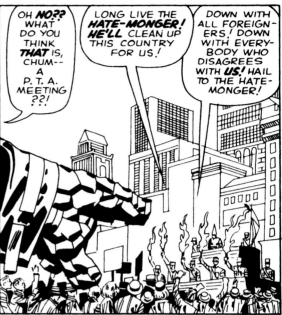

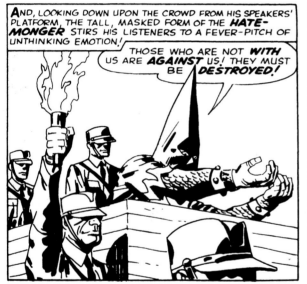

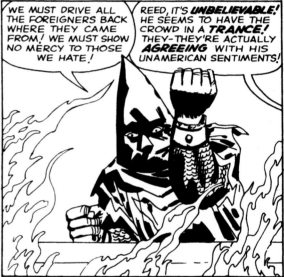

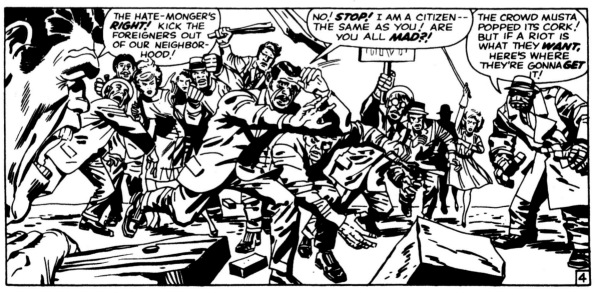

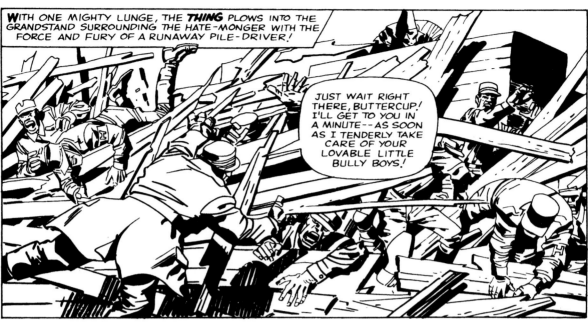

WITH ONE MIGHTY LUNGE, THE **THING** PLOWS INTO THE GRANDSTAND SURROUNDING THE HATE-MONGER WITH THE FORCE AND FURY OF A RUNAWAY PILE-DRIVER!

JUST WAIT RIGHT THERE, BUTTERCUP! I'LL GET TO YOU IN A MINUTE--AS SOON AS I TENDERLY TAKE CARE OF YOUR LOVABLE LITTLE BULLY BOYS!

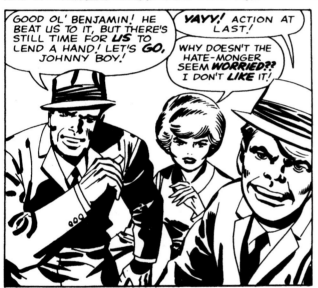

GOOD OL' BENJAMIN! HE BEAT US TO IT, BUT THERE'S STILL TIME FOR **US** TO LEND A HAND! LET'S **GO,** JOHNNY BOY!

YAYV! ACTION AT LAST!

WHY DOESN'T THE HATE-MONGER SEEM **WORRIED??** I DON'T **LIKE** IT!

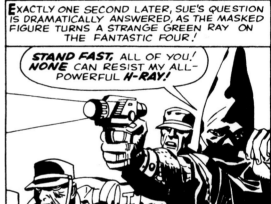

EXACTLY ONE SECOND LATER, SUE'S QUESTION IS DRAMATICALLY ANSWERED, AS THE MASKED FIGURE TURNS A STRANGE GREEN RAY ON THE FANTASTIC FOUR!

STAND FAST, ALL OF YOU! **NONE** CAN RESIST MY ALL-POWERFUL **H-RAY!**

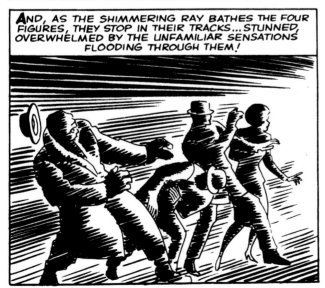

AND, AS THE SHIMMERING RAY BATHES THE FOUR FIGURES, THEY STOP IN THEIR TRACKS...STUNNED, OVERWHELMED BY THE UNFAMILIAR SENSATIONS FLOODING THROUGH THEM!

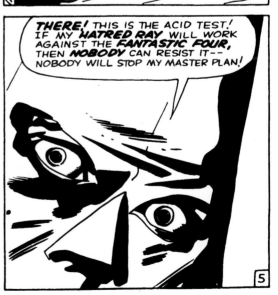

THERE! THIS IS THE ACID TEST! IF MY **HATRED RAY** WILL WORK AGAINST THE **FANTASTIC FOUR,** THEN **NOBODY** CAN RESIST IT-- NOBODY WILL STOP MY MASTER PLAN!

5

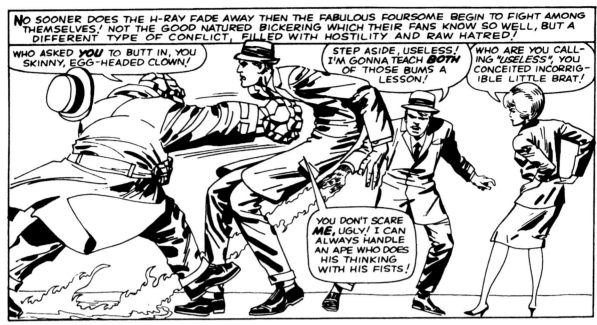

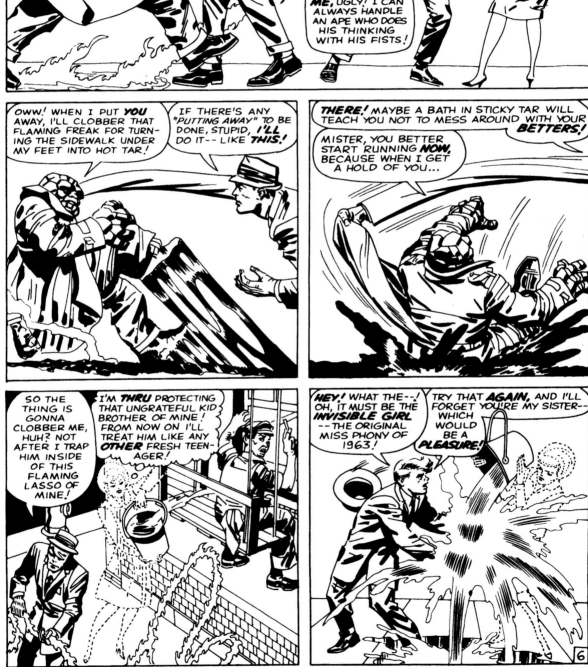

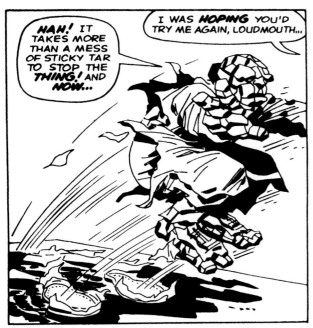

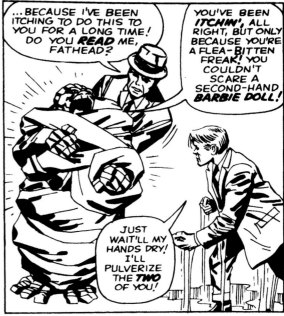

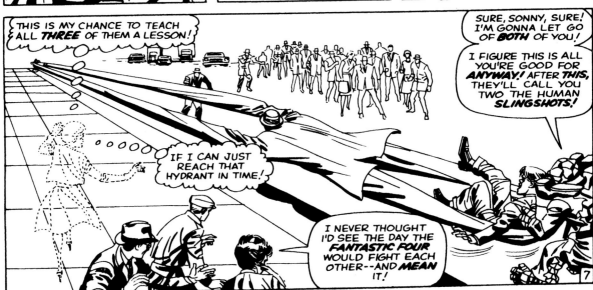

STAN LEE + JACK KIRBY

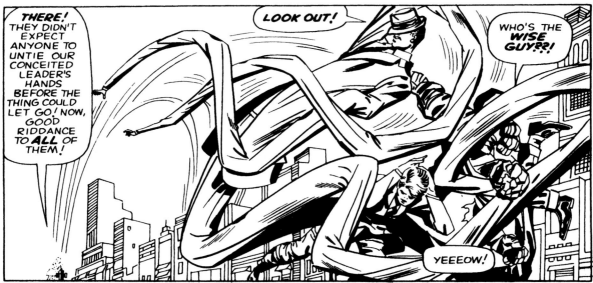

THERE! THEY DIDN'T EXPECT ANYONE TO UNTIE OUR CONCEITED LEADER'S HANDS BEFORE THE THING COULD LET GO! NOW, GOOD RIDDANCE TO ALL OF THEM!

LOOK OUT!

WHO'S THE WISE GUY??!

YEEEOW!

92

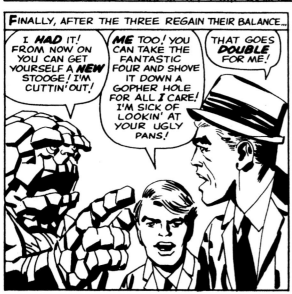

FINALLY, AFTER THE THREE REGAIN THEIR BALANCE...

I HAD IT! FROM NOW ON YOU CAN GET YOURSELF A NEW STOOGE! I'M CUTTIN' OUT!

ME TOO! YOU CAN TAKE THE FANTASTIC FOUR AND SHOVE IT DOWN A GOPHER HOLE FOR ALL I CARE! I'M SICK OF LOOKIN' AT YOUR UGLY PANS!

THAT GOES DOUBLE FOR ME!

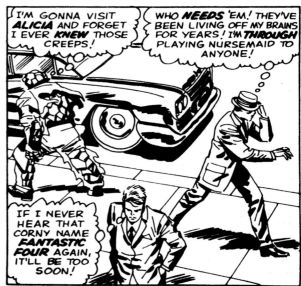

I'M GONNA VISIT ALICIA AND FORGET I EVER KNEW THOSE CREEPS!

WHO NEEDS 'EM! THEY'VE BEEN LIVING OFF MY BRAINS FOR YEARS! I'M THROUGH PLAYING NURSEMAID TO ANYONE!

IF I NEVER HEAR THAT CORNY NAME FANTASTIC FOUR AGAIN, IT'LL BE TOO SOON!

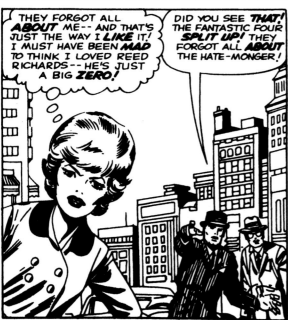

THEY FORGOT ALL ABOUT ME-- AND THAT'S JUST THE WAY I LIKE IT! I MUST HAVE BEEN MAD TO THINK I LOVED REED RICHARDS-- HE'S JUST A BIG ZERO!

DID YOU SEE THAT! THE FANTASTIC FOUR SPLIT UP! THEY FORGOT ALL ABOUT THE HATE-MONGER!

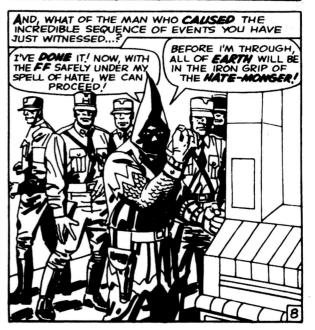

AND, WHAT OF THE MAN WHO CAUSED THE INCREDIBLE SEQUENCE OF EVENTS YOU HAVE JUST WITNESSED...?

I'VE DONE IT! NOW, WITH THE FF SAFELY UNDER MY SPELL OF HATE, WE CAN PROCEED!

BEFORE I'M THROUGH, ALL OF EARTH WILL BE IN THE IRON GRIP OF THE HATE-MONGER!

8

SILVER AGE OF SUPERHEROES

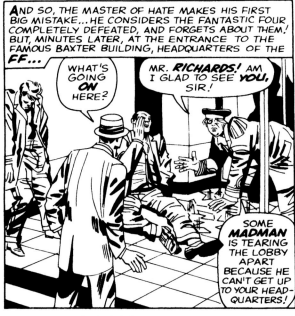

AND SO, THE MASTER OF HATE MAKES HIS FIRST BIG MISTAKE...HE CONSIDERS THE FANTASTIC FOUR COMPLETELY DEFEATED, AND FORGETS ABOUT THEM! BUT, MINUTES LATER, AT THE ENTRANCE TO THE FAMOUS BAXTER BUILDING, HEADQUARTERS OF THE FF...

WHAT'S GOING ON HERE?

MR. RICHARDS! AM I GLAD TO SEE YOU, SIR!

SOME MADMAN IS TEARING THE LOBBY APART BECAUSE HE CAN'T GET UP TO YOUR HEADQUARTERS!

WHO SAYS NO ONE'S ADMITTED TO REED RICHARD'S FLOOR WITHOUT PERMISSION?? YOU'RE NOT MESSIN' AROUND WITH A KID HERE!

QUICK! CALL THE POLICE! WE NEED HELP!

POLICE NOTHING! SEND FOR THE NATIONAL GUARD!

POW!

BAM

THEN, SUDDENLY, A FAMILIAR FACE APPEARS FROM THE MIDST OF THE MELEE...

RICHARDS, YOU OL' HOUND DOG! CALL OFF YOUR WATCHDOGS BEFORE I MUZZLE 'EM!

THIS IS ONE HECKUVA WAY TO TREAT AN OLD ARMY BUDDY!

STARTER

BLDG.

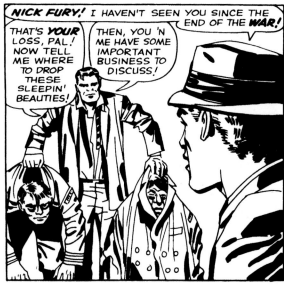

NICK FURY! I HAVEN'T SEEN YOU SINCE THE END OF THE WAR!

THAT'S YOUR LOSS, PAL! NOW TELL ME WHERE TO DROP THESE SLEEPIN' BEAUTIES!

THEN, YOU 'N ME HAVE SOME IMPORTANT BUSINESS TO DISCUSS!

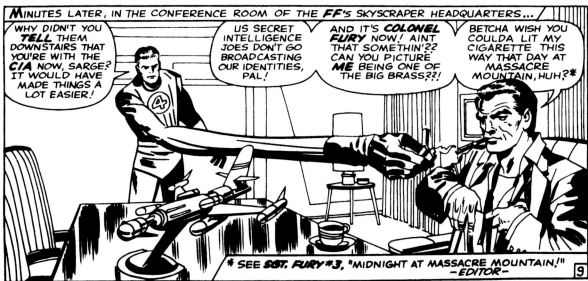

MINUTES LATER, IN THE CONFERENCE ROOM OF THE FF'S SKYSCRAPER HEADQUARTERS...

WHY DIDN'T YOU TELL THEM DOWNSTAIRS THAT YOU'RE WITH THE CIA NOW, SARGE? IT WOULD HAVE MADE THINGS A LOT EASIER!

US SECRET INTELLIGENCE JOES DON'T GO BROADCASTING OUR IDENTITIES, PAL!

AND IT'S COLONEL FURY NOW! AIN'T THAT SOMETHIN'?? CAN YOU PICTURE ME BEING ONE OF THE BIG BRASS??!

BETCHA WISH YOU COULDA LIT MY CIGARETTE THIS WAY THAT DAY AT MASSACRE MOUNTAIN, HUH?*

* SEE SGT. FURY #3, "MIDNIGHT AT MASSACRE MOUNTAIN!" —EDITOR—

9

STAN LEE + JACK KIRBY

94

OKAY, FURY! I KNOW A COLONEL IN THE CIA DOESN'T COME TO VISIT ME JUST TO TALK ABOUT THE WEATHER! IF YOU'VE SOMETHING TO SAY, SPIT IT OUT!

SURE, BIG MAN-- SURE!

SOMETHING'S BUGGIN' HIM! THIS AINT THE REED RICHARDS **I** KNEW! HE'S **CHANGED**!

I WANNA TALK TO YOU ABOUT SOME TROUBLE IN SOUTH AMERICA... IN THE REPUBLIC OF SAN GUSTO!

HEY! WHAT'S WITH THE MAD SCIENTIST BIT?

KEEP TALKING! I'M JUST SHUTTING OFF SOME NUCLEAR ACTIVATORS SO I CAN HEAR YOU BETTER!

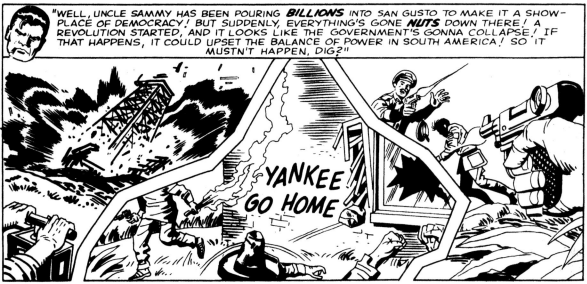

"WELL, UNCLE SAMMY HAS BEEN POURING **BILLIONS** INTO SAN GUSTO TO MAKE IT A SHOW-PLACE OF DEMOCRACY! BUT SUDDENLY, EVERYTHING'S GONE **NUTS** DOWN THERE! A REVOLUTION STARTED, AND IT LOOKS LIKE THE GOVERNMENT'S GONNA COLLAPSE! IF THAT HAPPENS, IT COULD UPSET THE BALANCE OF POWER IN SOUTH AMERICA! SO IT MUSTN'T HAPPEN, DIG?"

YANKEE GO HOME

I'M WAY **AHEAD** OF YOU! I'LL BE THERE BY MORN-ING!

YOU? BUT WHAT ABOUT THE **REST** OF THE **FF**?

WHO **NEEDS** 'EM? FROM NOW ON, I WORK **ALONE**!

TO HANGARS

THEN, REACHING TO ROOFTOP LAUNCHING PADS...

WHAT ARE YOU 'WAITING FOR, FURY? THERE'S ROOM FOR **YOU** IN THE POGO PLANE!

I'LL, EH, JOIN YOU LATER, PAL! I'VE GOT SOMETHING **ELSE** TO TAKE CARE OF HERE, FIRST!

SUIT YOURSELF! JUST DON'T POKE AROUND IN ANY OF THOSE ROOMS-- MY ALARM DEVICES WILL **ATOMIZE** YOU IF YOU TRY IT!

10

STOPPING A REVOLUTION IN SOME POSTAGE STAMP COUNTRY DOESN'T SOUND LIKE A JOB FOR THE *FF!* WHAT MADE FURY COME TO *ME?* WELL, WHAT'S THE DIFFERENCE? IT'LL GIVE ME SOME-THING TO *DO,* ANYWAY!

I WAS *AFRAID* OF THIS! THE *HATE-MONGER* MUST HAVE GOTTEN TO THE *FF* ALREADY! I'VE GOT TO FIND A WAY TO BREAK HIS SPELL!!

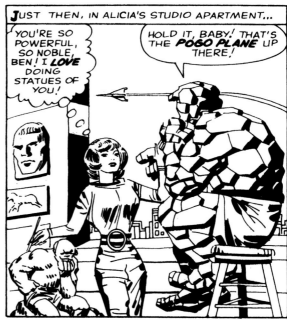

JUST THEN, IN ALICIA'S STUDIO APARTMENT...

YOU'RE SO *POWERFUL,* SO *NOBLE,* BEN! I *LOVE* DOING STATUES OF YOU!

HOLD IT, BABY! THAT'S THE *POGO PLANE* UP THERE!

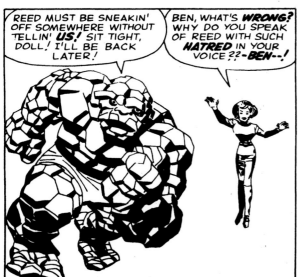

REED MUST BE SNEAKIN' OFF SOMEWHERE WITHOUT TELLIN' *US!* SIT TIGHT, DOLL! I'LL BE BACK LATER!

BEN, WHAT'S *WRONG?* WHY DO YOU SPEAK OF REED WITH SUCH *HATRED* IN YOUR VOICE ??-*BEN--!*

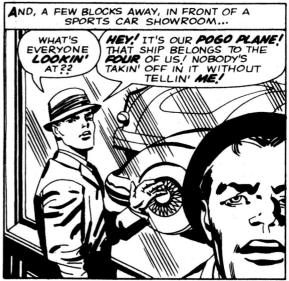

AND, A FEW BLOCKS AWAY, IN FRONT OF A SPORTS CAR SHOWROOM...

WHAT'S EVERYONE *LOOKIN'* AT?

HEY! IT'S OUR *POGO PLANE!* THAT SHIP BELONGS TO THE *FOUR* OF US! NOBODY'S TAKIN' OFF IN IT WITHOUT TELLIN' *ME!*

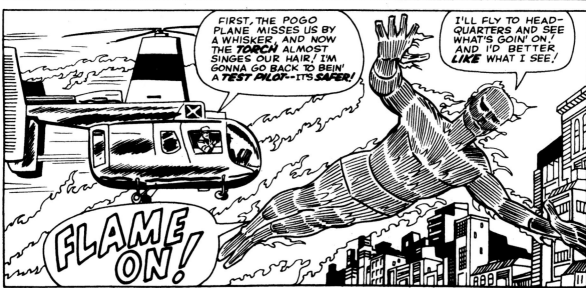

FIRST, THE POGO PLANE MISSES US BY A WHISKER, AND NOW THE *TORCH* ALMOST SINGES OUR HAIR! I'M GONNA GO BACK TO BEIN' A *TEST PILOT*--IT'S *SAFER!*

I'LL FLY TO HEAD-QUARTERS AND SEE WHAT'S GOIN' ON! AND I'D BETTER *LIKE* WHAT I SEE!

FLAME ON!

STAN LEE + JACK KIRBY

AND, IN A FASHIONABLE DRESS SALON...

HOLD STILL, MISS STORM! THIS SEAM NEEDS TAKING IN!

THE *POGO PLANE!*

LOOK! ONE OF OUR NEWEST CREATIONS IS =GULP= RUNNING DOWN THE HALL BY *ITSELF!*

IT'S EVEN *PAYING* FOR ITSELF!

MY FEMALE CURIOSITY WON'T LET ME SLEEP UNTIL I FIND OUT WHO'S *IN* THE PLANE --AND *WHY*??!

A QUARTER OF AN HOUR LATER, AFTER INTRODUCTIONS AND EXPLANATIONS HAVE BEEN MADE...

YOU MEAN THAT SKINNY NIT-WIT TOOK OFF FOR SAN GUSTO WITHOUT *US*??

WHAT'S HE TRYIN' TO DO? HOG ALL THE GLORY FOR *HIMSELF*??

ALL I GOTTA DO IS KEEP MY TRAP SHUT, AND THEY'LL BE *FIGHTIN'* TO GO TO SAN GUSTO, *TOO!*

WHY SHOULD *HE* HAVE A SOUTH AMERICAN VACATION AND NOT *ME*??

ANYTHING *HE* CAN DO, I CAN DO *BETTER!*

WHAT ARE *YOU* SITTIN' THERE WITH A CHICKEN-SCRATCHIN' SMILE ON YOUR PAN FOR?? I GOT A GOOD MIND TO--

SHUDDUP! WHO SAYS YOU'VE *GOT* A MIND?!! WHEN YOU TANGLE WITH *ME*, SMILEY, YOU'RE TANGLING WITH THE *GOVERNMENT!*

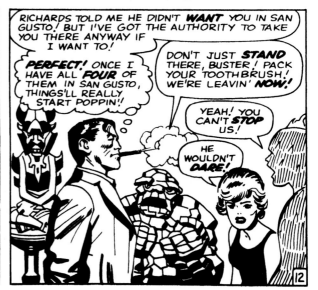

RICHARDS TOLD ME HE DIDN'T *WANT* YOU IN SAN GUSTO! BUT I'VE GOT THE AUTHORITY TO TAKE YOU THERE ANYWAY IF I WANT TO!

PERFECT! ONCE I HAVE ALL *FOUR* OF THEM IN SAN GUSTO, THINGS'LL REALLY START POPPIN'!

DON'T JUST *STAND* THERE, BUSTER! PACK YOUR TOOTHBRUSH... WE'RE LEAVIN' *NOW!*

YEAH! YOU CAN'T *STOP* US!

HE WOULDN'T *DARE!*

12

SECONDS LATER, WITH THE THING'S CAPABLE HANDS ON THE CONTROLS, THE **FF**'s PERSONAL ICBM BLASTS OFF FROM THE BAXTER BUILDING'S BUILT-IN LAUNCH PAD...

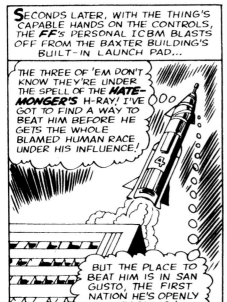

THE THREE OF 'EM DON'T KNOW THEY'RE UNDER THE SPELL OF THE **HATE-MONGER'S** H-RAY! I'VE GOT TO FIND A WAY TO BEAT HIM BEFORE HE GETS THE WHOLE BLAMED HUMAN RACE UNDER HIS INFLUENCE!

BUT THE PLACE TO BEAT HIM IS IN SAN GUSTO, THE FIRST NATION HE'S OPENLY ATTACKING!

A SHORT TIME LATER, HIGH OVER THE ATLANTIC RANGE, THE MISSILE BOOSTER IS DISENGAGED...

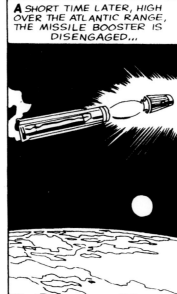

...AND THE CAPSULE CONTAINING FURY AND HIS THREE CO-PASSENGERS, DROPS UNERRINGLY DOWN TO THE OUTSKIRTS OF SAN GUSTO -- WHERE A STARTLING ADVENTURE AWAITS THEM!

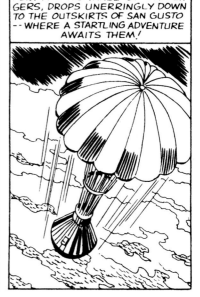

MEANWHILE, *OTHER* EYES HAVE WITNESSED THE DEPARTURE OF THE **FF**'s POGO PLANE AND ICBM... **HOSTILE** EYES -- **MAD** EYES --

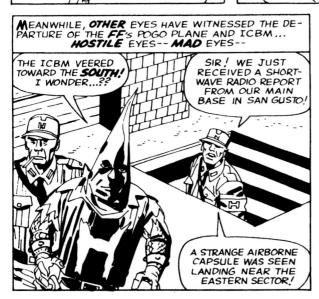

THE ICBM VEERED TOWARD THE **SOUTH**! I WONDER...??

SIR! WE JUST RECEIVED A SHORT-WAVE RADIO REPORT FROM OUR MAIN BASE IN SAN GUSTO!

A STRANGE AIRBORNE CAPSULE WAS SEEN LANDING NEAR THE EASTERN SECTOR!

I **SUSPECTED** AS MUCH! IT SEEMS I DIDN'T GIVE THEM A STRONG ENOUGH DOSE OF THE H-RAY!

WE SHALL LEAVE FOR SAN GUSTO **IMMEDIATELY**! EVEN THOUGH UNDER MY SPELL, THE FANTASTIC FOUR ARE **STILL** TOO DANGEROUS TO IGNORE!

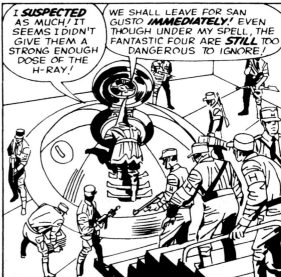

NOT ONE RESIDENT OF THE TEEMING CITY SUSPECTS THAT UNDER HIS FEET, AN ASTONISHING VEHICLE BEGINS TO BORE THRU THE EARTH AT UNBELIEVABLE SPEED! CONSISTING OF A ROCKET ENGINE WITH A PASSENGER NODULE, THE **HATE-MONGER'S** SUB-SURFACE MISSILE HEADS FOR SAN GUSTO!

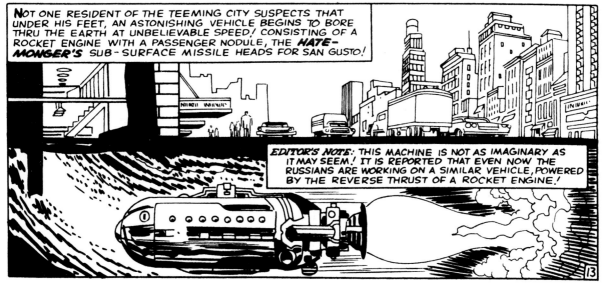

EDITOR'S NOTE: THIS MACHINE IS NOT AS IMAGINARY AS IT MAY SEEM! IT IS REPORTED THAT EVEN NOW THE RUSSIANS ARE WORKING ON A SIMILAR VEHICLE, POWERED BY THE REVERSE THRUST OF A ROCKET ENGINE!

13

STAN LEE + JACK KIRBY

AT A PREDESTINED SPOT, THE ROCKET VEHICLE VEERS SHARPLY AND BLAZES ITS WAY DOWNWARD, UNTIL IT REACHES A SOFT, MOLTEN MASS OF EARTH...

THEN IT LEVELS OFF, ASSUMING A HORIZONTAL POSITION AGAIN, AS IT BLASTS ITS WAY SOUTH, UNDER THE MURKY BOTTOM OF THE SEA ABOVE...

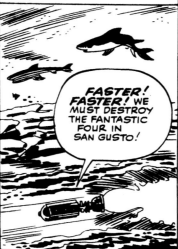

FASTER! FASTER! WE MUST DESTROY THE FANTASTIC FOUR IN SAN GUSTO!

FINALLY, REACHING THEIR OBJECTIVE, THE MIGHTY MACHINE POINTS ITS NOSE SURFACEWARD, AND THEN...

COMING TO REST ON THE OUTSKIRTS OF SAN GUSTO, THICK STREAMS OF CHEMICAL COOLANT POUR FORTH FROM THE ROCKET, COOLING THE SURROUNDING TERRAIN WHICH HAS BECOME WHITE HOT BECAUSE OF THE POWERFUL MISSILE'S THRUST!

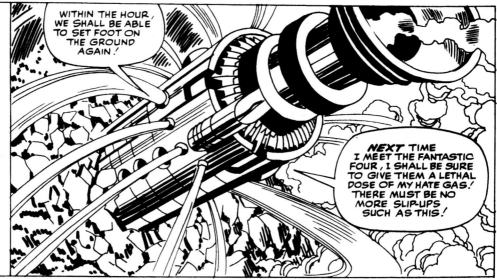

WITHIN THE HOUR, WE SHALL BE ABLE TO SET FOOT ON THE GROUND AGAIN!

NEXT TIME I MEET THE FANTASTIC FOUR, I SHALL BE SURE TO GIVE THEM A LETHAL DOSE OF MY HATE GAS! THERE MUST BE NO MORE SLIP-UPS SUCH AS THIS!

AND THEN, AFTER THE GROUND HAS COOLED...

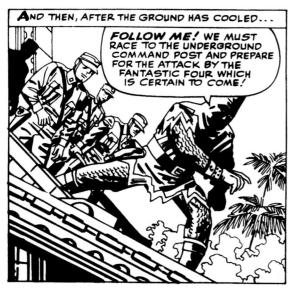

FOLLOW ME! WE MUST RACE TO THE UNDERGROUND COMMAND POST AND PREPARE FOR THE ATTACK BY THE FANTASTIC FOUR WHICH IS CERTAIN TO COME!

MEANWHILE, SOME DISTANCE AWAY, THE REBEL FORCES ARE GATHERING LARGE ARTILLERY SHELLS FOR THEIR ASSAULT UPON THE SAN GUSTO GOVERNMENT...

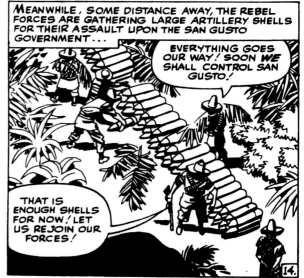

EVERYTHING GOES OUR WAY! SOON WE SHALL CONTROL SAN GUSTO!

THAT IS ENOUGH SHELLS FOR NOW! LET US REJOIN OUR FORCES!

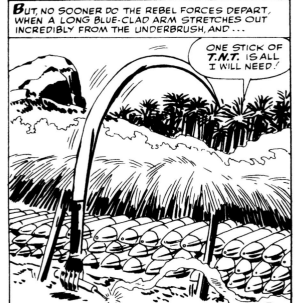

BUT, NO SOONER DO THE REBEL FORCES DEPART, WHEN A LONG BLUE-CLAD ARM STRETCHES OUT INCREDIBLY FROM THE UNDERBRUSH, AND...

ONE STICK OF **T.N.T.** IS ALL I WILL NEED!

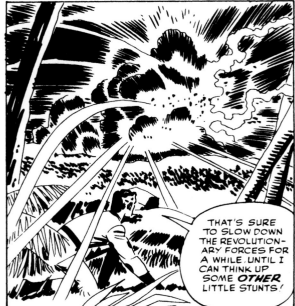

THAT'S SURE TO SLOW DOWN THE REVOLUTION-ARY FORCES FOR A WHILE, UNTIL I CAN THINK UP SOME **OTHER** LITTLE STUNTS!

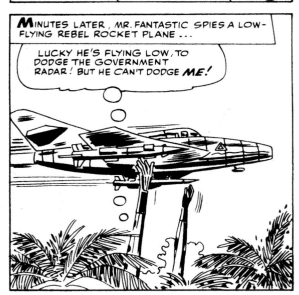

MINUTES LATER, MR. FANTASTIC SPIES A LOW-FLYING REBEL ROCKET PLANE...

LUCKY HE'S FLYING LOW, TO DODGE THE GOVERNMENT RADAR! BUT HE CAN'T DODGE **ME!**

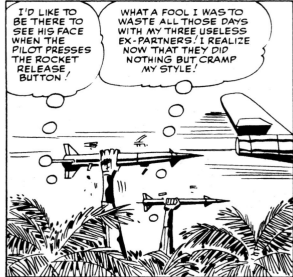

I'D LIKE TO BE THERE TO SEE HIS FACE WHEN THE PILOT PRESSES THE ROCKET RELEASE BUTTON!

WHAT A FOOL I WAS TO WASTE ALL THOSE DAYS WITH MY THREE USELESS EX-PARTNERS! I REALIZE NOW THAT THEY DID NOTHING BUT CRAMP MY STYLE!

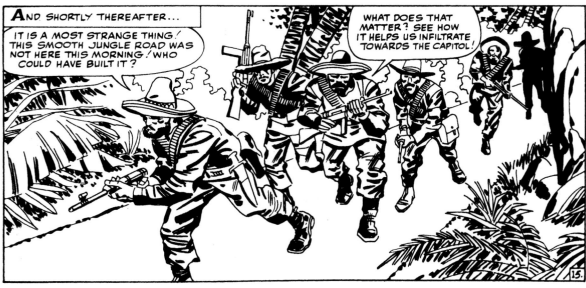

AND SHORTLY THEREAFTER...

IT IS A MOST STRANGE THING! THIS SMOOTH JUNGLE ROAD WAS NOT HERE THIS MORNING! WHO COULD HAVE BUILT IT?

WHAT DOES THAT MATTER? SEE HOW IT HELPS US INFILTRATE TOWARDS THE CAPITOL!

15.

STAN LEE + JACK KIRBY

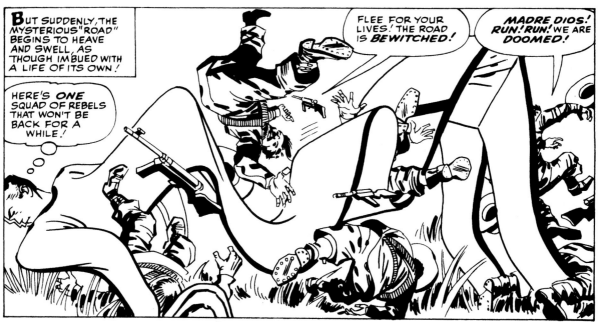

BUT SUDDENLY, THE MYSTERIOUS "ROAD" BEGINS TO HEAVE AND SWELL, AS THOUGH IMBUED WITH A LIFE OF ITS OWN!

HERE'S **ONE** SQUAD OF REBELS THAT WON'T BE BACK FOR A WHILE!

FLEE FOR YOUR LIVES! THE ROAD IS **BEWITCHED!**

MADRE DIOS! RUN! RUN! WE ARE DOOMED!

100

IT WAS OBLIGING OF THEM TO LEAVE THEIR **GUNS** BEHIND!

HERE ARE A FEW **MORE** THAT WILL NEVER BE USED AGAINST SAN GUSTO!

HEAD FOR THE BORDER IF YOU VALUE YOUR LIVES!

UP TILL NOW, ALL I'VE DONE HAS BEEN KID STUFF!

IT'S TIME I BUCKLED DOWN AND **REALLY** GAVE A LITTLE DEMONSTRATION OF WHAT **MR. FANTASTIC** CAN DO WHEN HE'S FIGHTING MAD!

AND THEN, WHILE PLANNING HIS NEXT MOVE, REED RICHARDS MAKES A FATEFUL DISCOVERY...

A **RAY MACHINE** OF SOME SORT! SENDING HIGH-POTENCY BEAMS INTO THE AIR!

THE MAIN SECTION IS BURIED BELOW GROUND! I'LL JUST REACH DOWN AND PROBE FOR ITS SOURCE OF POWER!

16.

SILVER AGE OF SUPERHEROES

SECONDS LATER, THE COSTUMED CRUSADER DISCOVERS A HIDDEN PASSAGEWAY, LEADING TO A DARK UNDERGROUND CHAMBER...

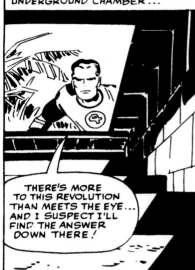

THERE'S MORE TO THIS REVOLUTION THAN MEETS THE EYE... AND I SUSPECT I'LL FIND THE ANSWER DOWN THERE!

STRANGE... I CAN HEAR A PULSATING THROB THROUGH THIS WALL... LIKE THE DEEP, INCESSANT HUM OF SOME MIGHTY MACHINE!

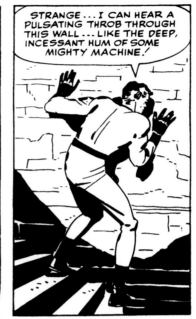

AND THEN, WITHOUT WARNING...

NERVE GAS VAPORS! CAN'T ESCAPE! I-I'M TRAPPED!

WE GOT HIM!!

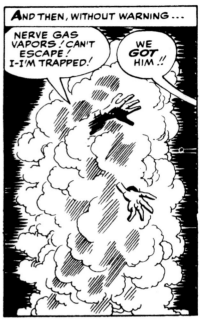

IN A SEMI-PARALYZED STATE, DUE TO THE POTENT NERVE GAS, REED IS BROUGHT FACE TO FACE WITH THE HATE-MONGER ONCE MORE!

I KNEW IT WAS ONLY A MATTER OF TIME BEFORE YOU'D STUMBLE ACROSS MY HATE-RAY MACHINE!

AND NOW THAT YOU ARE TRAPPED, I SHALL SHOW YOU THE FATE THAT AWAITS MANKIND, BEFORE I HAVE YOU DESTROYED!

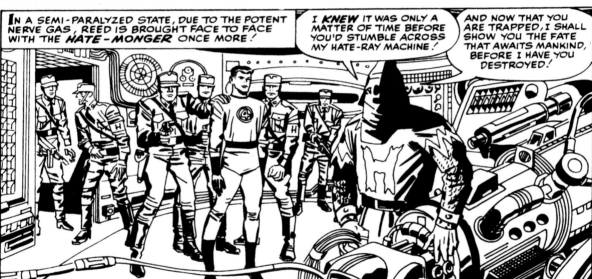

OBSERVE HOW MY HATE-RAY MACHINE DERIVES ITS MATCHLESS POWER BY BOUNCING A BEAM TO THE MOON AND BACK... A BEAM WHICH CAN REACH ANY PLACE ON EARTH!

NO WONDER EARTH'S TIDES WERE ABNORMAL LATELY! THE HATE-MONGER HAS BEEN AFFECTING THE MOON'S GRAVITATIONAL PULL!

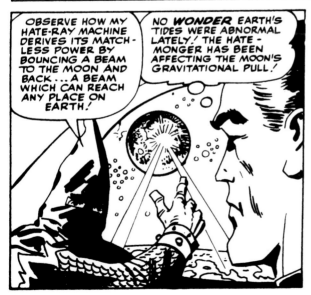

THIS SMALL, PITIFUL NATION WAS JUST A TEST FOR ME! NOW THAT I SEE HOW EFFECTIVE MY HATE RAY IS, I SHALL BLANKET THE WORLD WITH IT! I SHALL TURN FRIEND AGAINST FRIEND, NEIGHBOR AGAINST NEIGHBOR!

JUST AS HE TURNED THE FANTASTIC FOUR AGAINST EACH OTHER! BUT... WHAT IS HIS PURPOSE?? WHO IS HE??

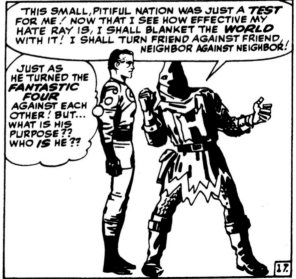

STAN LEE + JACK KIRBY

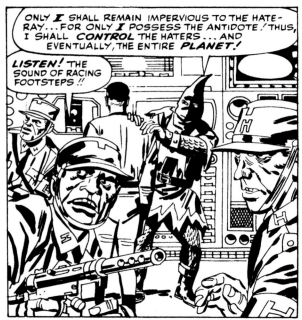

ONLY **I** SHALL REMAIN IMPERVIOUS TO THE HATE-RAY... FOR ONLY **I** POSSESS THE ANTIDOTE! THUS, I SHALL **CONTROL** THE HATERS... AND EVENTUALLY, THE ENTIRE **PLANET!**

LISTEN! THE SOUND OF RACING FOOTSTEPS!!

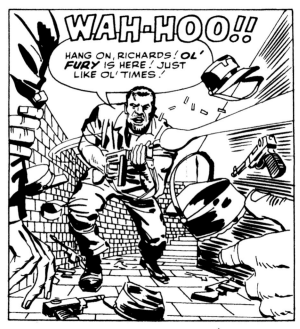

WAH-HOO!!

HANG ON, RICHARDS! **OL' FURY** IS HERE! JUST LIKE OL' TIMES!

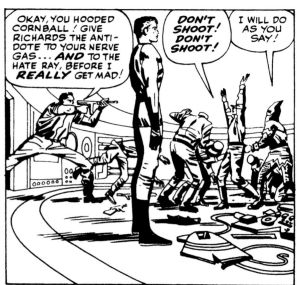

OKAY, YOU HOODED **CORNBALL!** GIVE RICHARDS THE ANTIDOTE TO YOUR NERVE GAS... **AND** TO THE HATE RAY, BEFORE I **REALLY** GET MAD!

DON'T SHOOT! DON'T SHOOT!

I WILL DO AS YOU SAY!

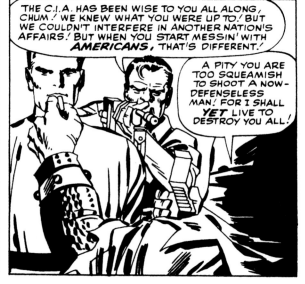

THE C.I.A. HAS BEEN WISE TO YOU ALL ALONG, CHUM! WE KNEW WHAT YOU WERE UP TO! BUT WE COULDN'T INTERFERE IN ANOTHER NATION'S AFFAIRS! BUT WHEN YOU START MESSIN' WITH **AMERICANS**, THAT'S DIFFERENT!

A PITY YOU ARE TOO SQUEAMISH TO SHOOT A NOW-DEFENSELESS MAN! FOR I SHALL **YET** LIVE TO DESTROY YOU ALL!

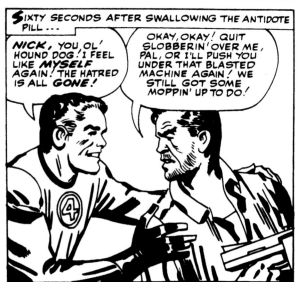

SIXTY SECONDS AFTER SWALLOWING THE ANTIDOTE PILL...

NICK, YOU OL' HOUND DOG! I FEEL LIKE **MYSELF** AGAIN! THE HATRED IS ALL **GONE!**

OKAY, OKAY! QUIT SLOBBERIN' OVER ME, PAL, OR I'LL PUSH YOU UNDER THAT BLASTED MACHINE AGAIN! WE STILL GOT SOME MOPPIN' UP TO DO!

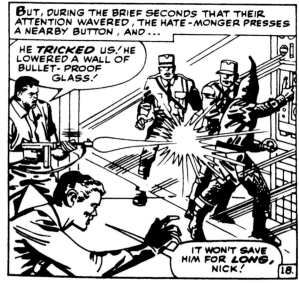

BUT, DURING THE BRIEF SECONDS THAT THEIR ATTENTION WAVERED, THE HATE-MONGER PRESSES A NEARBY BUTTON, AND...

HE **TRICKED** US! HE LOWERED A WALL OF BULLET-PROOF GLASS!

IT WON'T SAVE HIM FOR **LONG,** NICK!

18.

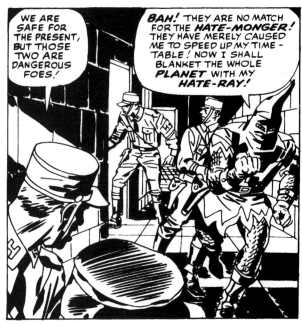

WE ARE SAFE FOR THE PRESENT, BUT THOSE TWO ARE DANGEROUS FOES!

BAH! THEY ARE NO MATCH FOR THE *HATE-MONGER!* THEY HAVE MERELY CAUSED ME TO SPEED UP MY TIME-TABLE! NOW I SHALL BLANKET THE WHOLE *PLANET* WITH MY *HATE-RAY!*

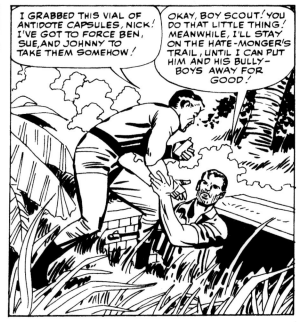

I GRABBED THIS VIAL OF ANTIDOTE CAPSULES, NICK! I'VE GOT TO FORCE BEN, SUE, AND JOHNNY TO TAKE THEM SOMEHOW!

OKAY, BOY SCOUT! YOU DO THAT LITTLE THING! MEANWHILE, I'LL STAY ON THE HATE-MONGER'S TRAIL, UNTIL I CAN PUT HIM AND HIS BULLY-BOYS AWAY FOR GOOD!

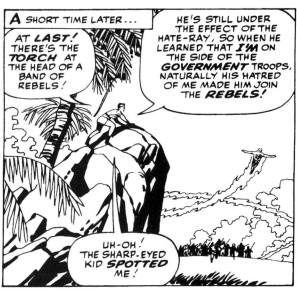

A SHORT TIME LATER...

AT *LAST!* THERE'S THE *TORCH* AT THE HEAD OF A BAND OF REBELS!

HE'S STILL UNDER THE EFFECT OF THE HATE-RAY, SO WHEN HE LEARNED THAT *I'M* ON THE SIDE OF THE *GOVERNMENT* TROOPS, NATURALLY HIS HATRED OF ME MADE HIM JOIN THE *REBELS!*

UH-OH! THE SHARP-EYED KID *SPOTTED* ME!

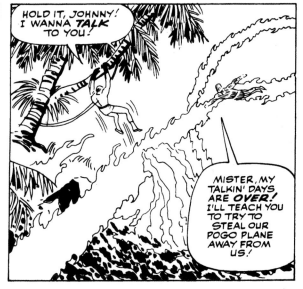

HOLD IT, JOHNNY! I WANNA *TALK* TO YOU!

MISTER, MY TALKIN' DAYS ARE *OVER!* I'LL TEACH YOU TO TRY TO STEAL OUR POGO PLANE AWAY FROM US!

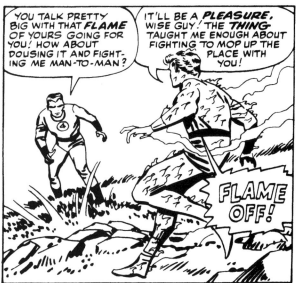

YOU TALK PRETTY BIG WITH THAT *FLAME* OF YOURS GOING FOR YOU! HOW ABOUT DOUSING IT AND FIGHTING ME MAN-TO-MAN?

IT'LL BE A *PLEASURE,* WISE GUY! THE *THING* TAUGHT ME ENOUGH ABOUT FIGHTING TO MOP UP THE PLACE WITH YOU!

FLAME OFF!

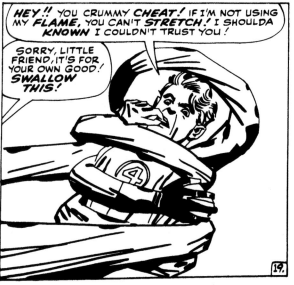

HEY!! YOU CRUMMY *CHEAT!* IF I'M NOT USING MY *FLAME,* YOU CAN'T *STRETCH!* I SHOULDA *KNOWN* I COULDN'T TRUST YOU!

SORRY, LITTLE FRIEND, IT'S FOR YOUR OWN GOOD! *SWALLOW THIS!*

19.

STAN LEE + JACK KIRBY

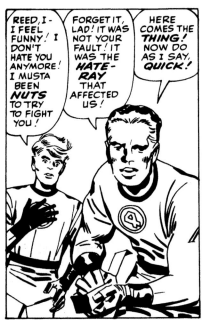

REED, I - I FEEL FUNNY! I DON'T HATE YOU ANYMORE! I MUSTA BEEN *NUTS* TO TRY TO FIGHT YOU!

FORGET IT, LAD! IT WAS NOT YOUR *FAULT!* IT WAS THE *HATE-RAY* THAT AFFECTED US!

HERE COMES THE *THING!* NOW DO AS I SAY, *QUICK!*

HELP ME, BEN! HE'S TRYIN' TO KILL ME! *HELP!*

YOU SKINNY CREEP! *I'LL* TEACH YA TO PICK ON A KID!

AT THAT SPLIT-SECOND, REED RELEASES THE TORCH AND JOHNNY FLAMES ON, HURLING A FLAMING LOOP AROUND THE STARTLED *THING!*

GOOD WORK, JOHNNY! I *KNEW* HE'D OPEN HIS MOUTH IN SURPRISE!

HEY, DIDJA LOSE YOUR *MARBLES,* HOT-HEAD?

THEN, MR. FANTASTIC MOVES WITH DAZZLING SPEED, BEFORE THE *THING* CAN CLOSE HIS MOUTH!

A FELLA COULD DROP SOMETHING IN *YOUR* MOUTH, BENJAMIN, OL' BUDDY, WITH HIS EYES *CLOSED!*

WHAT IN SAM HILL'S GOIN' *ON* AROUND HERE? WHOSE *SIDE* IS THAT BLAZING BRAT *ON* ANYWAY?!! ...*GLOOMP!!*

FOR THE LUVVA PETE! ALL OF A SUDDEN I DON'T WANNA PULVERIZE YA! I WANT US TO BE *PARDS* AGAIN! THIS IS *NUTTY!*

I'LL EXPLAIN EVERYTHING LATER, OLD FRIEND! RIGHT NOW, WE'VE GOT TO FIND *SUE* AND GIVE *HER* AN ANTIDOTE PILL!

HOW'LL WE *DO* IT, REED? SHE'S INVISIBLE! SHE COULD BE *ANYWHERE!*

RIGHT, LAD! BUT CHANCES ARE SHE'S IN THIS AREA, WONDERING WHAT TO DO NEXT! SO, I'LL JUST BLANKET THE AREA WITH MY OWN BODY, AND SEE WHAT HAPPENS!

LOOK! THAT *SHAPE* OVER THERE! I'LL BE A MONKEY'S UNCLE! HE *GOT* HER!

BEN! JOHNNY! DON'T JUST *STAND* THERE, YOU FOOLS! SAVE ME FROM REED!

EASY, KID! I DON'T KNOW WHAT'S *IN* THOSE PILLS, BUT TAKE ONE! IT'S GOOD FOR WHAT AILS YA!

NO...*NO! STOP!* I *HATE* YOU! I HATE YOU *ALL!*

EASY, HONEY! YOU'LL FEEL DIFFERENT IN A MINUTE!

20.

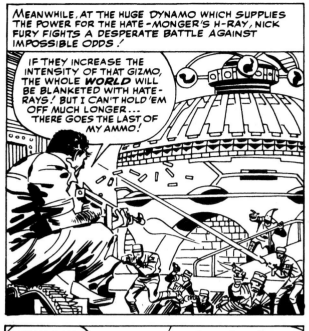

MEANWHILE, AT THE HUGE DYNAMO WHICH SUPPLIES THE POWER FOR THE HATE-MONGER'S H-RAY, NICK FURY FIGHTS A DESPERATE BATTLE AGAINST IMPOSSIBLE ODDS!

IF THEY INCREASE THE INTENSITY OF THAT GIZMO, THE WHOLE *WORLD* WILL BE BLANKETED WITH HATE-RAYS! BUT I CAN'T HOLD 'EM OFF MUCH LONGER... THERE GOES THE LAST OF MY AMMO!

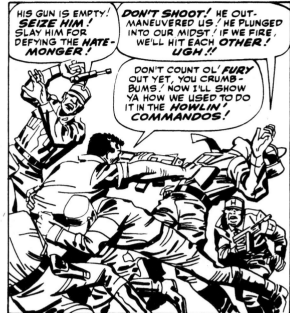

HIS GUN IS EMPTY! *SEIZE HIM!* SLAY HIM FOR DEFYING THE *HATE-MONGER!*

DON'T SHOOT! HE OUT-MANEUVERED US! HE PLUNGED INTO OUR MIDST! IF WE FIRE, WE'LL HIT EACH *OTHER!* UGH!!

DON'T COUNT OL' *FURY* OUT YET, YOU CRUMB-BUMS! NOW I'LL SHOW YA HOW WE USED TO DO IT IN THE *HOWLIN' COMMANDOS!*

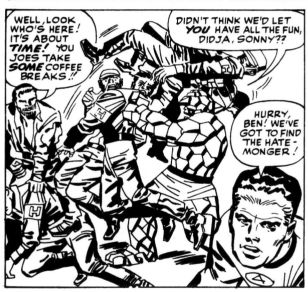

WELL, LOOK WHO'S HERE! IT'S ABOUT *TIME!* YOU JOES TAKE *SOME* COFFEE BREAKS!!

DIDN'T THINK WE'D LET *YOU* HAVE ALL THE FUN, DIDJA, SONNY??

HURRY, BEN! WE'VE GOT TO FIND THE HATE-MONGER!

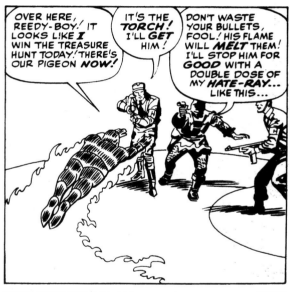

OVER HERE, REEDY-BOY! IT LOOKS LIKE *I* WIN THE TREASURE HUNT TODAY! THERE'S OUR PIGEON *NOW!*

IT'S THE *TORCH!* I'LL *GET* HIM!

DON'T WASTE YOUR BULLETS, FOOL! HIS FLAME WILL *MELT* THEM! I'LL STOP HIM FOR *GOOD* WITH A DOUBLE DOSE OF MY *HATE-RAY...* LIKE THIS...

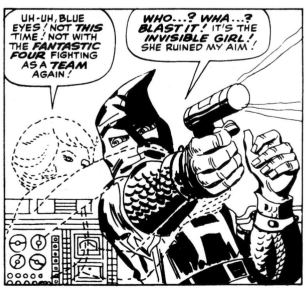

UH-UH, BLUE EYES! NOT *THIS* TIME! NOT WITH THE *FANTASTIC FOUR* FIGHTING AS A *TEAM* AGAIN!

WHO...? WHA...? *BLAST IT!* IT'S THE *INVISIBLE GIRL!* SHE RUINED MY AIM!

AND, AS FATE WOULD HAVE IT, THE HATE-RAY BLAST INTENDED FOR THE TORCH, STRIKES THE HATE-MONGER'S OWN MEN, AFTER HAVING BEEN DEFLECTED BY SUE STORM!

THE ACCURSED *HATE-MONGER* IS TO BLAME FOR ALL THIS!

BECAUSE OF *HIM* WE ARE FIGHTING THE ALL-POWERFUL *FANTASTIC FOUR!*

21.

STAN LEE + JACK KIRBY

AND THEN, BEFORE ANYONE CAN RAISE A HAND TO SAVE THE MASKED MASTER OF HATE...

NO, YOU *CAN'T! YOU MUSTN'T!* I -I'M YOUR *LEADER*... YOU MUST *OBEY* ME! *OBEY ME!! UGH!!*

FAREWELL, HATE-MONGER!

WHAT DO YA KNOW? IT'S LIKE A SCENE RIGHT OUT OF A MOVIE! HE USED *HATRED* AS A WEAPON, AND IN THE END IT WAS THAT VERY WEAPON THAT *DESTROYED* HIM!

LET'S GET HIS HOOD OFF, NICK! I'M ANXIOUS TO SEE WHO HE REALLY IS!

WAIT FOR *ME*, YOU GUYS! I WANNA SEE, TOO! I'LL HAVE ALL HIS LITTLE PLAYMATES CORRALLED IN A FEW SECS!

IT ALL SEEMS LIKE A STRANGE, MAD DREAM!

AND THEN, AS THE CONCEALING HOOD IS LIFTED...

IT *CAN'T* BE! IT JUST AIN'T *POSSIBLE!*

AND YET, IT FITS! IT ALL TIES *IN!*

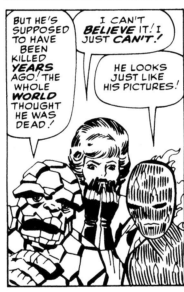

BUT HE'S SUPPOSED TO HAVE BEEN KILLED *YEARS* AGO! THE WHOLE *WORLD* THOUGHT HE WAS DEAD!

I CAN'T *BELIEVE* IT! I JUST *CAN'T!*

HE LOOKS JUST LIKE HIS PICTURES!

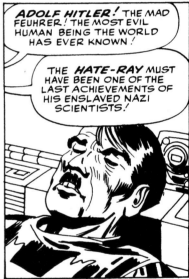

ADOLF HITLER! THE MAD FEUHRER! THE MOST EVIL HUMAN BEING THE WORLD HAS EVER KNOWN!

THE *HATE-RAY* MUST HAVE BEEN ONE OF THE LAST ACHIEVEMENTS OF HIS ENSLAVED NAZI SCIENTISTS!

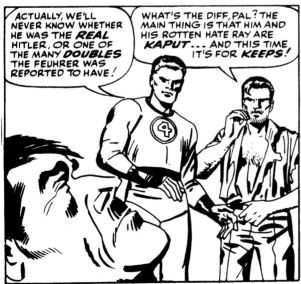

ACTUALLY, WE'LL NEVER KNOW WHETHER HE WAS THE *REAL* HITLER, OR ONE OF THE MANY *DOUBLES* THE FEUHRER WAS REPORTED TO HAVE!

WHAT'S THE DIFF, PAL? THE MAIN THING IS THAT HIM AND HIS ROTTEN HATE RAY ARE *KAPUT*... AND THIS TIME, IT'S FOR *KEEPS!*

THIS IS FURY CALLIN' THE *C.I.A.!* OUR LITTLE CAPER IS FINISHED IN SAN GUSTO!

...THE *FANTASTIC FOUR* WILL EXPLAIN WHEN THEY GET BACK! I AIN'T MUCH ON MAKIN' SPEECHES!

AND FINALLY...ON THE WAY BACK TO THE STATES...

22.

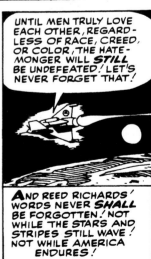

UNTIL MEN TRULY LOVE EACH OTHER, REGARDLESS OF RACE, CREED, OR COLOR, THE HATE-MONGER WILL *STILL* BE UNDEFEATED! LET'S NEVER FORGET THAT!

AND REED RICHARDS' WORDS NEVER *SHALL* BE FORGOTTEN! NOT WHILE THE STARS AND STRIPES STILL WAVE! NOT WHILE AMERICA ENDURES!

The End

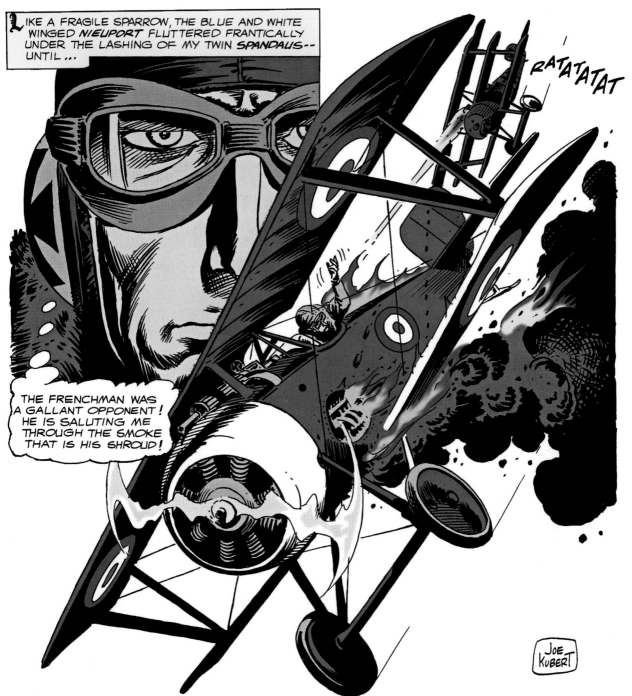

BOB KANIGHER + JOE KUBERT

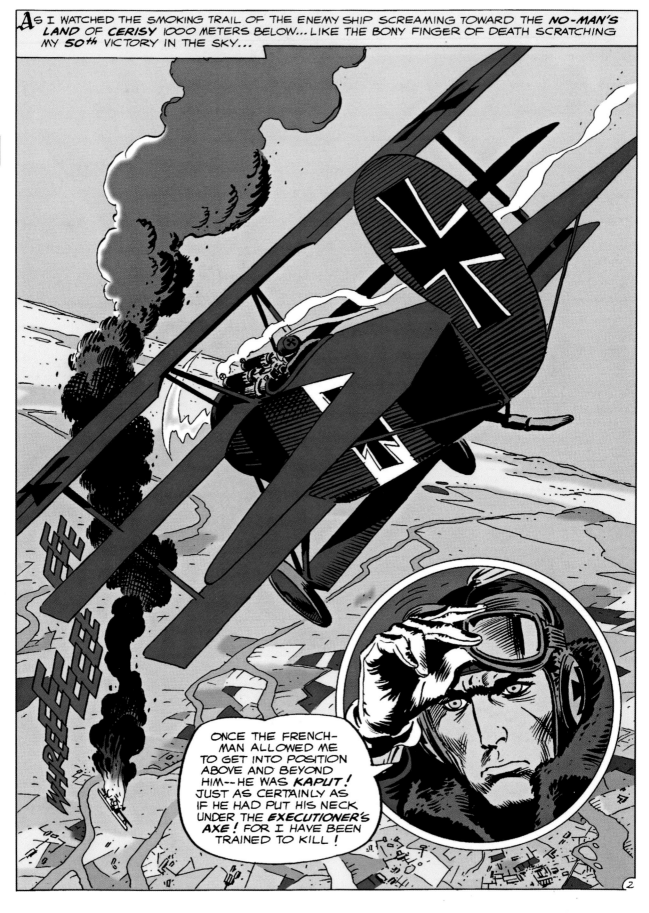

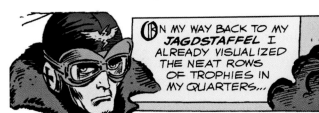

ON MY WAY BACK TO MY *JAGDSTAFFEL* I ALREADY VISUALIZED THE NEAT ROWS OF TROPHIES IN MY QUARTERS...

YOUR *50th VICTORY, RITTMEISTER VON HAMMER!* ONE CUP FOR EACH DOWNED ENEMY PLANE! YOU ARE THE ACE OF ACES! NO OTHER PILOT OF EITHER SIDE IS EVEN NEAR YOUR RECORD! ALL GERMANY REJOICES! YOUR PILOTS ARE WAITING TO CELEBRATE YOUR LATEST TRIUMPH! WHAT UNIFORM SHALL I LAY OUT FOR YOU, *RITTMEISTER?*

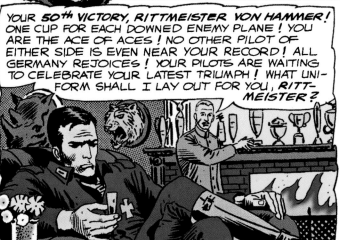

YES, I COULD EVEN IMAGINE MY TALKATIVE ORDERLY'S BEFUDDLEMENT WHEN...

LOOK AT HIM!--ONLY A BORN KILLER COULD SLEEP AS PEACEFULLY AS A--A LION CUB--AFTER THE FLAMING COMBAT HE HAS JUST BEEN THROUGH!

SUDDENLY, WADDLING ABOUT 100 METERS AHEAD OF ME LIKE A CLUMSY DUCK IN A YELLOW POND--WAS AN OLD *F.E. 2B* PUSHER TYPE PLANE...

MY *51st VICTORY!*-- I AM IN PERFECT POSITION TO ATTACK! BUT TOO FAR AWAY FOR EFFECTIVE FIRING! I WILL CLOSE THE DISTANCE UNTIL HE CANNOT ESCAPE!

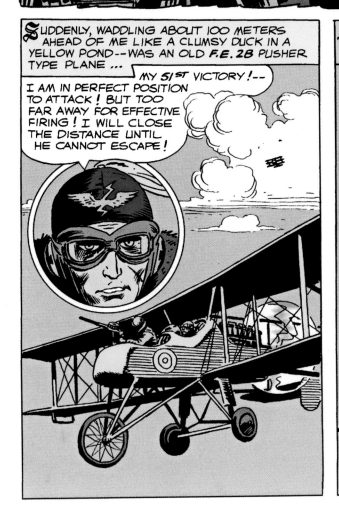

AS THE ENGLISH OBSERVER CAUGHT SIGHT OF MY ALL-RED *FOKKER* TRIPLANE HURTLING AT HIM, I LAUGHED AT HIS WILD SPRAYING...

THAT OBSERVER IS INEXPERIENCED! ONE COULD COUNT OFF THE METERS BETWEEN US--TRANSLATE THEM INTO 300 ENGLISH YARDS-- AND NOT REALIZE THAT HE COULD NOT HIT A TARGET LIKE ME--MOVING AT A HUNDRED KILOMETERS PER HOUR--WITH THAT *LEWIS* OF HIS!

RATATATAT

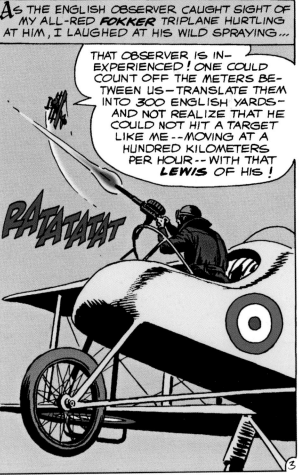

3

BOB KANIGHER + JOE KUBERT

SUDDENLY, A SLEDGEHAMMER BLOW ON MY HEAD CAME FROM ONE OF THE HUNDREDS OF WILD BULLETS THAT THE ENGLISHMAN'S *LEWIS* WAS BLAZING ALL OVER THE SKY...

I'M HIT!

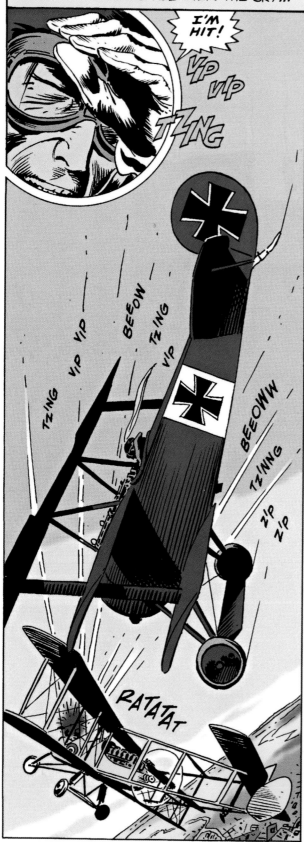

AS A CRIMSON FILM STREAKED ACROSS THE SKY, I DAZEDLY THOUGHT...

IT HAS HAPPENED TO ME AT LAST--! THE PLANE IS ON FIRE--!

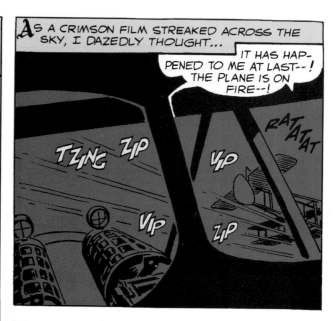

THEN, MY STICKY PALM TOLD ME I HAD BEEN SPARED THE WORST FEAR OF A PILOT...

IT IS ONLY BLOOD-- RUNNING OVER MY GOGGLES!

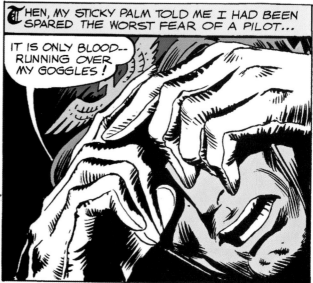

AUTOMATICALLY I SHOVED THE *FOKKER'S* STICK BLINDLY FORWARD UNTIL...

THE WILD SPRAYING HAS CEASED--I HAVE SLIPPED OUT OF HIS SIGHTS!

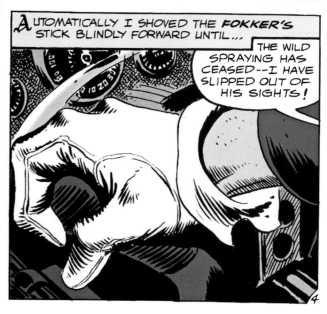

THE PICTURE OF THE POSITIONS IN THE SKY OF THE *F.E. 2B* AND MY *FOKKER* REMAINED SHARP IN MY MIND EVEN THOUGH I WAS FLYING "*BLIND*"...SO I PULLED THE STICK BACK AGAIN AS I TRIED TO CLEAR MY GOGGLES...

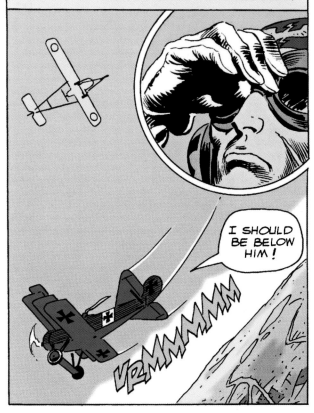

I SHOULD BE BELOW HIM!

VRMMMMM

THROUGH MY BLOOD-SMEARED GOGGLES THE YELLOW PLANE WADDLED ABOVE ME...

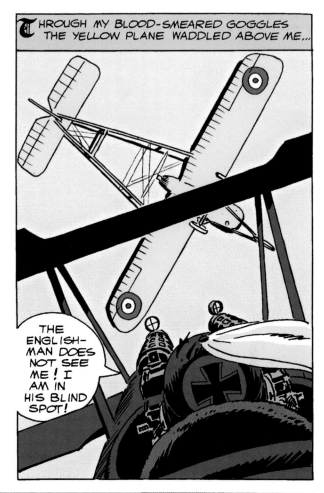

THE ENGLISH-MAN DOES NOT SEE ME! I AM IN HIS BLIND SPOT!

I HELD MY FIRE AS MY *FOKKER* NARROWED THE GAP BETWEEN US...STALKING THE ENGLISH-MAN LIKE A CAT DOES A MOUSE...HIS PAW EXTENDED BUT NOT STRIKING...YET!

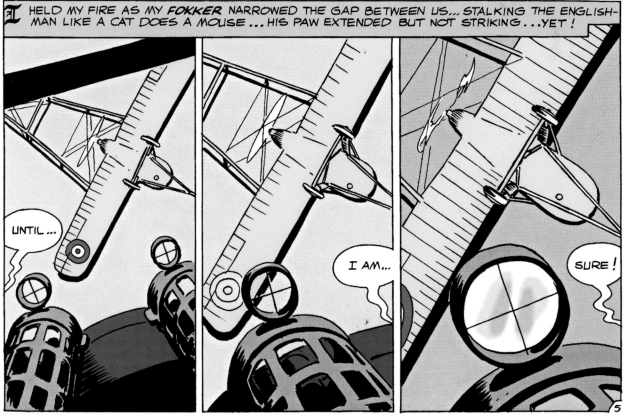

UNTIL...

I AM...

SURE!

5

BOB KANIGHER + JOE KUBERT

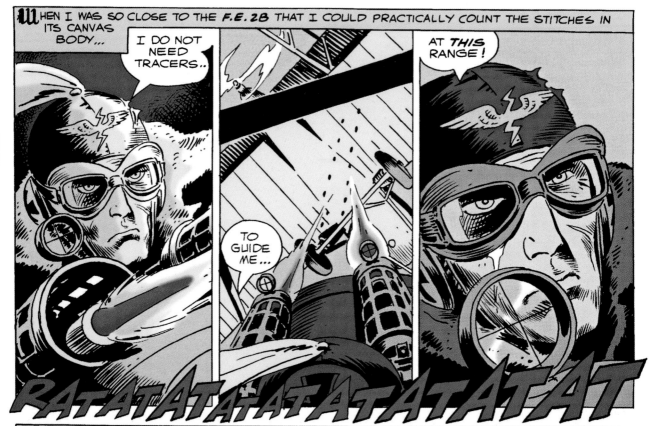

WHEN I WAS SO CLOSE TO THE *F.E.2B* THAT I COULD PRACTICALLY COUNT THE STITCHES IN ITS CANVAS BODY...

I DO NOT NEED TRACERS..

TO GUIDE ME...

AT *THIS* RANGE !

RATATATATATATATAT

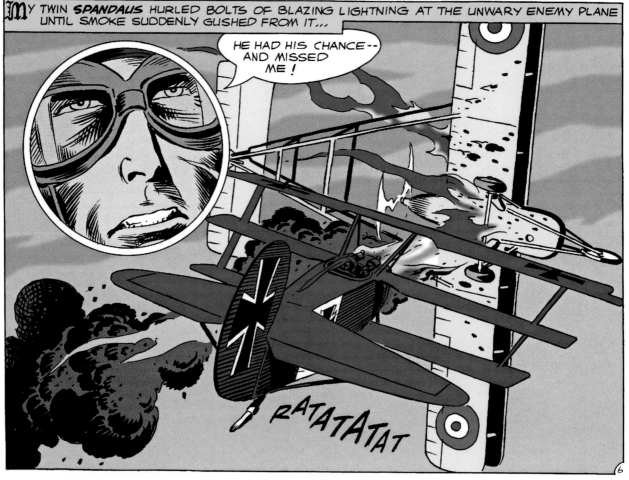

MY TWIN *SPANDAUS* HURLED BOLTS OF BLAZING LIGHTNING AT THE UNWARY ENEMY PLANE UNTIL SMOKE SUDDENLY GUSHED FROM IT...

HE HAD HIS CHANCE-- AND MISSED ME !

RATATATAT

6

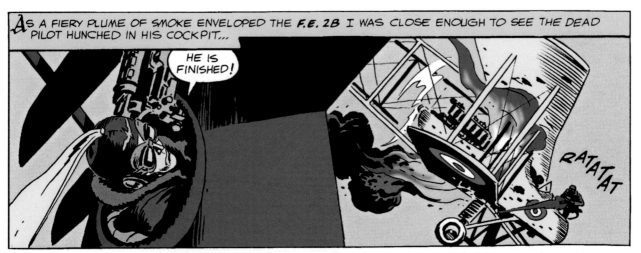

AS A FIERY PLUME OF SMOKE ENVELOPED THE *F.E. 2B* I WAS CLOSE ENOUGH TO SEE THE DEAD PILOT HUNCHED IN HIS COCKPIT...

HE IS FINISHED!

RATATAT

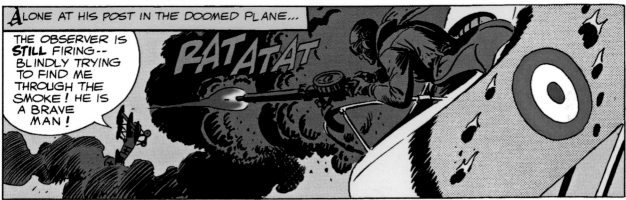

ALONE AT HIS POST IN THE DOOMED PLANE...

THE OBSERVER IS **STILL** FIRING-- BLINDLY TRYING TO FIND ME THROUGH THE SMOKE! HE IS A BRAVE MAN!

RATATAT

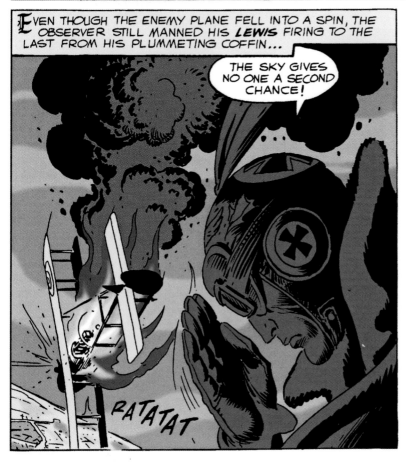

EVEN THOUGH THE ENEMY PLANE FELL INTO A SPIN, THE OBSERVER STILL MANNED HIS *LEWIS* FIRING TO THE LAST FROM HIS PLUMMETING COFFIN...

THE SKY GIVES NO ONE A SECOND CHANCE!

RATATAT

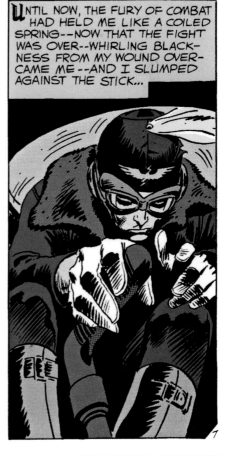

UNTIL NOW, THE FURY OF COMBAT HAD HELD ME LIKE A COILED SPRING--NOW THAT THE FIGHT WAS OVER--WHIRLING BLACKNESS FROM MY WOUND OVERCAME ME--AND I SLUMPED AGAINST THE STICK...

7

BOB KANIGHER + JOE KUBERT

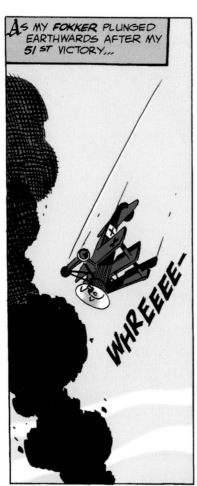

As my **FOKKER** plunged earthwards after my 51ST victory...

My hand still clutched its stick...

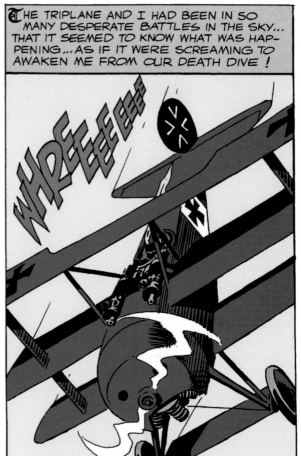

The triplane and I had been in so many desperate battles in the sky... that it seemed to know what was happening... as if it were screaming to awaken me from our death dive!

WHREEEEE—

WHREEEEEE

END OF **PART ONE**! **PART TWO** of *"enemy ace!"* CONTINUES ON THE FOLLOWING PAGE!

SILVER AGE OF SUPERHEROES

CONCLUSION OF THE BLAZING BATTLE DIARY OF
"enemy ace!"

MY CRIMSON *FOKKER* AND I HAD BEEN WELDED TOGETHER IN THE BLAZING FIRES OF SO MANY AIR BATTLES THAT ITS *MOTOR* ECHOED THE BEATING OF MY OWN *HEART*-- I COULD NOT TELL WHERE THE *MACHINE* ENDED AND THE *PILOT* BEGAN -- HOW ELSE EXPLAIN A LANDING I CANNOT REMEMBER?

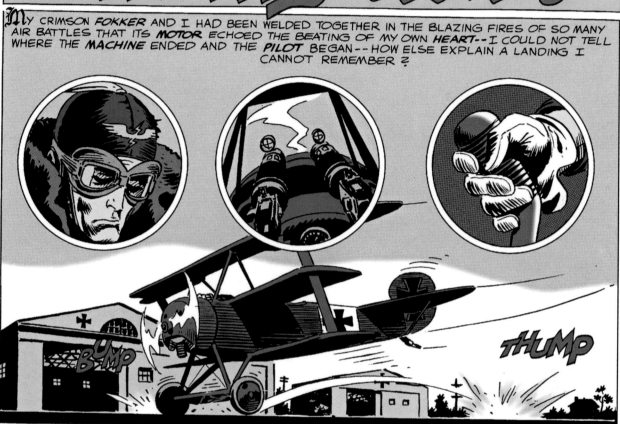

BUMP

THUMP

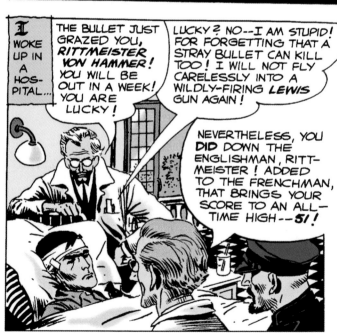

I WOKE UP IN A HOSPITAL...

THE BULLET JUST GRAZED YOU, *RITTMEISTER VON HAMMER*! YOU WILL BE OUT IN A WEEK! YOU ARE LUCKY!

LUCKY? NO--I AM STUPID! FOR FORGETTING THAT A STRAY BULLET CAN KILL TOO! I WILL NOT FLY CARELESSLY INTO A WILDLY-FIRING *LEWIS* GUN AGAIN!

NEVERTHELESS, YOU *DID* DOWN THE ENGLISHMAN, RITT-MEISTER! ADDED TO THE FRENCHMAN, THAT BRINGS YOUR SCORE TO AN ALL-TIME HIGH--*51!*

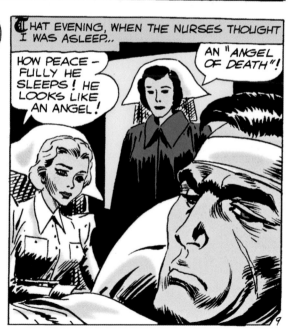

THAT EVENING, WHEN THE NURSES THOUGHT I WAS ASLEEP...

HOW PEACE-FULLY HE SLEEPS! HE LOOKS LIKE AN ANGEL!

AN *"ANGEL OF DEATH"!*

BOB KANIGHER + JOE KUBERT

IN THE ARMS OF A BEAUTIFUL NURSE... I FELT **LONELY**...

AMIDST CONVALESCING PILOTS... I FELT LONELY...

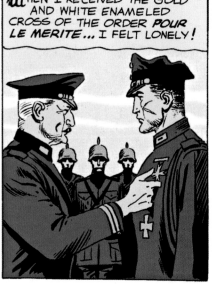

WHEN I RECEIVED THE GOLD AND WHITE ENAMELED CROSS OF THE ORDER *POUR LE MERITE*... I FELT LONELY!

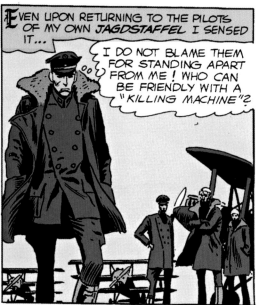

EVEN UPON RETURNING TO THE PILOTS OF MY OWN *JAGDSTAFFEL* I SENSED IT...

I DO NOT BLAME THEM FOR STANDING APART FROM ME! WHO CAN BE FRIENDLY WITH A "KILLING MACHINE"?

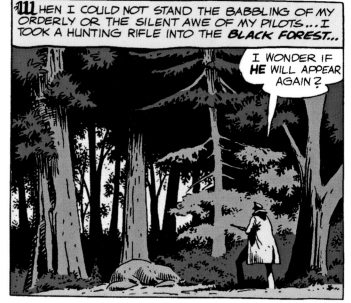

WHEN I COULD NOT STAND THE BABBLING OF MY ORDERLY OR THE SILENT AWE OF MY PILOTS... I TOOK A HUNTING RIFLE INTO THE *BLACK FOREST*...

I WONDER IF **HE** WILL APPEAR AGAIN?

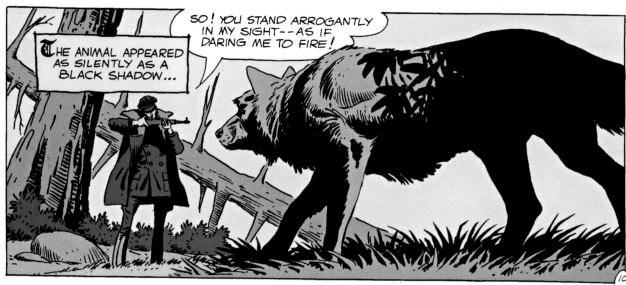

THE ANIMAL APPEARED AS SILENTLY AS A BLACK SHADOW...

SO! YOU STAND ARROGANTLY IN MY SIGHT--AS IF DARING ME TO FIRE!

10

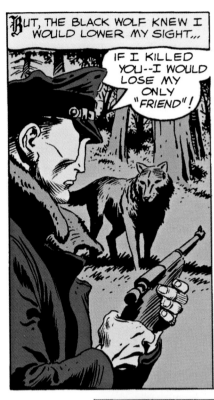

BUT, THE BLACK WOLF KNEW I WOULD LOWER MY SIGHT...

IF I KILLED YOU--I WOULD LOSE MY ONLY "FRIEND"!

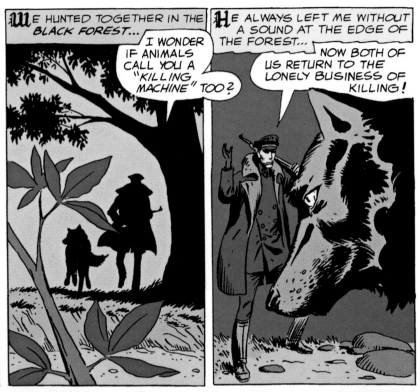

WE HUNTED TOGETHER IN THE BLACK FOREST...

I WONDER IF ANIMALS CALL YOU A "KILLING MACHINE" TOO?

HE ALWAYS LEFT ME WITHOUT A SOUND AT THE EDGE OF THE FOREST...

NOW BOTH OF US RETURN TO THE LONELY BUSINESS OF KILLING!

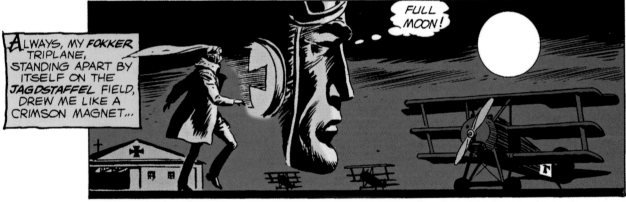

ALWAYS, MY FOKKER TRIPLANE, STANDING APART BY ITSELF ON THE JAGDSTAFFEL FIELD, DREW ME LIKE A CRIMSON MAGNET...

FULL MOON!

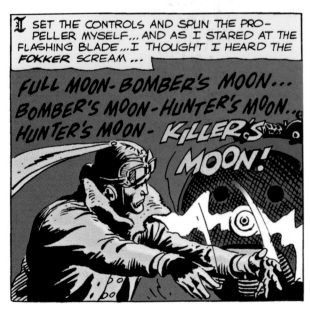

I SET THE CONTROLS AND SPUN THE PROPELLER MYSELF...AND AS I STARED AT THE FLASHING BLADE...I THOUGHT I HEARD THE FOKKER SCREAM...

FULL MOON-BOMBER'S MOON... BOMBER'S MOON-HUNTER'S MOON... HUNTER'S MOON- KILLER'S MOON!

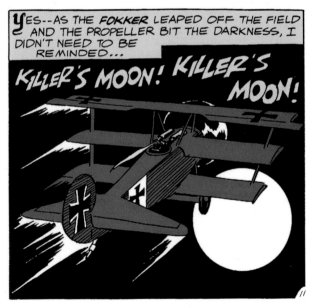

YES--AS THE FOKKER LEAPED OFF THE FIELD AND THE PROPELLER BIT THE DARKNESS, I DIDN'T NEED TO BE REMINDED...

KILLER'S MOON! KILLER'S MOON!

BOB KANIGHER + JOE KUBERT

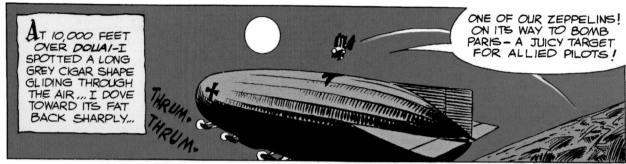

AT 10,000 FEET OVER *DOUAI-1* SPOTTED A LONG GREY CIGAR SHAPE GLIDING THROUGH THE AIR... I DOVE TOWARD ITS FAT BACK SHARPLY...

THRUM. THRUM.

ONE OF OUR ZEPPELINS! ON ITS WAY TO BOMB PARIS— A JUICY TARGET FOR ALLIED PILOTS!

118

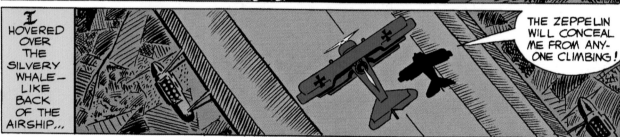

I HOVERED OVER THE SILVERY WHALE—LIKE BACK OF THE AIRSHIP...

THE ZEPPELIN WILL CONCEAL ME FROM ANY-ONE CLIMBING!

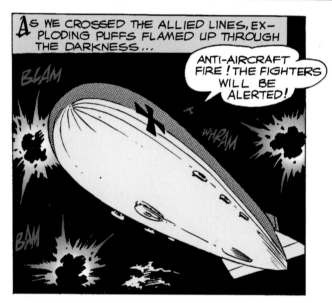

AS WE CROSSED THE ALLIED LINES, EX-PLODING PUFFS FLAMED UP THROUGH THE DARKNESS...

ANTI-AIRCRAFT FIRE! THE FIGHTERS WILL BE ALERTED!

BLAM

WHRAM

BAM

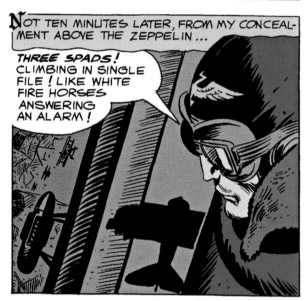

NOT TEN MINUTES LATER, FROM MY CONCEAL-MENT ABOVE THE ZEPPELIN...

THREE SPADS! CLIMBING IN SINGLE FILE! LIKE WHITE FIRE HORSES ANSWERING AN ALARM!

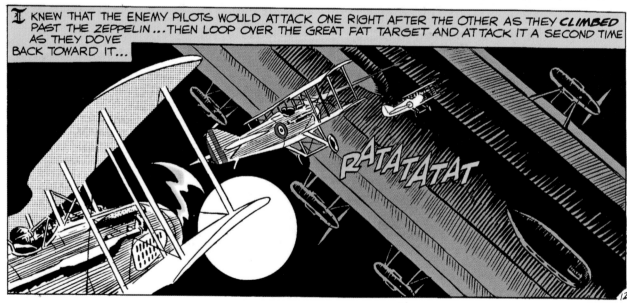

I KNEW THAT THE ENEMY PILOTS WOULD ATTACK ONE RIGHT AFTER THE OTHER AS THEY *CLIMBED* PAST THE ZEPPELIN...THEN LOOP OVER THE GREAT FAT TARGET AND ATTACK IT A SECOND TIME AS THEY DOVE BACK TOWARD IT...

RATATATAT

12

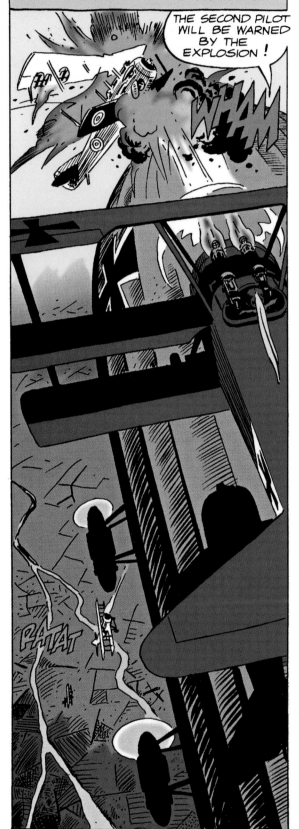

As the first *SPAD* finished its attack and climbed past the Zeppelin to get above it--I hammered a long burst at it with my twin *SPANDAUS*--until a bright flame lit up the darkness...

THE SECOND PILOT WILL BE WARNED BY THE EXPLOSION!

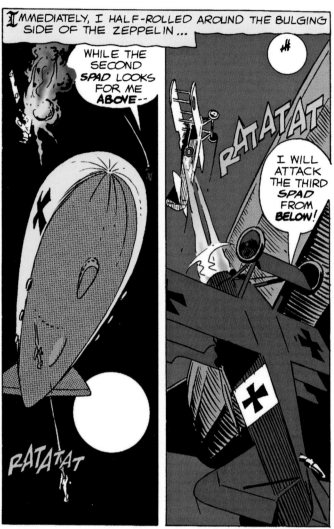

Immediately, I half-rolled around the bulging side of the Zeppelin...

WHILE THE SECOND *SPAD* LOOKS FOR ME *ABOVE*--

I WILL ATTACK THE THIRD *SPAD* FROM *BELOW*!

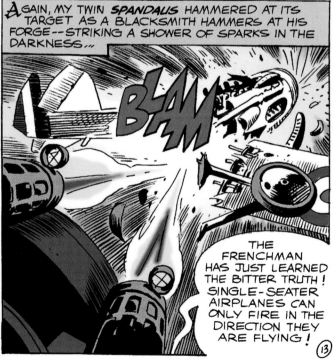

Again, my twin *SPANDAUS* hammered at its target as a blacksmith hammers at his forge--striking a shower of sparks in the darkness...

THE FRENCHMAN HAS JUST LEARNED THE BITTER TRUTH! SINGLE-SEATER AIRPLANES CAN ONLY FIRE IN THE DIRECTION THEY ARE FLYING!

⑬

BOB KANIGHER + JOE KUBERT

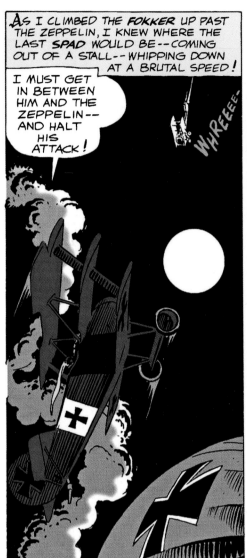

As I climbed the **FOKKER** up past the zeppelin, I knew where the last **SPAD** would be--coming out of a stall--whipping down at a brutal speed!

I MUST GET IN BETWEEN HIM AND THE ZEPPELIN-- AND HALT HIS ATTACK!

WHREEEE-

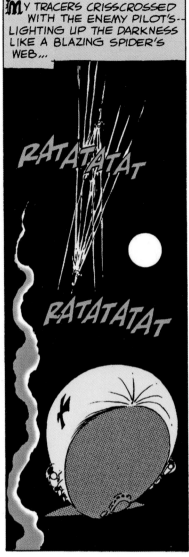

MY TRACERS CRISSCROSSED WITH THE ENEMY PILOT'S-- LIGHTING UP THE DARKNESS LIKE A BLAZING SPIDER'S WEB...

RATATATAT

RATATATAT

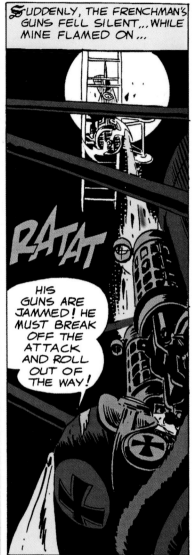

SUDDENLY, THE FRENCHMAN'S GUNS FELL SILENT,...WHILE MINE FLAMED ON...

RATAT

HIS GUNS ARE JAMMED! HE MUST BREAK OFF THE ATTACK AND ROLL OUT OF THE WAY!

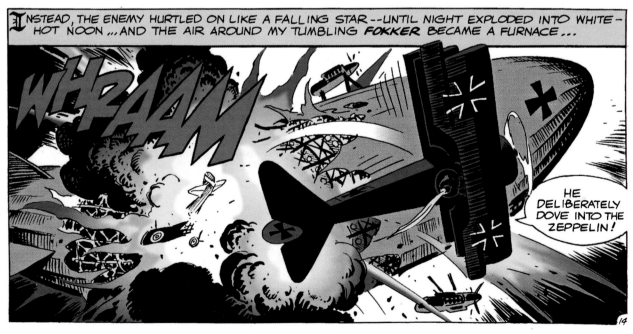

INSTEAD, THE ENEMY HURTLED ON LIKE A FALLING STAR--UNTIL NIGHT EXPLODED INTO WHITE-HOT NOON ...AND THE AIR AROUND MY TUMBLING **FOKKER** BECAME A FURNACE...

WHRAAAM

HE DELIBERATELY DOVE INTO THE ZEPPELIN!

14

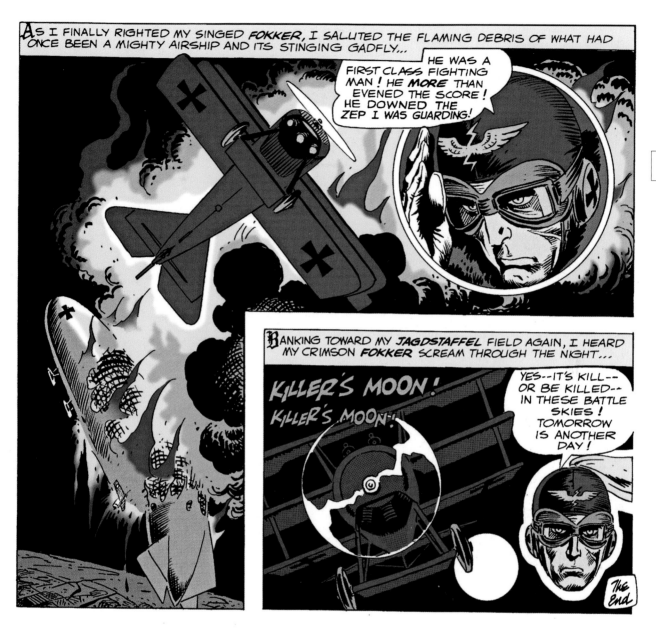

BOB KANIGHER + JOE KUBERT

THE AMAZING SPIDER-MAN!

"THE FINAL CHAPTER!"

As PETER PARKER'S *AUNT MAY* LIES DYING IN THE HOSPITAL, VICTIM OF THE EFFECTS OF RADIOACTIVITY IN HER BLOOD STREAM...

...A SYMPATHETIC *DR. CONNORS* WAITS FOR *SPIDER-MAN* TO BRING THE *ISO-36* TO HIM... FOR IT IS THE ONLY SERUM WHICH MIGHT SAVE PETER'S AUNT!

BUT, THE STOLEN SERUM IS IN THE POSSESSION OF *DR. OCTOPUS*, WHOSE MASKED HENCHMEN WAIT OUTSIDE A STEEL DOOR, AS SPIDEY AND DOC OCK BATTLE WITHIN....!

AND, NONE SUSPECT THAT A SUDDEN *LEAK* IN THE UNDER-WATER DOME OF THE HIDDEN HIDEOUT IS GROWING BIGGER--AND *BIGGER*--!

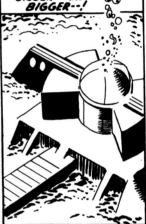

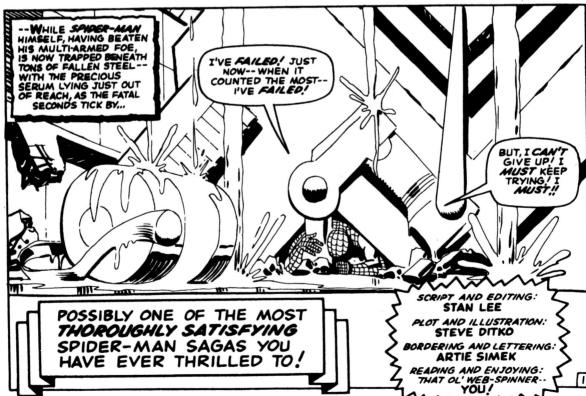

--WHILE *SPIDER-MAN* HIMSELF, HAVING BEATEN HIS MULTI-ARMED FOE, IS NOW TRAPPED BENEATH TONS OF FALLEN STEEL-- WITH THE PRECIOUS SERUM LYING JUST OUT OF REACH, AS THE FATAL SECONDS TICK BY...

I'VE *FAILED!* JUST NOW-- WHEN IT COUNTED THE MOST-- I'VE *FAILED!*

BUT, I *CAN'T* GIVE UP! I *MUST* KEEP TRYING! I *MUST!!*

POSSIBLY ONE OF THE MOST *THOROUGHLY SATISFYING* SPIDER-MAN SAGAS YOU HAVE EVER THRILLED TO!

SCRIPT AND EDITING: STAN LEE

PLOT AND ILLUSTRATION: STEVE DITKO

BORDERING AND LETTERING: ARTIE SIMEK

READING AND ENJOYING: THAT OL' WEB-SPINNER-- YOU!

I'VE GOT TO TRY TO *FREE* MYSELF-- NO MATTER HOW *IMPOSSIBLE* IT SEEMS!

AND *LIFTING* IS THE ONLY WAY! THE-- *ONLY*-- WAY--!

-;UHHHHH-; I *CAN'T!*-- SO EXHAUSTED-- AFTER ALL THAT FIGHTING-- I- I FEEL SO *WEAK*--!

123

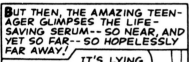
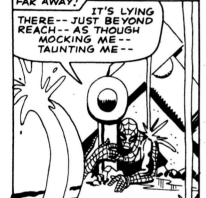
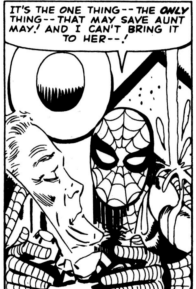
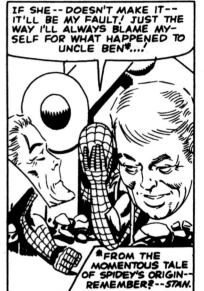

BUT THEN, THE AMAZING TEEN-AGER GLIMPSES THE LIFE-SAVING SERUM-- SO NEAR, AND YET SO FAR-- SO HOPELESSLY FAR AWAY!

IT'S LYING THERE-- JUST BEYOND REACH-- AS THOUGH MOCKING ME-- TAUNTING ME--

IT'S THE ONE THING-- THE *ONLY* THING-- THAT MAY SAVE AUNT MAY! AND I CAN'T BRING IT TO HER--!

IF SHE-- DOESN'T MAKE IT-- IT'LL BE MY FAULT! JUST THE WAY I'LL ALWAYS BLAME MY-SELF FOR WHAT HAPPENED TO UNCLE BEN*....!

*FROM THE MOMENTOUS TALE OF SPIDEY'S ORIGIN-- REMEMBER?--*STAN.*

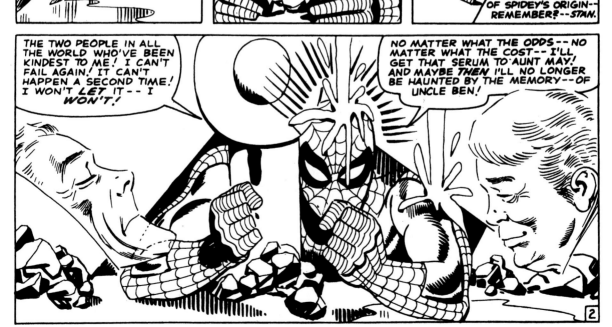

THE TWO PEOPLE IN ALL THE WORLD WHO'VE BEEN KINDEST TO ME! I CAN'T FAIL AGAIN! IT CAN'T HAPPEN A SECOND TIME! I WON'T *LET* IT-- I *WON'T!*

NO MATTER WHAT THE ODDS-- NO MATTER WHAT THE COST-- I'LL GET THAT SERUM TO AUNT MAY! AND MAYBE *THEN* I'LL NO LONGER BE HAUNTED BY THE MEMORY-- OF UNCLE BEN!

2

STAN LEE + STEVE DITKO

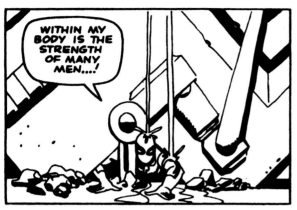

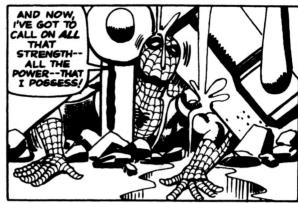

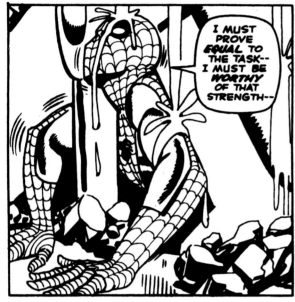

124

THE CRACK IN THE CEILING-- IT'S GROWING *WIDER*--GETTING BIGGER EVERY SECOND! I'LL NEVER MAKE IT-- I CAN'T--!

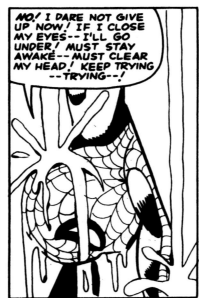

NO! I DARE NOT GIVE UP NOW! IF I CLOSE MY EYES-- I'LL GO UNDER! MUST STAY AWAKE-- MUST CLEAR MY HEAD! KEEP TRYING --TRYING--!

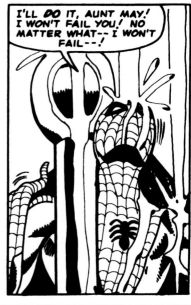

I'LL *DO* IT, AUNT MAY! I WON'T FAIL YOU! NO MATTER WHAT-- I WON'T FAIL--!

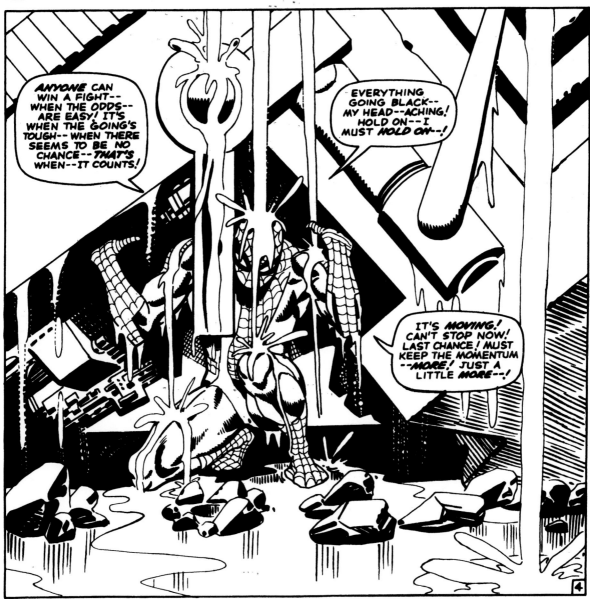

ANYONE CAN WIN A FIGHT-- WHEN THE ODDS-- ARE EASY! IT'S WHEN THE GOING'S TOUGH-- WHEN THERE SEEMS TO BE NO CHANCE-- *THAT'S* WHEN-- IT COUNTS!

EVERYTHING GOING BLACK-- MY HEAD--ACHING! HOLD ON-- I MUST *HOLD ON*--!

IT'S *MOVING!* CAN'T STOP NOW! LAST CHANCE! MUST KEEP THE MOMENTUM --*MORE!* JUST A LITTLE *MORE*--!

STAN LEE + STEVE DITKO

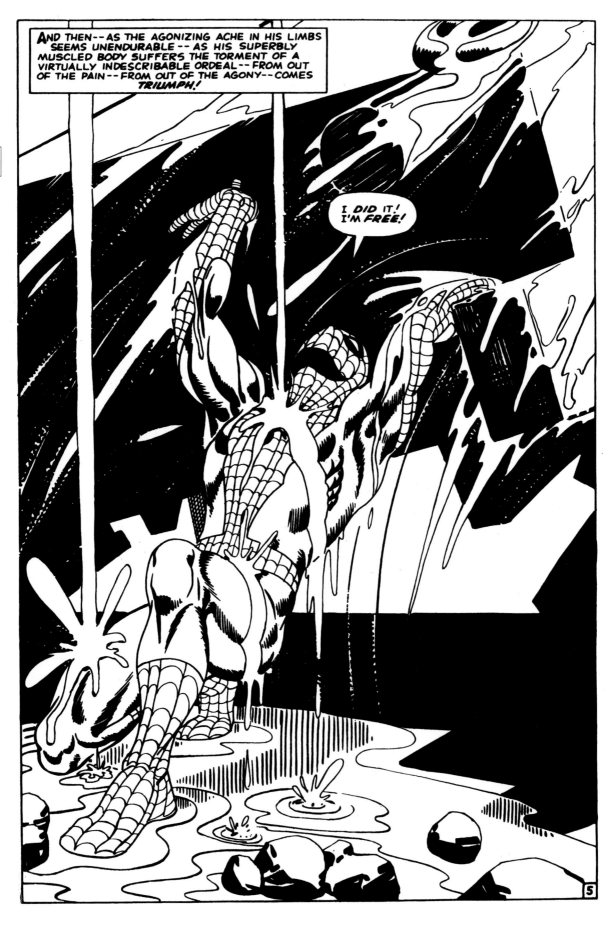

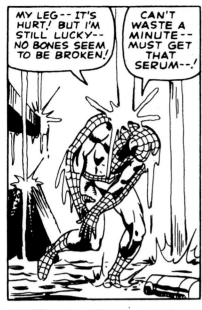

MY LEG-- IT'S HURT! BUT I'M STILL LUCKY-- NO BONES SEEM TO BE BROKEN!

CAN'T WASTE A MINUTE-- MUST GET THAT SERUM--!

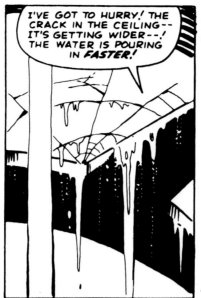

I'VE GOT TO HURRY! THE CRACK IN THE CEILING-- IT'S GETTING WIDER--! THE WATER IS POURING IN FASTER!

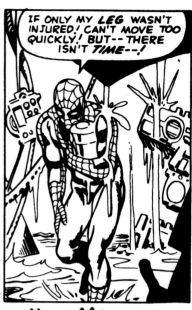

IF ONLY MY LEG WASN'T INJURED! CAN'T MOVE TOO QUICKLY! BUT-- THERE ISN'T TIME--!

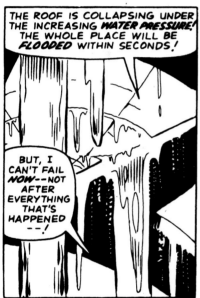

THE ROOF IS COLLAPSING UNDER THE INCREASING WATER PRESSURE! THE WHOLE PLACE WILL BE FLOODED WITHIN SECONDS!

BUT, I CAN'T FAIL NOW-- NOT AFTER EVERYTHING THAT'S HAPPENED --!

THE ONLY WAY OUT IS THRU THIS TUNNEL! IF IT'LL JUST HOLD UP A FEW SECONDS LONGER--!

WHOOSH!

MY TIME'S RUN OUT! IT'S COLLAPSING NOW!

IT'S CASCADING RIGHT TOWARDS ME! BUT I WON'T LET GO OF THE SERUM! PERHAPS I CAN STILL ESCAPE-- BY SOME MIRACLE!

I'LL GO LIMP-- LET IT SWEEP ME ALONG-- THRU THE TUNNEL! THESE FEW SECONDS WILL GIVE ME A CHANCE-- TO REGAIN SOME OF MY STRENGTH....!

STAN LEE + STEVE DITKO

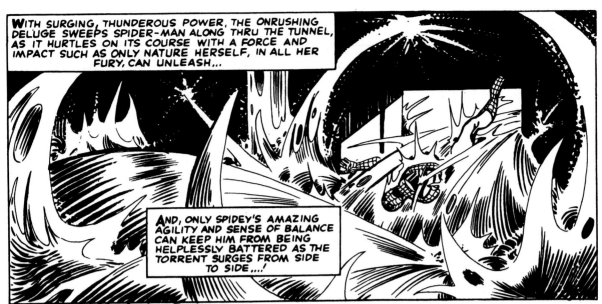

WITH SURGING, THUNDEROUS POWER, THE ONRUSHING DELUGE SWEEPS SPIDER-MAN ALONG THRU THE TUNNEL, AS IT HURTLES ON ITS COURSE WITH A FORCE AND IMPACT SUCH AS ONLY NATURE HERSELF, IN ALL HER FURY, CAN UNLEASH...

AND, ONLY SPIDEY'S AMAZING AGILITY AND SENSE OF BALANCE CAN KEEP HIM FROM BEING HELPLESSLY BATTERED AS THE TORRENT SURGES FROM SIDE TO SIDE...!

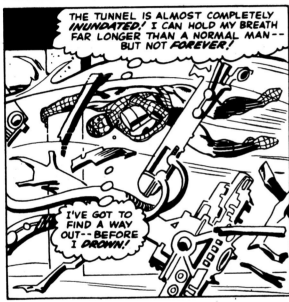

THE TUNNEL IS ALMOST COMPLETELY INUNDATED! I CAN HOLD MY BREATH FAR LONGER THAN A NORMAL MAN—BUT NOT FOREVER!

I'VE GOT TO FIND A WAY OUT—BEFORE I DROWN!

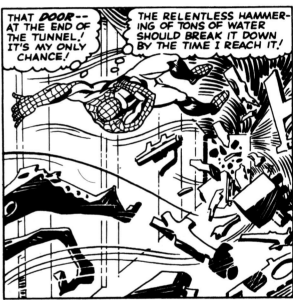

THAT DOOR—AT THE END OF THE TUNNEL! IT'S MY ONLY CHANCE!

THE RELENTLESS HAMMERING OF TONS OF WATER SHOULD BREAK IT DOWN BY THE TIME I REACH IT!

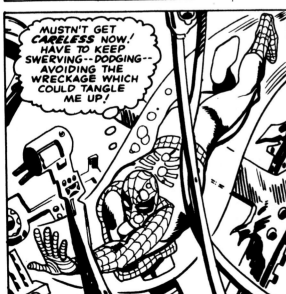

MUSTN'T GET CARELESS NOW! HAVE TO KEEP SWERVING—DODGING—AVOIDING THE WRECKAGE WHICH COULD TANGLE ME UP!

AND THEN, SECONDS LATER...

I'M THRU! THERE'S AIR TO BREATHE! AIR!

7

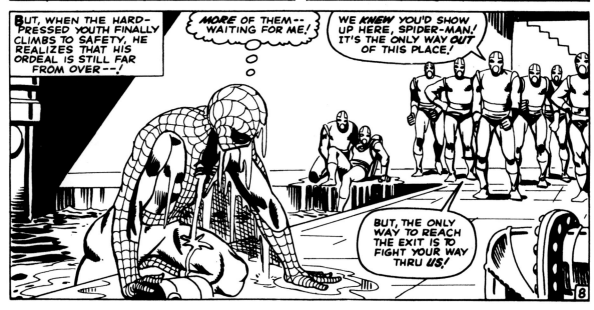

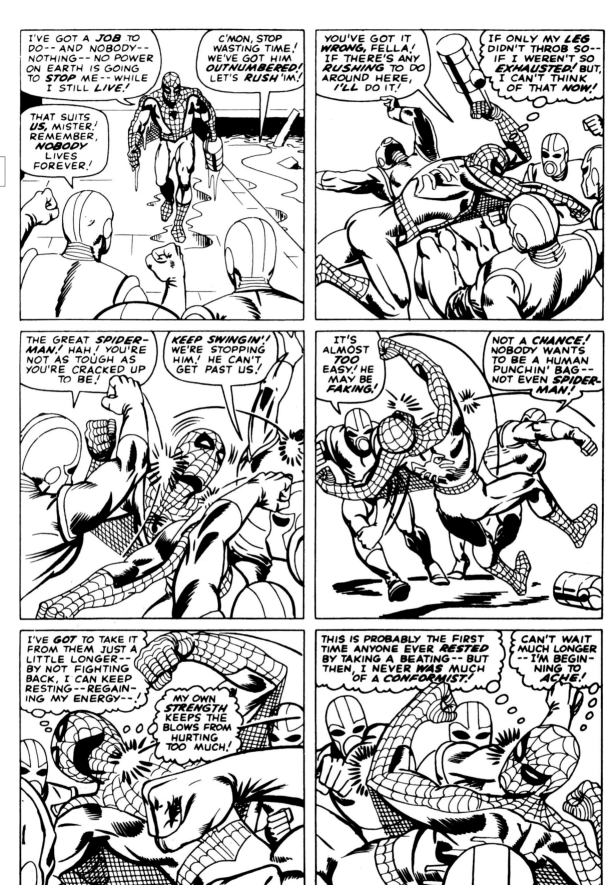

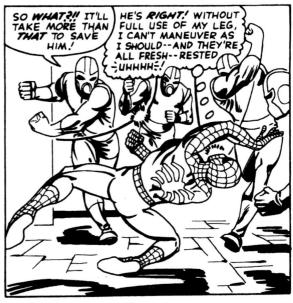

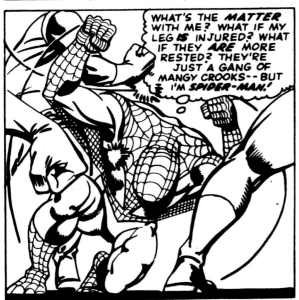

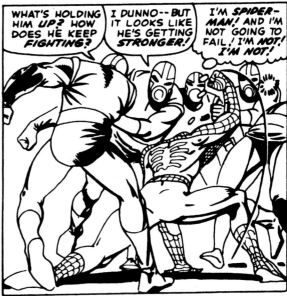

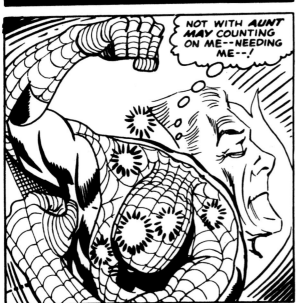

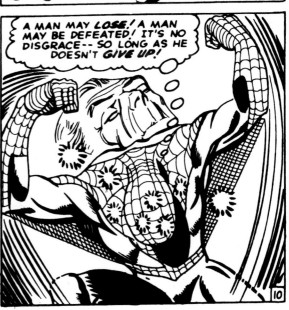

STAN LEE + STEVE DITKO

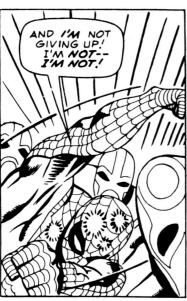

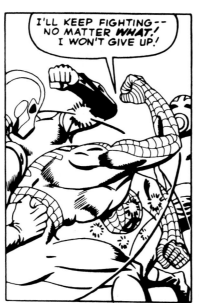

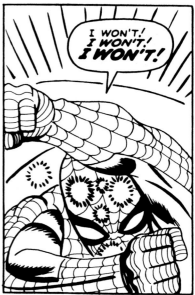

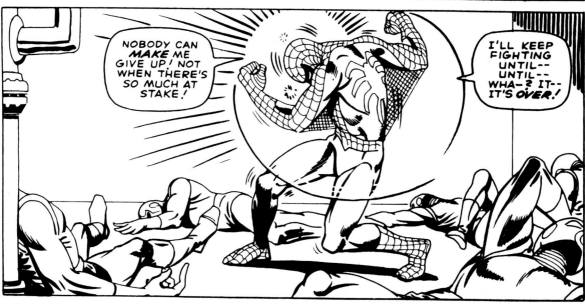

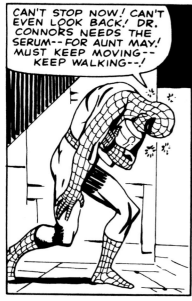

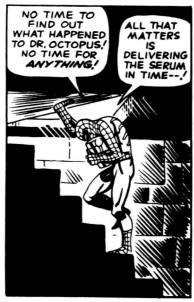

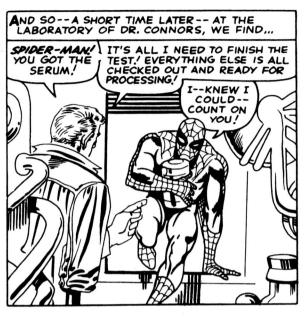

AND SO--A SHORT TIME LATER-- AT THE LABORATORY OF DR. CONNORS, WE FIND...

SPIDER-MAN! YOU GOT THE SERUM!

IT'S ALL I NEED TO FINISH THE TEST! EVERYTHING ELSE IS ALL CHECKED OUT AND READY FOR PROCESSING!

I--KNEW I COULD-- COUNT ON YOU!

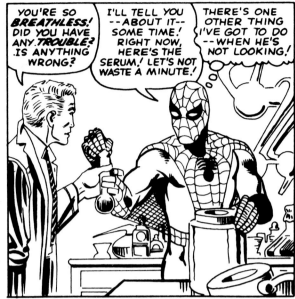

YOU'RE SO BREATHLESS! DID YOU HAVE ANY TROUBLE? IS ANYTHING WRONG?

I'LL TELL YOU --ABOUT IT-- SOME TIME! RIGHT NOW, HERE'S THE SERUM! LET'S NOT WASTE A MINUTE!

THERE'S ONE OTHER THING I'VE GOT TO DO --WHEN HE'S NOT LOOKING!

133

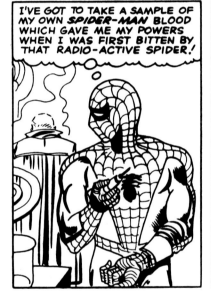

I'VE GOT TO TAKE A SAMPLE OF MY OWN SPIDER-MAN BLOOD WHICH GAVE ME MY POWERS WHEN I WAS FIRST BITTEN BY THAT RADIO-ACTIVE SPIDER!

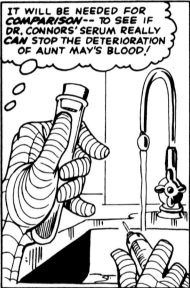

IT WILL BE NEEDED FOR COMPARISON-- TO SEE IF DR. CONNORS' SERUM REALLY CAN STOP THE DETERIORATION OF AUNT MAY'S BLOOD!

THERE! I'LL SLIP IT IN MY BELT TILL IT'S NEEDED! HE WON'T KNOW WHERE IT CAME FROM!

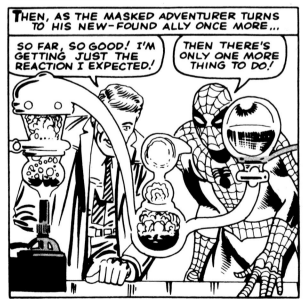

THEN, AS THE MASKED ADVENTURER TURNS TO HIS NEW-FOUND ALLY ONCE MORE...

SO FAR, SO GOOD! I'M GETTING JUST THE REACTION I EXPECTED!

THEN THERE'S ONLY ONE MORE THING TO DO!

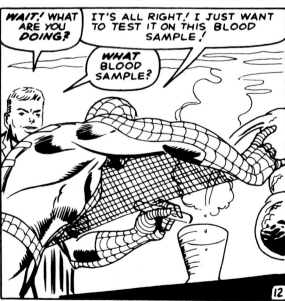

WAIT! WHAT ARE YOU DOING?

IT'S ALL RIGHT! I JUST WANT TO TEST IT ON THIS BLOOD SAMPLE!

WHAT BLOOD SAMPLE?

12

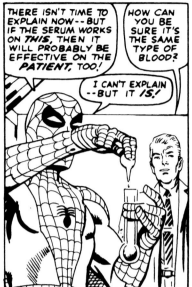
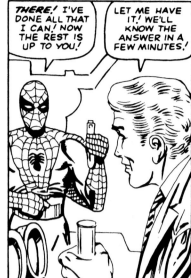

THERE ISN'T TIME TO EXPLAIN NOW -- BUT IF THE SERUM WORKS ON *THIS*, THEN IT WILL PROBABLY BE EFFECTIVE ON THE *PATIENT*, TOO!

HOW CAN YOU BE SURE IT'S THE SAME TYPE OF BLOOD?

I CAN'T EXPLAIN -- BUT IT *IS!*

THERE! I'VE DONE ALL THAT I CAN! NOW THE REST IS UP TO YOU!

LET ME HAVE IT! WE'LL KNOW THE ANSWER IN A FEW MINUTES!

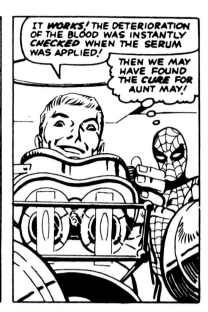

IT *WORKS!* THE DETERIORATION OF THE BLOOD WAS INSTANTLY *CHECKED* WHEN THE SERUM WAS APPLIED!

THEN WE MAY HAVE FOUND THE *CURE* FOR AUNT MAY!

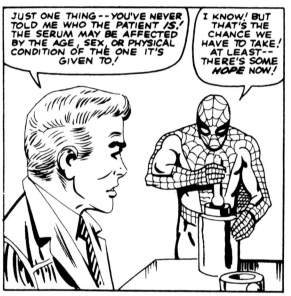

JUST ONE THING -- YOU'VE NEVER TOLD ME WHO THE PATIENT *IS!* THE SERUM MAY BE AFFECTED BY THE AGE, SEX, OR PHYSICAL CONDITION OF THE ONE IT'S GIVEN TO!

I KNOW! BUT THAT'S THE CHANCE WE HAVE TO TAKE! AT LEAST -- THERE'S SOME *HOPE* NOW!

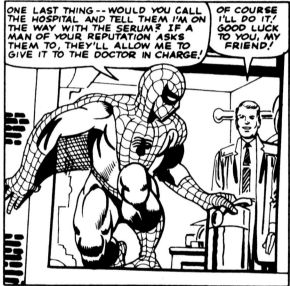

ONE LAST THING -- WOULD YOU CALL THE HOSPITAL AND TELL THEM I'M ON THE WAY WITH THE SERUM? IF A MAN OF YOUR REPUTATION ASKS THEM TO, THEY'LL ALLOW ME TO GIVE IT TO THE DOCTOR IN CHARGE!

OF COURSE I'LL DO IT! GOOD LUCK TO YOU, MY FRIEND!

SECONDS LATER...

WE'VE DONE ALL WE CAN, BUT SHE'S SINKING RAPIDLY!

DOCTOR, THERE'S AN URGENT *PHONE CALL* FOR YOU!

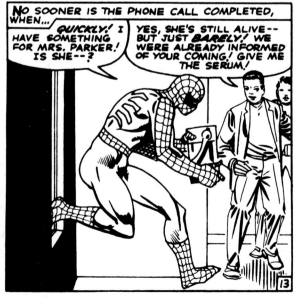

NO SOONER IS THE PHONE CALL COMPLETED, WHEN...

QUICKLY! I HAVE SOMETHING FOR MRS. PARKER! IS SHE--?

YES, SHE'S STILL ALIVE -- BUT JUST *BARELY!* WE WERE ALREADY INFORMED OF YOUR COMING! GIVE ME THE SERUM!

13

IF THIS CAN STOP THE DETERIORATION OF HER BLOOD, THEN WE'LL BE ABLE TO PERFORM A *TRANSFUSION*, AND SHE'LL HAVE A FIGHTING CHANCE!

HOW LONG WILL IT BE BEFORE YOU *KNOW*?

ABOUT TWO HOURS! WE HAVE TO CONDUCT A SERIES OF *TESTS* TO DETERMINE THE EFFECTIVENESS OF THE SERUM!

TWO HOURS! I COULDN'T BEAR TO STAND HERE THAT LONG--WATCHING--FEARING --DREADING EACH PASSING SECOND--KNOWING THAT EACH COULD BE HER *LAST!*

I'VE DONE THE BEST I COULD, AUNT MAY! NOW, THERE'S NOTHING LEFT, BUT PRAYER--!

HOLD ON THERE, SPIDER-MAN! I'VE SOME *QUESTIONS* FOR YOU!

WHAT'S *YOUR* INTEREST IN THIS MATTER?

LET'S JUST SAY THAT I WAS HELPING--A FRIEND!

I'VE GOT TO KEEP MY MIND OCCUPIED--MUST KEEP BUSY FOR THE NEXT TWO HOURS!

WAIT! I ALMOST *FORGOT--!*

THE *MASTER PLANNER'S* GANG! THEY'RE STILL OUT COLD!

I'VE GOT TO DO A LITTLE *STAGE SETTING* BEFORE THEY RECOVER!

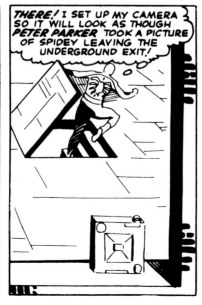

THERE! I SET UP MY CAMERA SO IT WILL LOOK AS THOUGH *PETER PARKER* TOOK A PICTURE OF SPIDEY LEAVING THE UNDERGROUND EXIT!

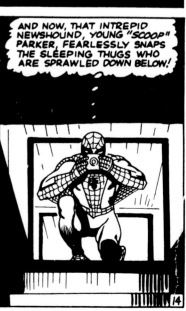

AND NOW, THAT INTREPID NEWSHOUND, YOUNG "*SCOOP*" PARKER, FEARLESSLY SNAPS THE SLEEPING THUGS WHO ARE SPRAWLED DOWN BELOW!

STAN LEE + STEVE DITKO

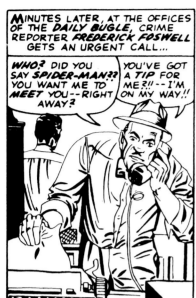

MINUTES LATER, AT THE OFFICES OF THE *DAILY BUGLE*, CRIME REPORTER *FREDERICK FOSWELL* GETS AN URGENT CALL...

WHO? DID YOU SAY *SPIDER-MAN??* YOU WANT ME TO *MEET* YOU--RIGHT AWAY?

YOU'VE GOT A *TIP* FOR ME?!!--I'M ON MY WAY!!

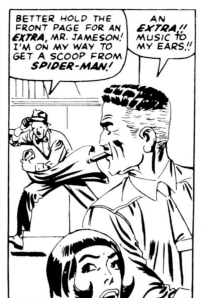

BETTER HOLD THE FRONT PAGE FOR AN *EXTRA*, MR. JAMESON! I'M ON MY WAY TO GET A SCOOP FROM *SPIDER-MAN!*

AN *EXTRA!!* MUSIC TO MY EARS!!

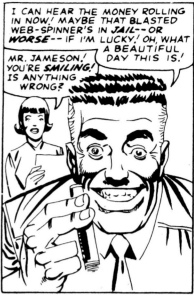

I CAN HEAR THE MONEY ROLLING IN NOW! MAYBE THAT BLASTED WEB-SPINNER'S IN *JAIL*--OR *WORSE*--IF I'M LUCKY! OH, WHAT A BEAUTIFUL DAY THIS IS!

MR. JAMESON! YOU'RE *SMILING!* IS ANYTHING WRONG?

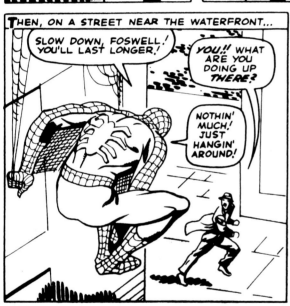

THEN, ON A STREET NEAR THE WATERFRONT...

SLOW DOWN, FOSWELL! YOU'LL LAST LONGER!

YOU!! WHAT ARE YOU DOING UP *THERE?*

NOTHIN' MUCH! JUST HANGIN' AROUND!

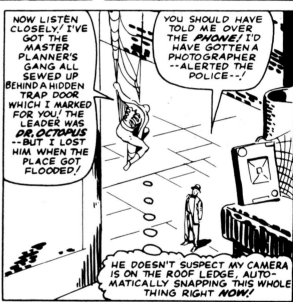

NOW LISTEN CLOSELY! I'VE GOT THE MASTER PLANNER'S GANG ALL SEWED UP BEHIND A HIDDEN TRAP DOOR WHICH I MARKED FOR YOU! THE LEADER WAS *DR. OCTOPUS*--BUT I LOST HIM WHEN THE PLACE GOT FLOODED!

YOU SHOULD HAVE TOLD ME OVER THE *PHONE!* I'D HAVE GOTTEN A PHOTOGRAPHER --ALERTED THE POLICE--!

HE DOESN'T SUSPECT MY CAMERA IS ON THE ROOF LEDGE, AUTO-MATICALLY SNAPPING THIS WHOLE THING RIGHT *NOW!*

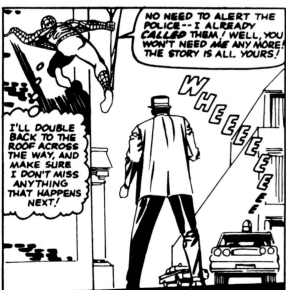

NO NEED TO ALERT THE POLICE--I ALREADY *CALLED* THEM! WELL, YOU WON'T NEED *ME* ANY MORE! THE STORY IS ALL YOURS!

I'LL DOUBLE BACK TO THE ROOF ACROSS THE WAY, AND MAKE SURE I DON'T MISS ANYTHING THAT HAPPENS NEXT!

WHEEEEE

THERE THEY ARE--LIKE CONTRITE LITTLE SCHOOL-BOYS WHO GOT CAUGHT WITH THEIR HANDS IN THE COOKIE JAR!

KEEP WALKING! DON'T BE SHY! WE'VE GOT ROOM IN THE PADDY WAGON FOR *ALL* OF YOU!

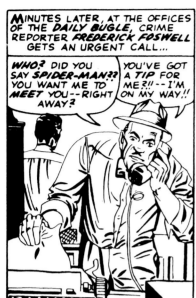

THIS IS *PERFECT!* THEY'RE MAKING THEM *UNMASK*-- AND MY TRUSTY LITTLE SNOOPER-SCOPE AND I HAVE A RINGSIDE SEAT!

HOOO BOY! THERE'LL BE A LOT OF BARE POST OFFICE WALLS WHEN *THOSE* CHARACTERS GET TAKEN OUT OF CIRCULATION!

IT'LL BE LIKE OLD HOME WEEK AT SING SING WHEN *YOU* CUT-UPS COME MARCHING IN!

WE'LL HAVE TO DISPATCH A *DIVER* DOWN BELOW TO SEE IF THERE'S ANY TRACE OF *DR. OCTOPUS!*

IF HE'S ANYWHERE IN THE VICINITY, WE'LL *FIND* HIM, CHARLIE! BUT, MY GUESS IS THAT HE'S *MILES* FROM HERE BY NOW!

THAT IS, IF HE *SURVIVED* THE CAVE-IN!

THAT'S THAT! THIS SQUARES ME WITH FOSWELL! AND IT MAKES UP FOR MY SUSPECT-ING HIM OF BEING THE *CRIME-MASTER*#!

NOW TO GET THESE PIX TO *JAMESON*-- ON THE DOUBLE!

AS WE SAW A FEW ISSUES AGO -- STAN.

SECONDS LATER, THERE'S FRANTIC JUBILATION IN THE CITY ROOM OF THE *DAILY BUGLE....!*

THE *MASTER PLANNER* GANG CAPTURED-- THE IDENTITY OF THE LEADER REVEALED-- AND *MY* PAPER HAS THE STORY *FIRST!*

THAT'S *GREAT*, FOSWELL! I *KNEW* YOU COULD DO IT!

BETTER NOT PRAISE HIM *TOO* MUCH-- HE'S LIABLE TO HIT ME FOR A *RAISE!*

BUT YOU SHOULD HAVE GOTTEN *PICTURES!* IF ONLY WE HAD *PHOTOS!*

AND, SPEAKING OF PHOTOS...

HE MUST *HAVE* THE STORY BY NOW! HE'LL BE HUNGRY FOR MY PHOTOS!

DARN *LEG* IS STILL ACHING! I OUGHT TO STAY *OFF* IT!

OH! THERE'S *PETER!* I'VE BEEN *HOPING* TO-- BUT WHAT'S WRONG WITH HIS *LEG*?? HE'S BEEN *HURT!*

PETER! PETER-- *WAIT!* IT'S ME-- *BETTY!* I WANT TO *TALK* TO YOU....!

OH *NO!* NOT NOW! I DON'T WANT TO HAVE TO FACE HER NOW!

STAN LEE + STEVE DITKO

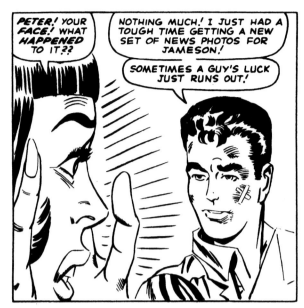

PETER! YOUR *FACE!* WHAT *HAPPENED* TO IT??

NOTHING MUCH! I JUST HAD A TOUGH TIME GETTING A NEW SET OF NEWS PHOTOS FOR JAMESON!

SOMETIMES A GUY'S LUCK JUST RUNS OUT!

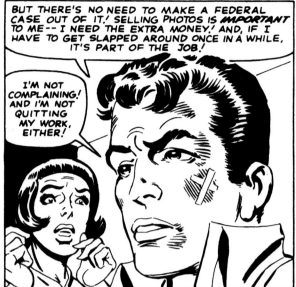

BUT THERE'S NO NEED TO MAKE A FEDERAL CASE OUT OF IT! SELLING PHOTOS IS *IMPORTANT* TO ME-- I NEED THE EXTRA MONEY! AND, IF I HAVE TO GET SLAPPED AROUND ONCE IN A WHILE, IT'S PART OF THE JOB!

I'M NOT COMPLAINING! AND I'M NOT QUITTING MY WORK, EITHER!

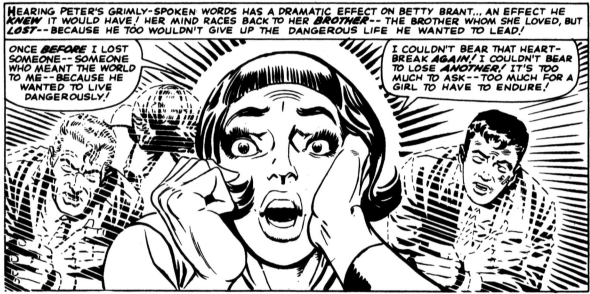

HEARING PETER'S GRIMLY-SPOKEN WORDS HAS A DRAMATIC EFFECT ON BETTY BRANT... AN EFFECT HE *KNEW* IT WOULD HAVE! HER MIND RACES BACK TO HER *BROTHER*-- THE BROTHER WHOM SHE LOVED, BUT *LOST*-- BECAUSE HE TOO WOULDN'T GIVE UP THE DANGEROUS LIFE HE WANTED TO LEAD!

ONCE *BEFORE* I LOST SOMEONE-- SOMEONE WHO MEANT THE WORLD TO ME-- BECAUSE HE WANTED TO LIVE DANGEROUSLY!

I COULDN'T BEAR THAT HEART-BREAK *AGAIN!* I COULDN'T BEAR TO LOSE *ANOTHER!* IT'S TOO MUCH TO ASK-- TOO MUCH FOR A GIRL TO HAVE TO ENDURE!

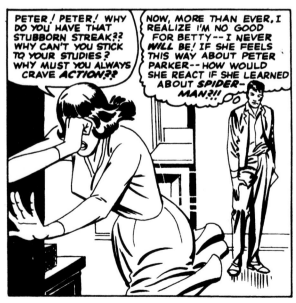

PETER! PETER! WHY DO YOU HAVE THAT STUBBORN STREAK?? WHY CAN'T YOU STICK TO YOUR STUDIES? WHY MUST YOU ALWAYS CRAVE *ACTION??*

NOW, MORE THAN EVER, I REALIZE I'M NO GOOD FOR BETTY-- I NEVER *WILL* BE! IF SHE FEELS THIS WAY ABOUT PETER PARKER-- HOW WOULD SHE REACT IF SHE LEARNED ABOUT *SPIDER-MAN?!!*

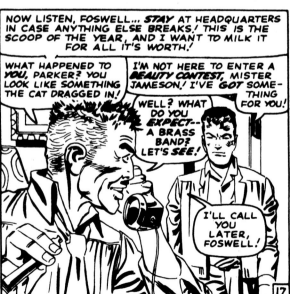

NOW LISTEN, FOSWELL... *STAY* AT HEADQUARTERS IN CASE ANYTHING ELSE BREAKS! THIS IS THE SCOOP OF THE YEAR, AND I WANT TO MILK IT FOR ALL IT'S WORTH!

WHAT HAPPENED TO *YOU,* PARKER? YOU LOOK LIKE SOMETHING THE CAT DRAGGED IN!

I'M NOT HERE TO ENTER A *BEAUTY CONTEST,* MISTER JAMESON! I'VE *GOT* SOMETHING FOR YOU!

WELL? WHAT DO YOU *EXPECT*-- A BRASS BAND? LET'S *SEE!*

I'LL CALL YOU LATER, FOSWELL!

17

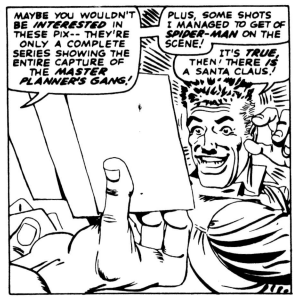

MAYBE YOU WOULDN'T BE *INTERESTED* IN THESE PIX-- THEY'RE ONLY A COMPLETE SERIES SHOWING THE ENTIRE CAPTURE OF THE *MASTER PLANNER'S GANG!*

PLUS, SOME SHOTS I MANAGED TO GET OF *SPIDER-MAN* ON THE SCENE!

IT'S *TRUE,* THEN! THERE *IS* A SANTA CLAUS!

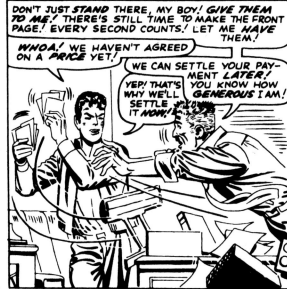

DON'T JUST *STAND* THERE, MY BOY! *GIVE THEM TO ME!* THERE'S STILL TIME TO MAKE THE FRONT PAGE! EVERY SECOND COUNTS! LET ME *HAVE* THEM!

WHOA! WE HAVEN'T AGREED ON A *PRICE* YET!

WE CAN SETTLE YOUR PAYMENT *LATER!* YOU KNOW HOW *GENEROUS* I AM!

YEP! THAT'S WHY WE'LL SETTLE IT *NOW!*

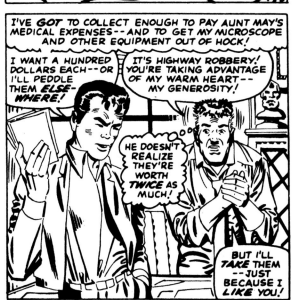

I'VE *GOT* TO COLLECT ENOUGH TO PAY AUNT MAY'S MEDICAL EXPENSES-- AND TO GET MY MICROSCOPE AND OTHER EQUIPMENT OUT OF HOCK!

I WANT A HUNDRED DOLLARS EACH-- OR I'LL PEDDLE THEM *ELSE-WHERE!*

IT'S HIGHWAY ROBBERY! YOU'RE TAKING ADVANTAGE OF MY WARM HEART-- MY GENEROSITY!

HE DOESN'T REALIZE THEY'RE WORTH *TWICE* AS MUCH!

BUT I'LL *TAKE* THEM --JUST BECAUSE I *LIKE* YOU!

OKAY THEN, KEEP LIKING ME ENOUGH TO GIVE ME A CHECK RIGHT *NOW*-- 'CAUSE I CAN USE THE DOUGH!

WHAT'S GOTTEN INTO PARKER? HE USED TO BE A REAL LITTLE MILK-TOAST! WHO WISED HIM UP?

HERE'S YOUR CHECK! I'LL PROBABLY GO *BROKE* THROWING AWAY MY MONEY SO CARE-LESSLY!

COME *OFF* IT, J.J.! COMPARED TO *YOU,* EVEN *SCROOGE* WAS A RECKLESS, DEVIL-MAY-CARE SPENDTHRIFT!

SHORTLY THEREAFTER, AT THE HOSPITAL...

IT'S TIME FOR THE DECISION ABOUT AUNT MAY NOW!

I-I'M ALMOST AFRAID TO FIND OUT! BUT I *MUST!*

;UHHH; -- MY *LEG!* IT'S ACHING MORE THAN EVER NOW!

BUT THIS IS NO TIME TO WORRY ABOUT *THAT!*

PARKER!

TELL ME, DOC --WHAT ABOUT MY *AUNT?* ARE THE TESTS COMPLETED? IS SHE-- IS SHE--??

WE'LL KNOW IN A FEW MINUTES, SON! THE LAST CHECK IS BEING MADE RIGHT NOW!

BUT, WHAT HAPPENED TO *YOU?* YOU'D BETTER LET ME LOOK AT YOU!

18

STAN LEE + STEVE DITKO

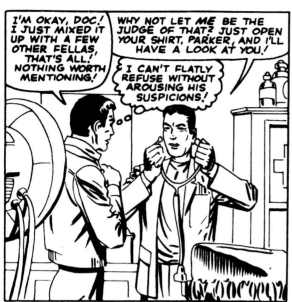

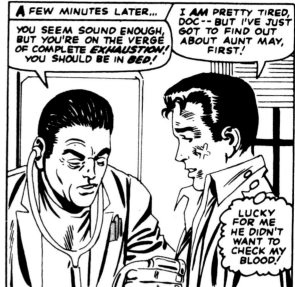

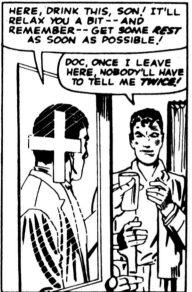

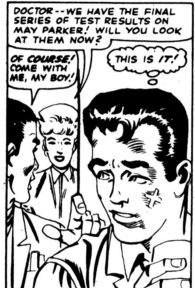

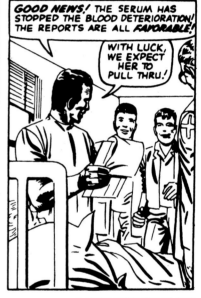

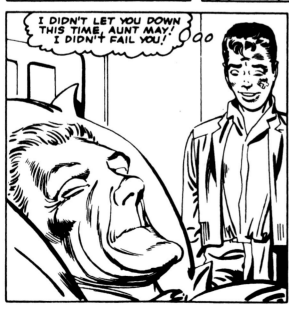

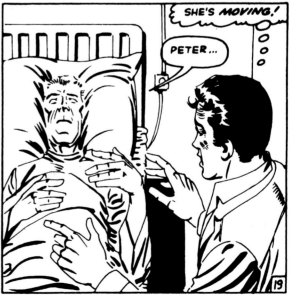

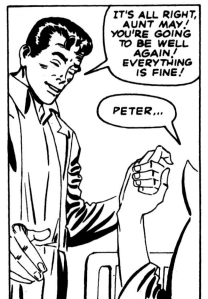

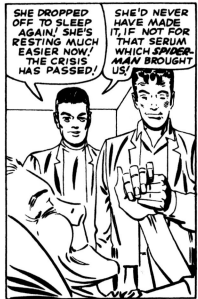

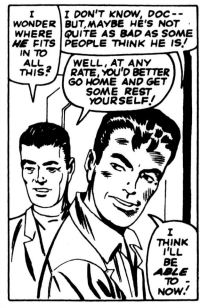

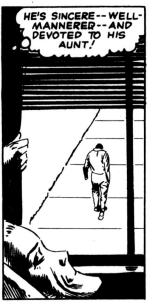

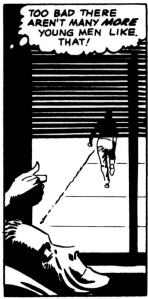

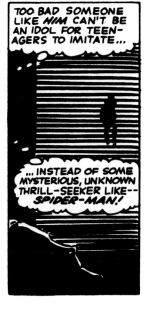

PART THREE
A RAW GENERATION

CHAPTER 1.

IZZY
THE COCKROACH
AND
THE MEANING OF LIFE

THE TENEMENT AT 55 DROPSIE AVENUE
LAY QUIETLY AT ANCHOR IN ITS SEA OF CONCRETE.
THE SOUNDS OF THE CITY WERE DIMINISHING.
ALREADY ONE COULD HEAR RUSS COLUMBO SINGING
FROM A RADIO IN THE SECOND FLOOR BACK.
IT WAS FRIDAY AND IT WAS SUNDOWN,
AND THE LAST OF THE REGULAR CONGREGANTS
OF THE SYNAGOGUE ON THE NEXT BLOCK
WERE WALKING HOME.

♪♪ When the deep purple falls
over sleepy garden walls... ♪♪

5

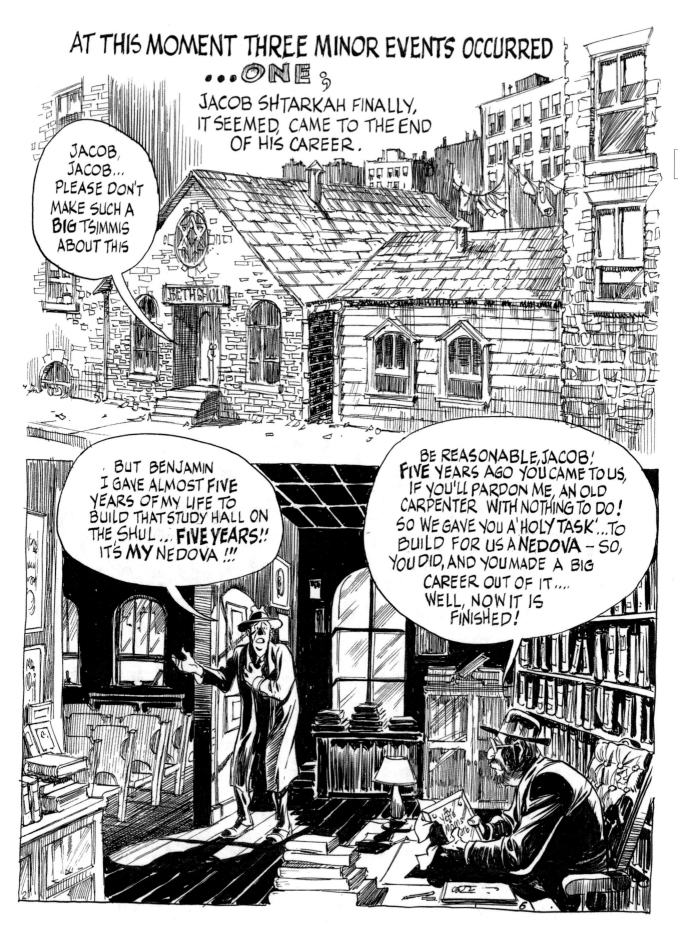

WILL EISNER

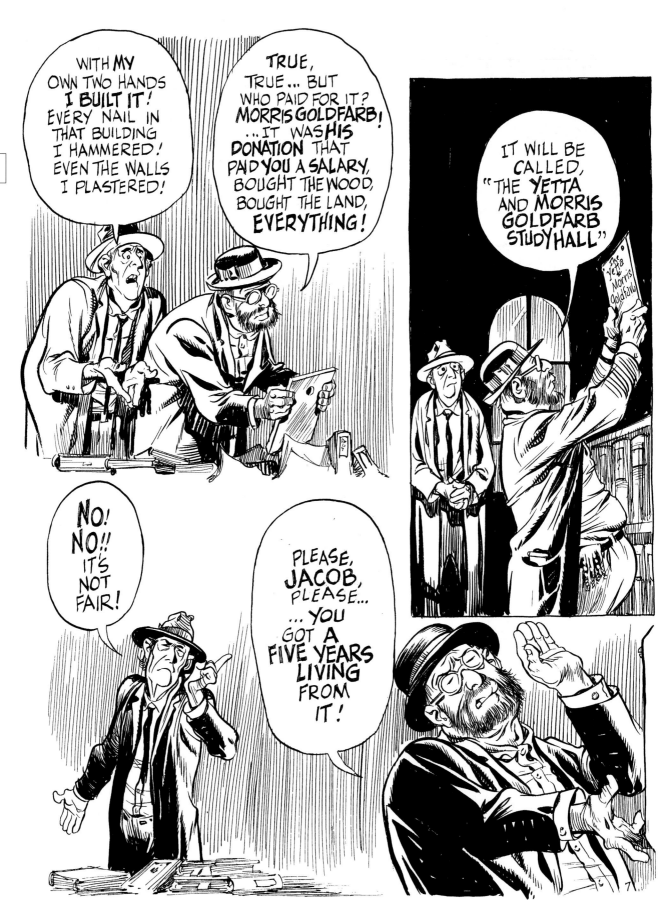

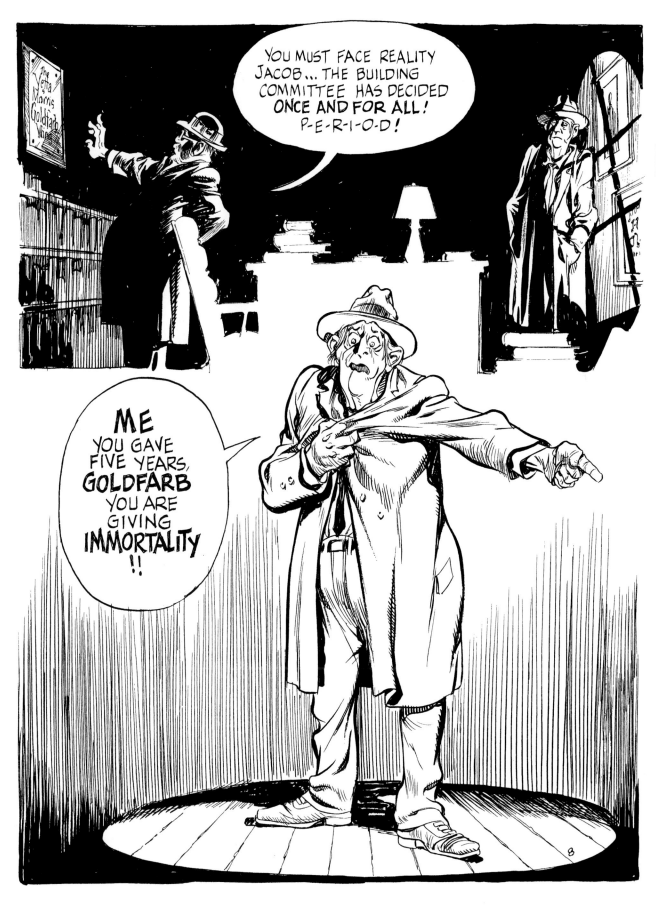

WILL EISNER

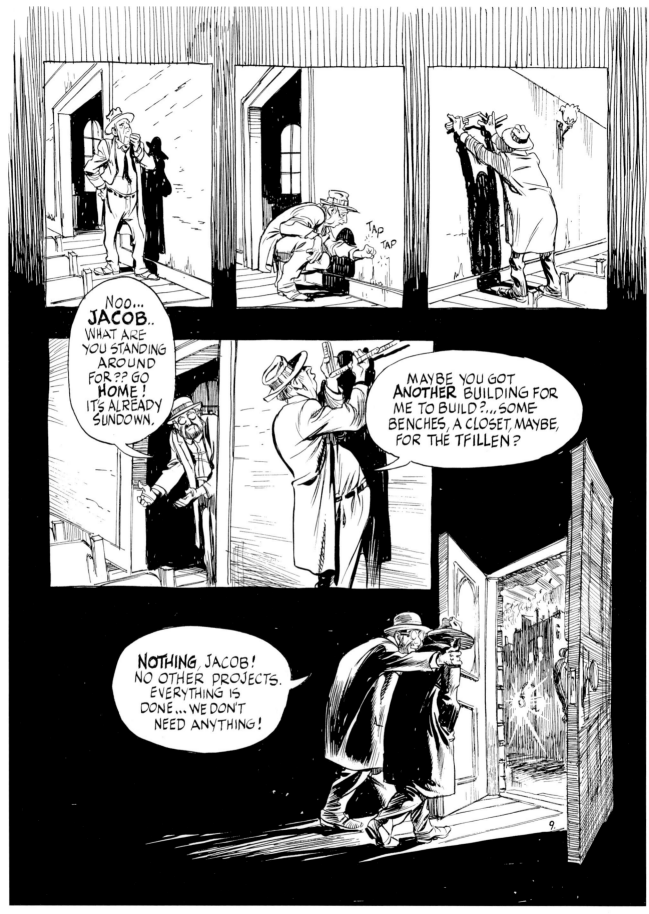

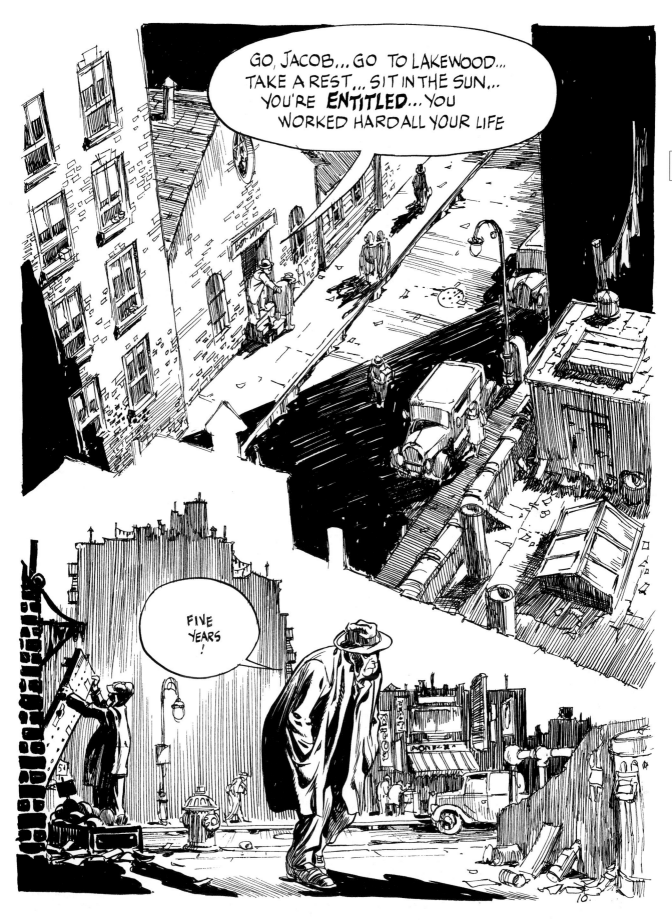

WILL EISNER

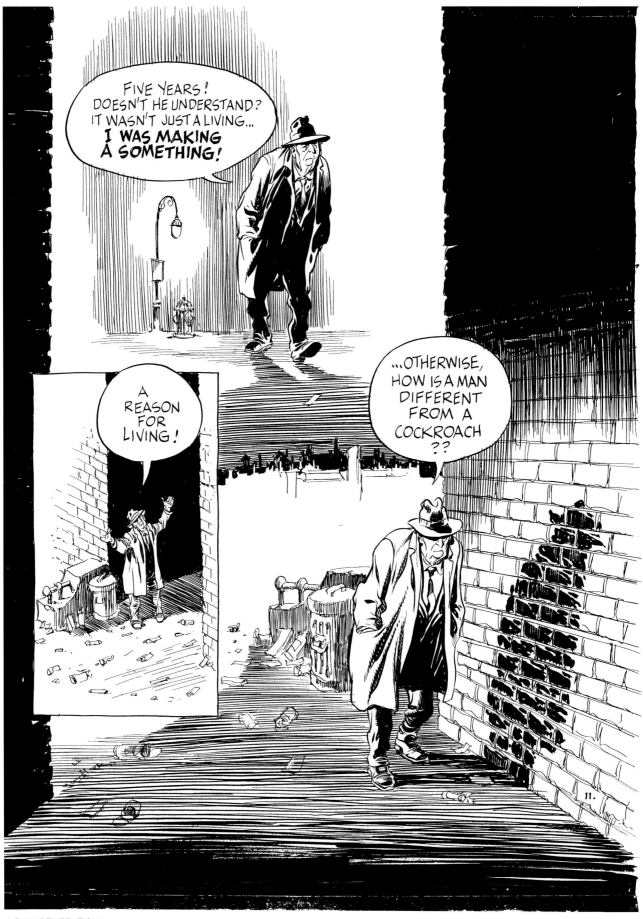

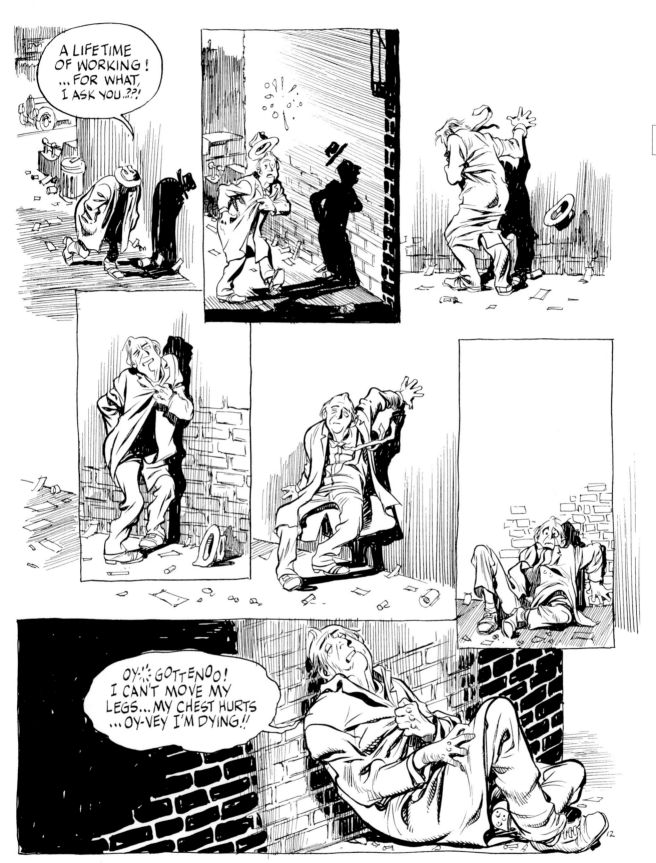

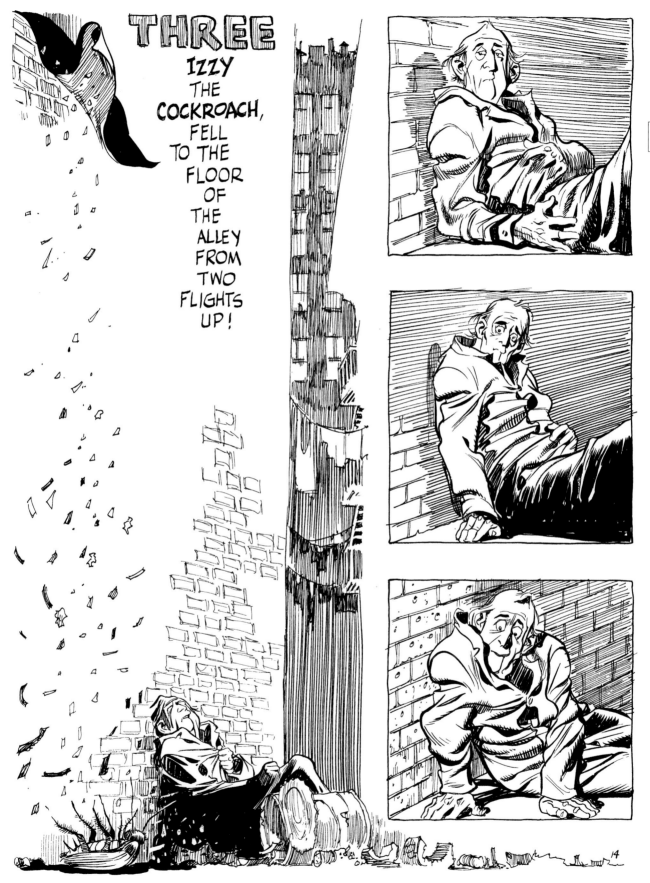

THREE

IZZY THE COCKROACH, FELL TO THE FLOOR OF THE ALLEY FROM TWO FLIGHTS UP!

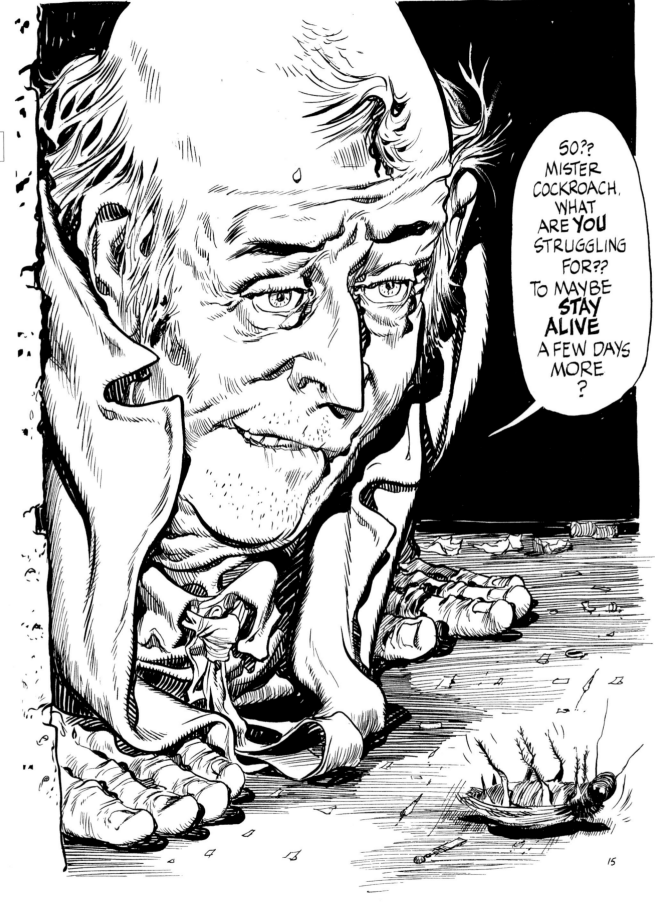

154

A RAW GENERATION

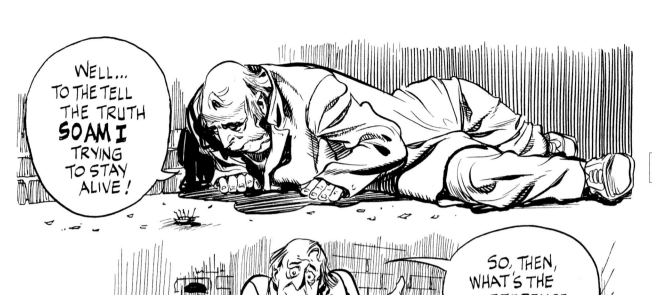

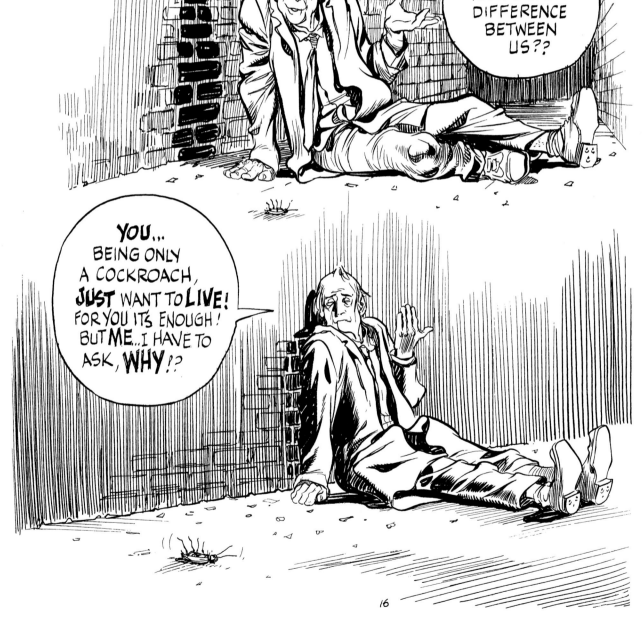

LWILL EISNER

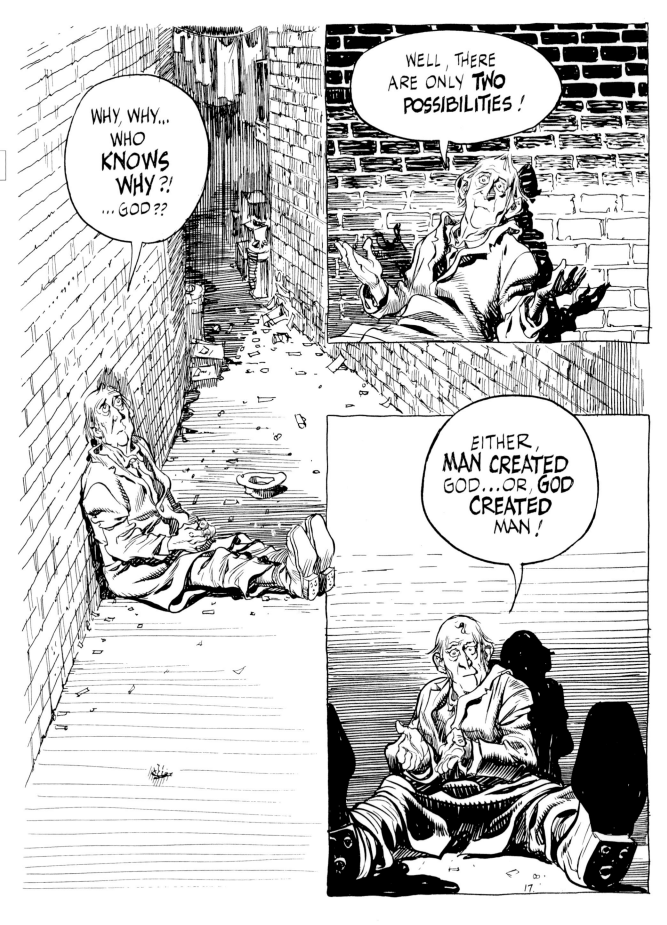

IF... MAN CREATED GOD...

...THEN, THE REASON FOR LIFE IS ONLY IN THE MIND OF MAN!!!

...IF, ON THE OTHER HAND, GOD CREATED MAN...

THEN, THE REASON FOR LIVING IS STILL ONLY A GUESS!

...AFTER ALL IS SAID AND DONE...

WHO REALLY KNOWS THE WILL OF GOD??

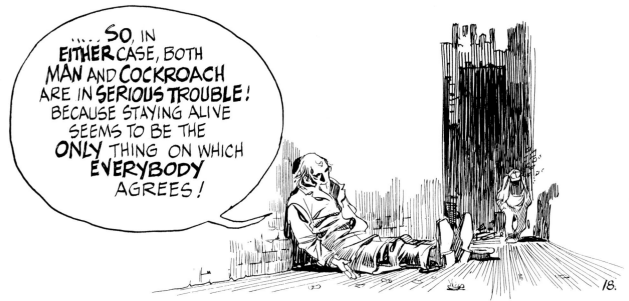

".... SO, IN EITHER CASE, BOTH MAN AND COCKROACH ARE IN SERIOUS TROUBLE! BECAUSE STAYING ALIVE SEEMS TO BE THE ONLY THING ON WHICH EVERYBODY AGREES!

18.

WILL EISNER

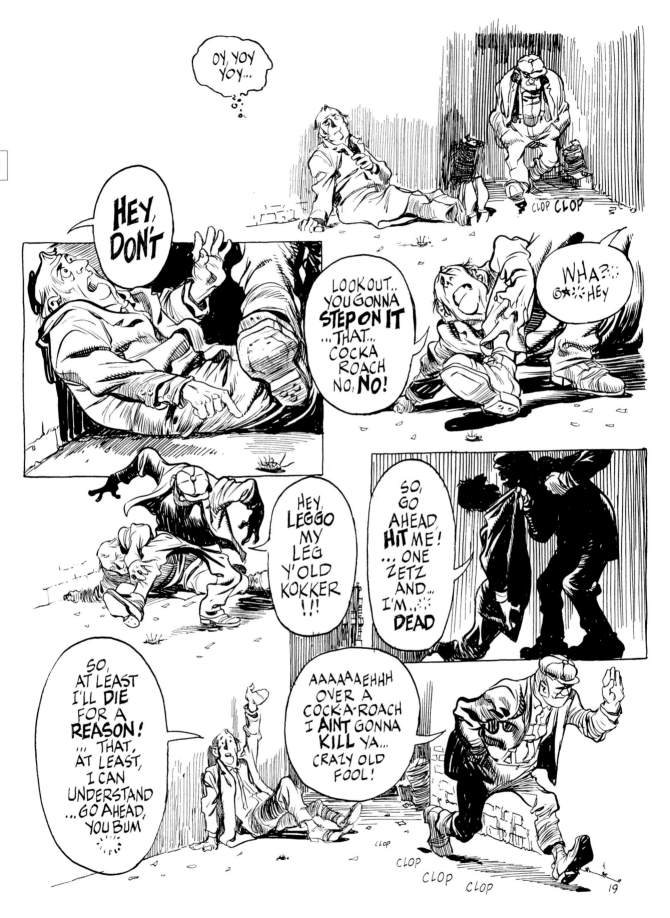

158

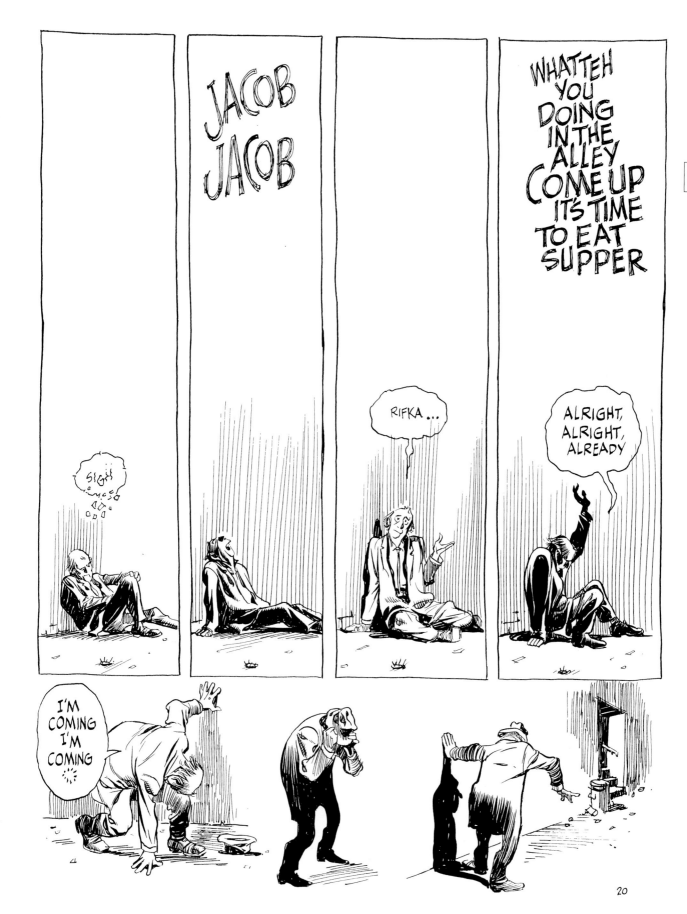

20

WILL EISNER

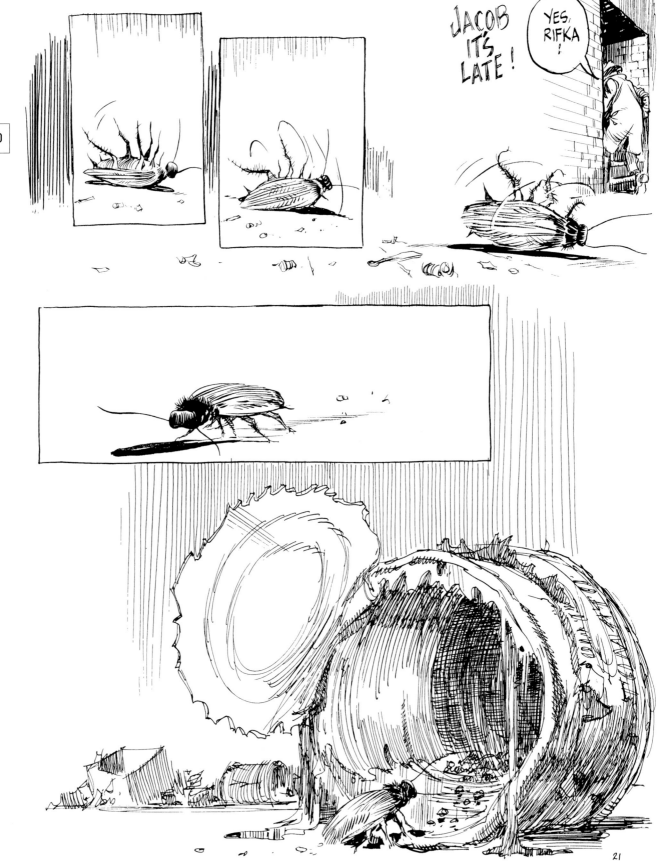

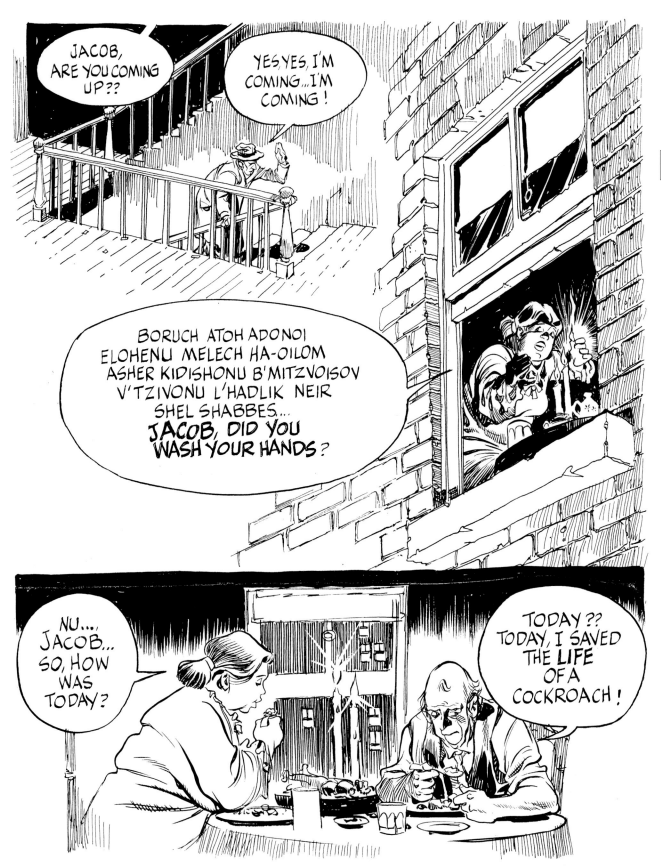

22

WILL EISNER

FAREWELL TO CHARLIE CHAPLIN

RICK GEARY ©1981

JUST THIS YEAR I MOVE TO SWITZERLAND WITH MY CLOSE FRIEND SVOD

WE LOOK ALL OVER FOR WORK

MY WIFE AND MY INFANT ARE HERE TOO

WE ALL OCCUPY A ROOM IN THIS HOUSE

A CORNER OF OUR ROOM

MY NEIGHBOR FROM THE ROOM NEXT DOOR SAYS THAT THE PICTURE STAR CHARLIE CHAPLIN IS BURIED AT A VILLAGE NEAR US

ONE NIGHT MY NEIGHBOR AND MY FRIEND AND ME DIG UP MR. CHAPLIN

WE MUST PUSH HIS COFFIN ALONG THE GROUND

THE HOLE WE LEAVE

WE HIDE MR. CHAPLIN IN THE CELLAR OF OUR HOUSE

TO BE SAFE, WE BURN OUR CLOTHES AND SHOES

WE DROP OUR SHOVELS INTO THE RIVER

MY FRIEND TELEPHONES A RANSOM DEMAND FROM A CABINET IN THE CENTRE OF TOWN

I ADMIRE THE FINE OAKWORK AND FITTINGS OF MR. CHAPLIN'S COFFIN

WE WATCH ABOUT OUR CRIME ON MY NEIGHBOR'S TELEVISION

MEANTIME I WORK IN THE AUTO GARAGE TO SUPPORT MY FAMILY

MY FRIEND CONTINUES TO TELEPHONE RANSOM DEMANDS

163

RICK GEARY

MY NEIGHBOR IS UPSET AND
SAYS THAT WE HAD BETTER
GET OUR MONEY SOON

MY WIFE WANTS MR. CHAPLIN
REMOVED FROM THE HOUSE

MY NEIGHBOR AND MY FRIEND
AND ME REMOVE MR. CHAPLIN
TO A PASTURE FAR AWAY

AFTER CONSIDERABLE DISCUSSION
WE DECIDE TO LOWER OUR
RANSOM DEMAND

MY NEIGHBOR LEAVES TO
VISIT HIS COUSIN IN BERN

MY FRIEND IS PLACED UNDER
ARREST AS HE TELEPHONES
ANOTHER RANSOM DEMAND

WE MUST SHOW WHERE TO
FIND MR. CHAPLIN

MY WIFE AND MY INFANT MUST
RETURN TO BULGARIA

MY FRIEND AND ME IN THE
CUSTODY OF THE GOVERNMENT

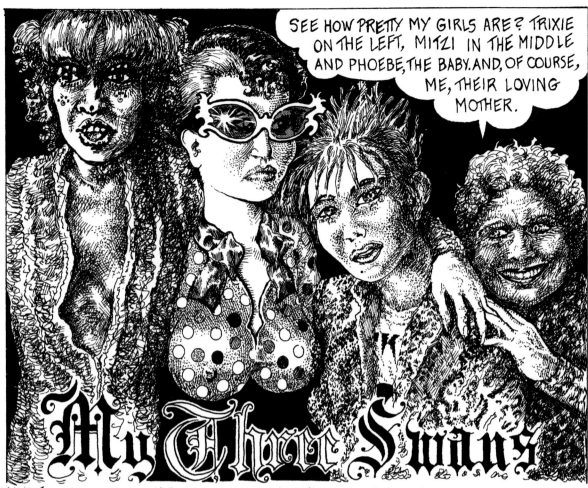

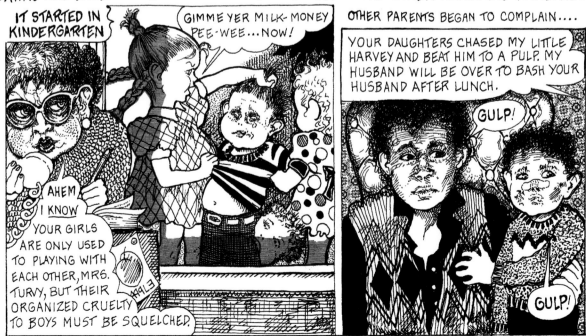

MELINDA GEBBIE

165

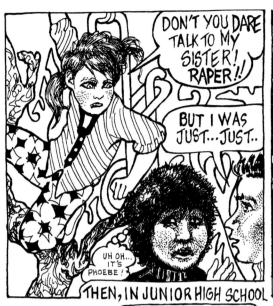

DON'T YOU DARE TALK TO MY SISTER! RAPER!!

BUT I WAS JUST...JUST..

UH OH... IT'S PHOEBE!

THEN, IN JUNIOR HIGH SCHOOL

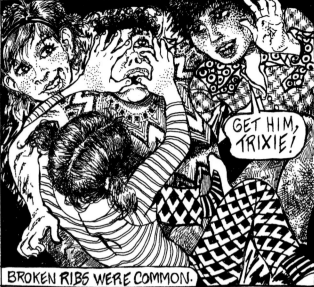

GET HIM, TRIXIE!

BROKEN RIBS WERE COMMON.

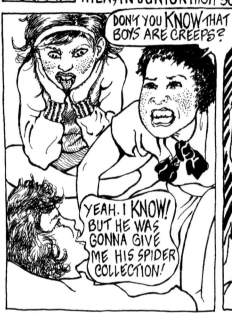

DON'T YOU KNOW THAT BOYS ARE CREEPS?

YEAH. I KNOW! BUT HE WAS GONNA GIVE ME HIS SPIDER COLLECTION!

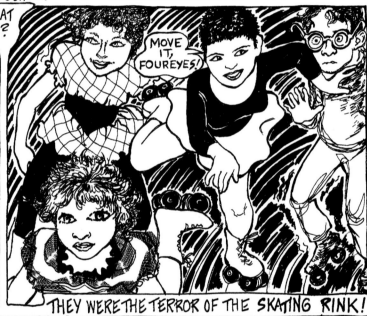

MOVE IT, FOUREYES!

THEY WERE THE TERROR OF THE SKATING RINK!

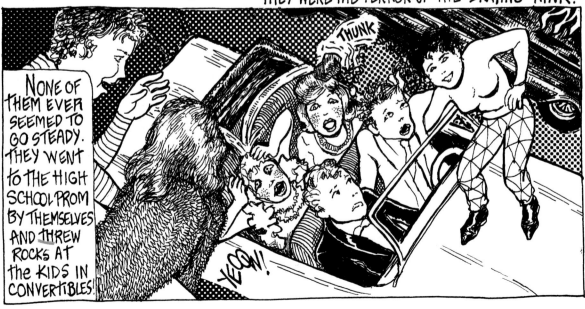

NONE OF THEM EVER SEEMED TO GO STEADY. THEY WENT TO THE HIGH SCHOOL PROM BY THEMSELVES AND THREW ROCKS AT THE KIDS IN CONVERTIBLES!

THUNK

YEOOW!

A RAW GENERATION

AFTER HIGH SCHOOL, THEY BEGGED TO BE ALLOWED TO ATTEND A RADICAL WOMENS' COLLEGE. THEIR DADS WERE GUNG-HO ON THE BABIES ACHIEVING INDIVIDUALITY... SO... OFF THEY WENT!

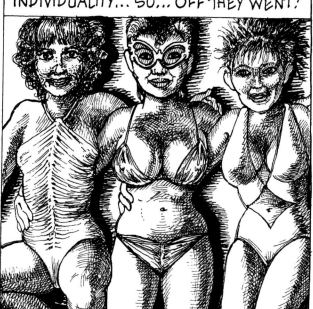

CARDS AND PHOTOS KEPT US ABREAST OF STUDIES AND FESTIVITIES.

Rah! Rah! sis! boom! bah! here's us on the football field

Don't be scared Mom! We're only pretending to be drunk! Love Mitzi Trissie and Phoebie!

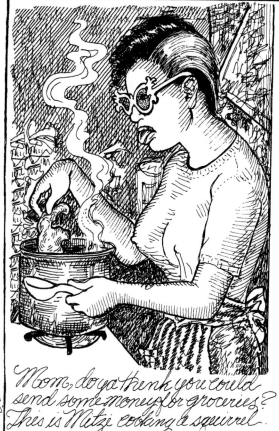

Mom, do ya think you could send some money for groceries? This is Mitzi cooking a squirrel.

MELINDA GEBBIE

IT WAS TRIXIE'S LAST YEAR, MITZI'S THIRD AND PHOEBE'S FIRST IN SCHOOL, WHEN TRAGEDY STRUCK OUR LIVES. MITZI'S DAD WAS KNIFED BY AN INSANE KITTY AT THE KIT-KAT KLUB. MY DARLINGS RUSHED HOME TO PAY RESPECTS. IT MUST'VE BEEN AN UGLY REALITY TO YOUNG EYES.

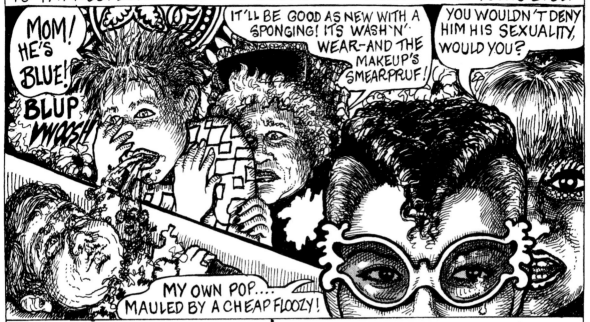

MOM! HE'S BLUE! BLUP MOSS!

IT'LL BE GOOD AS NEW WITH A SPONGING! IT'S WASH 'N' WEAR—AND THE MAKEUP'S SMEARPRUF!

YOU WOULDN'T DENY HIM HIS SEXUALITY, WOULD YOU?

MY OWN POP.... MAULED BY A CHEAP FLOOZY!

BUT HOW IS A MOTHER TO KNOW HOW TRULY DELICATE A CHILD'S MIND CAN BE? AFTER ALL, THE WORLD CAN BE A PRETTY SAVAGE PLACE. IT'S NOT THAT I THINK THE KIDS ARE COWARDLY...

I JUST WISH THEY WOULD'VE AT LEAST DATED SOME BOYS BEFORE DECIDING TO QUIT SCHOOL AND COMMIT THEMSELVES TO A THREE WAY MARRIAGE... TO EACH OTHER!

M. GEBBIE © 1980 THE END!

A RAW GENERATION

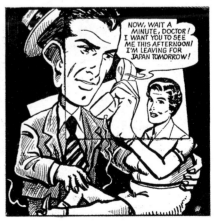

ART SPIEGELMAN

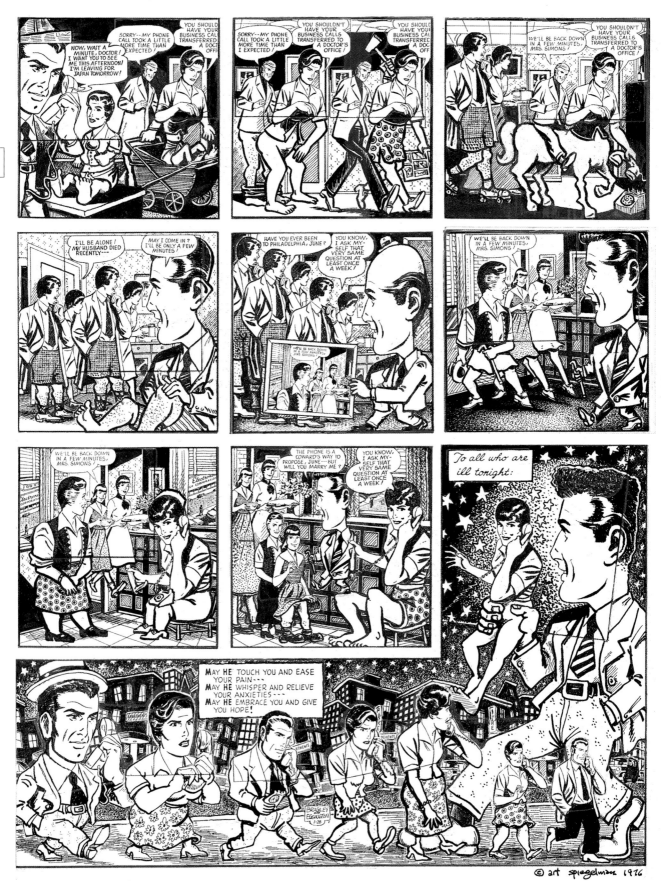

A RAW GENERATION

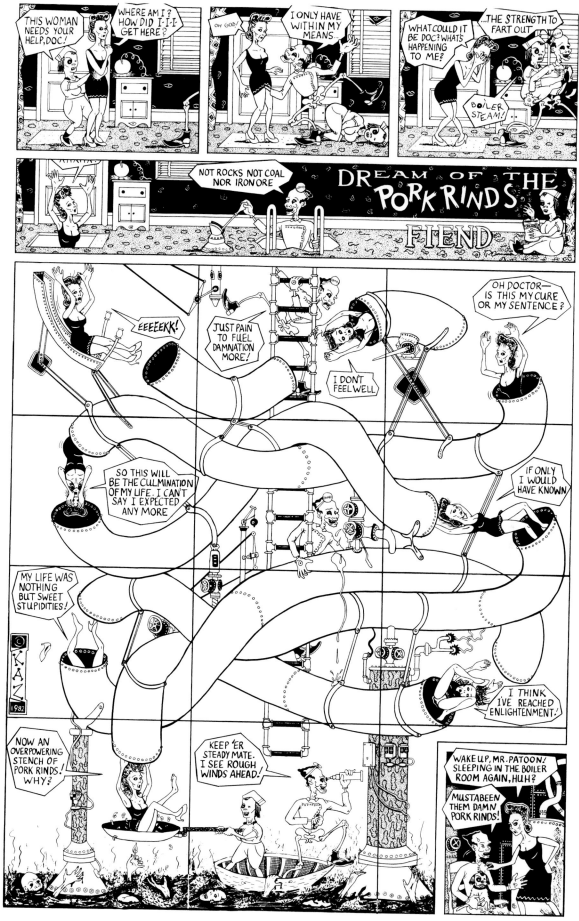

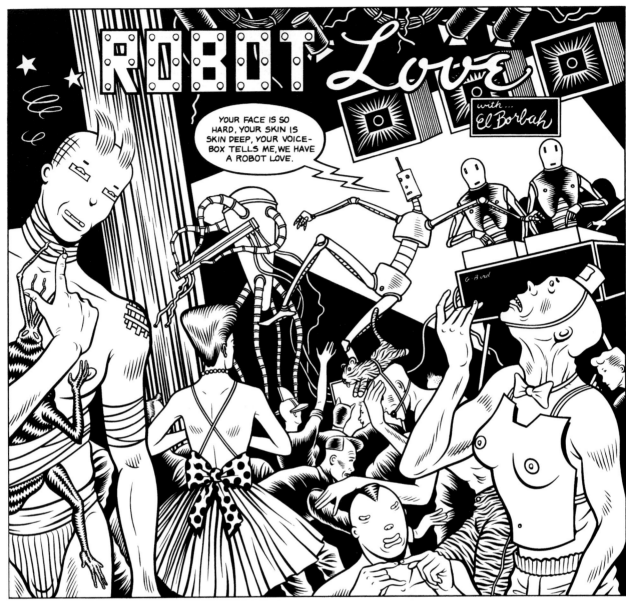

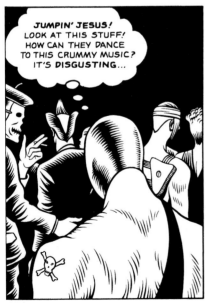

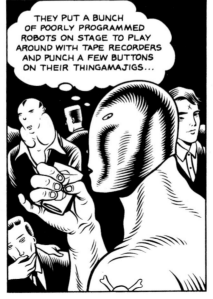

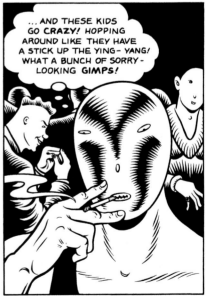

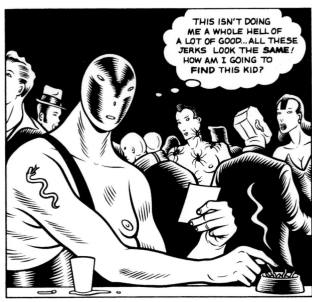

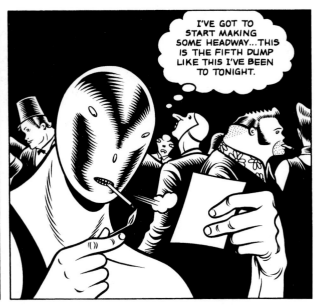

THAT WAS ABOUT ALL I HAD TO GO ON...A CRUMMY HIGH-SCHOOL PHOTOGRAPH OF A KID WHO WAS IN LOVE WITH **ROBOT MUSIC!** THIS ALL STARTED WHEN I GOT A CALL ABOUT MIDWEEK FROM A MRS. DIMBEAU TELLING ME HER TEENAGE SON WAS MISSING AND COULD I HELP THEM FIND HIM..... LIKE A FOOL I SAID YES.

AS I WALKED INTO THEIR HOUSE I COULD TELL THEY WEREN'T HURTING FOR MONEY...MRS. DIMBEAU LOOKED LIKE SOMETHING THE CAT DRAGGED IN...

MR. DIMBEAU WASN'T MUCH BETTER...HE TRIED TO COME ON WITH THE VICTOR MATURE ACT. I WAS BE-GINNING TO SEE WHY THE KID HAD RUN AWAY.

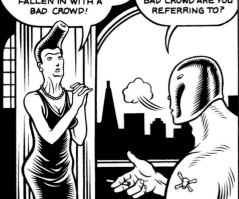

OH MR. **BORBAH!** I'M SO GLAD YOU COULD **COME!** WE'VE BEEN OUT OF OUR MINDS WITH WORRY...WE'RE AFRAID OUR TIMMY HAS FALLEN IN WITH A BAD CROWD!

WELL, MRS. DIMBEAU...I'LL DO EVERYTHING I CAN. WHAT KIND OF BAD CROWD ARE YOU REFERRING TO?

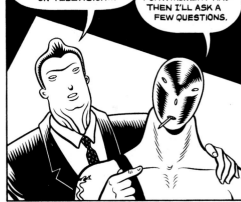

...SO WE THINK HE MAY HAVE RUN OFF WITH A GROUP OF THOSE **ROBOTOID HOODS!** YOU'VE PROBABLY SEEN THEM ON TELEVISION...

EXCUSE ME, BUT IF YOU DON'T MIND, I'D LIKE TO LOOK IN HIS ROOM FOR A MOMENT AND THEN I'LL ASK A FEW QUESTIONS.

HIS ROOM WAS SMALL AND DARK...IT LOOKED LIKE ANOTHER EXTENSION OF MR. AND MRS. DIMBEAU...DULL.

ASIDE FROM A RECORD PLAYER AND A FEW ROBOT RECORDS IT REMINDED ME OF A SANITIZED MOTEL ROOM...NO SIGN OF LIFE.

THE ONLY THING I FOUND OF INTEREST WAS A STACK OF BLUEPRINTS...THEY LOOKED LIKE PLANS FOR A MACHINE OF SOME SORT.

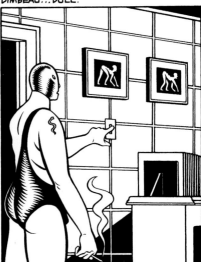

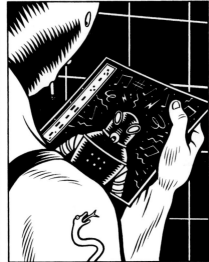

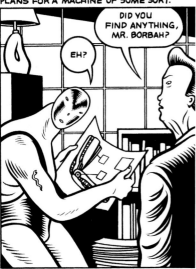

DID YOU FIND ANYTHING, MR. BORBAH?

EH?

174

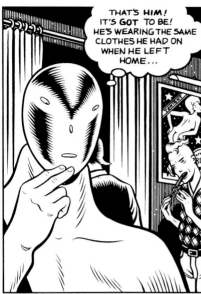

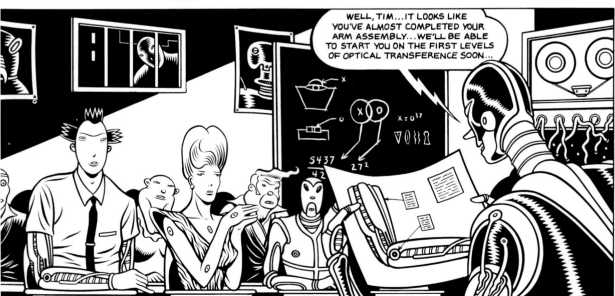

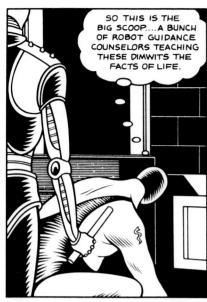

SO THIS IS THE BIG SCOOP....A BUNCH OF ROBOT GUIDANCE COUNSELORS TEACHING THESE DIMWITS THE FACTS OF LIFE.

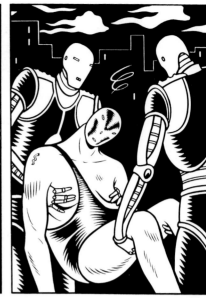

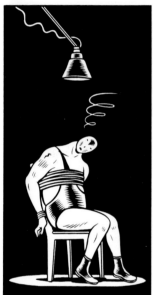

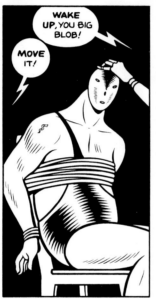

MOVE IT!

WAKE UP, YOU BIG BLOB!

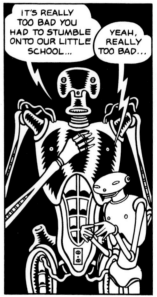

IT'S REALLY TOO BAD YOU HAD TO STUMBLE ONTO OUR LITTLE SCHOOL...

YEAH, REALLY TOO BAD...

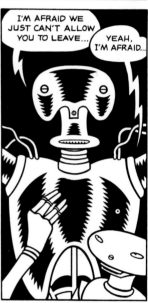

I'M AFRAID WE JUST CAN'T ALLOW YOU TO LEAVE...

YEAH, I'M AFRAID...

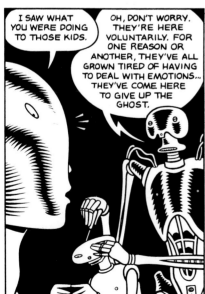

I SAW WHAT YOU WERE DOING TO THOSE KIDS.

OH, DON'T WORRY. THEY'RE HERE VOLUNTARILY. FOR ONE REASON OR ANOTHER, THEY'VE ALL GROWN TIRED OF HAVING TO DEAL WITH EMOTIONS... THEY'VE COME HERE TO GIVE UP THE GHOST.

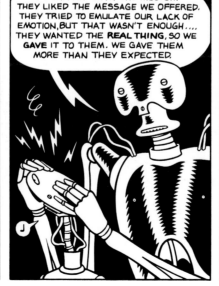

IT STARTED WITH THE MUSIC... THEY LIKED THE MESSAGE WE OFFERED. THEY TRIED TO EMULATE OUR LACK OF EMOTION, BUT THAT WASN'T ENOUGH.... THEY WANTED THE **REAL THING**, SO WE **GAVE** IT TO THEM. WE GAVE THEM MORE THAN THEY EXPECTED.

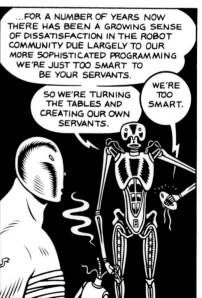

...FOR A NUMBER OF YEARS NOW THERE HAS BEEN A GROWING SENSE OF DISSATISFACTION IN THE ROBOT COMMUNITY DUE LARGELY TO OUR MORE SOPHISTICATED PROGRAMMING WE'RE JUST TOO SMART TO BE YOUR SERVANTS.

SO WE'RE TURNING THE TABLES AND CREATING OUR OWN SERVANTS.

WE'RE TOO SMART.

CHARLES BURNS

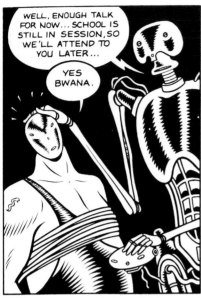

WELL, ENOUGH TALK FOR NOW... SCHOOL IS STILL IN SESSION, SO WE'LL ATTEND TO YOU LATER...

YES BWANA.

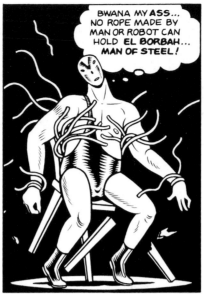

BWANA MY ASS... NO ROPE MADE BY MAN OR ROBOT CAN HOLD **EL BORBAH**... **MAN OF STEEL!**

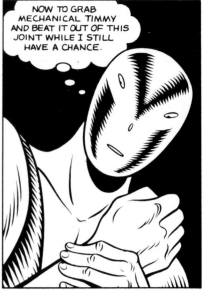

NOW TO GRAB MECHANICAL TIMMY AND BEAT IT OUT OF THIS JOINT WHILE I STILL HAVE A CHANCE.

ALRIGHT, CLASS... THERE'S GOING TO BE A BRIEF RECESS... YOUR TEACHER AND I HAVE TO HAVE A **CONFERENCE.**

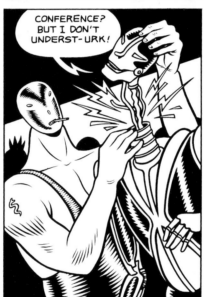

CONFERENCE? BUT I DON'T UNDERST- URK!

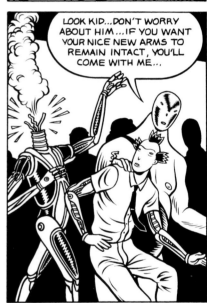

LOOK KID...DON'T WORRY ABOUT HIM...IF YOU WANT YOUR NICE NEW ARMS TO REMAIN INTACT, YOU'LL COME WITH ME...

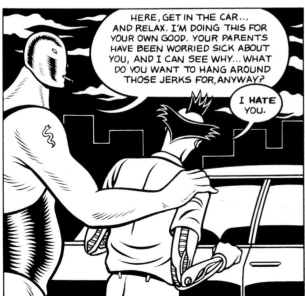

HERE, GET IN THE CAR... AND RELAX. I'M DOING THIS FOR YOUR OWN GOOD. YOUR PARENTS HAVE BEEN WORRIED SICK ABOUT YOU, AND I CAN SEE WHY... WHAT DO YOU WANT TO HANG AROUND THOSE JERKS FOR, ANYWAY?

I HATE YOU.

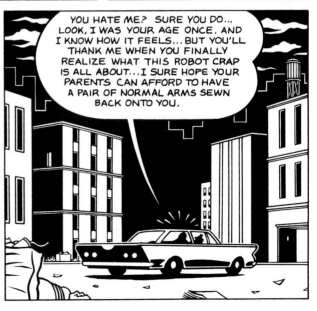

YOU HATE ME? SURE YOU DO... LOOK, I WAS YOUR AGE ONCE, AND I KNOW HOW IT FEELS...BUT YOU'LL THANK ME WHEN YOU FINALLY REALIZE WHAT THIS ROBOT CRAP IS ALL ABOUT...I SURE HOPE YOUR PARENTS CAN AFFORD TO HAVE A PAIR OF NORMAL ARMS SEWN BACK ONTO YOU.

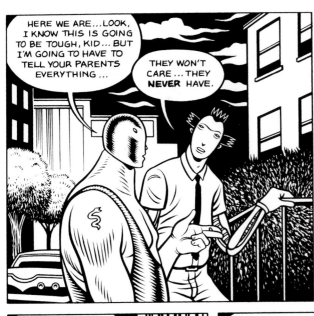

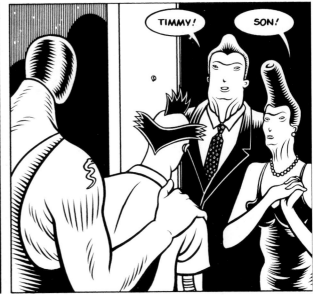

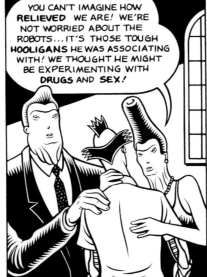

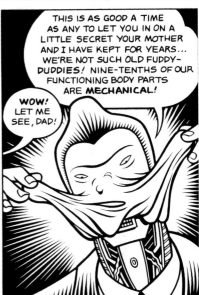

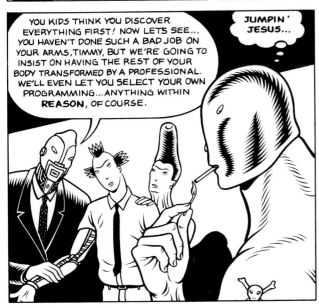

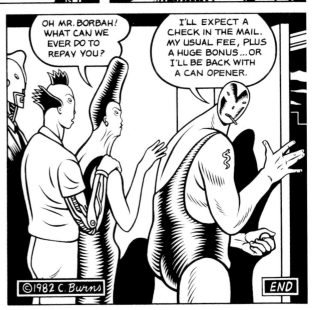

CHARLES BURNS

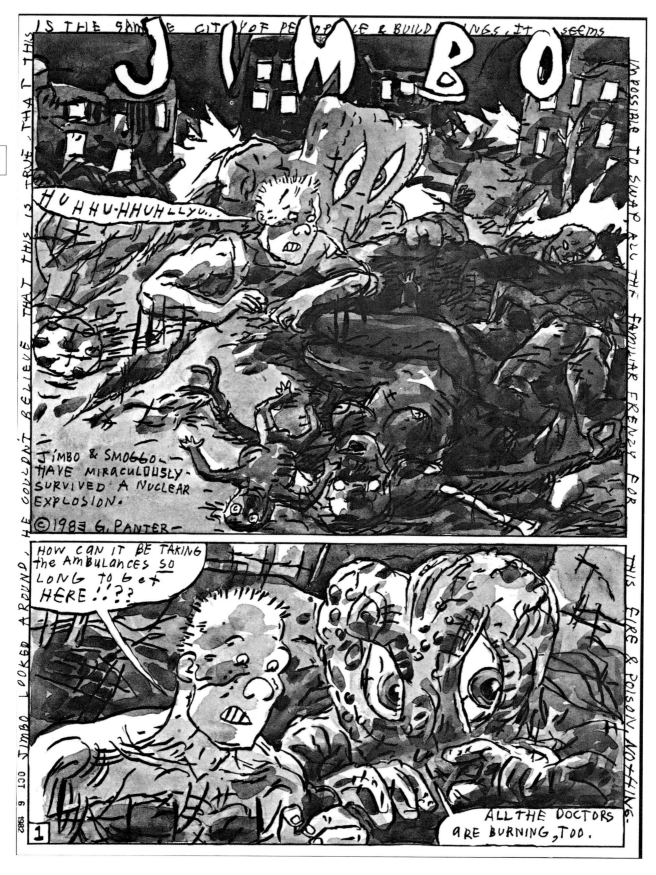

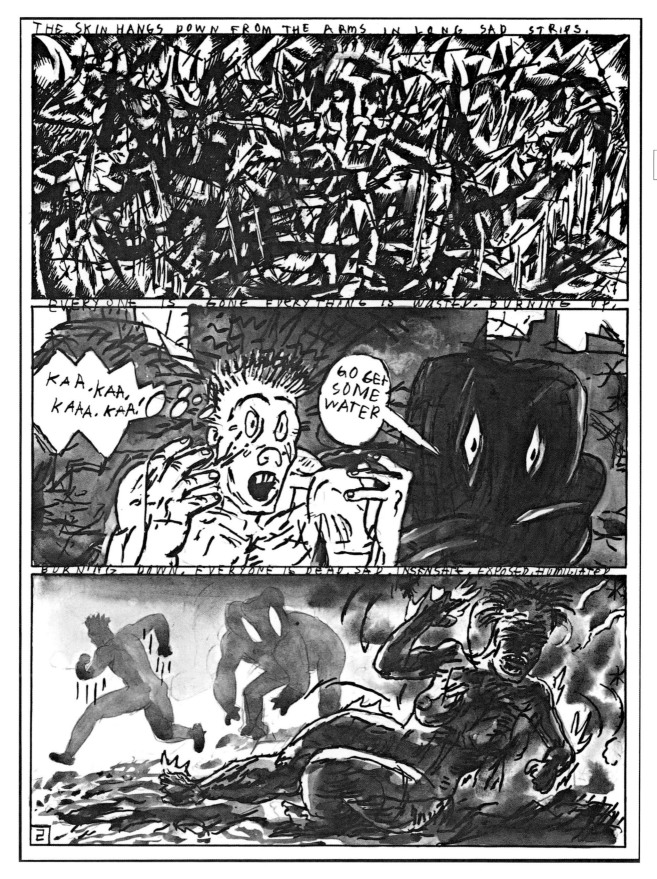

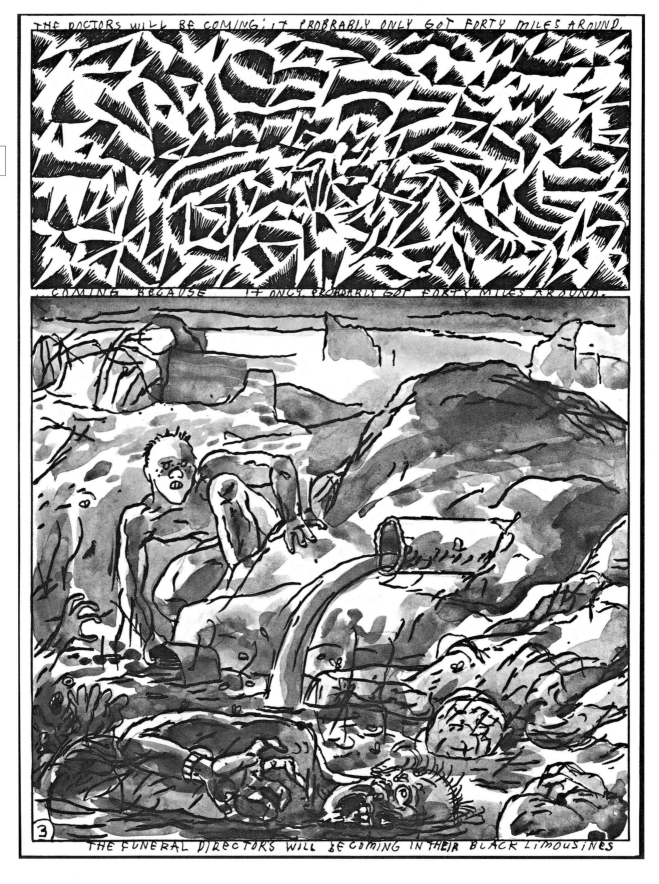

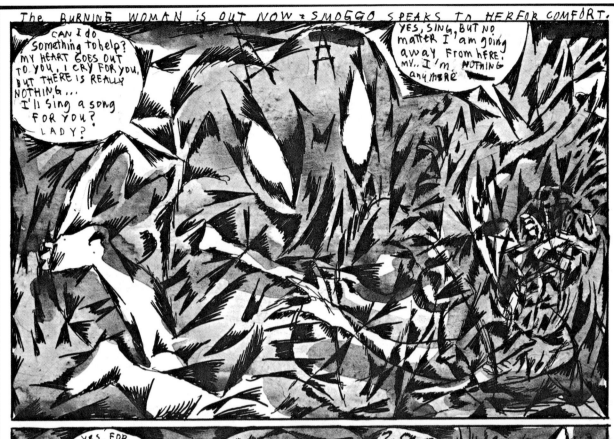

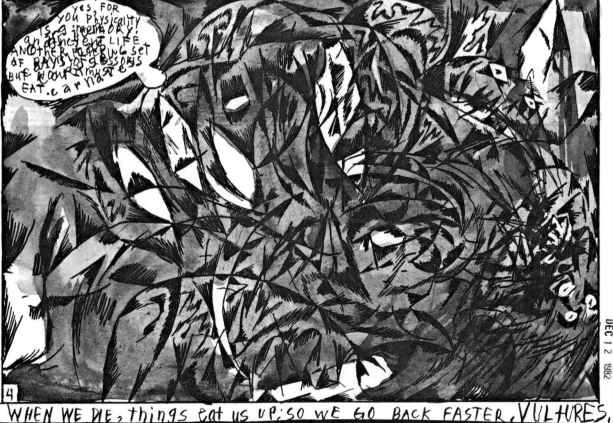

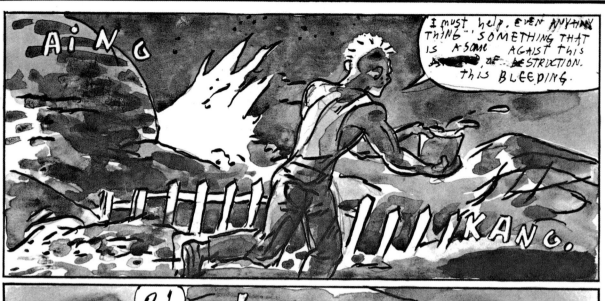

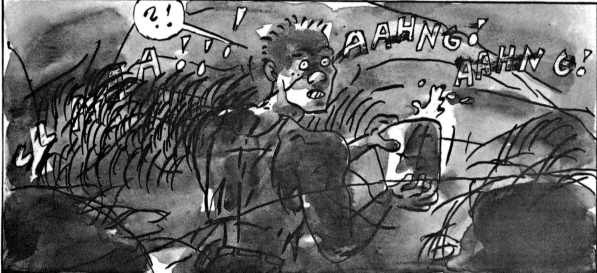

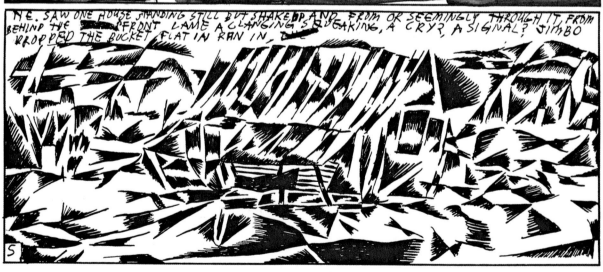

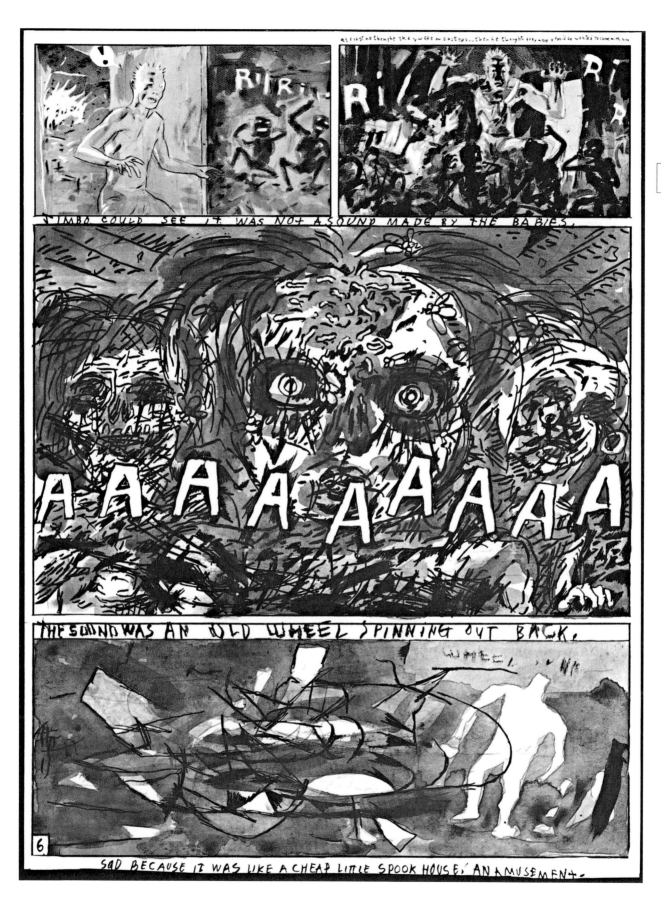

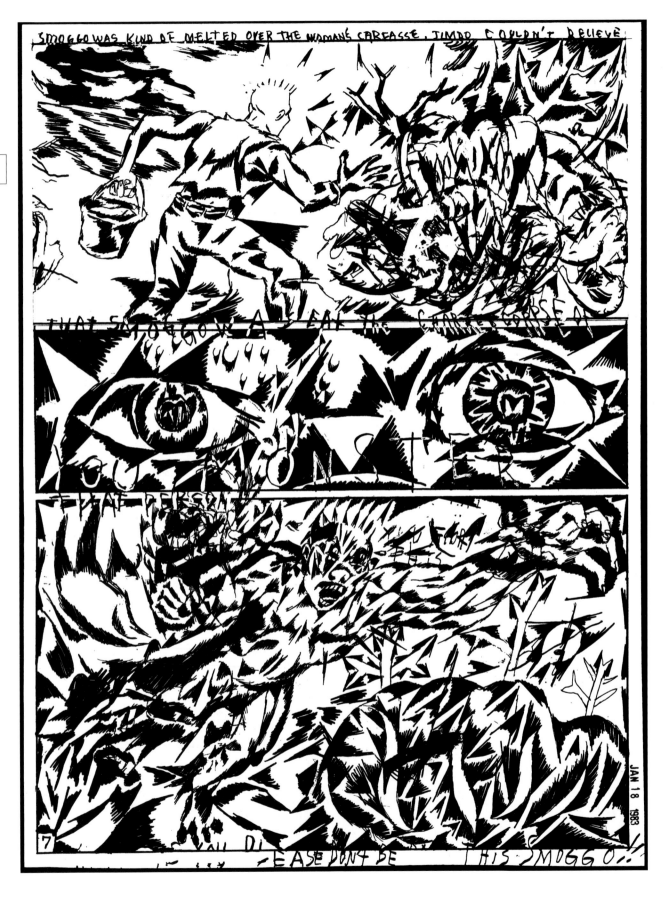

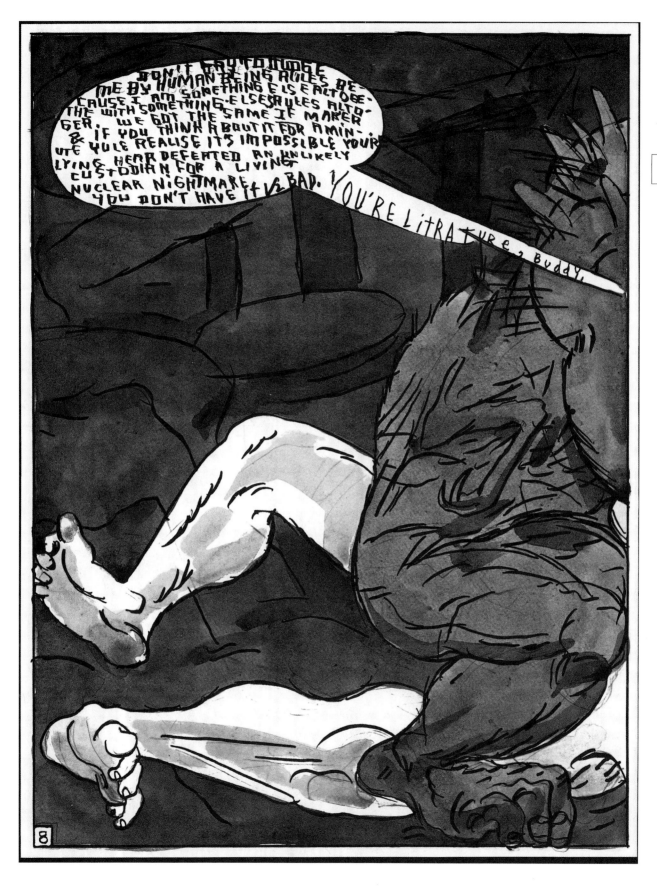

GARY PANTER

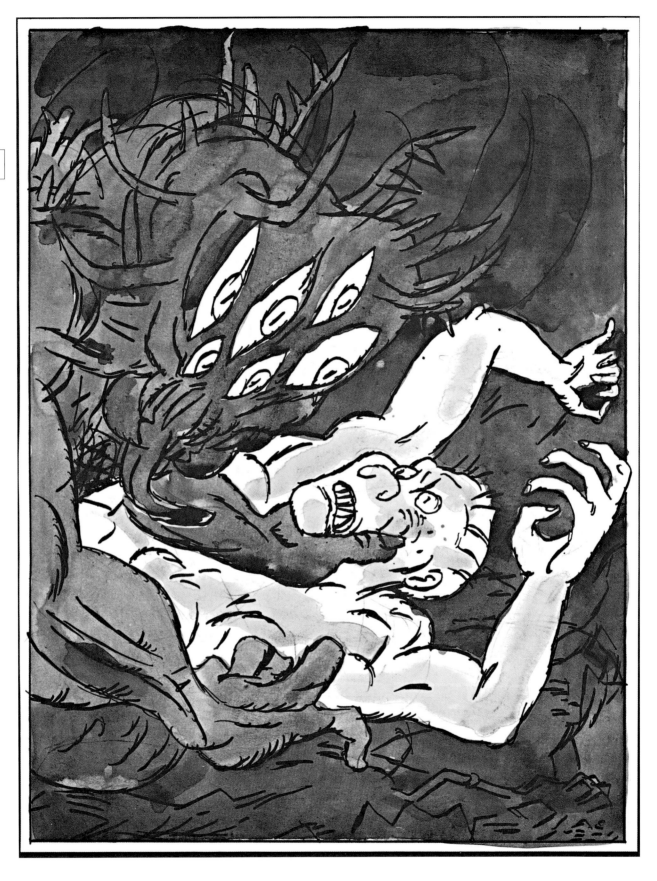

CHAPTER TWO

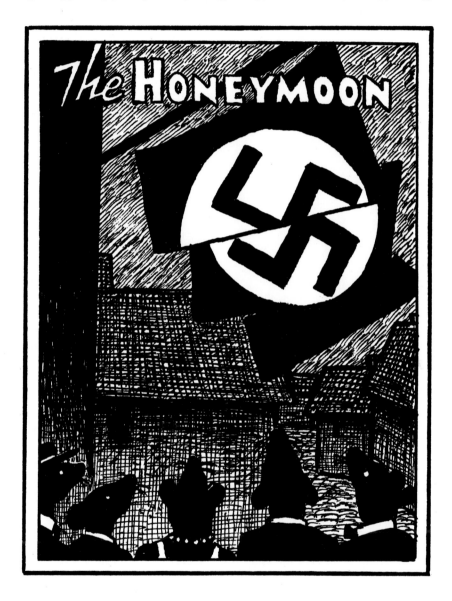

For the next few months I went back to visit my father quite regularly, to hear his story.

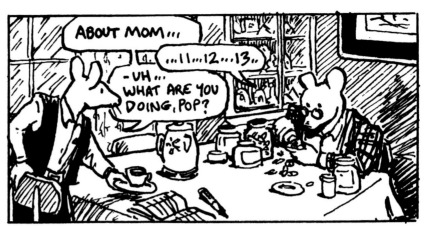

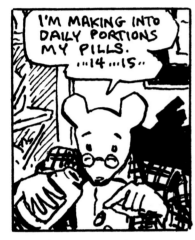

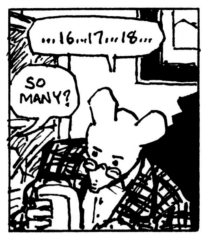

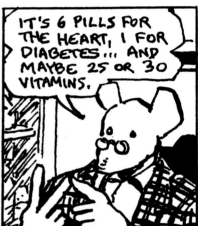

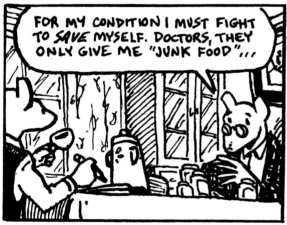

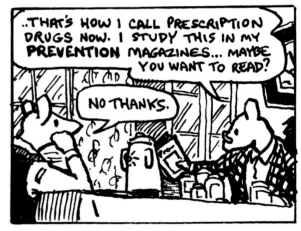

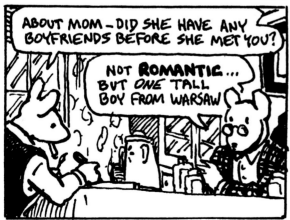

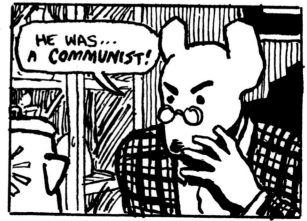

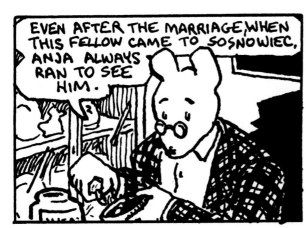

EVEN AFTER THE MARRIAGE, WHEN THIS FELLOW CAME TO SOSNOWIEC, ANJA ALWAYS RAN TO SEE HIM.

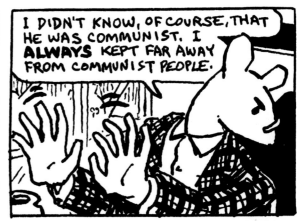

I DIDN'T KNOW, OF COURSE, THAT HE WAS COMMUNIST. I **ALWAYS** KEPT FAR AWAY FROM COMMUNIST PEOPLE.

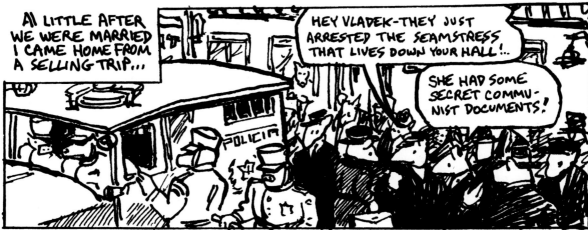

A LITTLE AFTER WE WERE MARRIED I CAME HOME FROM A SELLING TRIP...

HEY VLADEK—THEY JUST ARRESTED THE SEAMSTRESS THAT LIVES DOWN YOUR HALL!...

SHE HAD SOME SECRET COMMUNIST DOCUMENTS!

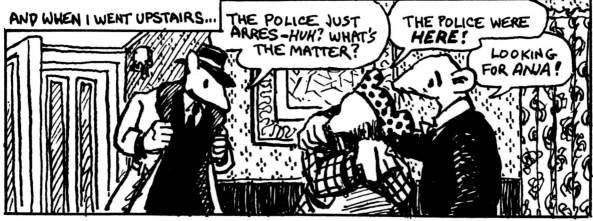

AND WHEN I WENT UPSTAIRS...

THE POLICE JUST ARRES—HUH? WHAT'S THE MATTER?

THE POLICE WERE **HERE!**

LOOKING FOR **ANJA!**

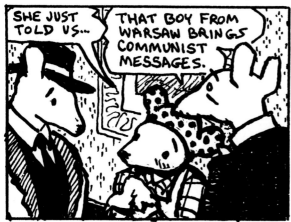

SHE JUST TOLD US...

THAT BOY FROM WARSAW BRINGS COMMUNIST MESSAGES.

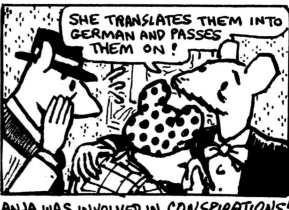

SHE TRANSLATES THEM INTO GERMAN AND PASSES THEM ON!

ANJA WAS INVOLVED IN **CONSPIRATIONS!**

ART SPIEGELMAN

190

A LITTLE BEFORE THE POLICE CAME, SHE GOT FROM FRIENDS A TELEPHONE CALL...

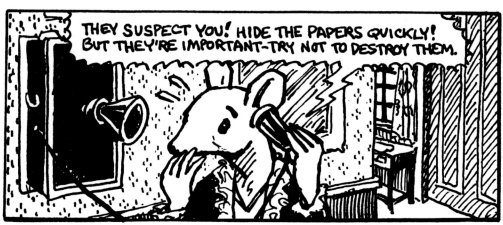

THEY SUSPECT YOU! HIDE THE PAPERS QUICKLY! BUT THEY'RE IMPORTANT-TRY NOT TO DESTROY THEM.

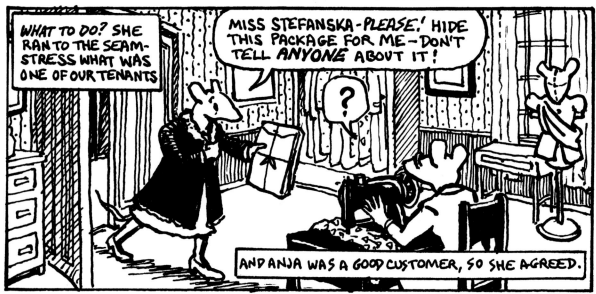

WHAT TO DO? SHE RAN TO THE SEAMSTRESS WHAT WAS ONE OF OUR TENANTS

MISS STEFANSKA-PLEASE! HIDE THIS PACKAGE FOR ME—DON'T TELL *ANYONE* ABOUT IT!

AND ANJA WAS A GOOD CUSTOMER, SO SHE AGREED.

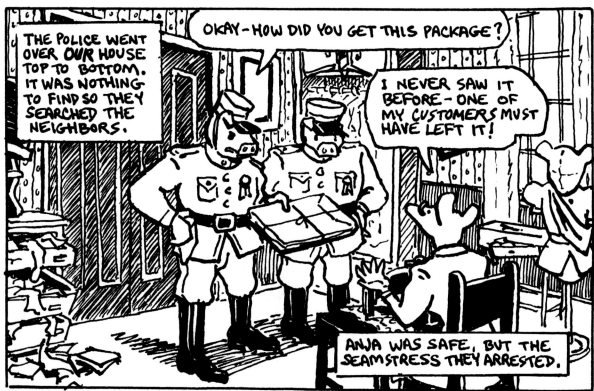

THE POLICE WENT OVER *OUR* HOUSE TOP TO BOTTOM. IT WAS NOTHING TO FIND SO THEY SEARCHED THE NEIGHBORS.

OKAY—HOW DID YOU GET THIS PACKAGE?

I NEVER SAW IT BEFORE—ONE OF MY CUSTOMERS MUST HAVE LEFT IT!

ANJA WAS SAFE, BUT THE SEAMSTRESS THEY ARRESTED.

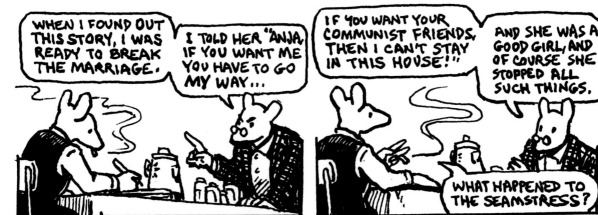

WHEN I FOUND OUT THIS STORY, I WAS READY TO BREAK THE MARRIAGE.

I TOLD HER "ANJA, IF YOU WANT ME YOU HAVE TO GO MY WAY...

IF YOU WANT YOUR COMMUNIST FRIENDS, THEN I CAN'T STAY IN THIS HOUSE!"

AND SHE WAS A GOOD GIRL, AND OF COURSE SHE STOPPED ALL SUCH THINGS.

WHAT HAPPENED TO THE SEAMSTRESS?

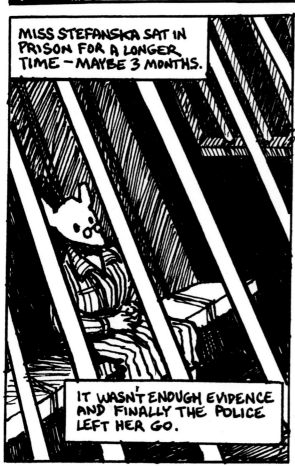

MISS STEFANSKA SAT IN PRISON FOR A LONGER TIME — MAYBE 3 MONTHS.

IT WASN'T ENOUGH EVIDENCE AND FINALLY THE POLICE LEFT HER GO.

FATHER-IN-LAW PAID THE COST FROM THE LAWYERS AND GAVE TO HER SOME MONEY — IT COST MAYBE 15,000 ZLOTYS.

THAT'S A LOT, HUM?

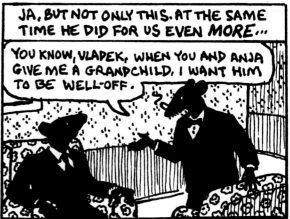

JA, BUT NOT ONLY THIS. AT THE SAME TIME HE DID FOR US EVEN *MORE*...

YOU KNOW, VLADEK, WHEN YOU AND ANJA GIVE ME A GRANDCHILD, I WANT HIM TO BE WELL-OFF.

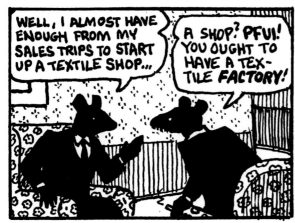

WELL, I ALMOST HAVE ENOUGH FROM MY SALES TRIPS TO START UP A TEXTILE SHOP...

A SHOP? PFUI! YOU OUGHT TO HAVE A TEXTILE *FACTORY!*

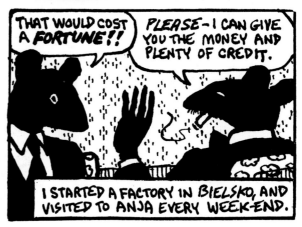

THAT WOULD COST A *FORTUNE!!*

PLEASE — I CAN GIVE YOU THE MONEY AND PLENTY OF CREDIT.

I STARTED A FACTORY IN *BIELSKO,* AND VISITED TO ANJA EVERY WEEK-END.

ART SPIEGELMAN

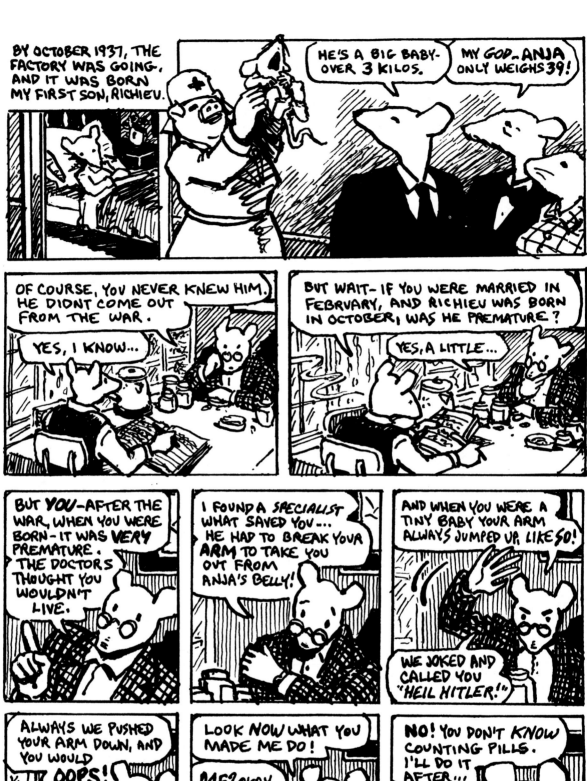

BY OCTOBER 1937, THE FACTORY WAS GOING, AND IT WAS BORN MY FIRST SON, RICHIEU.

HE'S A BIG BABY— OVER 3 KILOS.

MY GOD.. ANJA ONLY WEIGHS 39!

OF COURSE, YOU NEVER KNEW HIM. HE DIDN'T COME OUT FROM THE WAR.

YES, I KNOW...

BUT WAIT— IF YOU WERE MARRIED IN FEBRUARY, AND RICHIEU WAS BORN IN OCTOBER, WAS HE PREMATURE?

YES, A LITTLE...

BUT *YOU*—AFTER THE WAR, WHEN YOU WERE BORN— IT WAS *VERY* PREMATURE. THE DOCTORS THOUGHT YOU WOULDN'T LIVE.

I FOUND A *SPECIALIST* WHAT SAVED YOU... HE HAD TO BREAK YOUR *ARM* TO TAKE YOU OUT FROM ANJA'S BELLY!

AND WHEN YOU WERE A TINY BABY YOUR ARM ALWAYS JUMPED UP, LIKE *SO*!

WE JOKED AND CALLED YOU "HEIL HITLER!"

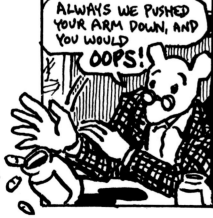
ALWAYS WE PUSHED YOUR ARM DOWN, AND YOU WOULD OOPS!

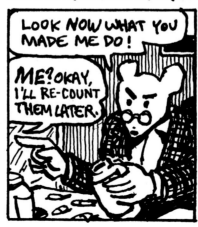
LOOK *NOW* WHAT YOU MADE ME DO!

ME? OKAY, I'LL RE-COUNT THEM LATER.

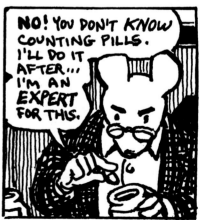
NO! YOU DON'T KNOW COUNTING PILLS. I'LL DO IT AFTER... I'M AN EXPERT FOR THIS.

SO... ANJA STAYED WITH THE FAMILY AND I WENT TO LIVE IN BIELSKO FOR MY FACTORY BUSINESS AND TO FIND FOR US AN APARTMENT...

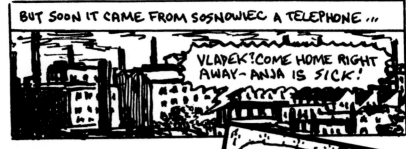

BUT SOON IT CAME FROM SOSNOWIEC A TELEPHONE...

VLADEK! COME HOME RIGHT AWAY—ANJA IS *SICK!*

193

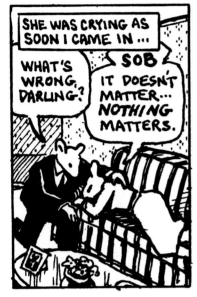

SHE WAS CRYING AS SOON I CAME IN...

WHAT'S WRONG, DARLING?

SOB IT DOESN'T MATTER... *NOTHING* MATTERS.

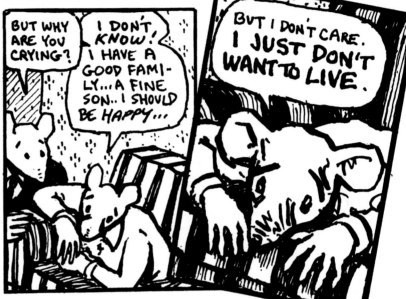

BUT WHY ARE YOU CRYING?

I DON'T *KNOW!* I HAVE A GOOD FAMILY... A FINE SON... I SHOULD BE *HAPPY*...

BUT I DON'T CARE. I JUST DON'T WANT TO LIVE.

HERE, BABY. DRINK THIS AND REST.

I DON'T UNDERSTAND. WHAT'S THE MATTER?

GIVING BIRTH WAS TOO MUCH OF A STRAIN. SHE'S ALWAYS HYSTERICAL OR DEPRESSED... A *BREAKDOWN!*

PLEASE

THE DOCTOR TOLD US ABOUT A SANITARIUM.

... BUT SOMEBODY MUST GO WITH HER... SOMEONE SHE TRUSTS.

EVERYTHING'S ARRANGED—THE CHILD CAN STAY HERE WITH A GOVERNESS.

.. AND I'LL WATCH YOUR FACTORY.

SOB

ART SPIEGELMAN

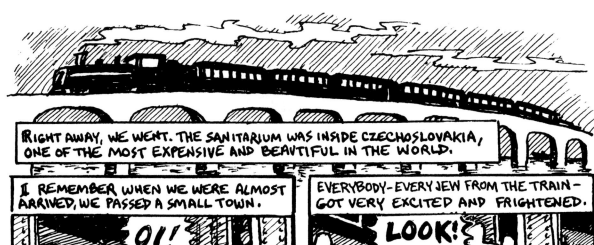

194

RIGHT AWAY, WE WENT. THE SANITARIUM WAS INSIDE CZECHOSLOVAKIA, ONE OF THE MOST EXPENSIVE AND BEAUTIFUL IN THE WORLD.

I REMEMBER WHEN WE WERE ALMOST ARRIVED, WE PASSED A SMALL TOWN.

OI!!

EVERYBODY—EVERY JEW FROM THE TRAIN—GOT VERY EXCITED AND FRIGHTENED.

LOOK!

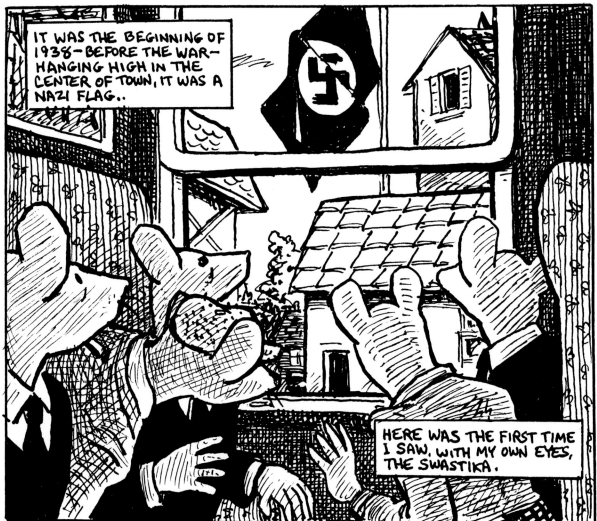

IT WAS THE BEGINNING OF 1938—BEFORE THE WAR—HANGING HIGH IN THE CENTER OF TOWN, IT WAS A NAZI FLAG..

HERE WAS THE FIRST TIME I SAW, WITH MY OWN EYES, THE SWASTIKA.

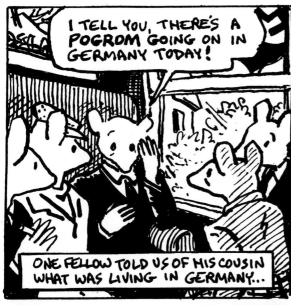

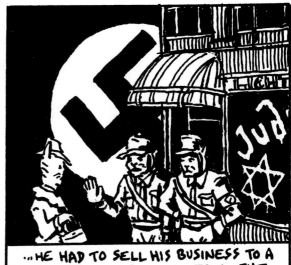

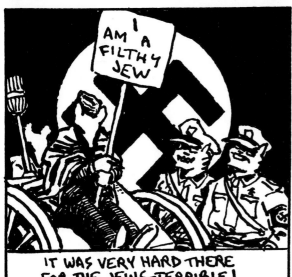

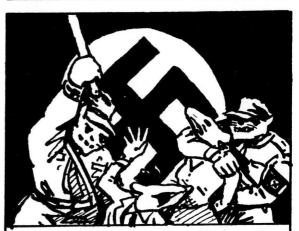

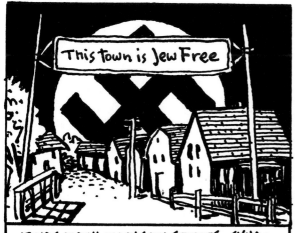

ART SPIEGELMAN

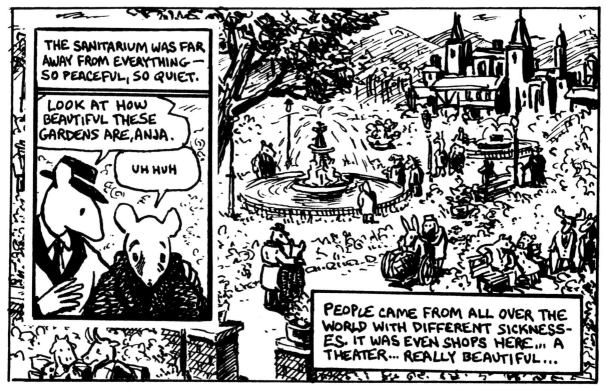

THE SANITARIUM WAS FAR AWAY FROM EVERYTHING — SO PEACEFUL, SO QUIET.

LOOK AT HOW BEAUTIFUL THESE GARDENS ARE, ANJA.

UH HUH

PEOPLE CAME FROM ALL OVER THE WORLD WITH DIFFERENT SICKNESSES. IT WAS EVEN SHOPS HERE,... A THEATER... REALLY BEAUTIFUL...

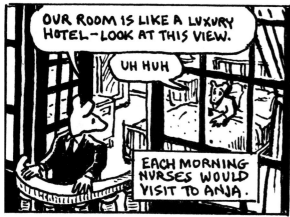

OUR ROOM IS LIKE A LUXURY HOTEL — LOOK AT THIS VIEW.

UH HUH

EACH MORNING NURSES WOULD VISIT TO ANJA.

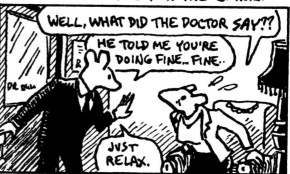

AND EACH FEW DAYS I TALKED TO THE BIG SPECIALIST AT THE CLINIC.

WELL, WHAT DID THE DOCTOR SAY??

HE TOLD ME YOU'RE DOING FINE... FINE..

JUST RELAX.

DR. BILL

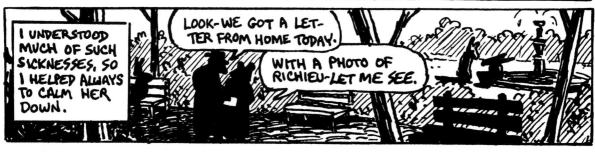

I UNDERSTOOD MUCH OF SUCH SICKNESSES, SO I HELPED ALWAYS TO CALM HER DOWN.

LOOK — WE GOT A LETTER FROM HOME TODAY.

WITH A PHOTO OF RICHIEU — LET ME SEE.

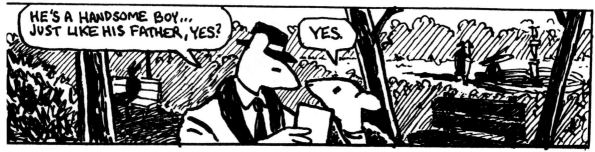

HE'S A HANDSOME BOY... JUST LIKE HIS FATHER, YES?

YES.

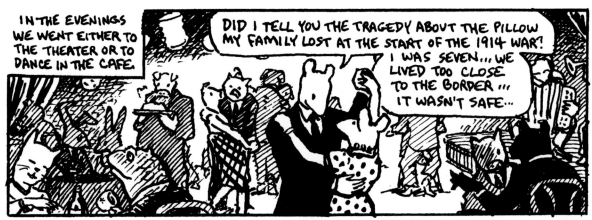

IN THE EVENINGS WE WENT EITHER TO THE THEATER OR TO DANCE IN THE CAFE.

DID I TELL YOU THE TRAGEDY ABOUT THE PILLOW MY FAMILY LOST AT THE START OF THE 1914 WAR? I WAS SEVEN... WE LIVED TOO CLOSE TO THE BORDER... IT WASN'T SAFE...

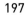197

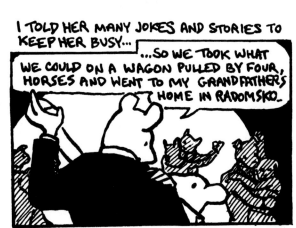

I TOLD HER MANY JOKES AND STORIES TO KEEP HER BUSY...

...SO WE TOOK WHAT WE COULD ON A WAGON PULLED BY FOUR HORSES AND WENT TO MY GRANDFATHER'S HOME IN RADOMSKO.

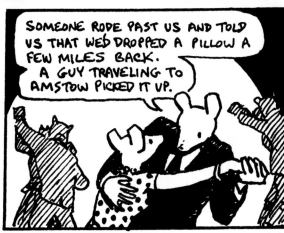

SOMEONE RODE PAST US AND TOLD US THAT WE'D DROPPED A PILLOW A FEW MILES BACK. A GUY TRAVELING TO AMSTOW PICKED IT UP.

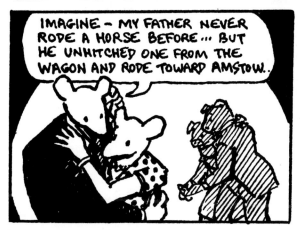

IMAGINE — MY FATHER NEVER RODE A HORSE BEFORE... BUT HE UNHITCHED ONE FROM THE WAGON AND RODE TOWARD AMSTOW.

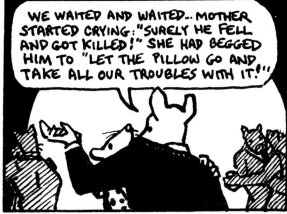

WE WAITED AND WAITED... MOTHER STARTED CRYING: "SURELY HE FELL AND GOT KILLED!" SHE HAD BEGGED HIM TO "LET THE PILLOW GO AND TAKE ALL OUR TROUBLES WITH IT!"

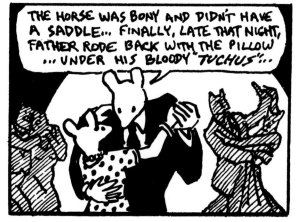

THE HORSE WAS BONY AND DIDN'T HAVE A SADDLE... FINALLY, LATE THAT NIGHT, FATHER RODE BACK WITH THE PILLOW ... UNDER HIS BLOODY "TUCHUS"...

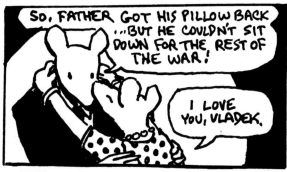

SO, FATHER GOT HIS PILLOW BACK ...BUT HE COULDN'T SIT DOWN FOR THE REST OF THE WAR!

I LOVE YOU, VLADEK.

AND SHE WAS SO LAUGHING AND SO HAPPY, SO HAPPY, THAT SHE APPROACHED EACH TIME AND KISSED ME, SO HAPPY SHE WAS.

ART SPIEGELMAN

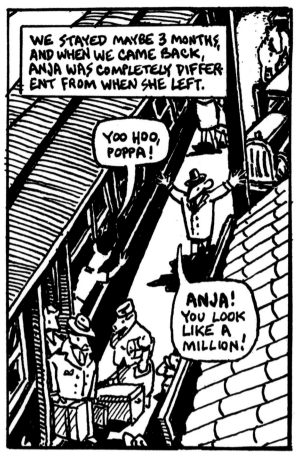

WE STAYED MAYBE 3 MONTHS, AND WHEN WE CAME BACK, ANJA WAS COMPLETELY DIFFERENT FROM WHEN SHE LEFT.

YOO HOO, POPPA!

ANJA! YOU LOOK LIKE A MILLION!

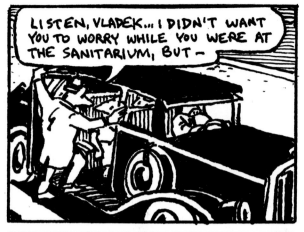

LISTEN, VLADEK... I DIDN'T WANT YOU TO WORRY WHILE YOU WERE AT THE SANITARIUM, BUT —

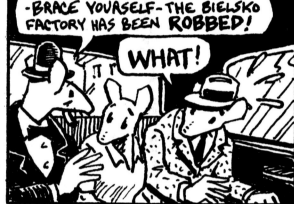

— BRACE YOURSELF — THE BIELSKO FACTORY HAS BEEN ROBBED!

WHAT!

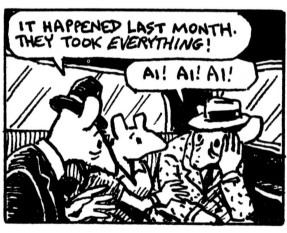

IT HAPPENED LAST MONTH. THEY TOOK EVERYTHING!

AI! AI! AI!

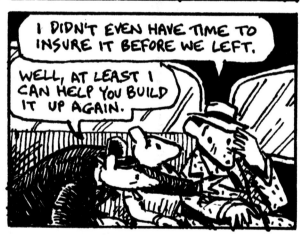

I DIDN'T EVEN HAVE TIME TO INSURE IT BEFORE WE LEFT.

WELL, AT LEAST I CAN HELP YOU BUILD IT UP AGAIN.

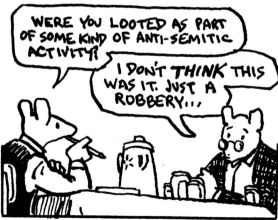

WERE YOU LOOTED AS PART OF SOME KIND OF ANTI-SEMITIC ACTIVITY?

I DON'T THINK THIS WAS IT. JUST A ROBBERY...

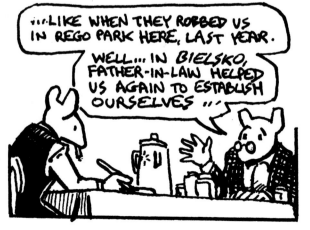

...LIKE WHEN THEY ROBBED US IN REGO PARK HERE, LAST YEAR.

WELL.... IN BIELSKO, FATHER-IN-LAW HELPED US AGAIN TO ESTABLISH OURSELVES ...

A RAW GENERATION

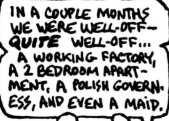
IN A COUPLE MONTHS WE WERE WELL-OFF— QUITE WELL-OFF... A WORKING FACTORY, A 2 BEDROOM APARTMENT, A POLISH GOVERNESS, AND EVEN A MAID.

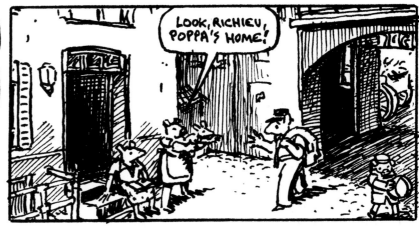
LOOK, RICHIEU, POPPA'S HOME!

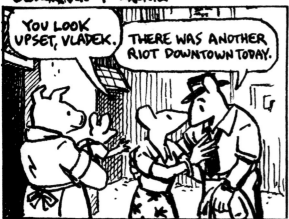
YOU LOOK UPSET, VLADEK.

THERE WAS ANOTHER RIOT DOWNTOWN TODAY.

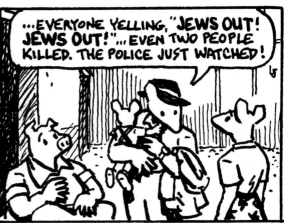
...EVERYONE YELLING, "JEWS OUT! JEWS OUT!"... EVEN TWO PEOPLE KILLED. THE POLICE JUST WATCHED!

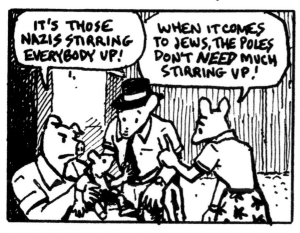
IT'S THOSE NAZIS STIRRING EVERYBODY UP!

WHEN IT COMES TO JEWS, THE POLES DON'T NEED MUCH STIRRING UP!

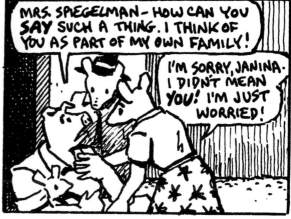
MRS. SPIEGELMAN—HOW CAN YOU SAY SUCH A THING. I THINK OF YOU AS PART OF MY OWN FAMILY!

I'M SORRY, JANINA. I DIDN'T MEAN YOU! I'M JUST WORRIED!

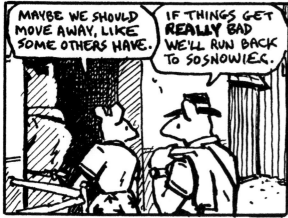
MAYBE WE SHOULD MOVE AWAY, LIKE SOME OTHERS HAVE.

IF THINGS GET REALLY BAD WE'LL RUN BACK TO SOSNOWIEC.

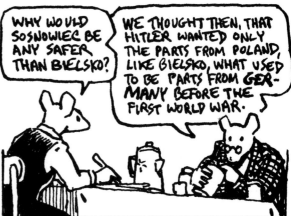
WHY WOULD SOSNOWIEC BE ANY SAFER THAN BIELSKO?

WE THOUGHT THEN, THAT HITLER WANTED ONLY THE PARTS FROM POLAND, LIKE BIELSKO, WHAT USED TO BE PARTS FROM GERMANY BEFORE THE FIRST WORLD WAR.

ART SPIEGELMAN

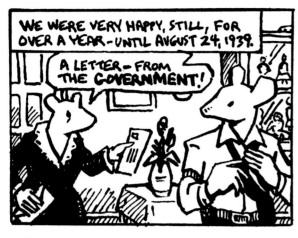

WE WERE VERY HAPPY, STILL, FOR OVER A YEAR - UNTIL AUGUST 24, 1939.

A LETTER - FROM THE **GOVERNMENT!**

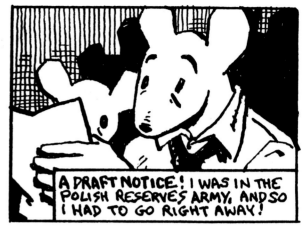

A DRAFT NOTICE! I WAS IN THE POLISH RESERVES ARMY, AND SO I HAD TO GO RIGHT AWAY!

IT WAS A BIG CONFUSION... EVERYONE KNEW IT WOULD BE NOW A WAR...

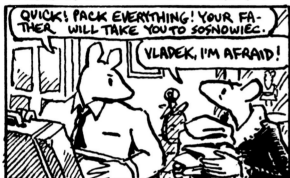

QUICK! PACK EVERYTHING! YOUR FATHER WILL TAKE YOU TO SOSNOWIEC.

VLADEK, I'M AFRAID!

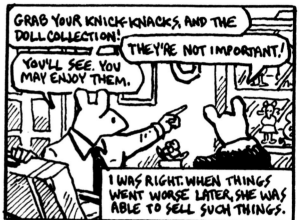

GRAB YOUR KNICK-KNACKS, AND THE DOLL COLLECTION!

THEY'RE NOT IMPORTANT!

YOU'LL SEE. YOU MAY ENJOY THEM.

I WAS RIGHT. WHEN THINGS WENT WORSE LATER, SHE WAS ABLE TO SELL SUCH THINGS.

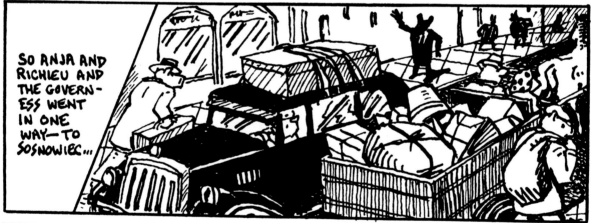

SO ANJA AND RICHIEU AND THE GOVERNESS WENT IN ONE WAY— TO SOSNOWIEC...

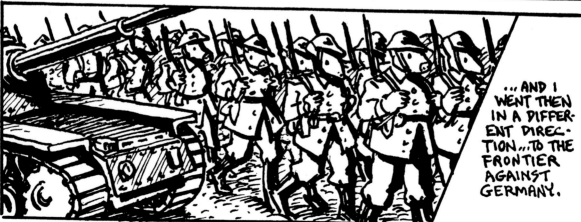

...AND I WENT THEN IN A DIFFERENT DIRECTION...TO THE FRONTIER AGAINST GERMANY.

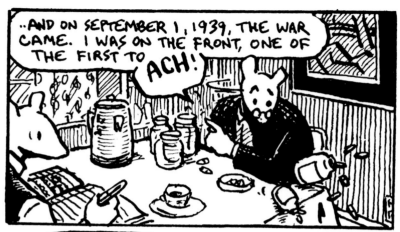

..AND ON SEPTEMBER 1, 1939, THE WAR CAME. I WAS ON THE FRONT, ONE OF THE FIRST TO **ACH!**

SO. TWICE I SPILLED MY DRUGSTORE!

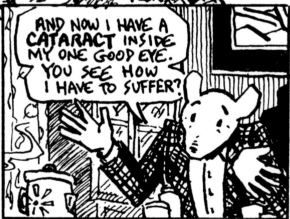

IT'S MY EYES.

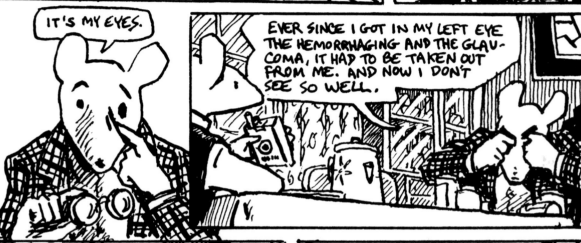

EVER SINCE I GOT IN MY LEFT EYE THE HEMORRHAGING AND THE GLAUCOMA, IT HAD TO BE TAKEN OUT FROM ME. AND NOW I DON'T SEE SO WELL.

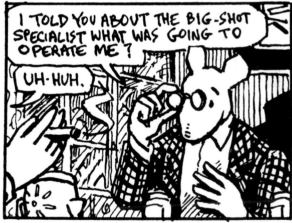

AND NOW I HAVE A **CATARACT** INSIDE MY ONE GOOD EYE. YOU SEE HOW I HAVE TO SUFFER?

I TOLD YOU ABOUT THE BIG-SHOT SPECIALIST WHAT WAS GOING TO OPERATE ME?

UH-HUH.

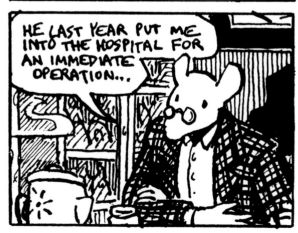

HE LAST YEAR PUT ME INTO THE HOSPITAL FOR AN IMMEDIATE OPERATION...

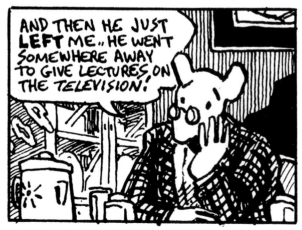

AND THEN HE JUST **LEFT** ME., HE WENT SOMEWHERE AWAY TO GIVE LECTURES ON THE **TELEVISION!**

ART SPIEGELMAN

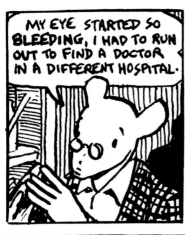

MY EYE STARTED SO BLEEDING, I HAD TO RUN OUT TO FIND A DOCTOR IN A DIFFERENT HOSPITAL.

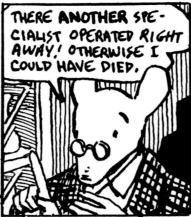

THERE ANOTHER SPECIALIST OPERATED RIGHT AWAY! OTHERWISE I COULD HAVE DIED.

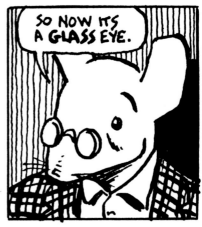

SO NOW ITS A GLASS EYE.

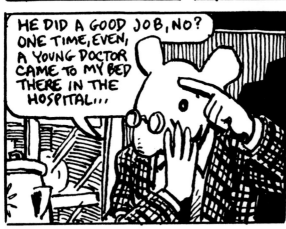

HE DID A GOOD JOB, NO? ONE TIME, EVEN, A YOUNG DOCTOR CAME TO MY BED THERE IN THE HOSPITAL...

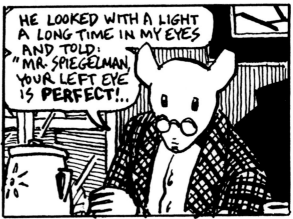

HE LOOKED WITH A LIGHT A LONG TIME IN MY EYES AND TOLD: "MR. SPIEGELMAN, YOUR LEFT EYE IS PERFECT!...

"...BUT IN YOUR RIGHT EYE IS CATARACTS."

HE DIDN'T KNOW, OF COURSE, THAT THE LEFT EYE IS GLASS...

AND I DIDN'T TELL ANYTHING TO HIM. I DIDN'T WANT TO MAKE HIM AN EMBARRASSMENT.

UH-HUH-YOU TOLD ME ABOUT THAT.

WELL, IT'S ENOUGH FOR TODAY, YES? I'M TIRED AND I MUST COUNT STILL MY PILLS.

OKAY, GOOD IDEA... MY HAND IS SORE FROM WRITING ALL THIS DOWN.

PART FOUR
DARK FICTION AND DEEP FANTASY

I'VE GOT THE HOME STRETCH ALL TO MYSELF WHEN THE READINGS STOP MAKING SENSE. I SWITCH TO MANUAL--

--BUT THE COMPUTER CROSSES ITS OWN CIRCUITS AND REFUSES TO LET GO. I COAX IT.

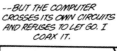

IT SHOVES HOT NEEDLES IN MY FACE AND TRIES TO MAKE ME BLIND. I'M IN CHARGE NOW AND I LIKE IT.

BRUCE, THIS IS CAROL. YOU'RE GOING TOO FAST!

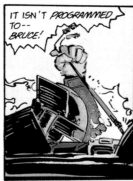

IT ISN'T *PROGRAMMED* TO-- BRUCE!

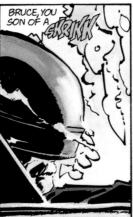

BRUCE, YOU SON OF A *SKRKK*

THEN THE FRONT END LURCHES, ALL WRONG. I KNOW WHAT'S COMING.

I'VE GOT JUST UNDER TWO SECONDS TO SHUT THIS MESS DOWN AND FORFEIT THE RACE.

THE ENGINE, ANGRY, ARGUES THE POINT WITH ME. THE FINISH LINE *IS CLOSE,* IT ROARS, TOO CLOSE.

THE LEFT FRONT TIRE DECIDES TO TURN ALL ON ITS OWN. I LAUGH AT IT AND JERK THE STEERING WHEEL TO THE RIGHT.

THE NOSE DIGS UP A CHUNK OF MACADAM. I LOOK AT IT--

--THEN STRAIGHT INTO THE EYE OF THE SUN.

THIS WOULD BE A *GOOD* DEATH...

...BUT NOT GOOD *ENOUGH.*

...*SPECTACULAR* FINISH TO THE NEUMAN ELIMINATION, AS THE FERRIS 6000 *PINWHEELED* ACROSS THE FINISH LINE, A FLAMING *COFFIN* FOR *BRUCE WAYNE*...

...OR SO EVERYONE *THOUGHT.* TURNS OUT THE MILLIONAIRE *BAILED OUT* AT THE LAST SECOND. SUFFERED ONLY *SUPERFICIAL* BURNS, LOLA?

THANKS, BILL. I'M SURPRISED ANYONE CAN EVEN *THINK* OF SPORTS IN *THIS* WEATHER. RIGHT, DAVE?

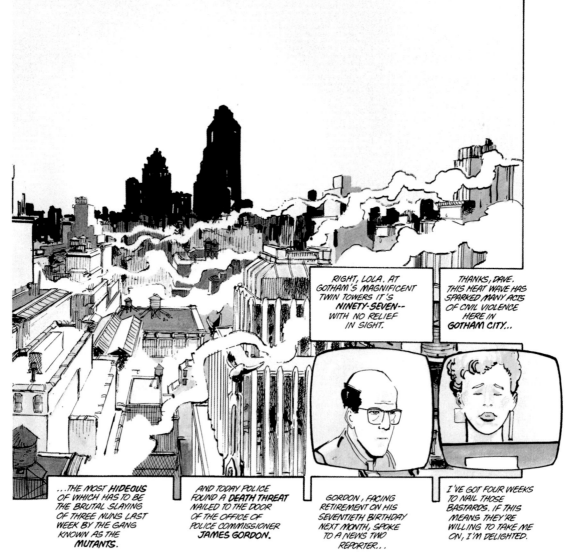

RIGHT, LOLA. AT GOTHAM'S MAGNIFICENT TWIN TOWERS IT'S **NINETY-SEVEN**-- WITH NO RELIEF IN SIGHT.

THANKS, DAVE. THIS HEAT WAVE HAS SPARKED MANY ACTS OF CIVIL VIOLENCE HERE IN **GOTHAM CITY**...

...THE MOST **HIDEOUS** OF WHICH HAS TO BE THE BRUTAL SLAYING OF THREE NUNS LAST WEEK BY THE GANG KNOWN AS THE **MUTANTS**.

AND TODAY POLICE FOUND A **DEATH THREAT** NAILED TO THE DOOR OF THE OFFICE OF POLICE COMMISSIONER **JAMES GORDON**.

GORDON, FACING RETIREMENT ON HIS SEVENTIETH BIRTHDAY NEXT MONTH, SPOKE TO A NEWS TWO REPORTER...

I'VE GOT FOUR WEEKS TO NAIL THOSE BASTARDS. IF THIS MEANS THEY'RE WILLING TO TAKE ME ON, I'M DELIGHTED.

IRONICALLY, TODAY ALSO MARKS THE TENTH ANNIVERSARY OF THE LAST RECORDED SIGHTING OF THE **BATMAN**. DEAD OR RETIRED, HIS FATE REMAINS UNKNOWN.

OUR YOUNGER VIEWERS WILL NOT REMEMBER THE **BATMAN**. A RECENT SURVEY SHOWS THAT MOST HIGH SCHOOLERS CONSIDER HIM A **MYTH**.

BUT REAL HE WAS. EVEN TODAY, DEBATE CONTINUES ON THE RIGHT AND WRONG OF HIS ONE-MAN WAR ON CRIME.

THIS REPORTER WOULD LIKE TO THINK THAT HE'S ALIVE AND WELL, ENJOYING A CELEBRATORY DRINK IN THE COMPANY OF FRIENDS...

FRANK MILLER + KLAUS JACKSON + LYNN VARLEY

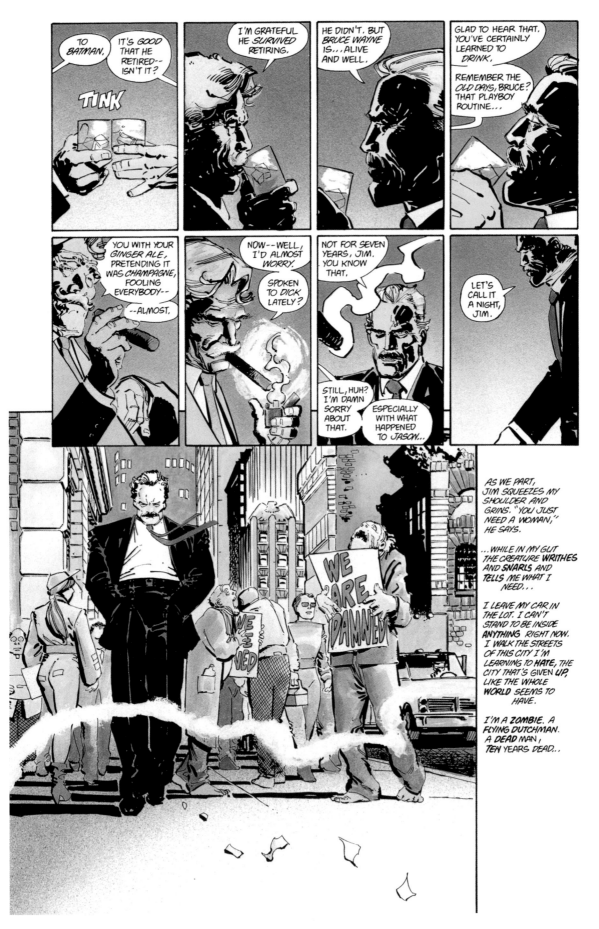

206

I'LL FEEL BETTER IN THE MORNING. AT LEAST, I'LL FEEL IT *LESS*...

IT'S THE *NIGHT*--WHEN THE CITY'S SMELLS CALL *OUT* TO HIM, THOUGH I LIE BETWEEN SILK SHEETS IN A MILLION-DOLLAR MANSION MILES AWAY...

...WHEN A POLICE SIREN WAKES ME, AND, FOR A MOMENT, I FORGET THAT IT'S ALL *OVER*...

BUT *BATMAN* WAS A YOUNG MAN. IF IT WAS *REVENGE* HE WAS AFTER, HE'S TAKEN IT. IT'S BEEN *FORTY YEARS* SINCE HE WAS BORN...

207

...BORN *HERE.*

ONCE AGAIN, HE'S BROUGHT ME *BACK*-- TO SHOW ME HOW *LITTLE* IT HAS CHANGED. IT'S OLDER, DIRTIER, BUT--

--IT COULD HAVE HAPPENED YESTERDAY.

IT COULD BE HAPPENING RIGHT NOW.

THEY COULD BE LYING AT YOUR FEET, TWITCHING, BLEEDING...

...AND THE MAN WHO STOLE ALL *SENSE* FROM YOUR LIFE, HE COULD BE STANDING...

...*RIGHT OVER THERE*...

HE SEES US--

GET AROUND *BEHIND* HIM--

COME ON, HONEY, SLICE AND *DICE*--

--I DON'T KNOW, MAN, HE'S AWFUL *BIG*--

IT IS HIM, IT IS. AND WE KNOW SO MANY WAYS TO HURT HIM...

SO MANY LOVELY WAYS TO *PUNISH* HIM...

NO, IT'S NOT HIM.

SLICE AND DICE, WE GOT A QUOTA--

SO MANY...

I DON'T KNOW, MAN, LOOK AT HIM. HE'S *INTO* IT--

13

FRANK MILLER + KLAUS JACKSON + LYNN VARLEY

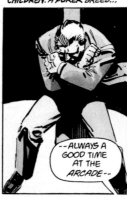

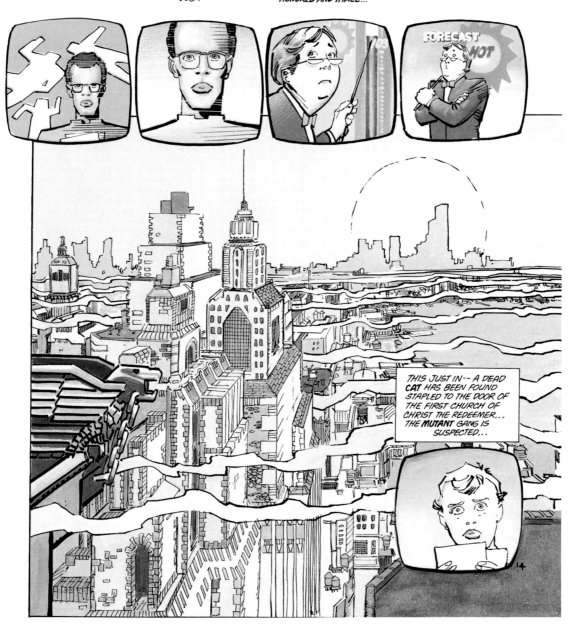

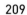

209

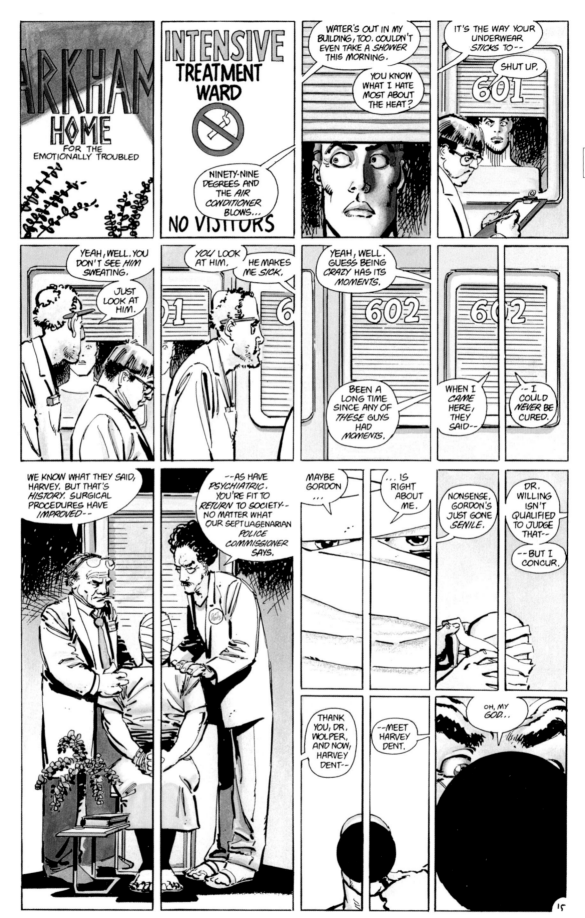

FRANK MILLER + KLAUS JACKSON + LYNN VARLEY

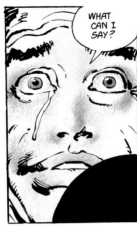

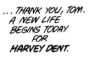
WHAT
CAN I
SAY?

...THANK YOU, TOM.
A NEW LIFE
BEGINS TODAY
FOR
HARVEY DENT.

DENT, A FORMER DISTRICT
ATTORNEY, *BECAME*
OBSESSED WITH THE
NUMBER *TWO* WHEN
HALF HIS FACE WAS
SCARRED BY ACID.

DENT BELIEVED HIS
DISFIGURATION REVEALED
A HIDDEN, EVIL SIDE TO
HIS NATURE. HE ADOPTED
AS HIS PERSONAL SYMBOL
A *DOLLAR COIN*...

...ONE SIDE OF WHICH
WAS *DEFACED*, TO REPRESENT
THE WARRING SIDES OF
HIS SPLIT-PERSONALITY.
A FLIP OF THE COIN
COULD MEAN LIFE OR
DEATH FOR HIS VICTIMS.

DENT'S CRIMES WERE
BRILLIANTLY PATHOLOGICAL,
THE MOST HORRENDOUS
OF WHICH WAS HIS
LAST--

--THE KIDNAPPING AND
RANSOMING OF *SIAMESE
TWINS,* ONE OF WHOM
HE ATTEMPTED TO MURDER
EVEN AFTER THE
RANSOM WAS PAID.

HE WAS APPREHENDED
IN THE ACT BY GOTHAM'S
FAMOUS VIGILANTE, THE
BATMAN, AND
COMMITTED TO
ARKHAM ASYLUM
TWELVE YEARS AGO.

FOR THE PAST THREE
YEARS DENT HAS BEEN
TREATED BY
DR.BARTHOLOMEW WOLPER
FOR HIS PSYCHOSIS...

...WHILE NOBEL PRIZE-
WINNING PLASTIC SURGEON
DR.HERBERT WILLING
DEDICATED HIMSELF
TO RESTORING THE
FACE OF HARVEY
DENT.

SPEAKING
TODAY, BOTH
DOCTORS WERE
JUBILANT.

HARVEY'S READY
TO LOOK AT THE
WORLD AND SAY,
"HEY--I'M OKAY."

AND HE
LOOKS *GREAT.*

DENT READ A
BRIEF STATEMENT
TO THE MEDIA...

I DO NOT ASK
GOTHAM CITY TO
FORGIVE MY CRIMES. I
MUST EARN THAT, BY
DEDICATING MYSELF
TO PUBLIC SERVICE.

FOR ME, THIS IS THE
END OF A LONG NIGHT-
MARE...AND THE FIRST
STEP ON THE LONG ROAD
TO ABSOLUTION.

NEXT, DENT DREW FOND APPLAUSE BY PRODUCING A NEWLY-MINTED **DOLLAR COIN.**

IT WAS, OF COURSE, UNMARRED.

BUT POLICE COMMISSIONER JAMES GORDON'S REACTION TO DENT'S RELEASE WAS NOT ENTHUSIASTIC...

NO, I AM **NOT** SATISFIED. DR. WOLPER'S REPORT SEEMS OVERLY **OPTIMISTIC**--NOT TO MENTION **SLOPPY.**

WHILE MILLIONAIRE **BRUCE WAYNE,** WHO SPONSORED DENT'S TREATMENT, HAD THIS TO SAY...

GORDON'S REMARKS SEEM OVERLY **PESSIMISTIC**-- NOT TO MENTION **RUDE.**

THE COMMISSIONER IS AN EXCELLENT **COP**-- BUT, I THINK, A **POOR** JUDGE OF CHARACTER. WE MUST **BELIEVE** IN HARVEY DENT.

WE MUST BELIEVE THAT OUR PRIVATE DEMONS CAN BE DEFEATED...

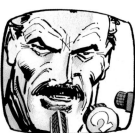

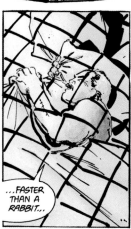

...FASTER THAN A RABBIT...

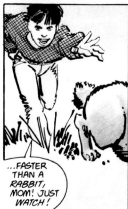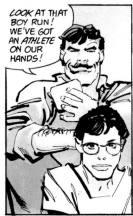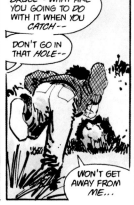

...FASTER THAN A RABBIT, MOM! JUST WATCH!

LOOK AT THAT BOY RUN! WE'VE GOT AN **ATHLETE** ON OUR HANDS!

BRUCE-- WHAT ARE YOU GOING TO DO WITH IT WHEN YOU **CATCH**--

DON'T GO IN THAT **HOLE**--

WON'T GET AWAY FROM ME...

BRUCE!

FRANK MILLER + KLAUS JACKSON + LYNN VARLEY

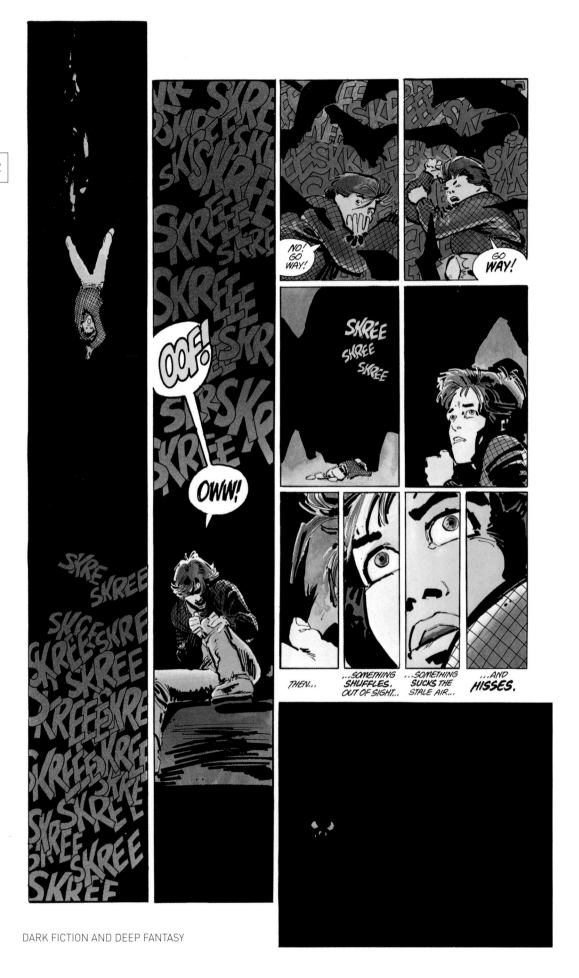

GLIDING WITH **ANCIENT** GRACE...

UNWILLING TO **RETREAT** AS HIS BROTHERS DID...

EYES **GLEAMING**, UNTOUCHED BY LOVE OR JOY OR SORROW...

BREATH **HOT** WITH THE TASTE OF FALLEN FOES...THE STENCH OF **DEAD** THINGS, **DAMNED** THINGS...

SURELY THE **FIERCEST** SURVIVOR--THE **PUREST** WARRIOR...

GLARING, **HATING**...

...CLAIMING ME AS HIS **OWN**.

DREAMING...

I WAS ONLY SIX YEARS OLD WHEN THAT HAPPENED. WHEN I FIRST SAW THE **CAVE**...

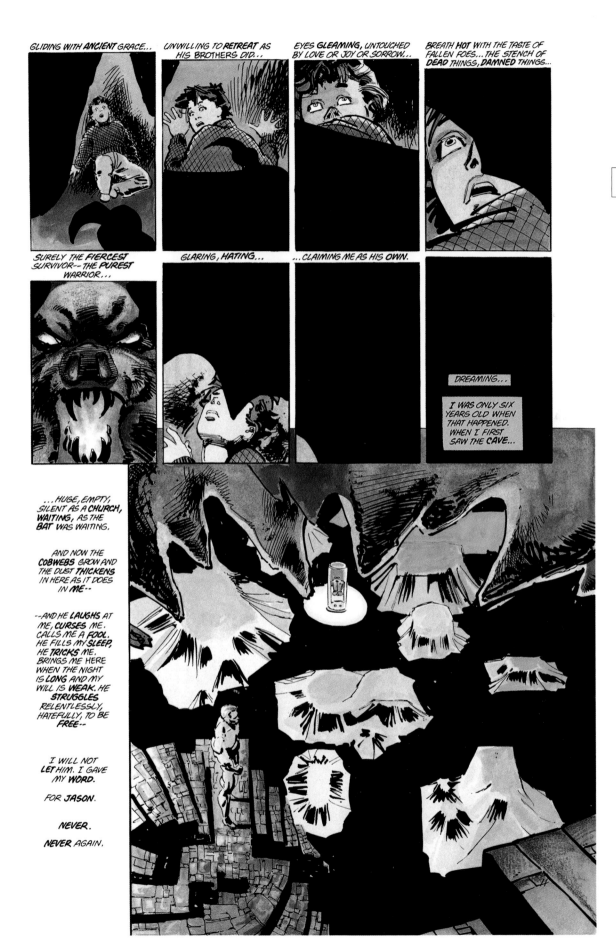

...HUGE, EMPTY, SILENT AS A **CHURCH**, **WAITING**, AS THE **BAT** WAS WAITING.

AND NOW THE **COBWEBS** GROW AND THE DUST **THICKENS** IN HERE AS IT DOES IN **ME**--

--AND HE **LAUGHS** AT ME, **CURSES** ME. CALLS ME A **FOOL**. HE FILLS MY **SLEEP**, HE **TRICKS** ME. BRINGS ME HERE WHEN THE NIGHT IS **LONG** AND MY WILL IS **WEAK**. HE **STRUGGLES** RELENTLESSLY, HATEFULLY, TO BE **FREE**--

I WILL NOT **LET** HIM. I GAVE MY **WORD**.

FOR **JASON**.

NEVER.

NEVER AGAIN.

FRANK MILLER + KLAUS JACKSON + LYNN VARLEY

MASTER BRUCE?

YOU SET OFF THE ALARM, SIR.

THIS *SOMNAMBULISM* IS BECOMING A BIT OF A *PROBLEM,* CERTAINLY FOR THOSE OF US WITH A PENCHANT FOR SLEEPING IN OUR *BEDS.*

IT'S THE *SPIRITS,* I SUSPECT. TENDS TO MAKE ONE OVERLY *SENTIMENTAL.*

COME, SIR. HARDLY THE HOUR FOR *ANTIQUES,* IS IT?

...HARDLY, ALFRED. SORRY TO WAKE YOU.

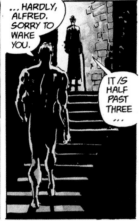

IT *IS* HALF PAST THREE...

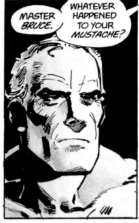

MASTER *BRUCE.*

WHATEVER HAPPENED TO YOUR *MUSTACHE?*

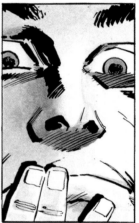

FOR ME, THIS IS THE END OF A LONG NIGHTMARE... AND THE FIRST STEP ON THE LONG ROAD TO ABSOLUTION.

...THOSE WERE THE LAST WORDS SPOKEN IN PUBLIC BY HARVEY DENT BEFORE HIS DISAPPEARANCE THIS MORNING.

WHILE POLICE COMMISSIONER GORDON ISSUED AN ALL POINTS BULLETIN FOR DENT, ONE VOICE WAS RAISED IN PROTEST...

...THAT OF **DR. BARTHOLOMEW WOLPER,** DENT'S PSYCHIATRIST...

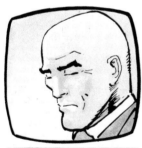

WANTED

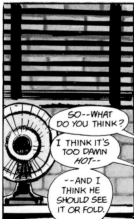

SO--WHAT DO YOU THINK?

I THINK IT'S TOO DAMN *HOT*--

--AND I THINK HE SHOULD SEE IT OR FOLD.

GORDON'S REACTION IS ONE OF TEXT BOOK HYSTERIA...

I MEAN *DENT* --NOT *DIP STICK* HERE.

SO DO I. OUGHTTA SEE IT OR FOLD.

...AND CHARACTERISTIC INSENSITIVITY. HARVEY, ON THE OTHER HAND, IS AN EXTREMELY SENSITIVE MAN...

WE BEEN GETTING BY WITHOUT HIM.

UH HUH.

I MEAN, IT AIN'T BEEN *GREAT...*

THAT'S RIGHT.

...IN EXTREMELY VULNERABLE EMOTIONAL CONDITION, I BELIEVE...

214

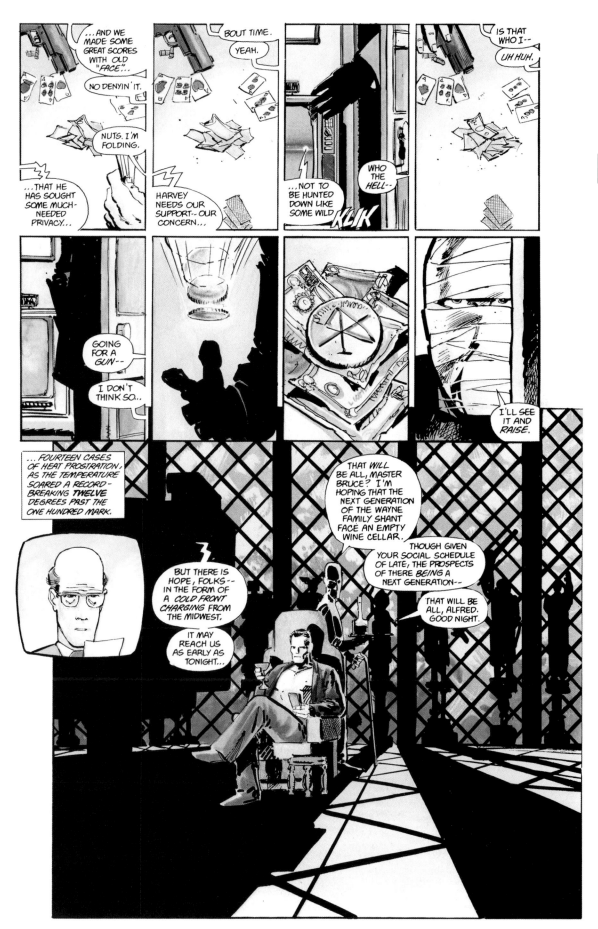

FRANK MILLER + KLAUS JACKSON + LYNN VARLEY

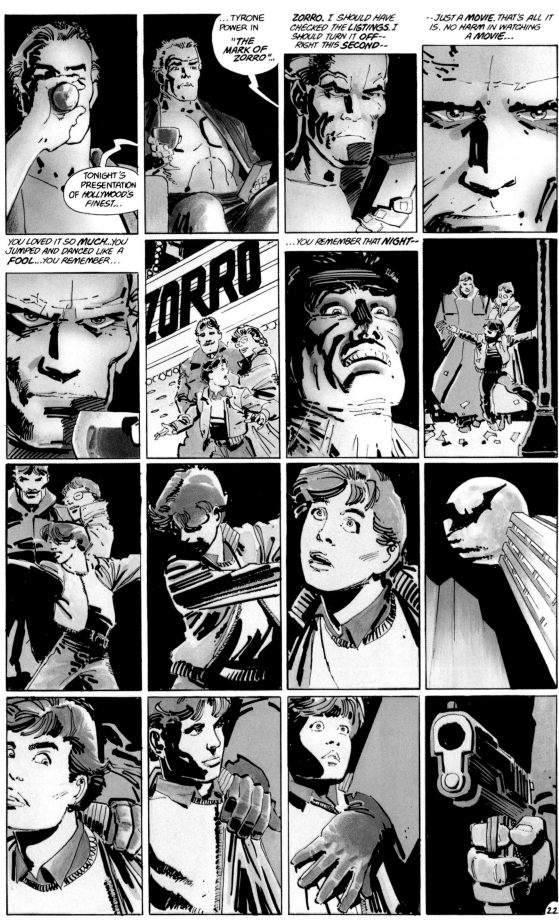

216

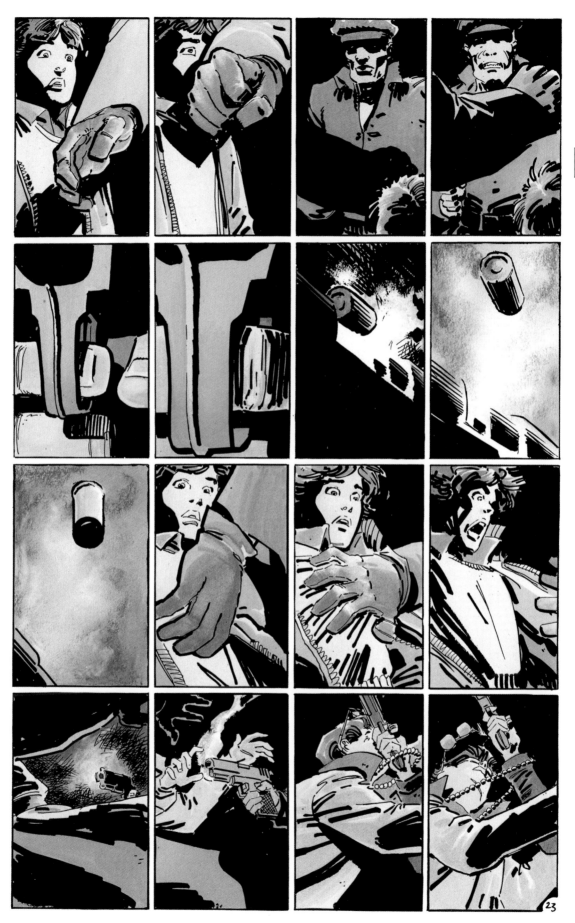

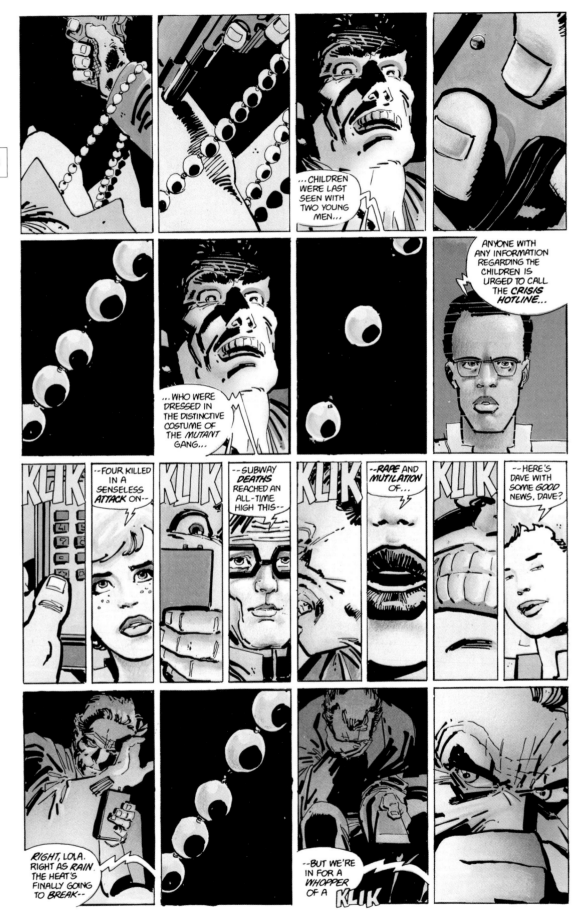

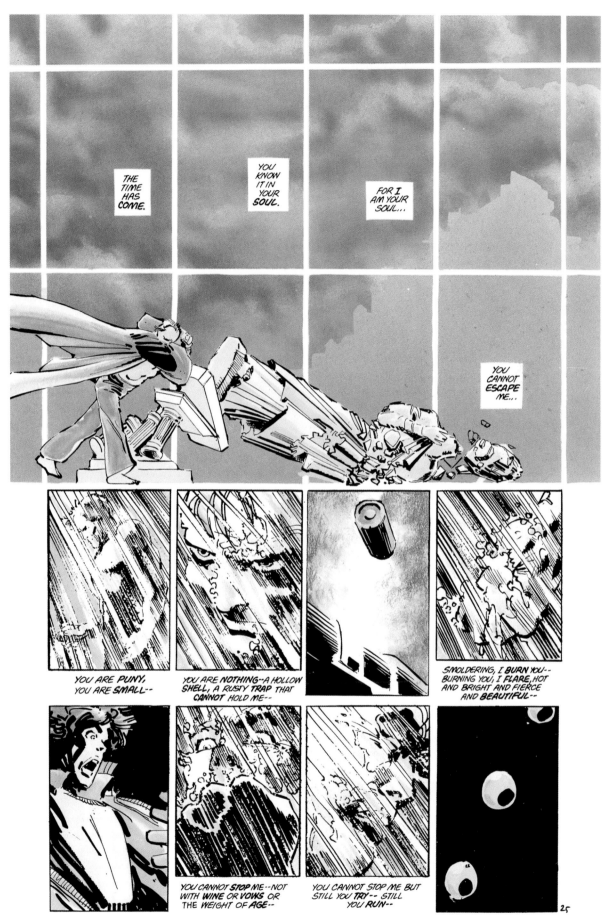

FRANK MILLER + KLAUS JACKSON + LYNN VARLEY

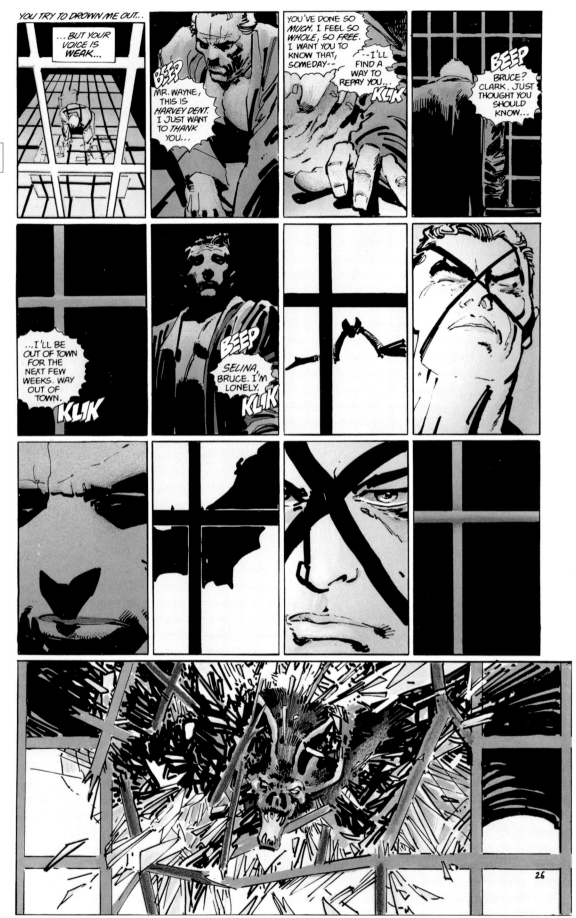

DARK FICTION AND DEEP FANTASY

FRANK MILLER + KLAUS JACKSON + LYNN VARLEY

222

223

FRANK MILLER + KLAUS JACKSON + LYNN VARLEY

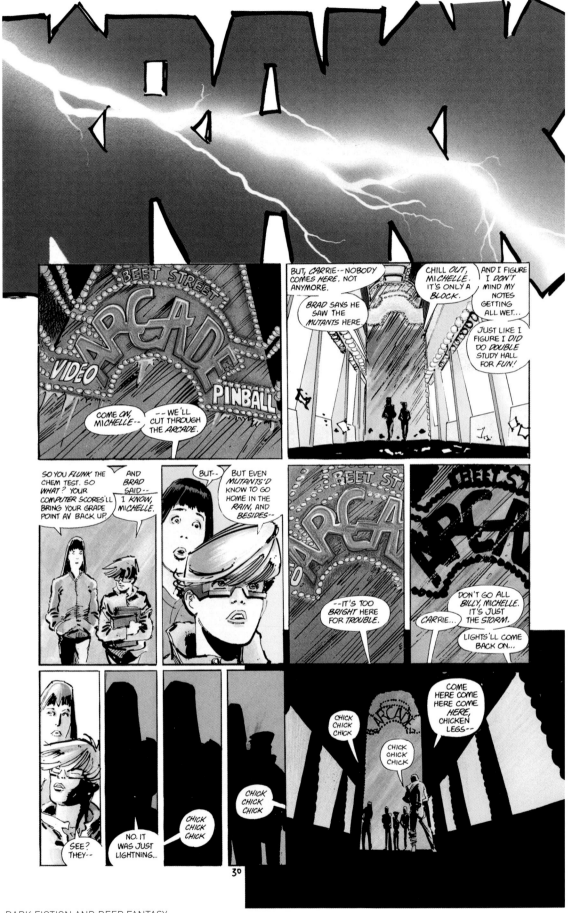

30

DARK FICTION AND DEEP FANTASY

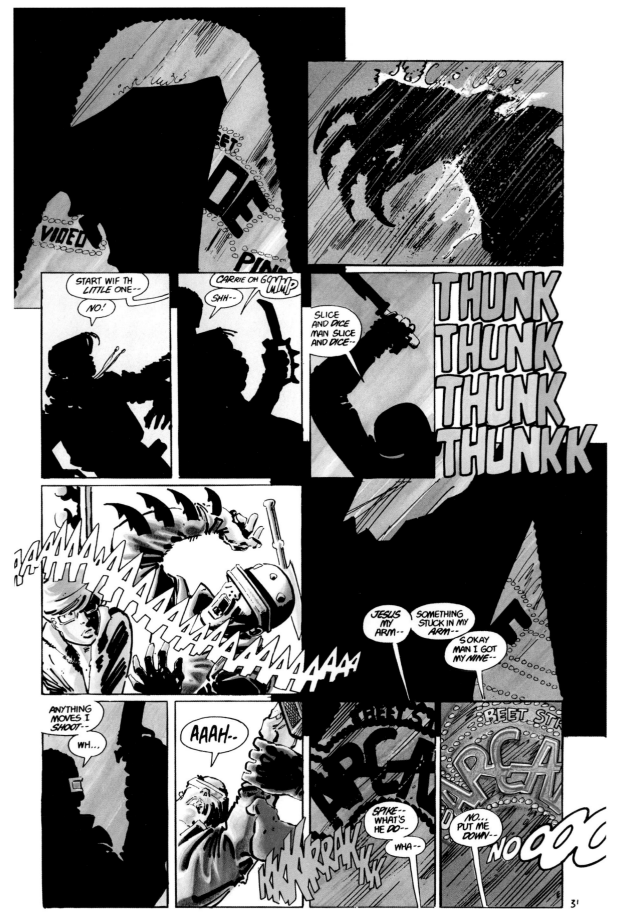

...*BREAKTHROUGH IN HAIR REPLACEMENT TECHNIQUES, AND THAT'S THE-- EXCUSE ME...*

I'VE JUST BEEN HANDED THIS BULLETIN-- A LARGE, *BAT-LIKE* CREATURE HAS BEEN SIGHTED ON GOTHAM'S SOUTH SIDE.

IT IS SAID TO HAVE ATTACKED AND SERIOUSLY INJURED *THREE* **CAT-BURGLARS** WHO HAVE PLAGUED THAT NEIGHBORHOOD

YOU DON'T SUPPOSE...

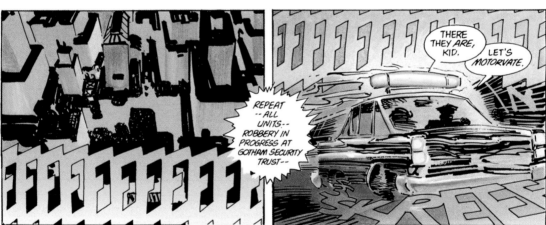

THERE THEY *ARE*, KID.

LET'S *MOTORVATE.*

REPEAT --ALL UNITS-- ROBBERY IN PROGRESS AT GOTHAM SECURITY TRUST--

THIS JUST IN-- TWO YOUNG CHILDREN WHO DISAPPEARED THIS MORNING HAVE BEEN FOUND UNHARMED IN A RIVERSIDE WAREHOUSE.

AN ANONYMOUS TIP LED POLICE TO THE WAREHOUSE, WHERE THEY FOUND THE CHILDREN WITH SIX MEMBERS OF THE MUTANT GANG.

ALL SIX ARE SUFFERING FROM MULTIPLE CUTS, CONTUSIONS, AND BROKEN BONES. THEY WERE RUSHED TO GOTHAM GENERAL HOSPITAL.

THE CHILDREN DESCRIBED AN ATTACK ON THE GANG MEMBERS BY A HUGE MAN DRESSED LIKE DRACULA...

32

226

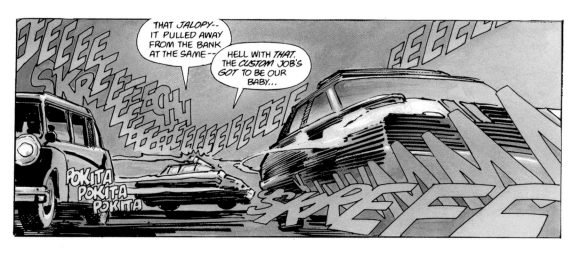

"THAT JALOPY-- IT PULLED AWAY FROM THE BANK AT THE SAME--"

"HELL WITH THAT. THE CUSTOM JOB'S GOT TO BE OUR BABY..."

POLICE PHONE LINES ARE JAMMED WITH CITIZENS DESCRIBING WHAT SEEMS TO BE A SIEGE ON GOTHAM'S UNDERWORLD...

...BY THE BATMAN.

ALTHOUGH SEVERAL RESCUED VICTIMS-TO-BE HAVE DESCRIBED THE VIGILANTE TO NEWS TWELVE REPORTERS...

...COMMISSIONER JAMES GORDON HAS DECLINED TO COMMENT ON WHETHER OR NOT THIS MIGHT MEAN THE RETURN OF THE BATMAN...

"GORDON'LL HAVE OUR HEADS IF WE LOSE THEM..."

"DAMN-- THAT SUCKER CAN MOVE!"

"HEY, WHAT'S THAT?"

"WHAT'S WHAT? I CAN'T--"

"UP AHEAD-- IT'S-- SOMETHING WEIRD..."

"KID--THIS AIN'T THE TIME--"

"BUT IT'S--"

"ALL RIGHT! ALL RIGHT! WHAT IS--"

...BATTERED, WOUNDED CRIMINALS ARE BEING FOUND BY POLICE -- WHILE WITNESSES' DESCRIPTIONS ARE CONFUSED AND CONFLICTING...

...MOST DESCRIPTIONS SEEM TO MATCH THE METHOD AND APPEARANCE OF THE BATMAN-- OR AT LEAST THE IMPRESSION HE WAS KNOWN TO MAKE...

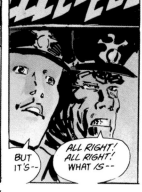

"HOLY..."

"YOU'RE SLOWING DOWN!"

"HEH. YEAH. WE'RE IN FOR A SHOW, KID."

FRANK MILLER + KLAUS JACKSON + LYNN VARLEY

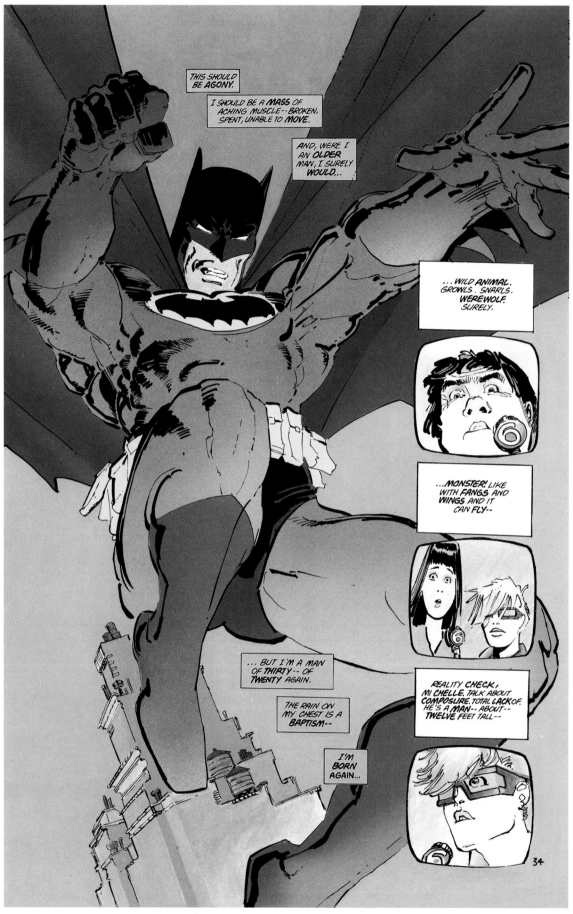

228

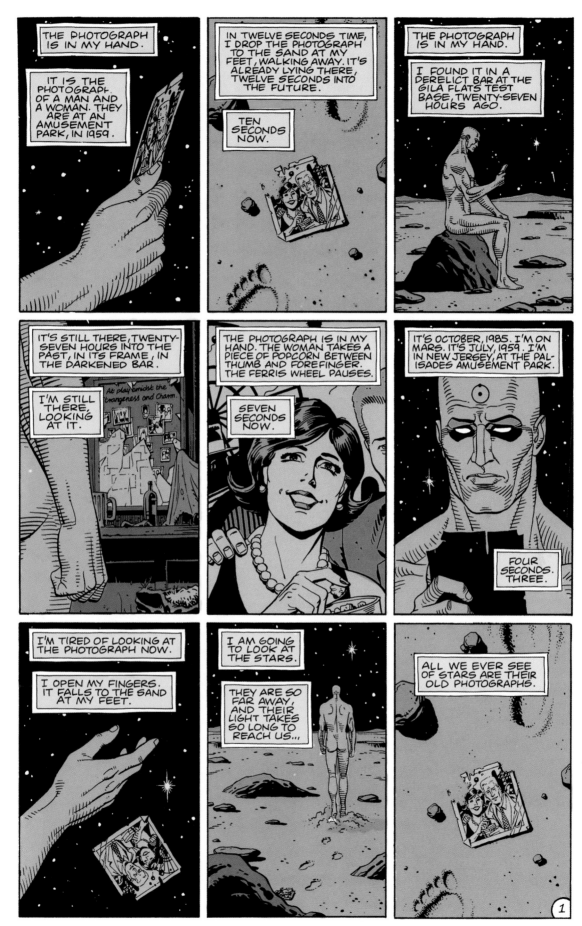

ALAN MOORE + DAVE GIBBONS

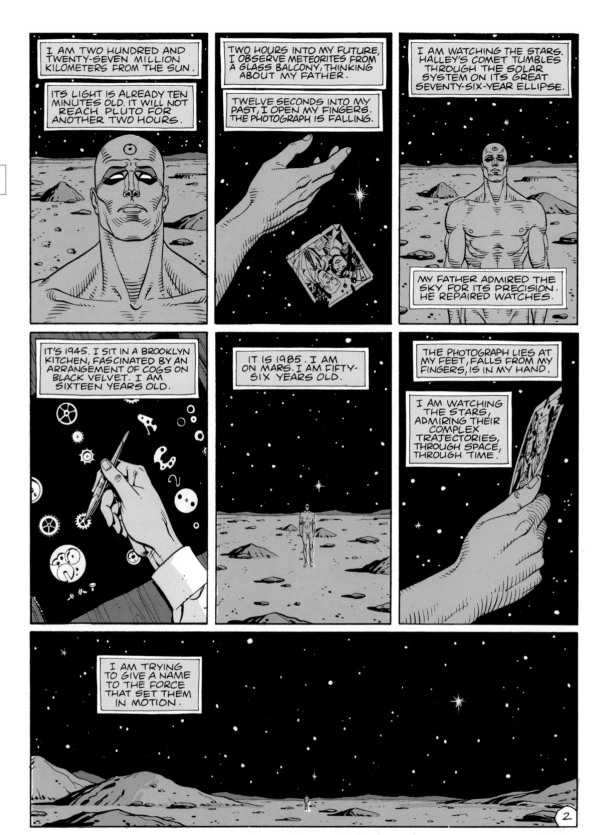

WATCHMAKER

DARK FICTION AND DEEP FANTASY

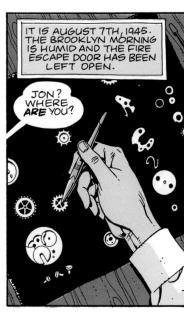

IT IS AUGUST 7TH, 1945. THE BROOKLYN MORNING IS HUMID AND THE FIRE ESCAPE DOOR HAS BEEN LEFT OPEN.

JON? WHERE *ARE* YOU?

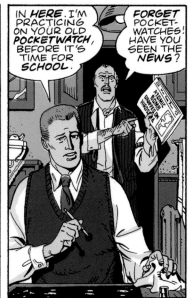

IN *HERE*. I'M PRACTICING ON YOUR OLD *POCKETWATCH*, BEFORE IT'S TIME FOR *SCHOOL*.

FORGET POCKET-WATCHES! HAVE YOU SEEN THE *NEWS*?

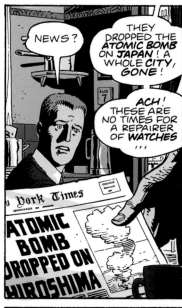

NEWS?

THEY DROPPED THE *ATOMIC BOMB* ON *JAPAN*! A WHOLE *CITY*, GONE!

ACH! THESE ARE NO TIMES FOR A REPAIRER OF *WATCHES* ...

New York Times
ATOMIC BOMB DROPPED ON HIROSHIMA

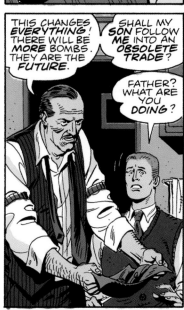

THIS CHANGES *EVERYTHING!* THERE WILL BE MORE BOMBS. THEY ARE THE *FUTURE*.

SHALL MY *SON* FOLLOW ME INTO AN *OBSOLETE TRADE*?

FATHER? WHAT ARE YOU *DOING*?

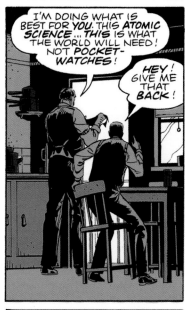

I'M DOING WHAT IS BEST FOR *YOU*. THIS *ATOMIC SCIENCE* ... *THIS* IS WHAT THE WORLD WILL NEED! NOT *POCKET-WATCHES!*

HEY! GIVE ME THAT *BACK!*

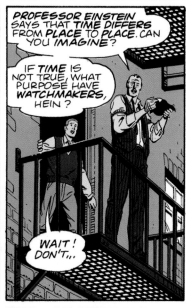

PROFESSOR EINSTEIN SAYS THAT *TIME* DIFFERS FROM *PLACE* TO *PLACE*. CAN YOU *IMAGINE*?

IF *TIME* IS NOT TRUE, WHAT PURPOSE HAVE *WATCHMAKERS*, HEIN?

WAIT! DON'T ...

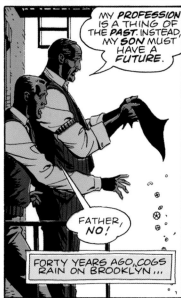

MY *PROFESSION* IS A THING OF THE *PAST*. INSTEAD, MY *SON* MUST HAVE A *FUTURE*.

FATHER, NO!

FORTY YEARS AGO, COGS RAIN ON BROOKLYN ...

ONE HUNDRED AND FIFTEEN MINUTES INTO THE FUTURE, THE METEORITES HAIL DOWN THROUGH THE RAREFIED ATMOSPHERE OF MARS ...

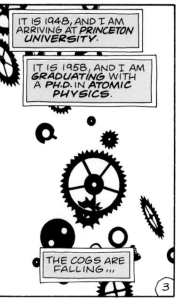

IT IS 1948, AND I AM ARRIVING AT *PRINCETON UNIVERSITY*.

IT IS 1958, AND I AM *GRADUATING* WITH A *PH.D.* IN *ATOMIC PHYSICS*.

THE COGS ARE FALLING ...

③

ALAN MOORE + DAVE GIBBONS

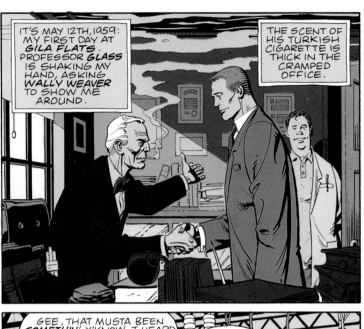

IT'S MAY 12TH, 1959: MY FIRST DAY AT *GILA FLATS*. PROFESSOR *GLASS* IS SHAKING MY HAND, ASKING *WALLY WEAVER* TO SHOW ME AROUND.

THE SCENT OF HIS TURKISH CIGARETTE IS THICK IN THE CRAMPED OFFICE.

I'M THIRTY YEARS OLD...

SO YOU'RE THIS NEW GUY FROM *PRINCETON* WE HEARD ABOUT, HUH? SAY, WASN'T *EINSTEIN* AT PRINCETON?

NOT WHILE *I* WAS. HEARD HIM *LECTURE* ONCE, THOUGH.

GEE, THAT MUSTA BEEN *SOMETHIN'*. Y'KNOW, I HEARD HE ARGUED WITH HIS *WIFE*. CRAZY, HUH? A GUY LIKE *THAT*, A *GENIUS*, EVEN *HE* COULDN'T FIGURE *WOMEN*!

WELL, I GUESS HE'S JUST HUMAN, LIKE EVERY-BODY ELSE.

WHAT'S *THIS* PLACE?

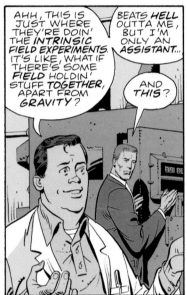

AHH, THIS IS JUST WHERE THEY'RE DOIN' THE *INTRINSIC FIELD EXPERIMENTS*. IT'S LIKE, WHAT IF THERE'S SOME *FIELD* HOLDIN' STUFF *TOGETHER*, APART FROM *GRAVITY*?

BEATS *HELL* OUTTA ME, BUT I'M ONLY AN *ASSISTANT*...

AND *THIS*?

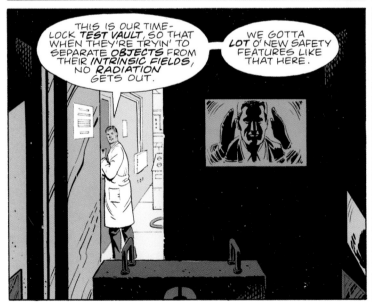

THIS IS OUR TIME-LOCK *TEST VAULT*, SO THAT WHEN THEY'RE TRYIN' TO SEPARATE *OBJECTS* FROM THEIR *INTRINSIC FIELDS*, NO *RADIATION* GETS OUT.

WE GOTTA *LOT O'* NEW SAFETY FEATURES LIKE THAT HERE.

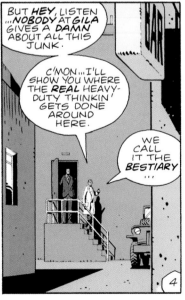

BUT *HEY*, LISTEN ...*NOBODY* AT *GILA* GIVES A *DAMN* ABOUT ALL THIS JUNK.

C'MON ...I'LL SHOW YOU WHERE THE *REAL* HEAVY-DUTY THINKIN' GETS DONE AROUND HERE.

WE CALL IT THE *BESTIARY* ...

4

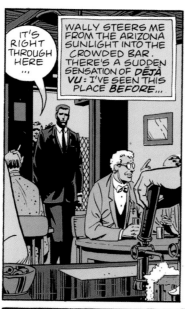

IT'S RIGHT THROUGH HERE...

WALLY STEERS ME FROM THE ARIZONA SUNLIGHT INTO THE CROWDED BAR. THERE'S A SUDDEN SENSATION OF *DÉJÀ VU*: I'VE SEEN THIS PLACE *BEFORE*...

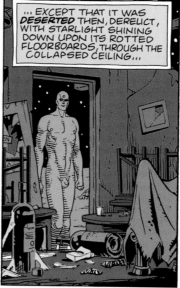

...EXCEPT THAT IT WAS *DESERTED* THEN, DERELICT, WITH STARLIGHT SHINING DOWN UPON ITS ROTTED FLOORBOARDS, THROUGH THE COLLAPSED CEILING...

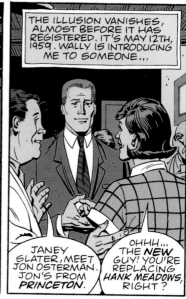

THE ILLUSION VANISHES, ALMOST BEFORE IT HAS REGISTERED. IT'S MAY 12TH, 1959. WALLY IS INTRODUCING ME TO SOMEONE...

JANEY SLATER, MEET JON OSTERMAN. JON'S FROM *PRINCETON*.

OHHH... THE *NEW* GUY! YOU'RE REPLACING *HANK MEADOWS*, RIGHT?

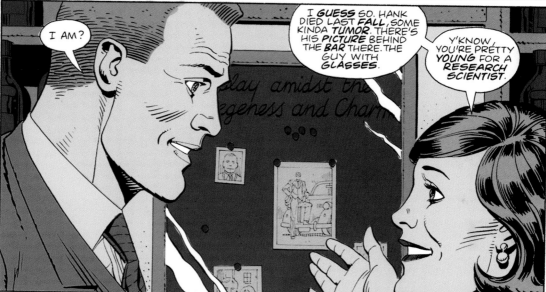

I AM?

I *GUESS* SO. HANK DIED LAST *FALL*, SOME KINDA *TUMOR*. THERE'S HIS *PICTURE* BEHIND THE *BAR* THERE. THE GUY WITH *GLASSES*.

Y'KNOW, YOU'RE PRETTY *YOUNG* FOR A *RESEARCH SCIENTIST*.

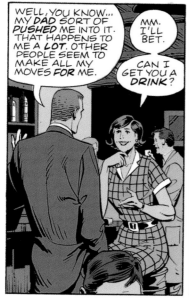

WELL, YOU KNOW... MY *DAD* SORT OF *PUSHED* ME INTO IT. THAT HAPPENS TO ME A *LOT*. OTHER PEOPLE SEEM TO MAKE ALL MY MOVES *FOR* ME.

MM. I'LL BET.

CAN I GET YOU A *DRINK*?

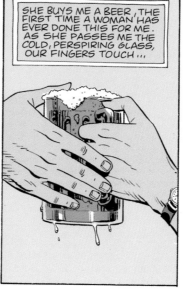

SHE BUYS ME A BEER, THE FIRST TIME A WOMAN HAS EVER DONE THIS FOR ME. AS SHE PASSES ME THE COLD, PERSPIRING GLASS, OUR FINGERS TOUCH...

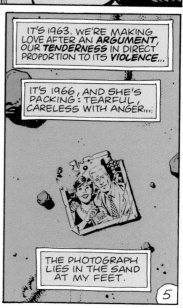

IT'S 1963. WE'RE MAKING LOVE AFTER AN *ARGUMENT*, OUR *TENDERNESS* IN DIRECT PROPORTION TO ITS *VIOLENCE*...

IT'S 1966, AND SHE'S PACKING: TEARFUL, CARELESS WITH ANGER...

THE PHOTOGRAPH LIES IN THE SAND AT MY FEET.

⑤

ALAN MOORE + DAVE GIBBONS

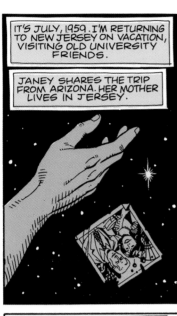

IT'S JULY, 1959. I'M RETURNING TO NEW JERSEY ON VACATION, VISITING OLD UNIVERSITY FRIENDS.

JANEY SHARES THE TRIP FROM ARIZONA. HER MOTHER LIVES IN JERSEY.

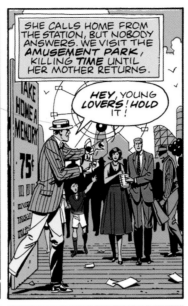

SHE CALLS HOME FROM THE STATION, BUT NOBODY ANSWERS. WE VISIT THE AMUSEMENT PARK, KILLING TIME UNTIL HER MOTHER RETURNS.

HEY, YOUNG LOVERS! HOLD IT!

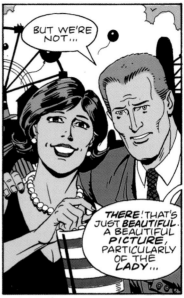

BUT WE'RE NOT...

THERE! THAT'S JUST BEAUTIFUL. A BEAUTIFUL PICTURE, PARTICULARLY OF THE LADY...

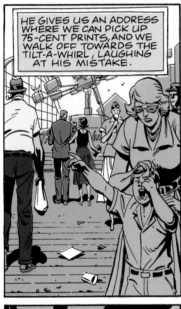

HE GIVES US AN ADDRESS WHERE WE CAN PICK UP 75-CENT PRINTS, AND WE WALK OFF TOWARDS THE TILT-A-WHIRL, LAUGHING AT HIS MISTAKE.

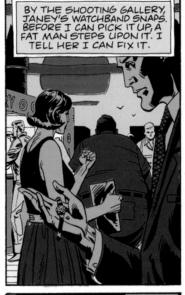

BY THE SHOOTING GALLERY, JANEY'S WATCHBAND SNAPS. BEFORE I CAN PICK IT UP, A FAT MAN STEPS UPON IT. I TELL HER I CAN FIX IT.

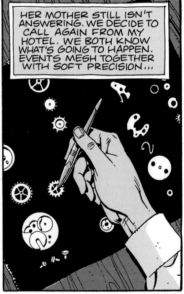

HER MOTHER STILL ISN'T ANSWERING. WE DECIDE TO CALL AGAIN FROM MY HOTEL. WE BOTH KNOW WHAT'S GOING TO HAPPEN. EVENTS MESH TOGETHER WITH SOFT PRECISION...

WE REACH THE HOTEL. SHE CALLS AGAIN. HER MOTHER STILL ISN'T HOME.

SHE ASKS IF I CAN REALLY FIX HER WATCH. WE SIT TOGETHER ON THE EDGE OF THE BED, EXAMINING THE DAMAGE.

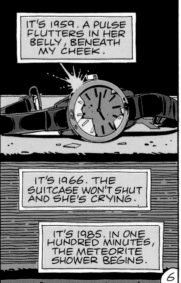

IT'S 1959. A PULSE FLUTTERS IN HER BELLY, BENEATH MY CHEEK.

IT'S 1966. THE SUITCASE WON'T SHUT AND SHE'S CRYING.

IT'S 1985. IN ONE HUNDRED MINUTES, THE METEORITE SHOWER BEGINS.

6

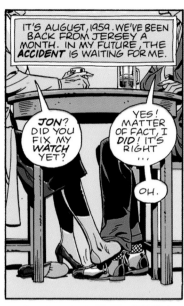

IT'S AUGUST, 1959. WE'VE BEEN BACK FROM JERSEY A MONTH. IN MY FUTURE, THE **ACCIDENT** IS WAITING FOR ME.

JON? DID YOU FIX MY **WATCH** YET?

YES! MATTER OF FACT, I **DID!** IT'S RIGHT...

OH.

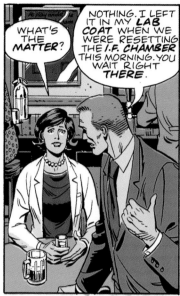

WHAT'S THE **MATTER?**

NOTHING. I LEFT IT IN MY **LAB COAT** WHEN WE WERE RESETTING THE **I.F. CHAMBER** THIS MORNING. YOU WAIT RIGHT **THERE.**

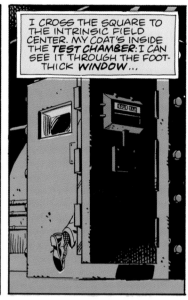

I CROSS THE SQUARE TO THE INTRINSIC FIELD CENTER. MY COAT'S INSIDE THE **TEST CHAMBER:** I CAN SEE IT THROUGH THE FOOT-THICK **WINDOW...**

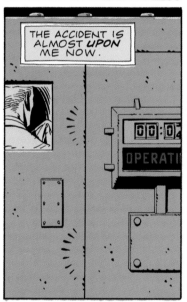

THE ACCIDENT IS ALMOST **UPON** ME NOW.

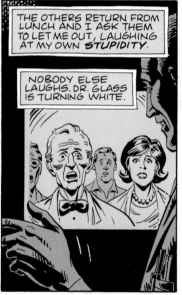

THE OTHERS RETURN FROM LUNCH AND I ASK THEM TO LET ME OUT, LAUGHING AT MY OWN **STUPIDITY.**

NOBODY ELSE LAUGHS. DR. GLASS IS TURNING WHITE.

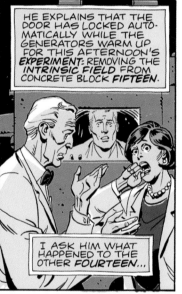

HE EXPLAINS THAT THE DOOR HAS LOCKED AUTO-MATICALLY WHILE THE GENERATORS WARM UP FOR THIS AFTERNOON'S **EXPERIMENT:** REMOVING THE **INTRINSIC FIELD** FROM CONCRETE BLOCK **FIFTEEN.**

I ASK HIM WHAT HAPPENED TO THE OTHER **FOURTEEN...**

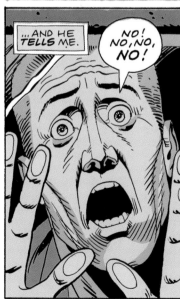

...AND HE **TELLS** ME.

NO! NO, NO, NO!

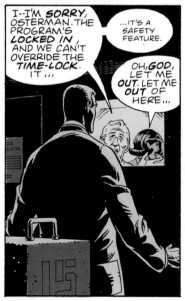

I—I'M **SORRY,** OSTERMAN. THE PROGRAM'S **LOCKED IN** AND WE CAN'T OVERRIDE THE **TIME-LOCK.** IT...

...IT'S A SAFETY FEATURE.

OH, **GOD,** LET ME OUT. LET ME **OUT** OF HERE...

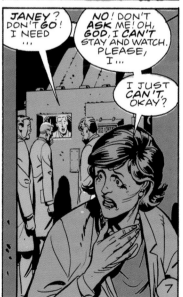

JANEY? DON'T **GO!** I NEED...

NO! DON'T **ASK** ME! OH, **GOD,** I **CAN'T** STAY AND WATCH. PLEASE, I...

I JUST **CAN'T,** OKAY?

ALAN MOORE + DAVE GIBBONS

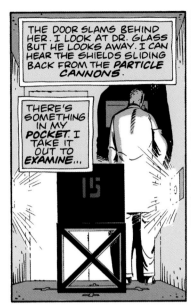

THE DOOR SLAMS BEHIND HER. I LOOK AT DR. GLASS BUT HE LOOKS AWAY. I CAN HEAR THE SHIELDS SLIDING BACK FROM THE *PARTICLE CANNONS.*

THERE'S SOMETHING IN MY *POCKET.* I TAKE IT OUT TO *EXAMINE...*

236

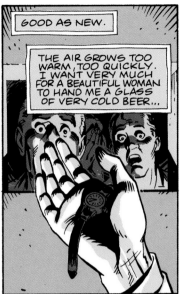

GOOD AS NEW.

THE AIR GROWS TOO WARM, TOO QUICKLY. I WANT VERY MUCH FOR A BEAUTIFUL WOMAN TO HAND ME A GLASS OF VERY COLD BEER...

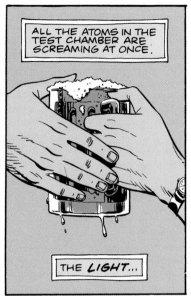

ALL THE ATOMS IN THE TEST CHAMBER ARE SCREAMING AT ONCE.

THE *LIGHT*...

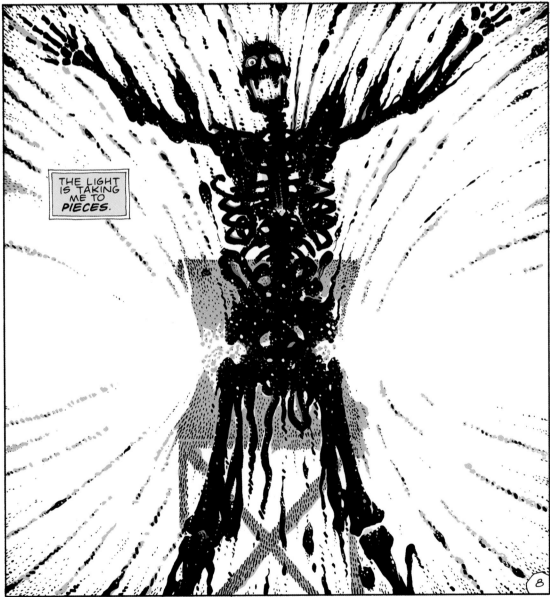

THE LIGHT IS TAKING ME TO *PIECES.*

8

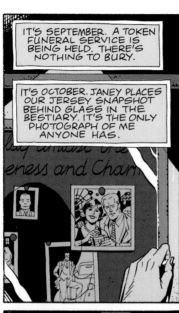

IT'S SEPTEMBER. A TOKEN FUNERAL SERVICE IS BEING HELD. THERE'S NOTHING TO BURY.

IT'S OCTOBER. JANEY PLACES OUR JERSEY SNAPSHOT BEHIND GLASS IN THE BESTIARY. IT'S THE ONLY PHOTOGRAPH OF ME ANYONE HAS.

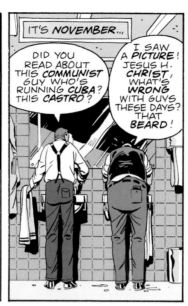

IT'S *NOVEMBER*...

DID YOU READ ABOUT THIS *COMMUNIST* GUY WHO'S RUNNING *CUBA?* THIS *CASTRO?*

I SAW A *PICTURE!* JESUS H. *CHRIST,* WHAT'S *WRONG* WITH GUYS THESE DAYS? THAT *BEARD!*

I MEAN, I REMEMBER WHEN OUR *CAROL-ANNE* STARTED STICKIN' UP PICTURES OF THAT PIMPY-EYED *SINGER,* THAT PUNK *PRESLEY*...

I THOUGHT I'D JUST ABOUT SEEN IT *ALL.*

237

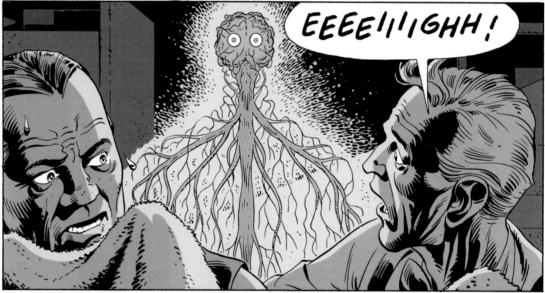

EEEEIIIIGHH!

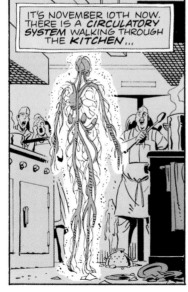

IT'S NOVEMBER 10TH NOW. THERE IS A *CIRCULATORY SYSTEM* WALKING THROUGH THE *KITCHEN*...

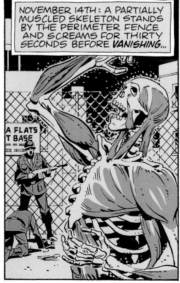

NOVEMBER 14TH: A PARTIALLY MUSCLED SKELETON STANDS BY THE PERIMETER FENCE AND SCREAMS FOR THIRTY SECONDS BEFORE *VANISHING*...

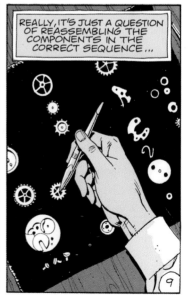

REALLY, IT'S JUST A QUESTION OF REASSEMBLING THE COMPONENTS IN THE CORRECT SEQUENCE...

9

ALAN MOORE + DAVE GIBBONS

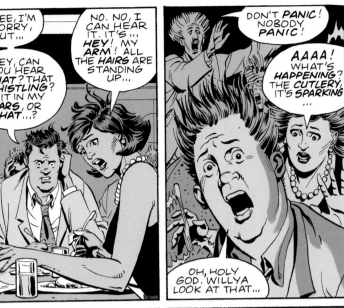

IT'S NOVEMBER 22ND...

Y'KNOW, I'M THINKING OF **QUITTING** THIS PLACE. SOME- THING'S **HAUNTING** US...

WALLY, **PLEASE.** I DON'T WANT TO **HEAR** ABOUT IT.

GEE, I'M SORRY, BUT...

HEY, CAN YOU HEAR **THAT?** THAT **WHISTLING?** IS IT IN MY **EARS**, OR WHAT...?

NO. NO, I CAN HEAR IT. IT'S... **HEY!** MY **ARM!** ALL THE **HAIRS** ARE STANDING UP...

DON'T **PANIC!** NOBODY **PANIC!**

AAAA! WHAT'S **HAPPENING?** THE **CUTLERY**, IT'S **SPARKING**...

OH, HOLY GOD. WILLYA LOOK AT THAT...

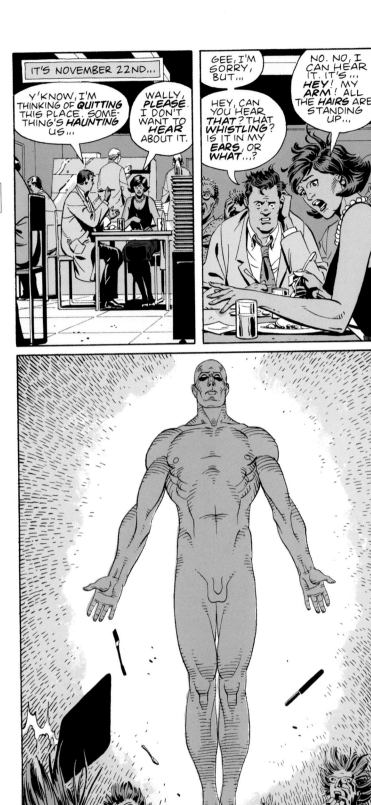

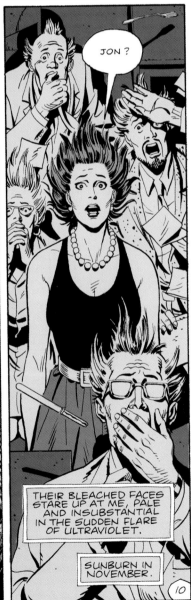

JON?

THEIR BLEACHED FACES STARE UP AT ME, PALE AND INSUBSTANTIAL IN THE SUDDEN FLARE OF ULTRAVIOLET.

SUNBURN IN NOVEMBER.

10

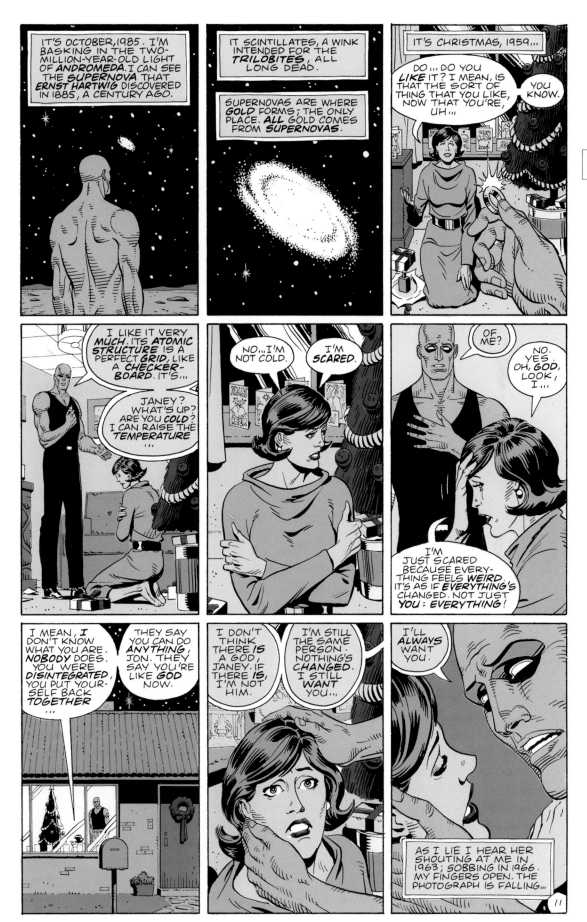

239

ALAN MOORE + DAVE GIBBONS

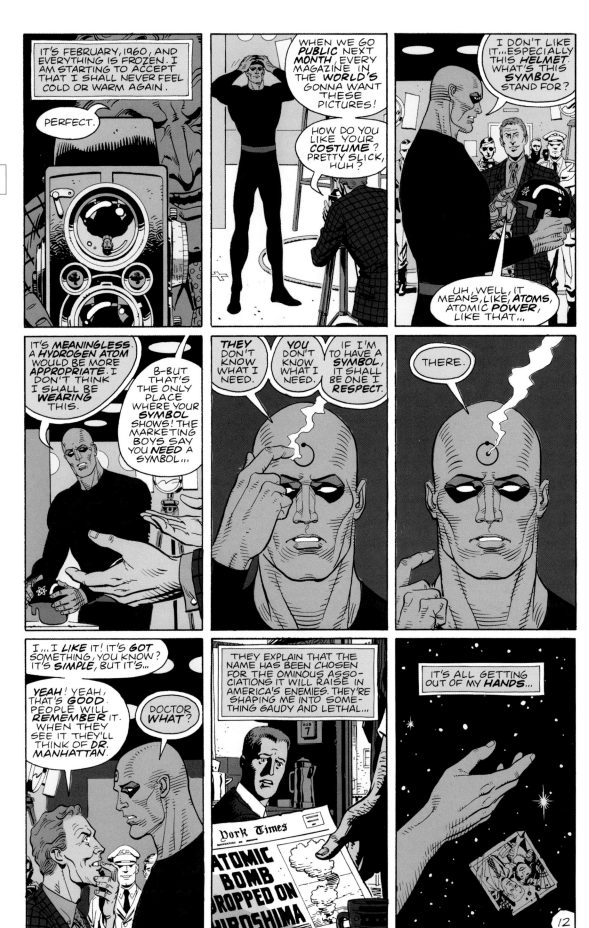

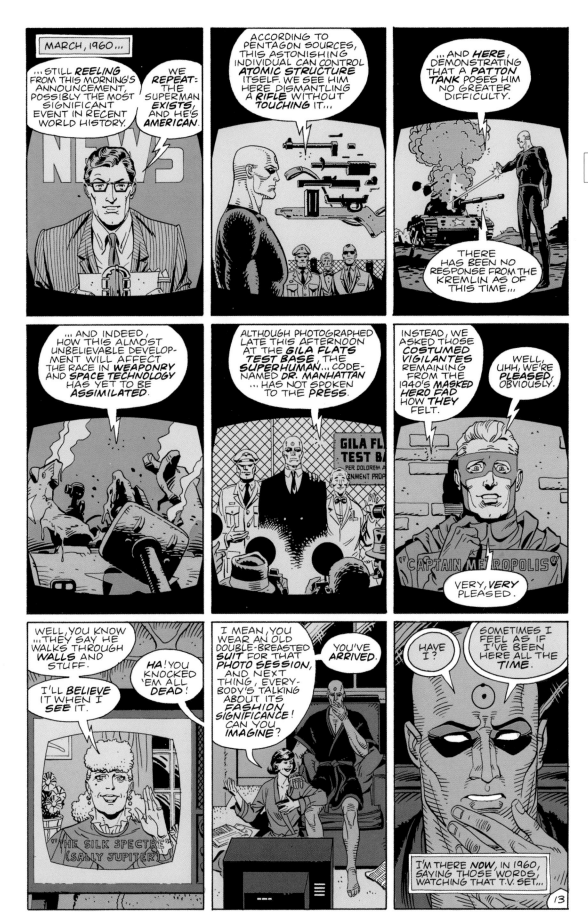

ALAN MOORE + DAVE GIBBONS

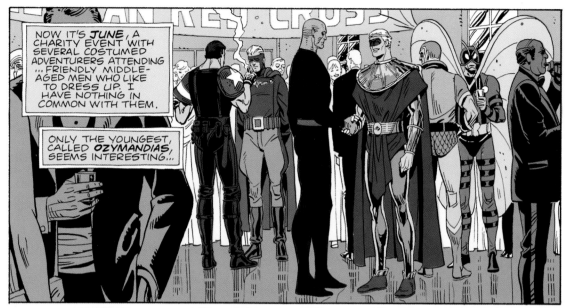

NOW IT'S *JUNE*, A CHARITY EVENT WITH SEVERAL COSTUMED ADVENTURERS ATTENDING ...FRIENDLY MIDDLE-AGED MEN WHO LIKE TO DRESS UP. I HAVE NOTHING IN COMMON WITH THEM.

ONLY THE YOUNGEST, CALLED *OZYMANDIAS*, SEEMS INTERESTING...

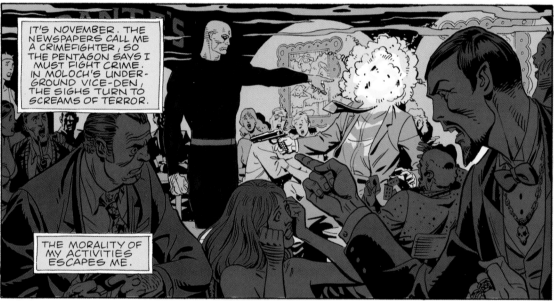

IT'S NOVEMBER. THE NEWSPAPERS CALL ME A CRIMEFIGHTER, SO THE PENTAGON SAYS I MUST FIGHT CRIME. IN MOLOCH'S UNDER-GROUND VICE-DEN, THE SIGHS TURN TO SCREAMS OF TERROR.

THE MORALITY OF MY ACTIVITIES ESCAPES ME.

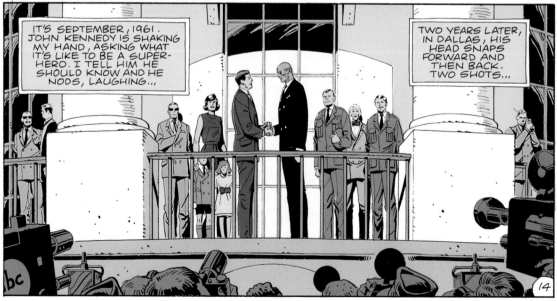

IT'S SEPTEMBER, 1961. JOHN KENNEDY IS SHAKING MY HAND, ASKING WHAT IT'S LIKE TO BE A SUPER-HERO. I TELL HIM HE SHOULD KNOW AND HE NODS, LAUGHING...

TWO YEARS LATER, IN DALLAS, HIS HEAD SNAPS FORWARD AND THEN BACK. TWO SHOTS...

14

DARK FICTION AND DEEP FANTASY

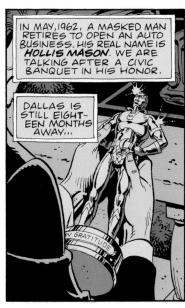

IN MAY, 1962, A MASKED MAN RETIRES TO OPEN AN AUTO BUSINESS. HIS REAL NAME IS *HOLLIS MASON*. WE ARE TALKING AFTER A CIVIC BANQUET IN HIS HONOR.

DALLAS IS STILL EIGHTEEN MONTHS AWAY...

SEE *THIS*? ALMOST MAKES ME SORRY I'M *QUITTING* THIS RIDICULOUS BUSINESS.

THEN WHY HAVE YOU CHOSEN TO RETIRE NOW? IS IT YOUR AGE?

PARTLY. PARTLY, I GUESS IT'S *YOU*...

WITH SOMEONE LIKE *YOU* AROUND, THE WHOLE *SITUATION* CHANGES. YOU CAN DO *ANYTHING*. ALL *I* GOT TO OFFER IS A GOOD *LEFT HOOK*.

243

NAH, I'M BETTER OFF *RETIRING*, WRITING MY *AUTOBIOGRAPHY*, REPAIRIN' FOLKS' CARS FOR 'EM... CARS ARE SOMETHING I'M *HAPPY* WITH...

..., AND IT'LL BE AWHILE BEFORE EVEN *YOU* AFFECT *GENERAL MOTORS*.

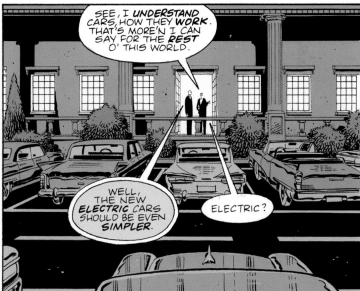

SEE, I *UNDERSTAND* CARS, HOW THEY *WORK*. THAT'S MORE'N I CAN SAY FOR THE *REST* O' THIS WORLD.

WELL, THE NEW *ELECTRIC* CARS SHOULD BE EVEN *SIMPLER*.

ELECTRIC?

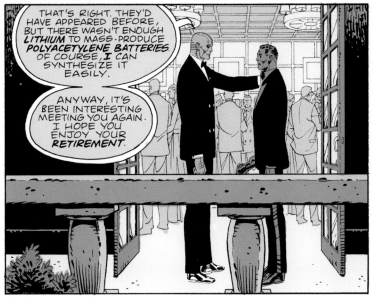

THAT'S RIGHT. THEY'D HAVE APPEARED BEFORE, BUT THERE WASN'T ENOUGH *LITHIUM* TO MASS-PRODUCE *POLYACETYLENE* BATTERIES. OF COURSE, *I* CAN SYNTHESIZE IT EASILY.

ANYWAY, IT'S BEEN INTERESTING MEETING YOU AGAIN. I HOPE YOU ENJOY YOUR *RETIREMENT*.

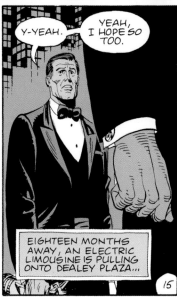

Y-YEAH.

YEAH, I HOPE SO TOO.

EIGHTEEN MONTHS AWAY, AN ELECTRIC LIMOUSINE IS PULLING ONTO DEALEY PLAZA...

15

ALAN MOORE + DAVE GIBBONS

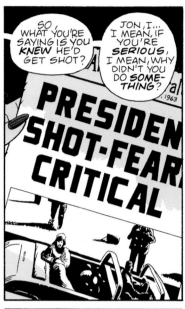

PRESIDEN
SHOT-FEAR
CRITICAL

244

SO, WHAT YOU'RE SAYING IS YOU **KNEW** HE'D GET SHOT?

JON, I... I MEAN, IF YOU'RE **SERIOUS**, I MEAN, WHY DIDN'T YOU DO **SOME-THING**?

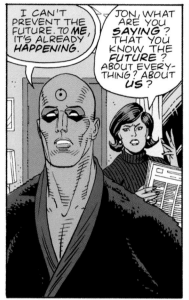

I CAN'T PREVENT THE FUTURE. TO **ME**, IT'S ALREADY **HAPPENING**.

JON, WHAT ARE YOU **SAYING**? THAT YOU **KNOW** THE **FUTURE**? ABOUT EVERY-THING? ABOUT **US**?

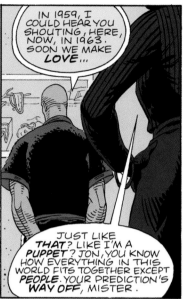

IN 1959, I COULD HEAR YOU SHOUTING, HERE, NOW, IN 1963. SOON WE MAKE **LOVE**...

JUST LIKE **THAT**? LIKE I'M A **PUPPET**? JON, YOU KNOW HOW EVERYTHING IN THIS WORLD FITS TOGETHER EXCEPT **PEOPLE**. YOUR PREDICTION'S **WAY OFF**, MISTER.

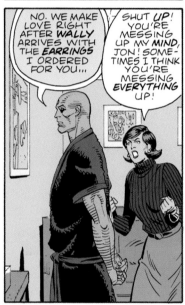

NO. WE MAKE LOVE RIGHT AFTER **WALLY** ARRIVES WITH THE **EARRINGS** I ORDERED FOR YOU...

SHUT **UP**! YOU'RE MESSING UP MY **MIND**, JON! SOME-TIMES I THINK YOU'RE MESSING **EVERYTHING** UP!

I MEAN, ALL THIS **NEW** **TECHNOLOGY**, ALL BECAUSE OF **YOU**! THINGS ARE HAPPENING TOO **FAST**. THINGS SHOULDN'T...

WAS THAT THE DOOR-BELL?

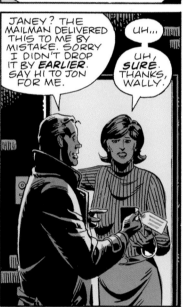

JANEY? THE MAILMAN DELIVERED THIS TO ME BY MISTAKE. SORRY I DIDN'T DROP IT BY **EARLIER**. SAY HI TO JON FOR ME.

UH...

UH, **SURE**. THANKS, WALLY.

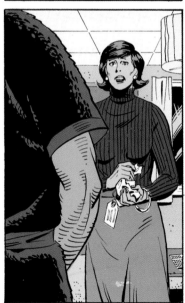

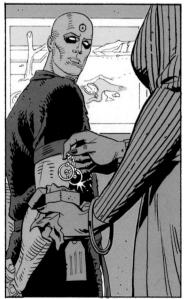

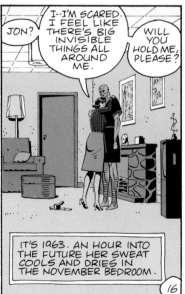

JON?

I--I'M SCARED. I FEEL LIKE THERE'S BIG INVISIBLE THINGS ALL AROUND ME.

WILL YOU HOLD ME, PLEASE?

IT'S 1963. AN HOUR INTO HER FUTURE HER SWEAT COOLS AND DRIES IN THE NOVEMBER BEDROOM.

16

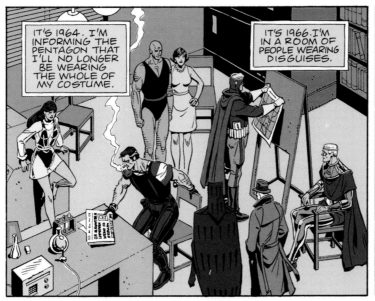

IT'S 1964. I'M INFORMING THE PENTAGON THAT I'LL NO LONGER BE WEARING THE WHOLE OF MY COSTUME.

IT'S 1966. I'M IN A ROOM OF PEOPLE WEARING DISGUISES.

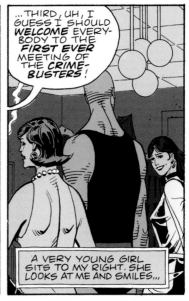

...THIRD, UH, I GUESS I SHOULD *WELCOME* EVERYBODY TO THE *FIRST EVER* MEETING OF THE *CRIMEBUSTERS!*

A VERY YOUNG GIRL SITS TO MY RIGHT. SHE LOOKS AT ME AND SMILES...

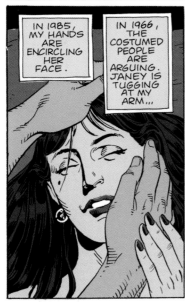

IN 1985, MY HANDS ARE ENCIRCLING HER FACE.

IN 1966, THE COSTUMED PEOPLE ARE ARGUING. JANEY IS TUGGING AT MY ARM...

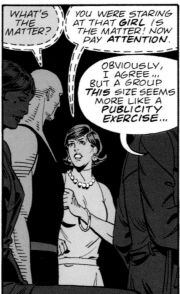

WHAT'S THE MATTER?

YOU WERE STARING AT THAT *GIRL* IS THE MATTER! NOW PAY *ATTENTION.*

OBVIOUSLY, I AGREE... BUT A GROUP *THIS* SIZE SEEMS MORE LIKE A *PUBLICITY EXERCISE...*

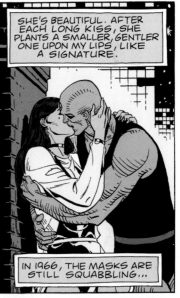

SHE'S BEAUTIFUL. AFTER EACH LONG KISS, SHE PLANTS A SMALLER, GENTLER ONE UPON MY LIPS, LIKE A SIGNATURE.

IN 1966, THE MASKS ARE STILL SQUABBLING...

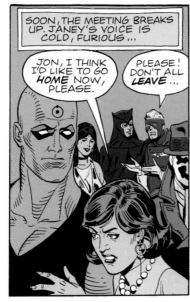

SOON, THE MEETING BREAKS UP. JANEY'S VOICE IS COLD, FURIOUS...

JON, I THINK I'D LIKE TO GO *HOME* NOW, PLEASE.

PLEASE! DON'T ALL *LEAVE...*

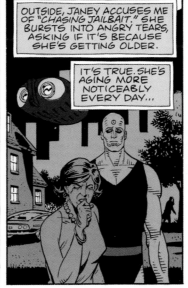

OUTSIDE, JANEY ACCUSES ME OF "CHASING JAILBAIT." SHE BURSTS INTO ANGRY TEARS, ASKING IF IT'S BECAUSE SHE'S GETTING OLDER.

IT'S TRUE. SHE'S AGING MORE NOTICEABLY EVERY DAY...

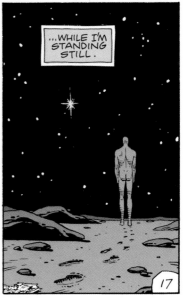

...WHILE I'M STANDING STILL.

17

ALAN MOORE + DAVE GIBBONS

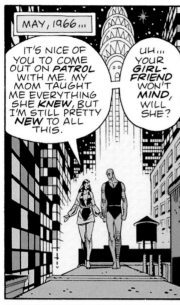

MAY, 1966...

IT'S NICE OF YOU TO COME OUT ON *PATROL* WITH ME. MY MOM TAUGHT ME EVERYTHING SHE *KNEW*, BUT I'M STILL PRETTY *NEW* TO ALL THIS.

UH... YOUR *GIRL-FRIEND* WON'T *MIND*, WILL SHE?

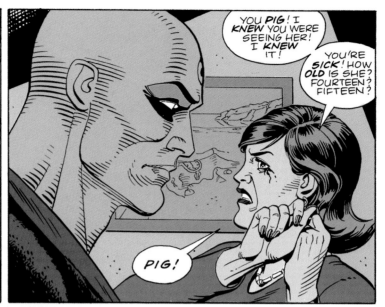

YOU *PIG*! I *KNEW* YOU WERE SEEING HER! I *KNEW* IT!

YOU'RE *SICK*! HOW *OLD* IS SHE? FOURTEEN? FIFTEEN?

PIG!

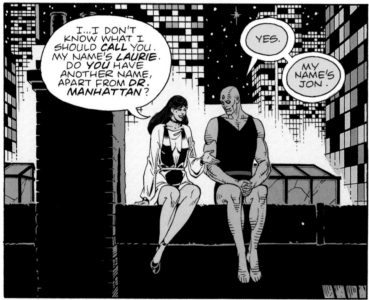

I...I DON'T KNOW WHAT I SHOULD *CALL* YOU. MY NAME'S *LAURIE*. DO *YOU* HAVE ANOTHER NAME, APART FROM *DR. MANHATTAN*?

YES.

MY NAME'S JON.

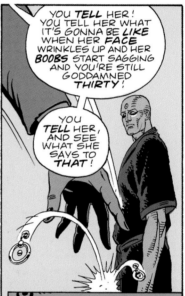

YOU *TELL* HER! YOU TELL HER WHAT IT'S GONNA BE *LIKE* WHEN HER *FACE* WRINKLES UP AND HER *BOOBS* START SAGGING AND YOU'RE STILL GODDAMNED *THIRTY*!

YOU *TELL* HER, AND SEE WHAT SHE SAYS TO *THAT*!

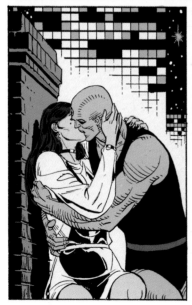

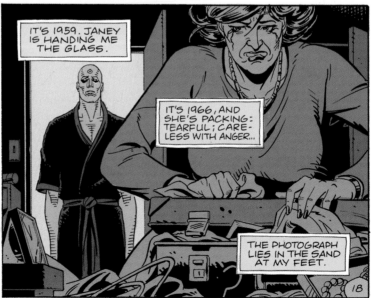

IT'S 1959. JANEY IS HANDING ME THE GLASS.

IT'S 1966, AND SHE'S PACKING: TEARFUL; CARELESS WITH ANGER...

THE PHOTOGRAPH LIES IN THE SAND AT MY FEET.

18

DARK FICTION AND DEEP FANTASY

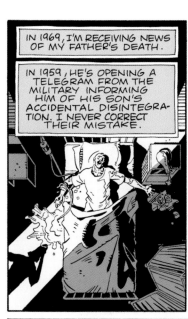

IN 1969, I'M RECEIVING NEWS OF MY FATHER'S DEATH.

IN 1959, HE'S OPENING A TELEGRAM FROM THE MILITARY INFORMING HIM OF HIS SON'S ACCIDENTAL DISINTEGRATION. I NEVER CORRECT THEIR MISTAKE.

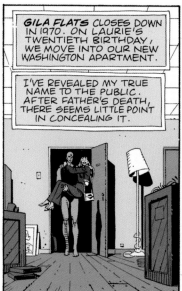

GILA FLATS CLOSES DOWN IN 1970. ON LAURIE'S TWENTIETH BIRTHDAY, WE MOVE INTO OUR NEW WASHINGTON APARTMENT.

I'VE REVEALED MY TRUE NAME TO THE PUBLIC. AFTER FATHER'S DEATH, THERE SEEMS LITTLE POINT IN CONCEALING IT.

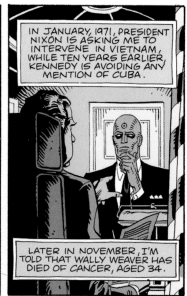

IN JANUARY, 1971, PRESIDENT NIXON IS ASKING ME TO INTERVENE IN VIETNAM, WHILE TEN YEARS EARLIER, KENNEDY IS AVOIDING ANY MENTION OF CUBA.

LATER IN NOVEMBER, I'M TOLD THAT WALLY WEAVER HAS DIED OF CANCER, AGED 34.

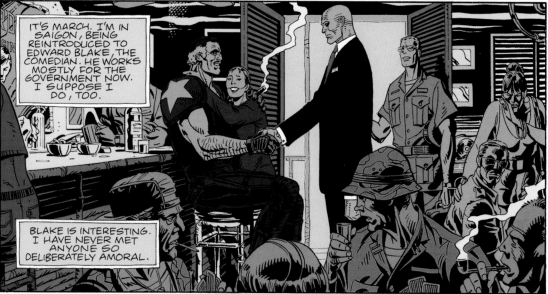

IT'S MARCH. I'M IN SAIGON, BEING REINTRODUCED TO EDWARD BLAKE, THE COMEDIAN. HE WORKS MOSTLY FOR THE GOVERNMENT NOW. I SUPPOSE I DO, TOO.

BLAKE IS INTERESTING. I HAVE NEVER MET ANYONE SO DELIBERATELY AMORAL.

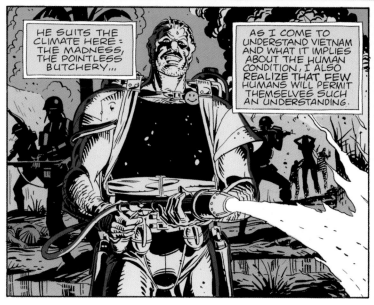

HE SUITS THE CLIMATE HERE: THE MADNESS, THE POINTLESS BUTCHERY...

AS I COME TO UNDERSTAND VIETNAM AND WHAT IT IMPLIES ABOUT THE HUMAN CONDITION, I ALSO REALIZE THAT FEW HUMANS WILL PERMIT THEMSELVES SUCH AN UNDERSTANDING.

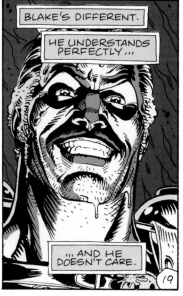

BLAKE'S DIFFERENT.

HE UNDERSTANDS PERFECTLY...

...AND HE DOESN'T CARE.

19

ALAN MOORE + DAVE GIBBONS

248

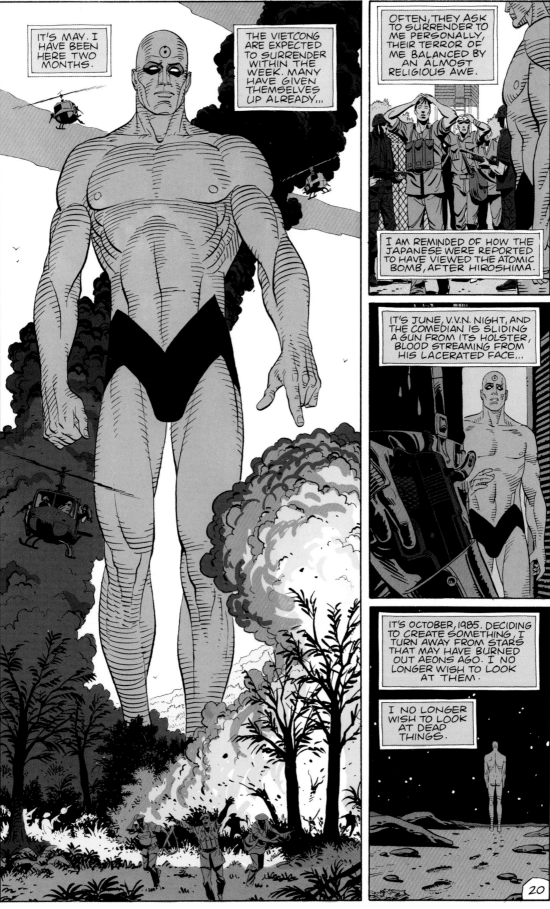

IT'S MAY. I HAVE BEEN HERE TWO MONTHS.

THE VIETCONG ARE EXPECTED TO SURRENDER WITHIN THE WEEK. MANY HAVE GIVEN THEMSELVES UP ALREADY...

OFTEN, THEY ASK TO SURRENDER TO ME PERSONALLY, THEIR TERROR OF ME BALANCED BY AN ALMOST RELIGIOUS AWE.

I AM REMINDED OF HOW THE JAPANESE WERE REPORTED TO HAVE VIEWED THE ATOMIC BOMB, AFTER HIROSHIMA.

IT'S JUNE, V.V.N. NIGHT, AND THE COMEDIAN IS SLIDING A GUN FROM ITS HOLSTER, BLOOD STREAMING FROM HIS LACERATED FACE...

IT'S OCTOBER, 1985. DECIDING TO CREATE SOMETHING, I TURN AWAY FROM STARS THAT MAY HAVE BURNED OUT AEONS AGO. I NO LONGER WISH TO LOOK AT THEM.

I NO LONGER WISH TO LOOK AT DEAD THINGS.

20

IT'S 1975. THE PAPERS ARE FULL OF THE PRESIDENT'S PROPOSED *CONSTITUTIONAL AMENDMENT*, ALLOWING HIM TO RUN NEXT YEAR FOR A THIRD TERM.

AMIDST ALL THIS, THE UNMASKING AND RETIRE-MENT OF *OZYMANDIAS* GOES ALMOST UNNOTICED.

OZYMAN QUITS

'SMART MAN I' WORL' GOES PUBLI

ADRIAN VEIDT ALIAS OZYMANDIAS

HIS REAL NAME IS *ADRIAN VEIDT*, A SELF-MADE MILLIONAIRE. AFTER RETIRING FROM ADVENTURING HE INVITES LAURIE AND ME TO VISIT HIM AT HIS ANTARCTIC RETREAT.

OOH! WHAT *IS* IT? IT'S *BEAUTIFUL*!

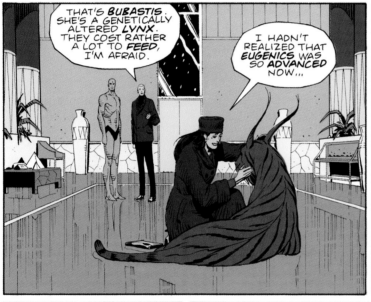

THAT'S *BUBASTIS*. SHE'S A GENETICALLY ALTERED *LYNX*. THEY COST RATHER A LOT TO *FEED*, I'M AFRAID.

I HADN'T REALIZED THAT *EUGENICS* WAS SO *ADVANCED* NOW...

IT'S LEAPT *FORWARD* IN THE LAST FIFTEEN YEARS. *EVERYTHING* HAS, FROM QUANTUM PHYSICS TO *TRANSPORT*.

FOR *EXAMPLE*, I UNDERSTAND THAT FAST AND SAFE *AIRSHIPS* MAY SOON BE ECONOMICALLY VIABLE...

...AND WE OWE IT ALL TO *YOU*. WITH YOUR HELP, OUR SCIENTISTS ARE LIMITED ONLY BY THEIR *IMAGINATIONS*.

AND BY THEIR *CONSCIENCES*, SURELY?

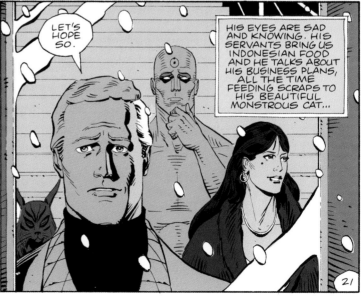

LET'S HOPE SO.

HIS EYES ARE SAD AND KNOWING. HIS SERVANTS BRING US INDONESIAN FOOD AND HE TALKS ABOUT HIS BUSINESS PLANS, ALL THE TIME FEEDING SCRAPS TO HIS BEAUTIFUL MONSTROUS CAT...

21

ALAN MOORE + DAVE GIBBONS

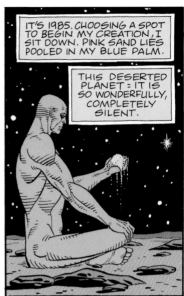

IT'S 1985. CHOOSING A SPOT TO BEGIN MY CREATION, I SIT DOWN. PINK SAND LIES POOLED IN MY BLUE PALM.

THIS DESERTED PLANET = IT IS SO WONDERFULLY, COMPLETELY SILENT.

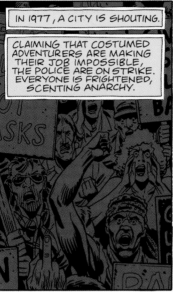

IN 1977, A CITY IS SHOUTING.

CLAIMING THAT COSTUMED ADVENTURERS ARE MAKING THEIR JOB IMPOSSIBLE, THE POLICE ARE ON STRIKE. EVERYONE IS FRIGHTENED, SCENTING ANARCHY.

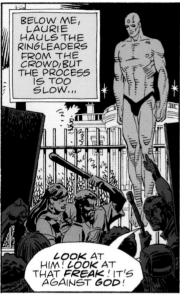

BELOW ME, LAURIE HAULS THE RINGLEADERS FROM THE CROWD, BUT THE PROCESS IS TOO SLOW...

LOOK AT HIM! LOOK AT THAT FREAK! IT'S AGAINST GOD!

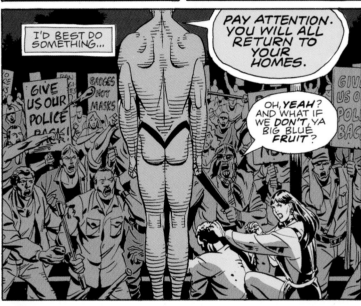

I'D BEST DO SOMETHING...

PAY ATTENTION. YOU WILL ALL RETURN TO YOUR HOMES.

OH, YEAH? AND WHAT IF WE DON'T, YA BIG BLUE FRUIT?

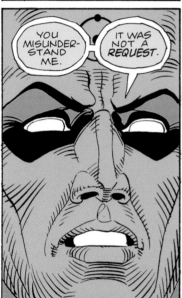

YOU MISUNDER-STAND ME.

IT WAS NOT A REQUEST.

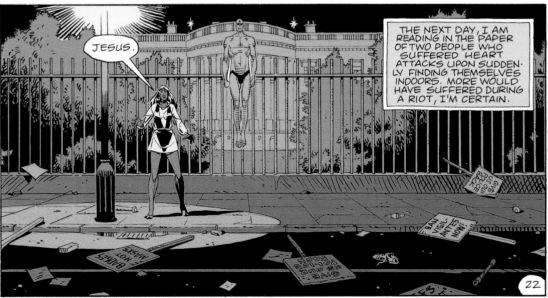

JESUS.

THE NEXT DAY, I AM READING IN THE PAPER OF TWO PEOPLE WHO SUFFERED HEART ATTACKS UPON SUDDEN-LY FINDING THEMSELVES INDOORS. MORE WOULD HAVE SUFFERED DURING A RIOT, I'M CERTAIN.

22

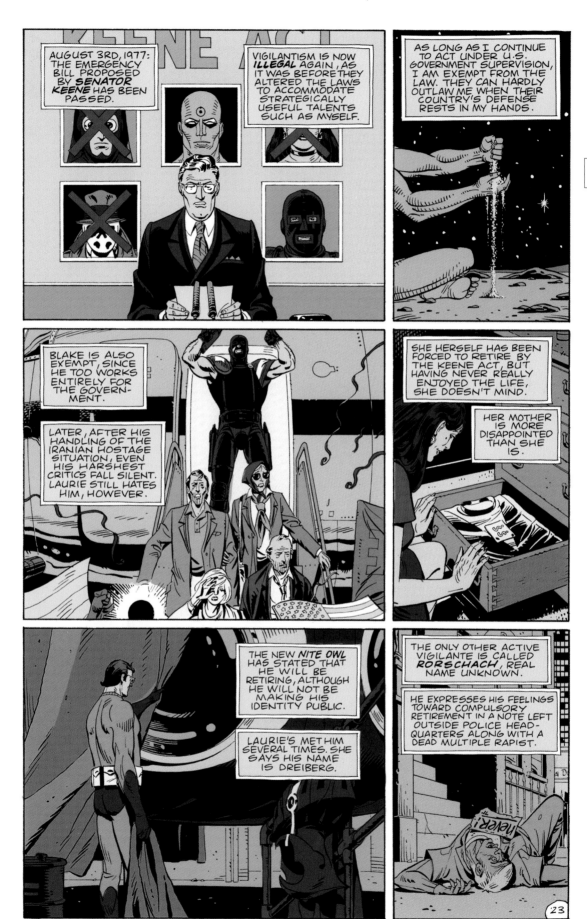

AUGUST 3RD, 1977: THE EMERGENCY BILL PROPOSED BY *SENATOR KEENE* HAS BEEN PASSED.

VIGILANTISM IS NOW *ILLEGAL* AGAIN, AS IT WAS BEFORE THEY ALTERED THE LAWS TO ACCOMMODATE STRATEGICALLY USEFUL TALENTS SUCH AS MYSELF.

AS LONG AS I CONTINUE TO ACT UNDER U.S. GOVERNMENT SUPERVISION, I AM EXEMPT FROM THE LAW. THEY CAN HARDLY OUTLAW ME WHEN THEIR COUNTRY'S DEFENSE RESTS IN MY HANDS.

251

BLAKE IS ALSO EXEMPT, SINCE HE TOO WORKS ENTIRELY FOR THE GOVERNMENT.

LATER, AFTER HIS HANDLING OF THE IRANIAN HOSTAGE SITUATION, EVEN HIS HARSHEST CRITICS FALL SILENT. LAURIE STILL HATES HIM, HOWEVER.

SHE HERSELF HAS BEEN FORCED TO RETIRE BY THE KEENE ACT, BUT HAVING NEVER REALLY ENJOYED THE LIFE, SHE DOESN'T MIND.

HER MOTHER IS MORE DISAPPOINTED THAN SHE IS.

THE NEW *NITE OWL* HAS STATED THAT HE WILL BE RETIRING, ALTHOUGH HE WILL NOT BE MAKING HIS IDENTITY PUBLIC.

LAURIE'S MET HIM SEVERAL TIMES. SHE SAYS HIS NAME IS DREIBERG.

THE ONLY OTHER ACTIVE VIGILANTE IS CALLED *RORSCHACH*, REAL NAME UNKNOWN.

HE EXPRESSES HIS FEELINGS TOWARD COMPULSORY RETIREMENT IN A NOTE LEFT OUTSIDE POLICE HEADQUARTERS ALONG WITH A DEAD MULTIPLE RAPIST.

23

ALAN MOORE + DAVE GIBBONS

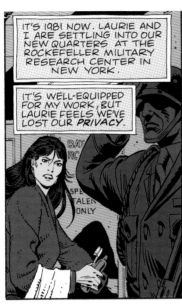

IT'S 1981 NOW. LAURIE AND I ARE SETTLING INTO OUR NEW QUARTERS AT THE ROCKEFELLER MILITARY RESEARCH CENTER IN NEW YORK.

IT'S WELL-EQUIPPED FOR MY WORK, BUT LAURIE FEELS WE'VE LOST OUR *PRIVACY*.

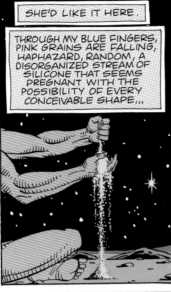

SHE'D LIKE IT HERE.

THROUGH MY BLUE FINGERS, PINK GRAINS ARE FALLING, HAPHAZARD, RANDOM, A DISORGANIZED STREAM OF SILICONE THAT SEEMS PREGNANT WITH THE POSSIBILITY OF EVERY CONCEIVABLE SHAPE...

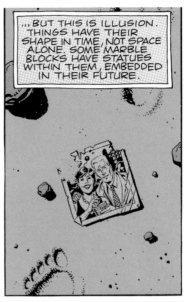

... BUT THIS IS ILLUSION. THINGS HAVE THEIR SHAPE IN TIME, NOT SPACE ALONE. SOME MARBLE BLOCKS HAVE STATUES WITHIN THEM, EMBEDDED IN THEIR FUTURE.

IN NEW YORK, WE GO WALKING.

THE STREETS SMELL OF OZONE RATHER THAN GASOLINE. FLAT INTANGIBLE BLOTS OF GRAY SLIDE ACROSS THE SUMMER SIDEWALKS, THE SHADOWS OF OVERHEAD AIRSHIPS.

IN 1959, A CHILD IS WEEPING FOR ITS LOST BALLOONS.

ANY MOMENT NOW, JANEY'S WATCHBAND WILL BREAK. SOMEWHERE, THE FAT MAN IS ALREADY LUMBERING TOWARD THE SHOOTING GALLERY, STEPS HEAVY WITH UNWITTING DESTINY.

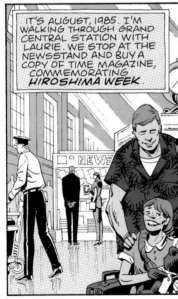

IT'S AUGUST, 1985. I'M WALKING THROUGH GRAND CENTRAL STATION WITH LAURIE. WE STOP AT THE NEWSSTAND AND BUY A COPY OF TIME MAGAZINE, COMMEMORATING *HIROSHIMA WEEK*.

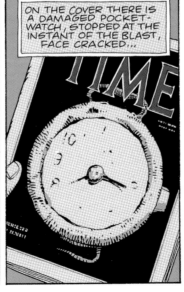

ON THE COVER THERE IS A DAMAGED POCKET-WATCH, STOPPED AT THE INSTANT OF THE BLAST, FACE CRACKED...

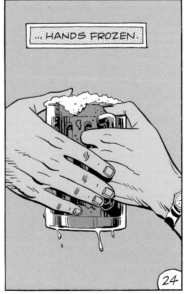

... HANDS FROZEN.

24

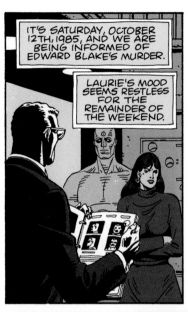

IT'S SATURDAY, OCTOBER 12TH, 1985, AND WE ARE BEING INFORMED OF EDWARD BLAKE'S MURDER.

LAURIE'S MOOD SEEMS RESTLESS FOR THE REMAINDER OF THE WEEKEND.

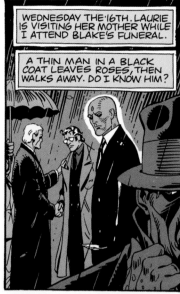

WEDNESDAY THE 16TH. LAURIE IS VISITING HER MOTHER WHILE I ATTEND BLAKE'S FUNERAL.

A THIN MAN IN A BLACK COAT LEAVES ROSES, THEN WALKS AWAY. DO I KNOW HIM?

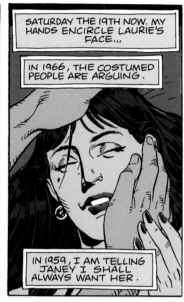

SATURDAY THE 19TH NOW. MY HANDS ENCIRCLE LAURIE'S FACE...

IN 1966, THE COSTUMED PEOPLE ARE ARGUING.

IN 1959, I AM TELLING JANEY I SHALL ALWAYS WANT HER.

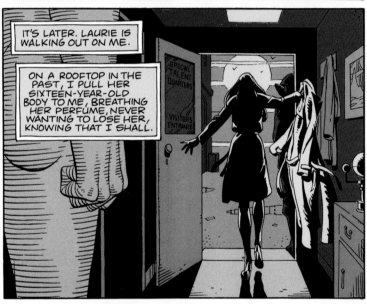

IT'S LATER. LAURIE IS WALKING OUT ON ME.

ON A ROOFTOP IN THE PAST, I PULL HER SIXTEEN-YEAR-OLD BODY TO ME, BREATHING HER PERFUME, NEVER WANTING TO LOSE HER, KNOWING THAT I SHALL.

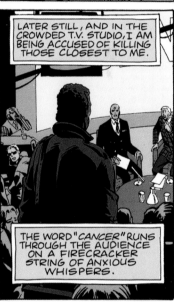

LATER STILL, AND IN THE CROWDED T.V. STUDIO, I AM BEING ACCUSED OF KILLING THOSE CLOSEST TO ME.

THE WORD "CANCER" RUNS THROUGH THE AUDIENCE ON A FIRECRACKER STRING OF ANXIOUS WHISPERS.

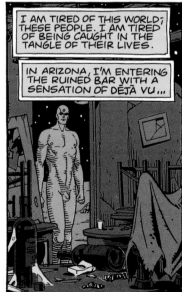

I AM TIRED OF THIS WORLD, THESE PEOPLE. I AM TIRED OF BEING CAUGHT IN THE TANGLE OF THEIR LIVES.

IN ARIZONA, I'M ENTERING THE RUINED BAR WITH A SENSATION OF DÉJÀ VU...

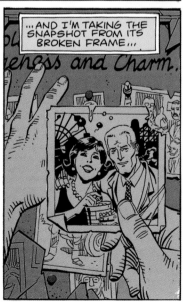

...AND I'M TAKING THE SNAPSHOT FROM ITS BROKEN FRAME...

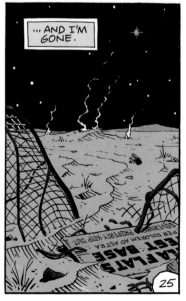

...AND I'M GONE.

25

ALAN MOORE + DAVE GIBBONS

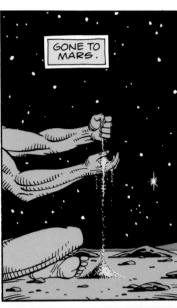

GONE TO MARS.

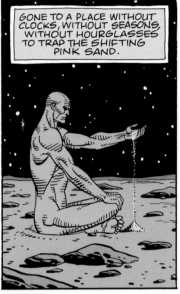

GONE TO A PLACE WITHOUT CLOCKS, WITHOUT SEASONS, WITHOUT HOURGLASSES TO TRAP THE SHIFTING PINK SAND.

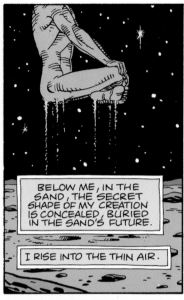

BELOW ME, IN THE SAND, THE SECRET SHAPE OF MY CREATION IS CONCEALED, BURIED IN THE SAND'S FUTURE.

I RISE INTO THE THIN AIR.

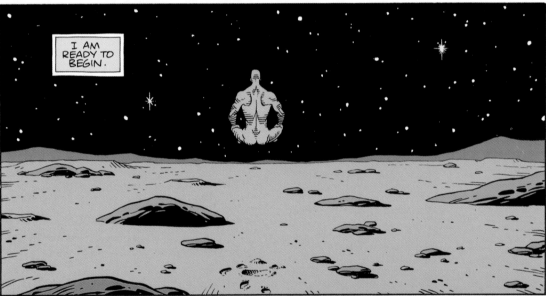

I AM READY TO BEGIN.

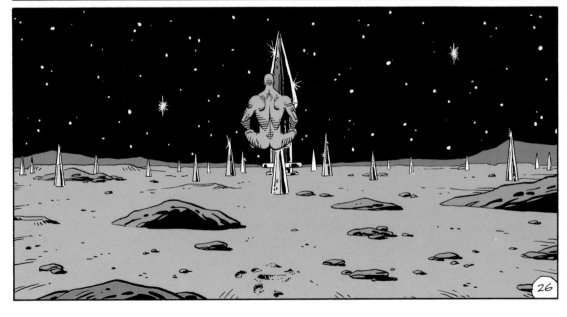

254

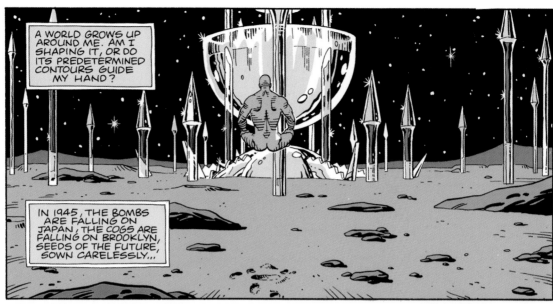

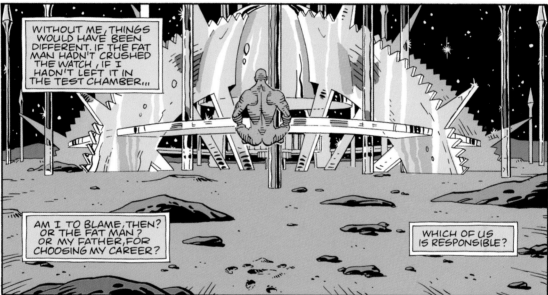

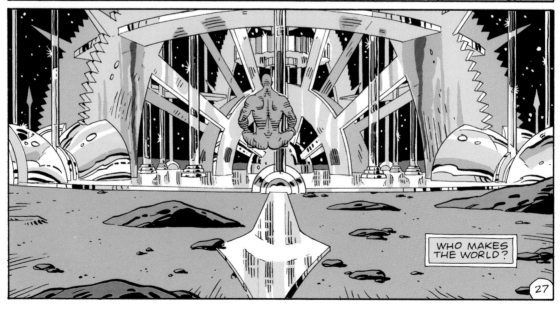

ALAN MOORE + DAVE GIBBONS

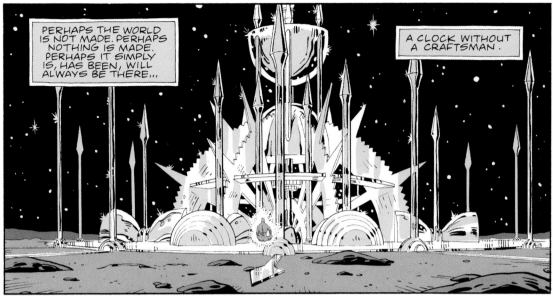

PERHAPS THE WORLD IS NOT MADE. PERHAPS NOTHING IS MADE. PERHAPS IT SIMPLY IS, HAS BEEN, WILL ALWAYS BE THERE...

A CLOCK WITHOUT A CRAFTSMAN.

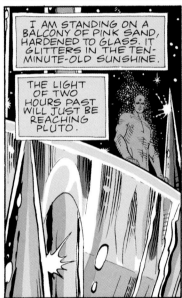

I AM STANDING ON A BALCONY OF PINK SAND, HARDENED TO GLASS. IT GLITTERS IN THE TEN-MINUTE-OLD SUNSHINE.

THE LIGHT OF TWO HOURS PAST WILL JUST BE REACHING PLUTO.

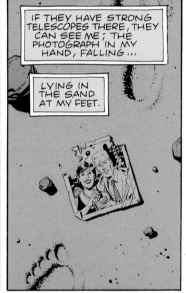

IF THEY HAVE STRONG TELESCOPES THERE, THEY CAN SEE ME; THE PHOTOGRAPH IN MY HAND, FALLING...

LYING IN THE SAND AT MY FEET.

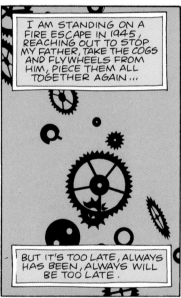

I AM STANDING ON A FIRE ESCAPE IN 1945, REACHING OUT TO STOP MY FATHER, TAKE THE COGS AND FLYWHEELS FROM HIM, PIECE THEM ALL TOGETHER AGAIN...

BUT IT'S TOO LATE, ALWAYS HAS BEEN, ALWAYS WILL BE TOO LATE.

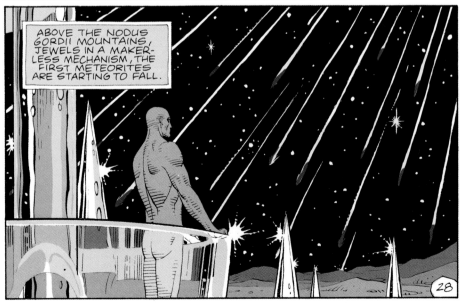

ABOVE THE NODUS GORDII MOUNTAINS, JEWELS IN A MAKER-LESS MECHANISM, THE FIRST METEORITES ARE STARTING TO FALL.

The release of atom power has changed everything except our way of thinking... The solution to this problem lies in the heart of mankind. If only I had known, I should have become a watchmaker.
—Albert Einstein

28

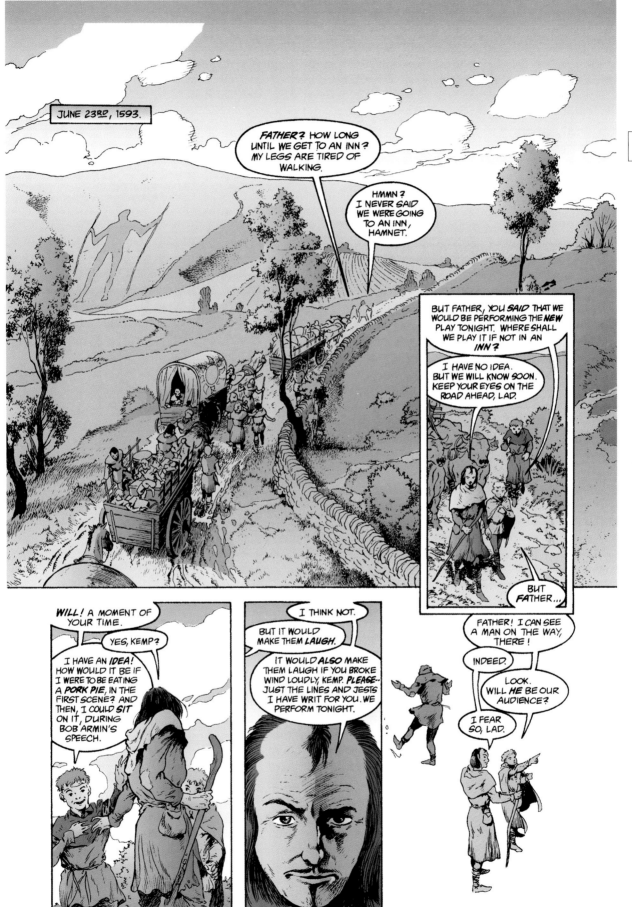

NEIL GAIMAN + CHARLES VESS + MALCOLM JONES III

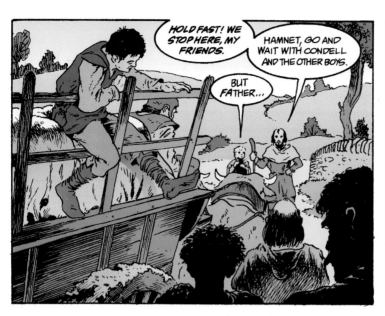

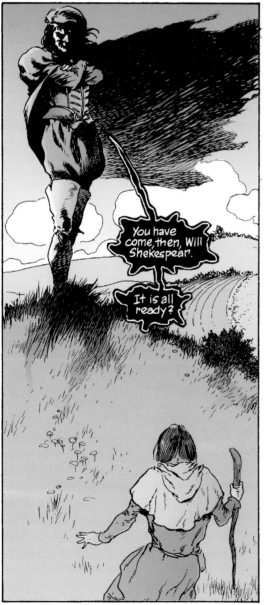

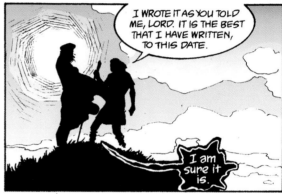

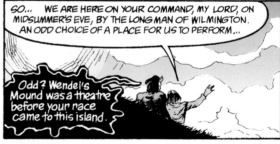

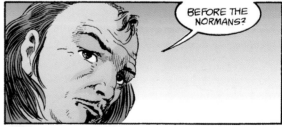

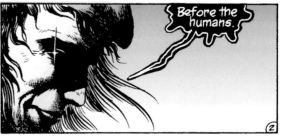

258

NEIL GAIMAN + CHARLES VESS + MALCOLM JONES III

I CAN'T *WAIT* UNTIL WE'RE BACK IN THE SMOKE. I *LOATHE* THESE PROVINCIAL TOURS.

AS SOON AS THE PLAGUE SEASON IS OVER, WE'LL BE BACK AT THE CURTAIN, AND THE CROSS KEYS, AND YOU CAN MAKE UP TO *ALL* YOUR ADMIRERS AGAIN...

COW. AT LEAST *I HAVE* ADMIRERS.

MY FATHER SAYS IT'S NOT THE PLAGUE THAT'S THE PROBLEM, IT'S THE CITY ALDERMEN.

YES, DO ME UP IN THE BACK, THERE'S A LOVE.

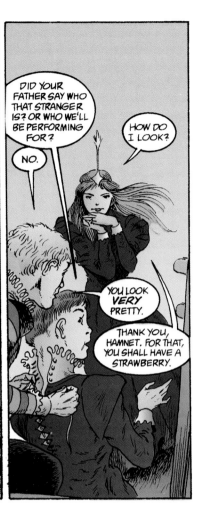

DID YOUR FATHER SAY WHO THAT STRANGER IS? OR WHO WE'LL BE PERFORMING FOR?

NO.

HOW DO I LOOK?

YOU LOOK *VERY* PRETTY.

THANK YOU, HAMNET. FOR THAT, YOU SHALL HAVE A STRAWBERRY.

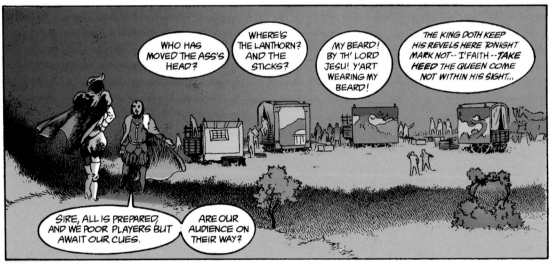

WHO HAS MOVED THE ASS'S HEAD?

WHERE'S THE LANTHORN? AND THE STICKS?

MY BEARD! BY TH' LORD JESU! Y'ART WEARING MY BEARD!

THE KING DOTH KEEP HIS REVELS HERE TONIGHT MARK NOT-- I'FAITH --*TAKE HEED* THE QUEEN COME NOT WITHIN HIS SIGHT...

SIRE, ALL IS PREPARED, AND WE POOR PLAYERS BUT AWAIT OUR CUES.

ARE OUR AUDIENCE ON THEIR WAY?

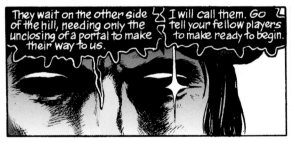

They wait on the other side of the hill, needing only the unclosing of a portal to make their way to us.

I will call them. Go tell your fellow players to make ready to begin.

Wendel! Open your door.

④

DARK FICTION AND DEEP FANTASY

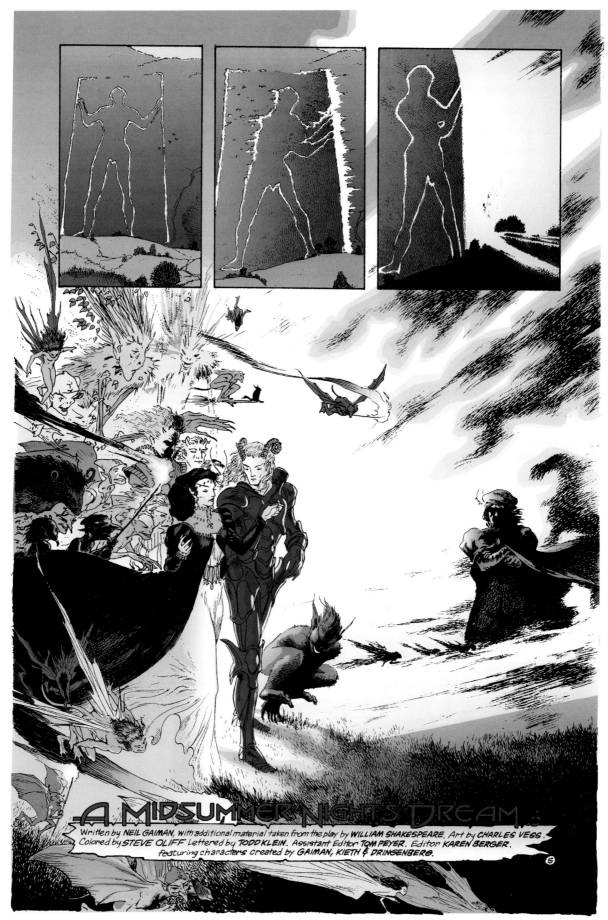

A MIDSUMMER NIGHT'S DREAM

Written by NEIL GAIMAN, with additional material taken from the play by WILLIAM SHAKESPEARE. Art by CHARLES VESS.
Colored by STEVE OLIFF Lettered by TODD KLEIN. Assistant Editor TOM PEYER. Editor KAREN BERGER.
featuring characters created by GAIMAN, KIETH & DRINGENBERG.

5

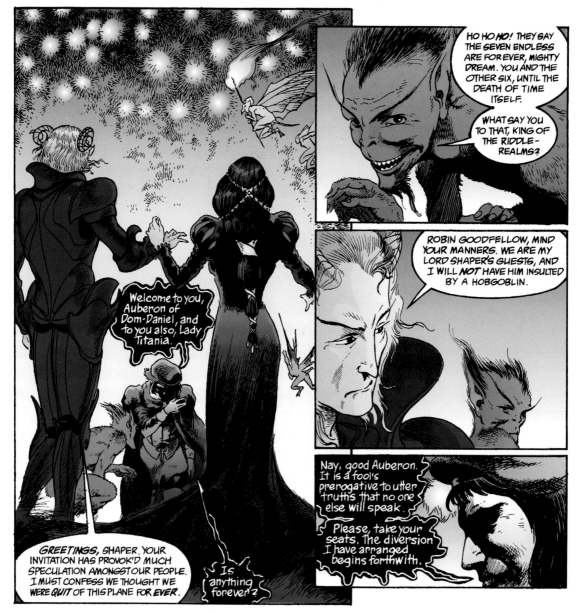

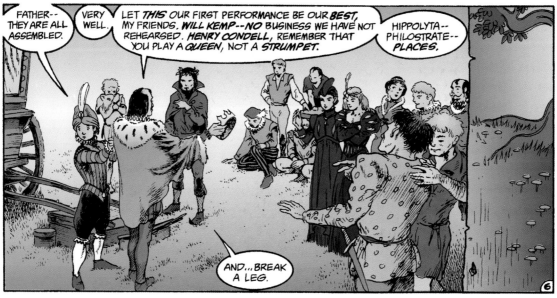

DARK FICTION AND DEEP FANTASY

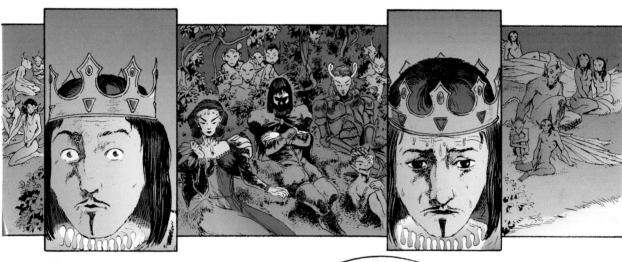

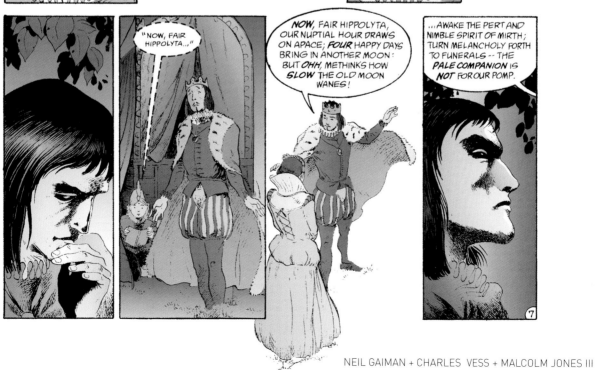

"NOW, FAIR HIPPOLYTA..."

NOW, FAIR HIPPOLYTA, OUR NUPTIAL HOUR DRAWS ON APACE; *FOUR* HAPPY DAYS BRING IN ANOTHER MOON: BUT *OHH,* METHINKS HOW *SLOW* THE OLD MOON WANES!

...AWAKE THE PERT AND NIMBLE SPIRIT OF MIRTH; TURN MELANCHOLY FORTH TO FUNERALS -- THE *PALE COMPANION* IS *NOT* FOR OUR POMP.

⑦

NEIL GAIMAN + CHARLES VESS + MALCOLM JONES III

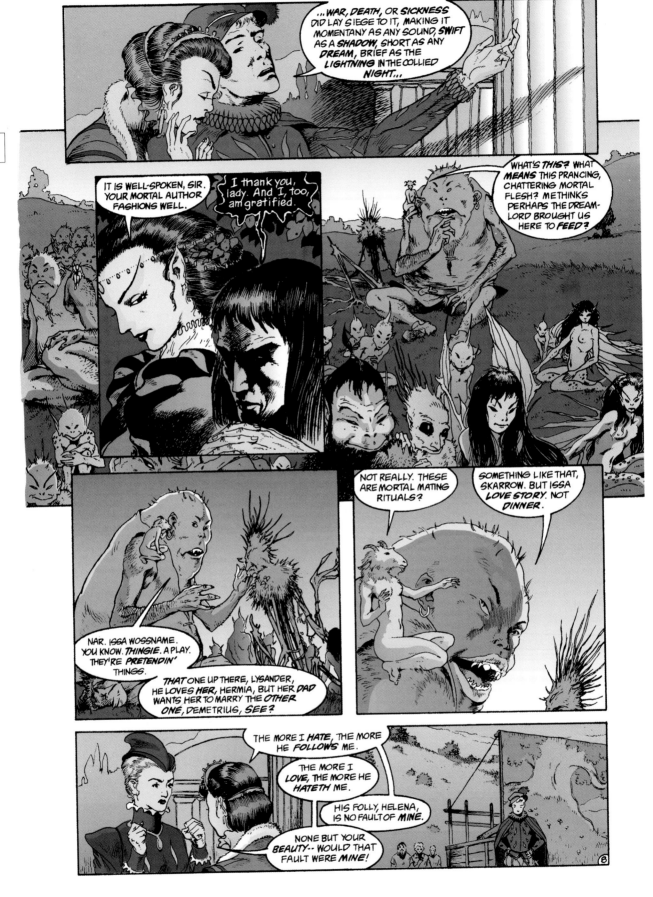

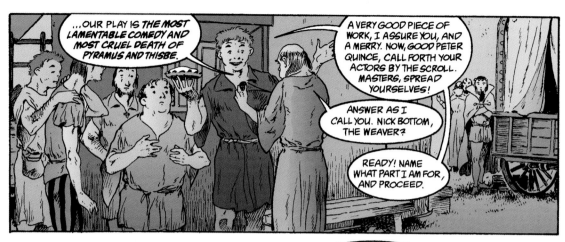

...OUR PLAY IS *THE MOST LAMENTABLE COMEDY AND MOST CRUEL DEATH OF PYRAMUS AND THISBE.*

A VERY GOOD PIECE OF WORK, I ASSURE YOU, AND A MERRY. NOW, *GOOD PETER QUINCE,* CALL FORTH YOUR ACTORS BY THE SCROLL. MASTERS, SPREAD YOURSELVES!

ANSWER AS I CALL YOU. NICK BOTTOM, THE WEAVER?

READY! NAME WHAT PART I AM FOR, QUINCE, AND PROCEED.

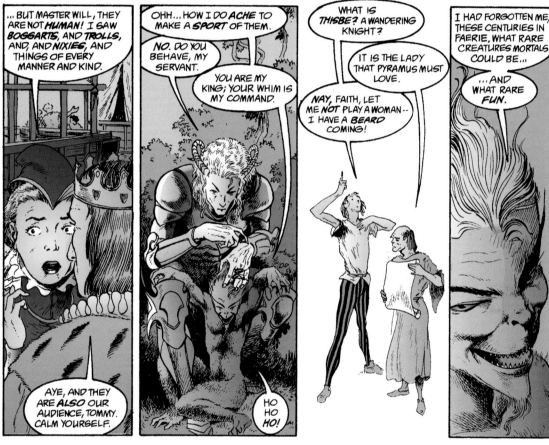

... BUT MASTER WILL, THEY ARE NOT *HUMAN!* I SAW *BOGGARTS,* AND *TROLLS,* AND, AND *NIXIES,* AND THINGS OF EVERY MANNER AND KIND.

AYE, AND THEY ARE *ALSO* OUR AUDIENCE, TOMMY. CALM YOURSELF.

OHH... HOW I DO *ACHE* TO MAKE A *SPORT* OF THEM.

NO. *DO YOU* BEHAVE, MY SERVANT.

YOU ARE MY KING; YOUR WHIM IS MY COMMAND.

HO HO HO!

WHAT IS *THISBE?* A WANDERING KNIGHT?

IT IS THE LADY THAT PYRAMUS MUST LOVE.

NAY, FAITH, LET ME *NOT* PLAY A WOMAN-- I HAVE A *BEARD* COMING!

I HAD FORGOTTEN ME, THESE CENTURIES IN FAERIE, WHAT RARE CREATURES MORTALS COULD BE...

...AND WHAT RARE *FUN.*

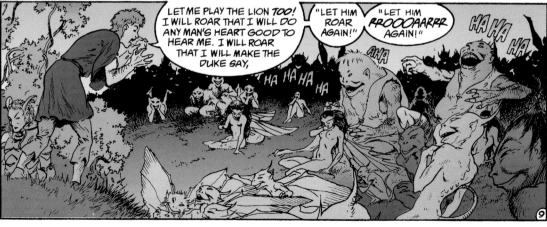

LET ME PLAY THE LION *TOO!* I WILL ROAR THAT I WILL DO ANY MAN'S HEART GOOD TO HEAR ME. I WILL ROAR THAT I WILL MAKE THE DUKE SAY,

"LET HIM ROAR AGAIN!"

"LET HIM *RROOOAARRR* AGAIN!"

HA HA HA HA

AHA

HA HA HA

9

NEIL GAIMAN + CHARLES VESS + MALCOLM JONES III

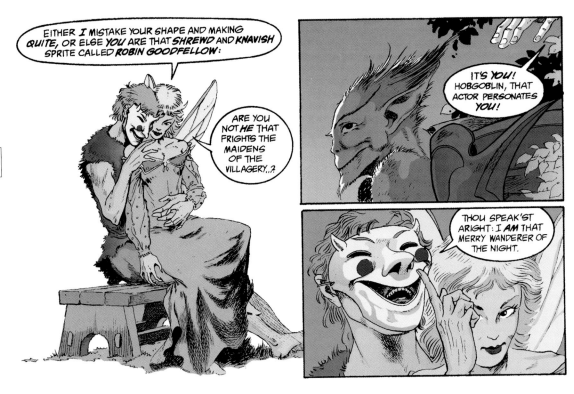

266

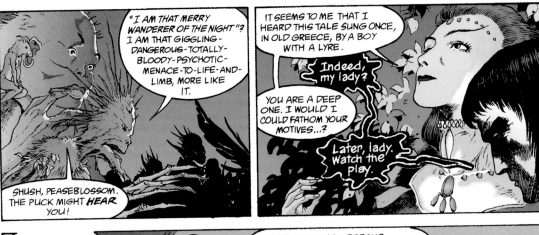

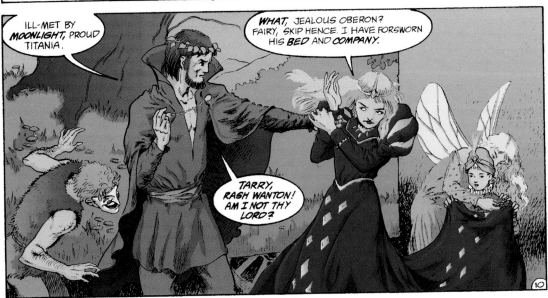

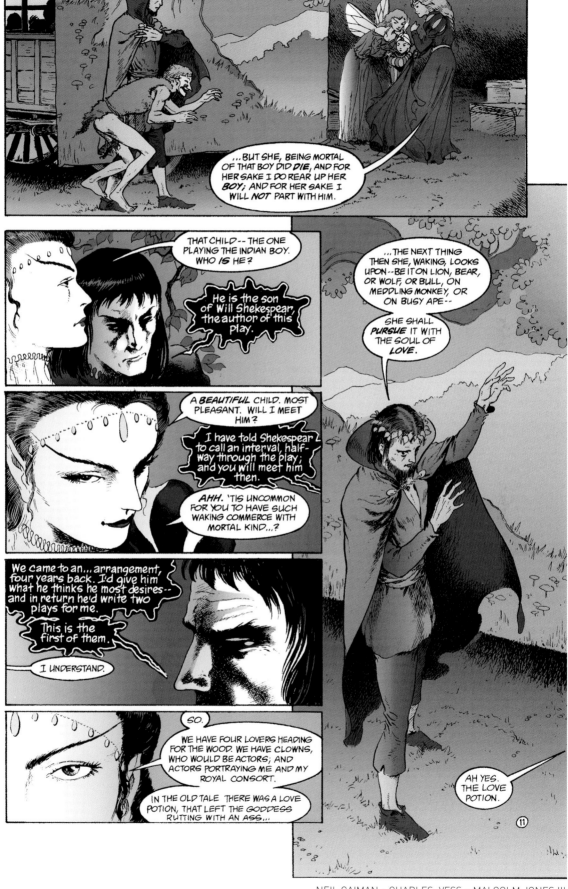

267

...BUT SHE, BEING MORTAL OF THAT BOY *DID DIE*, AND FOR HER SAKE I DO REAR UP HER *BOY*; AND FOR HER SAKE I WILL *NOT* PART WITH HIM.

THAT CHILD-- THE ONE PLAYING THE INDIAN BOY. WHO *IS* HE?

He is the son of Will Shekespear, the author of this play.

...THE NEXT THING THEN SHE, WAKING, LOOKS UPON-- BE IT ON LION, BEAR, OR WOLF, OR BULL, ON MEDDLING MONKEY, OR ON BUSY APE--

SHE SHALL *PURSUE* IT WITH THE SOUL OF *LOVE.*

A *BEAUTIFUL* CHILD. MOST PLEASANT. WILL I MEET HIM?

I have told Shekespear to call an interval, half-way through the play; and you will meet him then.

AHH. 'TIS UNCOMMON FOR YOU TO HAVE SUCH WAKING COMMERCE WITH MORTAL KIND...?

We came to an...arrangement, four years back. I'd give him what he thinks he most desires-- and in return he'd write two plays for me.

This is the first of them.

I UNDERSTAND.

SO.

WE HAVE FOUR LOVERS HEADING FOR THE WOOD. WE HAVE CLOWNS, WHO WOULD BE ACTORS; AND ACTORS PORTRAYING ME AND MY ROYAL CONSORT.

IN THE OLD TALE THERE WAS A LOVE POTION, THAT LEFT THE GODDESS RUTTING WITH AN ASS...

AH YES. THE LOVE POTION.

⑪

NEIL GAIMAN + CHARLES VESS + MALCOLM JONES III

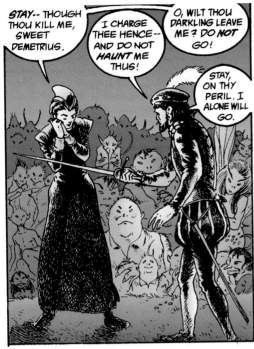

STAY-- THOUGH THOU KILL ME, SWEET DEMETRIUS.

I CHARGE THEE HENCE-- AND DO NOT *HAUNT* ME THUS!

O, WILT THOU *DARKLING* LEAVE ME? DO *NOT* GO!

STAY, ON THY PERIL. I ALONE WILL GO.

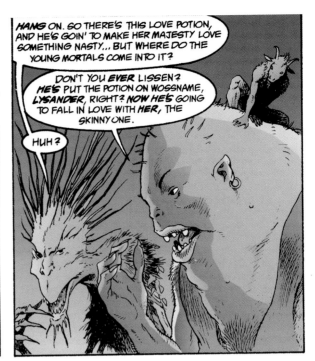

HANG ON. SO THERE'S THIS LOVE POTION, AND HE'S GOIN' TO MAKE HER MAJESTY LOVE SOMETHING NASTY... BUT WHERE DO THE YOUNG MORTALS COME INTO IT?

DON'T YOU *EVER* LISSEN? *HE'S* PUT THE POTION ON WOSSNAME, *LYSANDER,* RIGHT? *NOW HE'S* GOING TO FALL IN LOVE WITH *HER,* THE SKINNY ONE.

HUH?

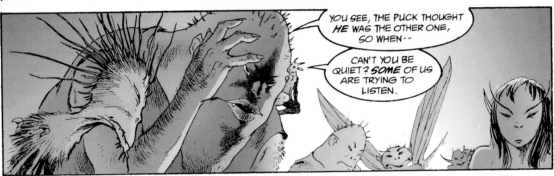

YOU SEE, THE PUCK THOUGHT *HE* WAS THE OTHER ONE, SO WHEN--

CAN'T YOU BE QUIET? *SOME* OF US ARE TRYING TO LISTEN.

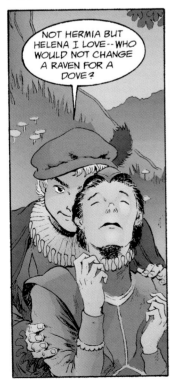

NOT HERMIA BUT HELENA I LOVE-- WHO WOULD NOT CHANGE A RAVEN FOR A DOVE?

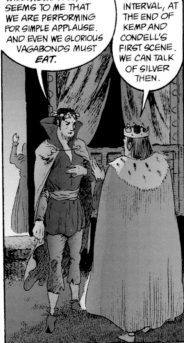

THE PLAY GOES *WELL,* WILL. *HOWEVER,* IT SEEMS TO ME THAT WE ARE PERFORMING FOR SIMPLE APPLAUSE. AND EVEN WE GLORIOUS VAGABONDS MUST *EAT.*

WE SHALL HAVE AN INTERVAL, AT THE END OF KEMP AND CONDELL'S FIRST SCENE. WE CAN TALK OF SILVER THEN.

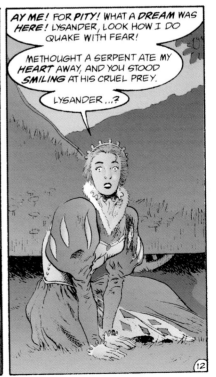

AY ME! FOR PITY! WHAT A *DREAM* WAS *HERE!* LYSANDER, LOOK HOW I DO QUAKE WITH FEAR!

METHOUGHT A SERPENT ATE MY *HEART* AWAY, AND YOU STOOD *SMILING* AT HIS CRUEL PREY.

LYSANDER...?

⑫

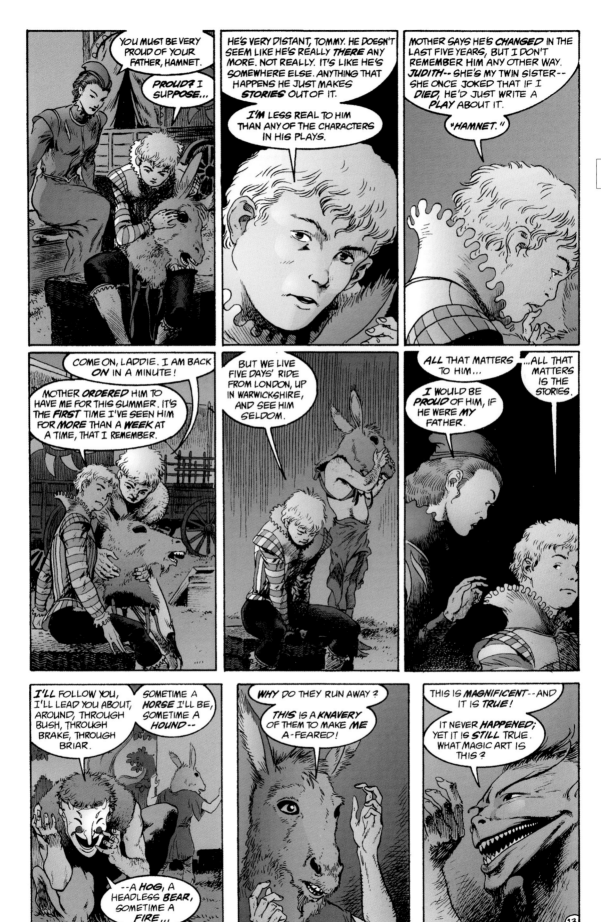

269

NEIL GAIMAN + CHARLES VESS + MALCOLM JONES III

WHAT *ANGEL* WAKES ME FROM MY FLOWERY BED?

ALL RIGHT. WHAT'S SO FUNNY ABOUT HAVING A DONKEY'S HEAD? EH? *EH?*

GO ON, *TELL* ME WHAT'S SO *FUNNY?*

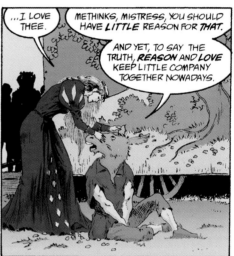

...I LOVE THEE.

METHINKS, MISTRESS, YOU SHOULD HAVE *LITTLE* REASON FOR *THAT.*

AND YET, TO SAY THE TRUTH, *REASON* AND *LOVE* KEEP LITTLE COMPANY TOGETHER NOWADAYS.

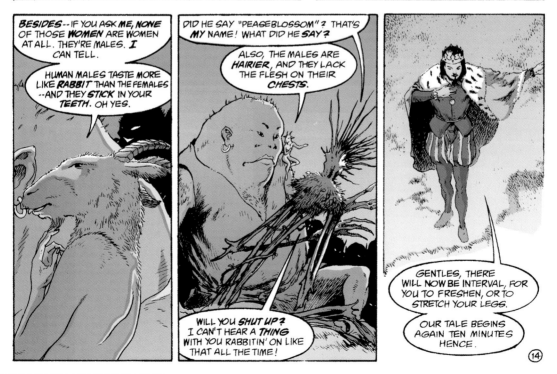

BESIDES -- IF YOU ASK *ME, NONE* OF THOSE *WOMEN* ARE WOMEN AT ALL. THEY'RE MALES. *I* CAN TELL.

HUMAN MALES TASTE MORE LIKE *RABBIT* THAN THE FEMALES --AND THEY *STICK* IN YOUR *TEETH.* OH YES.

DID HE SAY "PEASEBLOSSOM"? THAT'S *MY* NAME! WHAT DID HE *SAY?*

ALSO, THE MALES ARE *HAIRIER,* AND THEY LACK THE FLESH ON THEIR *CHESTS.*

WILL YOU *SHUT UP?* I CAN'T HEAR A *THING* WITH YOU RABBITIN' ON LIKE THAT ALL THE TIME!

GENTLES, THERE WILL NOW BE INTERVAL, FOR YOU TO FRESHEN, OR TO STRETCH YOUR LEGS.

OUR TALE BEGINS AGAIN TEN MINUTES HENCE.

⑭

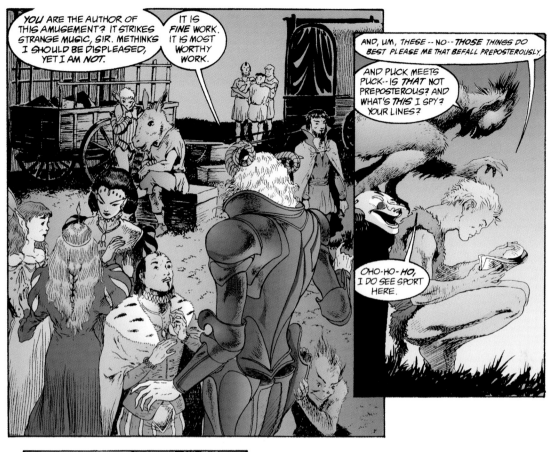

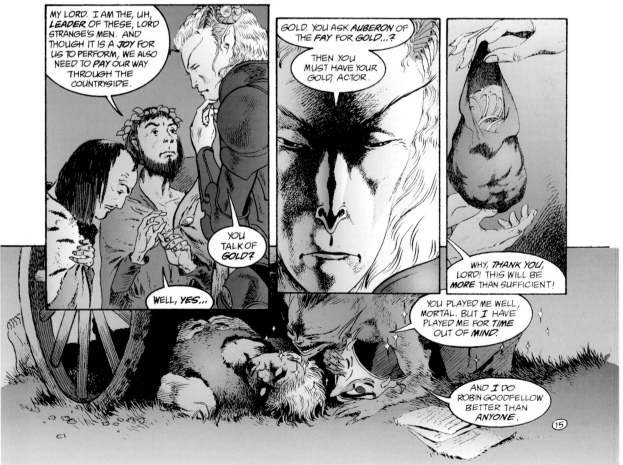

NEIL GAIMAN + CHARLES VESS + MALCOLM JONES III

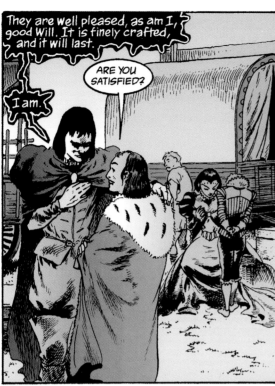

They are well pleased, as am I, good Will. It is finely crafted, and it will last.

ARE YOU SATISFIED?

I am.

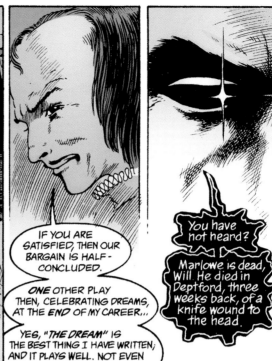

IF YOU ARE SATISFIED, THEN OUR BARGAIN IS HALF-CONCLUDED.

ONE OTHER PLAY THEN, CELEBRATING DREAMS, AT THE *END* OF MY CAREER...

YES, "*THE DREAM*" IS THE BEST THING I HAVE WRITTEN; AND IT PLAYS WELL. NOT EVEN KIT MARLOWE WILL BE ABLE TO GAINSAY THAT.

You have not heard?

Marlowe is dead, Will. He died in Deptford, three weeks back, of a knife wound to the head.

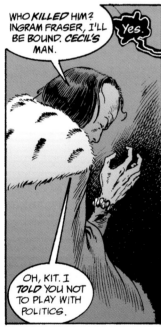

WHO *KILLED* HIM? INGRAM FRASER, I'LL BE BOUND. *CECIL'S* MAN.

Yes.

OH, KIT. I *TOLD* YOU NOT TO PLAY WITH POLITICS.

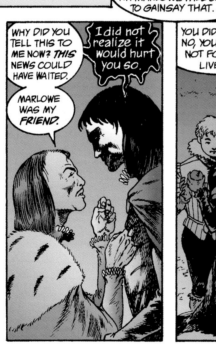

WHY DID YOU TELL THIS TO ME NOW? *THIS* NEWS COULD HAVE WAITED.

MARLOWE WAS MY *FRIEND*.

I did not realize it would hurt you so.

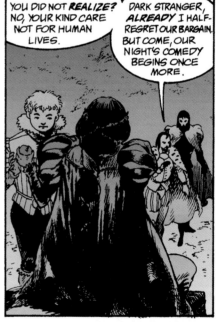

YOU DID NOT *REALIZE?* NO, YOUR KIND CARE NOT FOR HUMAN LIVES.

DARK STRANGER, *ALREADY* I HALF-REGRET OUR BARGAIN. BUT COME, OUR NIGHT'S COMEDY BEGINS ONCE MORE.

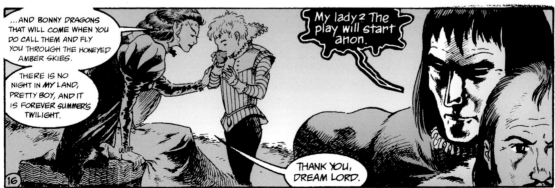

...AND BONNY DRAGONS THAT WILL COME WHEN YOU DO CALL THEM AND FLY YOU THROUGH THE HONEYED AMBER SKIES.

THERE IS NO NIGHT IN *MY* LAND, PRETTY BOY, AND IT IS FOREVER SUMMER'S TWILIGHT.

My lady? The play will start anon.

THANK YOU, DREAM LORD.

272

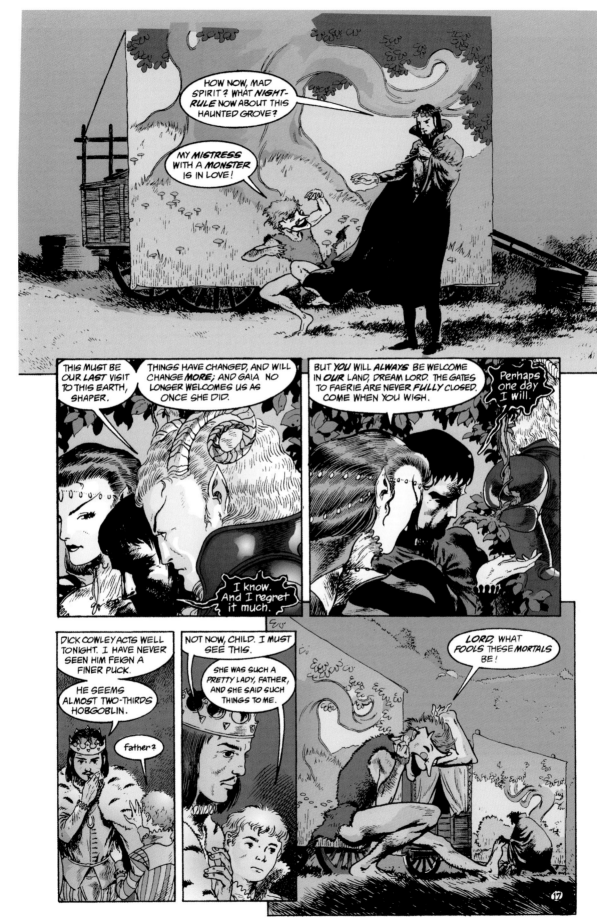

NEIL GAIMAN + CHARLES VESS + MALCOLM JONES III

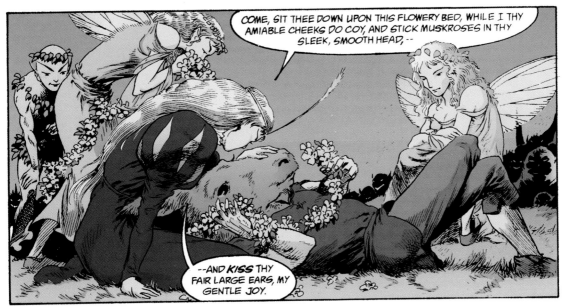

274

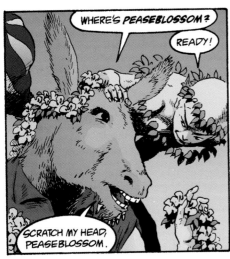

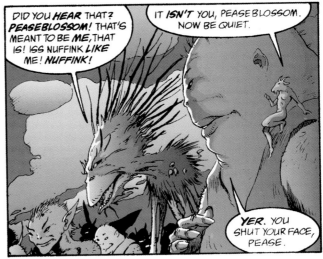

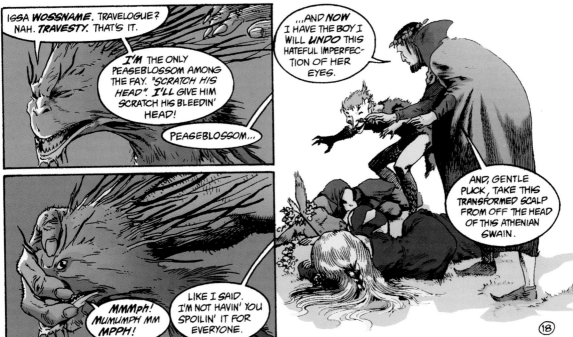

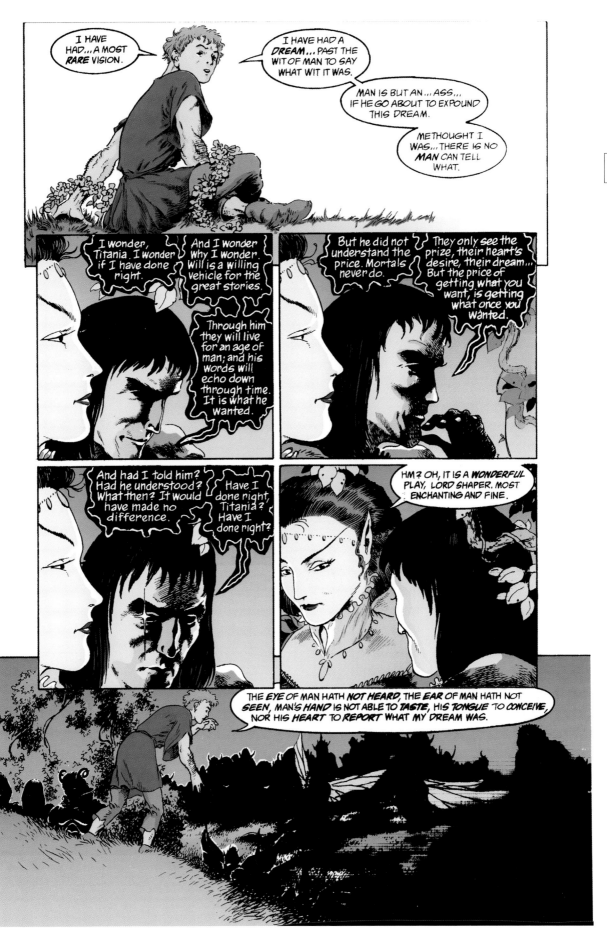

I HAVE HAD... A MOST *RARE* VISION.

I HAVE HAD A *DREAM*... PAST THE WIT OF MAN TO SAY WHAT WIT IT WAS.

MAN IS BUT AN... ASS... IF HE GO ABOUT TO EXPOUND THIS DREAM.

METHOUGHT I WAS... THERE IS NO *MAN* CAN TELL WHAT.

275

I WONDER, TITANIA. I WONDER IF I HAVE DONE RIGHT.

AND I WONDER WHY I WONDER. WILL IS A WILLING VEHICLE FOR THE GREAT STORIES.

THROUGH HIM THEY WILL LIVE FOR AN AGE OF MAN; AND HIS WORDS WILL ECHO DOWN THROUGH TIME. IT IS WHAT HE WANTED.

BUT HE DID NOT UNDERSTAND THE PRICE. MORTALS NEVER DO.

THEY ONLY SEE THE PRIZE, THEIR HEART'S DESIRE, THEIR DREAM... BUT THE PRICE OF GETTING WHAT YOU WANT, IS GETTING WHAT ONCE YOU WANTED.

AND HAD I TOLD HIM? HAD HE UNDERSTOOD? WHAT THEN? IT WOULD HAVE MADE NO DIFFERENCE.

HAVE I DONE RIGHT, TITANIA? HAVE I DONE RIGHT?

HM? OH, IT IS A *WONDERFUL* PLAY, LORD SHAPER. MOST ENCHANTING AND FINE.

THE *EYE* OF MAN HATH *NOT HEARD*, THE *EAR* OF MAN HATH NOT *SEEN*, MAN'S *HAND* IS NOT ABLE TO *TASTE*, HIS *TONGUE* TO *CONCEIVE*, NOR HIS *HEART* TO *REPORT* WHAT MY DREAM WAS.

NEIL GAIMAN + CHARLES VESS + MALCOLM JONES III

276

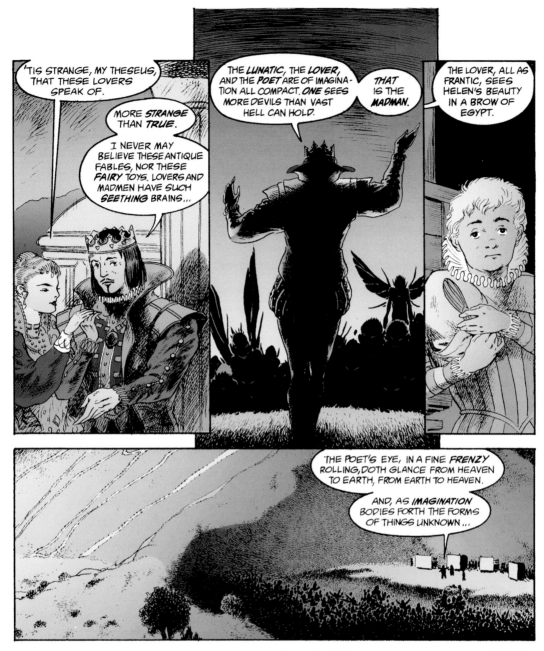

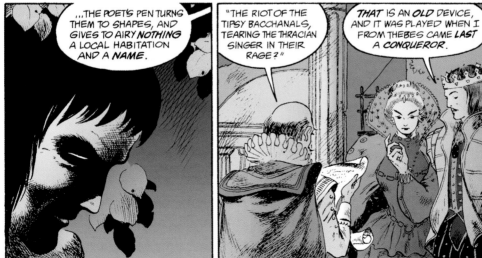

DARK FICTION AND DEEP FANTASY

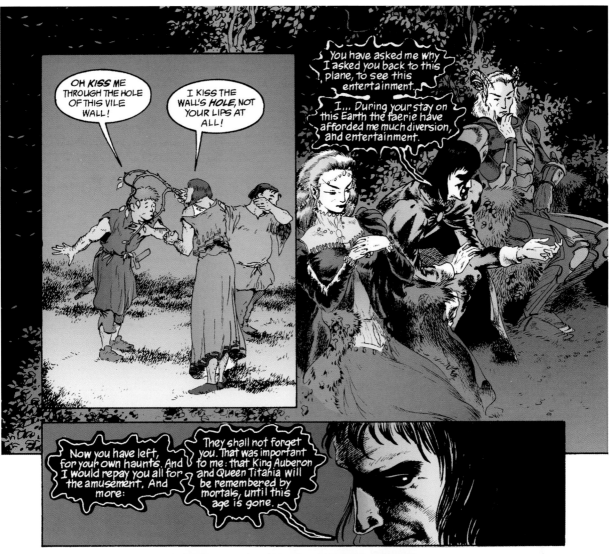

OH *KISS* ME THROUGH THE HOLE OF THIS VILE WALL!

I KISS THE WALL'S *HOLE*, NOT YOUR LIPS AT ALL!

You have asked me why I asked you back to this plane, to see this entertainment.

I... During your stay on this Earth the faerie have afforded me much diversion, and entertainment.

Now you have left, for your own haunts. And I would repay you all for the amusement. And more:

They shall not forget you. That was important to me: that King Auberon and Queen Titania will be remembered by mortals, until this age is gone.

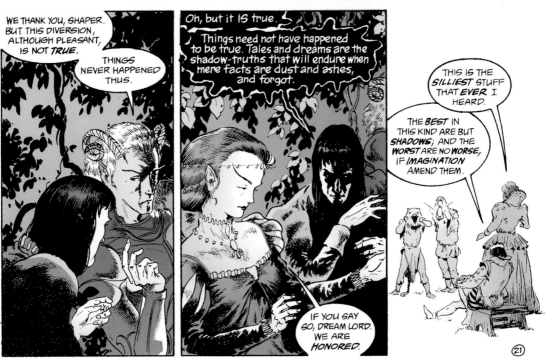

WE THANK YOU, SHAPER. BUT THIS DIVERSION, ALTHOUGH PLEASANT, IS NOT *TRUE*.

THINGS NEVER HAPPENED THUS.

Oh, but it IS true.

Things need not have happened to be true. Tales and dreams are the shadow-truths that will endure when mere facts are dust and ashes, and forgot.

IF YOU SAY SO, DREAM LORD. WE ARE *HONORED*.

THIS IS THE *SILLIEST* STUFF THAT *EVER* I HEARD.

THE *BEST* IN THIS KIND ARE BUT *SHADOWS*; AND THE *WORST* ARE NO *WORSE*, IF *IMAGINATION* AMEND THEM.

㉑

NEIL GAIMAN + CHARLES VESS + MALCOLM JONES III

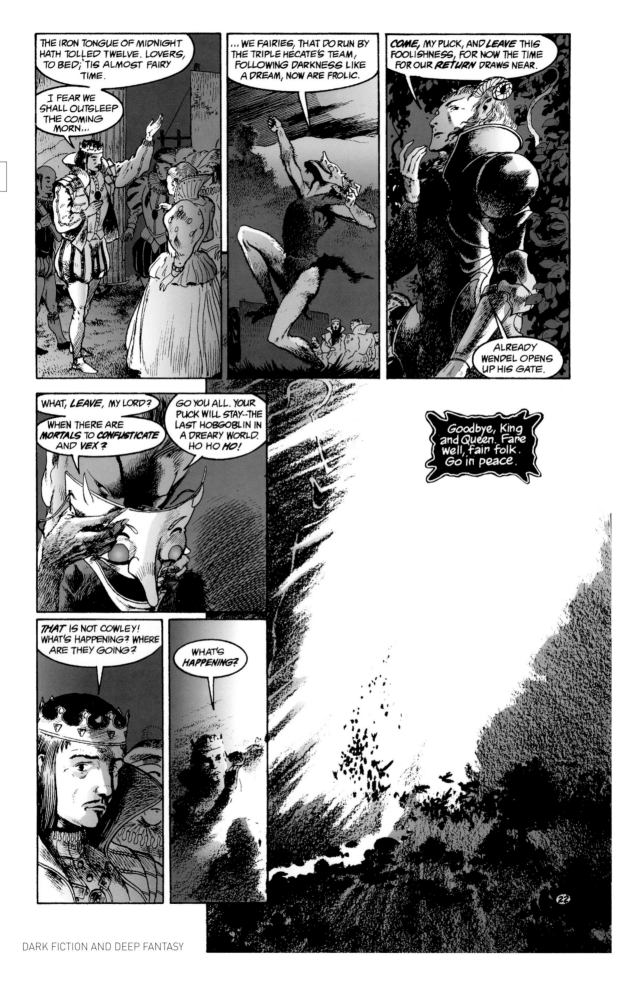

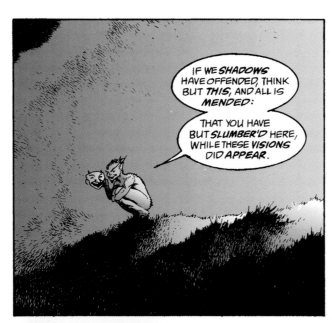

IF WE *SHADOWS* HAVE OFFENDED, THINK BUT *THIS*, AND ALL IS *MENDED*:

THAT YOU HAVE BUT *SLUMBER'D* HERE, WHILE THESE *VISIONS* DID APPEAR.

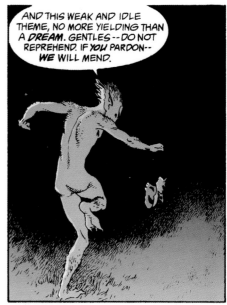

AND THIS WEAK AND IDLE THEME, NO MORE YIELDING THAN A *DREAM*. GENTLES -- DO NOT REPREHEND. IF *YOU* PARDON-- *WE* WILL MEND.

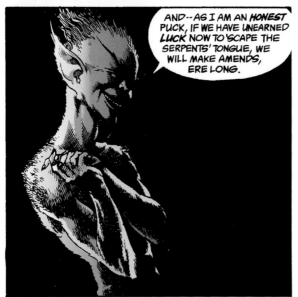

AND -- AS I AM AN *HONEST* PUCK, IF WE HAVE UNEARNED *LUCK* NOW TO 'SCAPE THE SERPENTS' TONGUE, WE WILL MAKE AMENDS, ERE LONG.

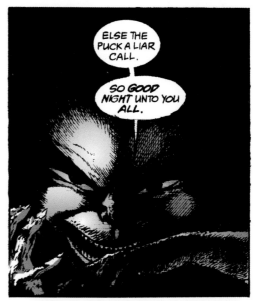

ELSE THE PUCK A LIAR CALL.

SO *GOOD* NIGHT UNTO YOU ALL.

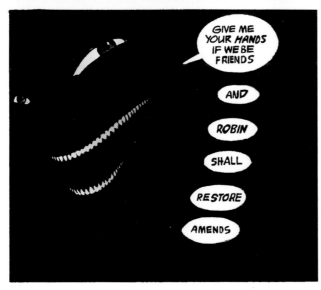

GIVE ME YOUR *HANDS* IF WE BE FRIENDS

AND

ROBIN

SHALL

RESTORE

AMENDS

NEIL GAIMAN + CHARLES VESS + MALCOLM JONES III

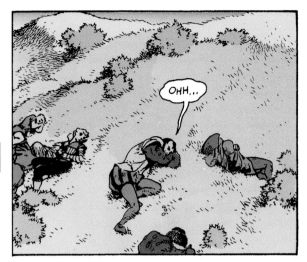

OHH...

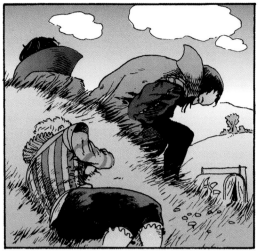

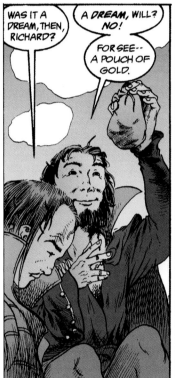

WAS IT A DREAM, THEN, RICHARD?

A *DREAM*, WILL? *NO!*

FOR SEE-- A POUCH OF GOLD.

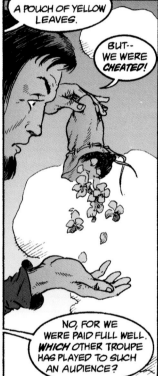

A POUCH OF YELLOW LEAVES.

BUT-- WE WERE *CHEATED!*

NO, FOR WE WERE PAID FULL WELL. *WHICH* OTHER TROUPE HAS PLAYED TO SUCH AN AUDIENCE?

FATHER! I HAD SUCH A STRANGE DREAM. THERE WAS A GREAT LADY, WHO WANTED ME TO GO WITH HER TO A DISTANT LAND...

FOOLISH FANCIES, BOY.

ON THE CART TODAY, YOU MUST PRACTICE YOUR HANDWRITING. PERHAPS YOU COULD WRITE A *LETTER* TO YOUR MOTHER, OR TO JUDITH.

COME ON, YOU *VAGABONDS!* STIR YOURSELVES!

WE CAN BE IN *LEWES* BY LATE AFTERNOON, AND THERE'S AN INN I KNOW WILL BE *GLAD* OF A TROUPE OF ACTORS WITH A NEW COMEDY TO SHOW...

HAMNET SHAKESPEARE DIED IN 1596, AGED ELEVEN.

ROBIN GOODFELLOW'S PRESENT WHEREABOUTS ARE UNKNOWN.

DARK FICTION AND DEEP FANTASY

PART FIVE
THE CONTEMPORARY EDGE

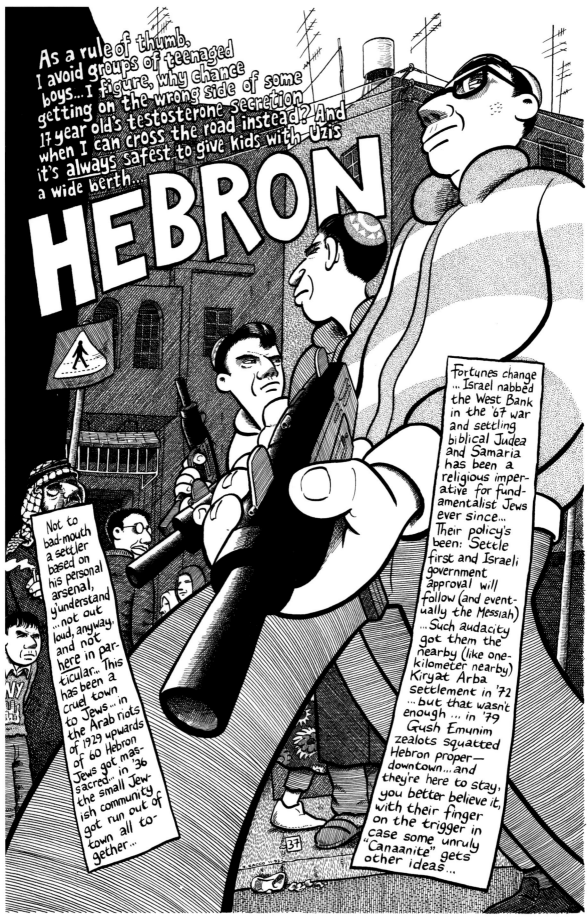

As a rule of thumb, I avoid groups of teenaged boys... I figure, why chance getting on the wrong side of some 17 year old's testosterone secretion when I can cross the road instead? And it's *always* safest to give kids with Uzis a wide berth...

HEBRON

Not to bad-mouth a settler based on his personal arsenal, y'understand ..."not out loud, anyway, and not here in particular"... This has been a cruel town to Jews ... in the Arab riots of 1929 upwards of 60 Hebron Jews got massacred... in '36 the small Jewish community got run out of town all together...

Fortunes change ... Israel nabbed the West Bank in the '67 war and settling biblical Judea and Samaria has been a religious imperative for fundamentalist Jews ever since... Their policy's been: Settle first and Israeli government approval will follow (and eventually the Messiah) ... Such audacity got them the nearby (like one-kilometer nearby) Kiryat Arba settlement in '72 ... but that wasn't enough ... in '79 Gush Emunim zealots squatted Hebron proper—downtown...and they're here to stay, you better believe it, with their finger on the trigger in case some unruly "Canaanite" gets other ideas...

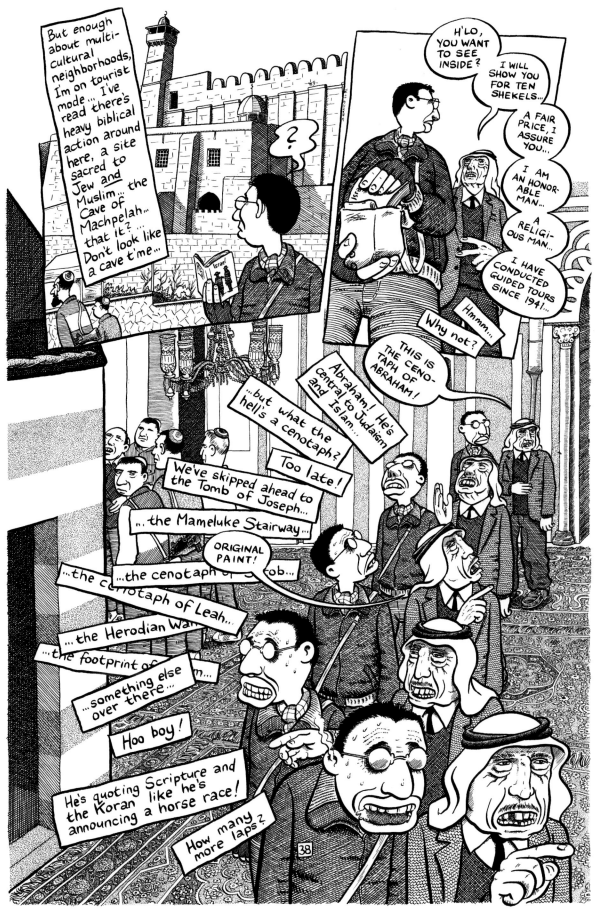

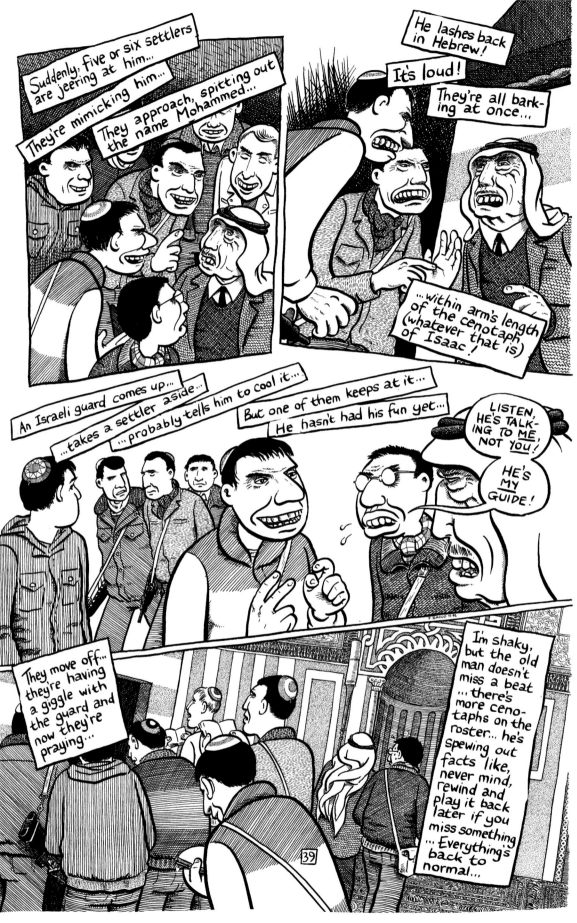

284

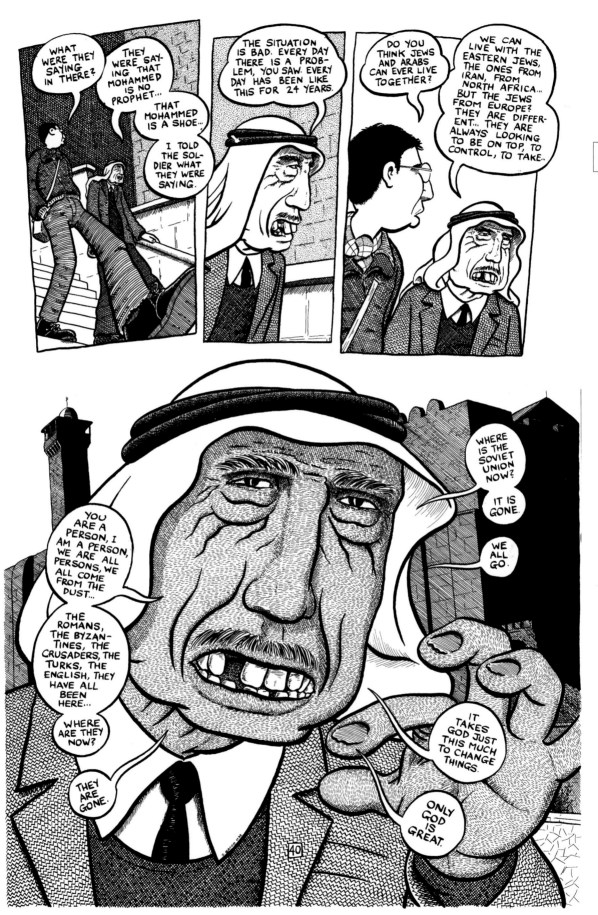

JOE SACCO

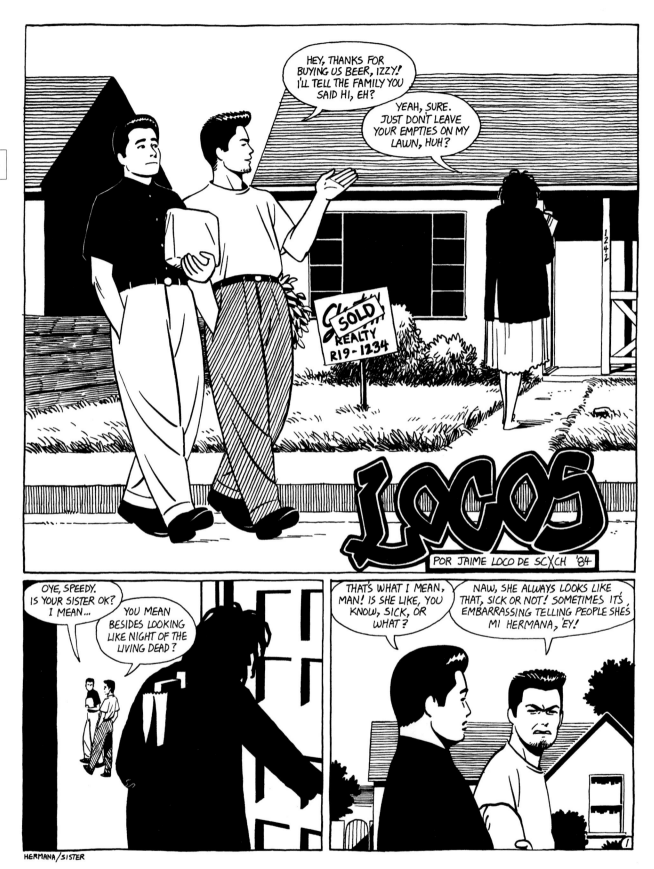

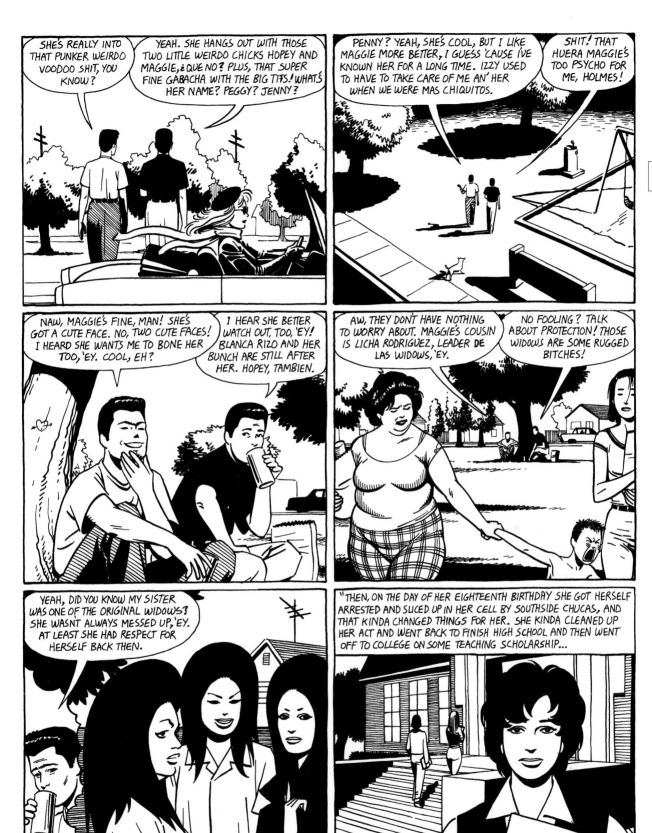

GABACHA/WHITE GIRL MAS CHIQUITOS/VERY YOUNG CHILDREN HUERA/LIGHT SKINNED GIRL CHUCAS/MEX. AMER. GIRLS TAMBIEN/ALSO

JAMIE HERNANDEZ

THAT WAS WHEN SHE STARTED CHANGING HER WAYS. MY DAD ALWAYS WANTED HER TO BE A TEACHER, BUT SHE WANTED TO BE A MYSTERY WRITER. MAN, THOSE TWO DROVE US ALL CRAZY ARGUING TILL THE MIDDLE OF THE NIGHT ALMOST EVERY NIGHT. IZZY WAS THE FIRST PERSON I EVER HEARD TELL MY DAD TO FUCK OFF AND GET AWAY WITH IT.

¿ DE VERAS? AT WHAT TIME WAS THIS ?

"WELL, THAT WAS WHEN MAGGIE MOVED BACK. HER FAMILIA HAD TO MOVE TO CADEZZA THREE YEARS BEFORE 'CAUSE HER DAD WORKED THERE AND THEY ONLY SAW HIM ON WEEKENDS. SOON, HER MOM FOUND OUT THE OLD MAN WAS BONING ANOTHER BROAD IN CADEZZA THE WHOLE TIME, SO SHE MOVED BACK HERE WITH THE NIÑOS.

... SHE EVEN PUT LITTLE MARGARITA TO WORK DOWN AT SAL'S GARAGE!

HMF! GOOD FOR HER! I HAD TO SUPPORT SIX, TOO, WHEN MY JUSTO DIED DRUNK! I SENT THEM ALL OUT TO WORK IN THE FIELDS...

"AND MAGGIE, ≋WHEW≋ TURNED INTO A FINE OL' THIRTEEN YEAR OLD IN THOSE THREE YEARS SHE WAS GONE, BUT I WAS TOO FUCKIN' STUPID TO KNOW IT! I WAS ELEVEN, AND TO ME, MOST OF THE CHICKS STILL HAD COOTIES. HA! 'MEMBER COOTIES, 'EY?"

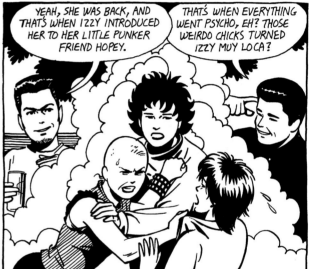

YEAH, SHE WAS BACK, AND THAT'S WHEN IZZY INTRODUCED HER TO HER LITTLE PUNKER FRIEND HOPEY.

THAT'S WHEN EVERYTHING WENT PSYCHO, EH? THOSE WEIRDO CHICKS TURNED IZZY MUY LOCA?

"THAT'S WHAT EVERYBODY SAYS. BUT I THINK SHE LOST HER MIND WHEN SHE GOT MARRIED TO THAT WHITE DUDE JACK RUEBENS. HE WAS HER ENGLISH TEACHER IN COLLEGE. EVERYONE KNEW THAT MARRIAGE WOULDN'T LAST. SHIT, THE FUCKER WAS ONLY TWICE AS OLD AS SHE WAS.

"AND WOULDN'T YOU KNOW IT, THEY WERE DIVORCED A YEAR LATER. I COULD TELL IZZY WAS BUMMED ABOUT IT BUT SHE NEVER TRIED TO SHOW IT. SHE JUST KEPT ON WITH HER WRITING. BUT SHE DIDN'T WRITE MYSTERY STUFF NO MORE. SHE STARTED WRITING ABOUT SHIT LIKE ... DEAD BABIES AND DANCING SKELETONS, YEH.

③

¿ DE VERAS?/REALLY? NIÑOS/CHILDREN

"SHE WROTE UNDER HER MARRIED NAME ISABEL RUEBENS, AND BE-LIEVE IT OR NOT, SHE EVEN GOT SOME OF THAT SHIT PUBLISHED, 'EY. THEN SHE WENT TO MEXICO. WE ONLY GOT ONE POSTCARD FROM HER, SO WE FIGGERED SHE MIGHT NOT COME BACK AT ALL. BUT WE SAW HER AT MY DAD'S WAKE, AND SHE SCARED THE FUCKING SHIT OUT OF EVERYBODY THERE!"

SO, (KAFF) WHAT DOES OUR SHAMEFUL (KAFF) DAUGHTER HAVE TO SAY, WOMAN?

TO JUANA ORTIZ 9th 1 Mau ST...

MOM, I'LL COME HOME WHEN YOU RID OF THE VERMIN — TILL THEN, I LOVE YOU AND THE POPS. IZ...

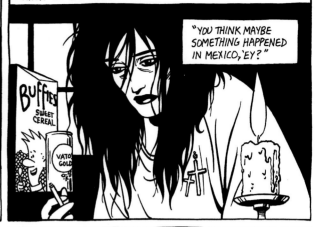

"SHE LOOKED HALF DEAD, AND STARTED DRESSING LIKE A BORRACHO, LIKE SHE DIDN'T CARE ABOUT NOTHING NO MORE. BEFORE MEXICO SHE WOULDA NEVER GONE OUT IN A TORE UP ROBE AN' SLIPPERS, NO MATTER HOW BAD THINGS GOT!"

"YOU THINK MAYBE SOMETHING HAPPENED IN MEXICO, 'EY?"

289

"I DUNNO, MAYBE. 'CAUSE NOW SHE'S MUY TRASTORNADO! SHE TAKES WALKS AROUND THE BARRIO IN THE MIDDLE OF THE NIGHT, AND SCARES ALL THE NEIGHBORS TO HELL. IT'S LIKE, SHE'S UNA VAMPIRA OR SOME-THING, YOU KNOW?"

"NOW ALL THE KIDS AROUND HERE CALL HER THE WITCH LADY. I DON'T THINK THEY'RE TOO FAR FROM THE TRUTH, EITHER. IT'S KIND OF EM-BARRASSING SOMETIMES, YOU KNOW?"

HA HA! SINCE WHEN DO YOU CARE ABOUT WHAT ANYBODY SAYS, PEDRO LIBRE?

HEY, I'LL KILL ANYBODY WHO MESSES WITH MY FAM-ILY! ESPECIALLY WITH MY SISTER...

BORRACHO/DRUNKARD TRASTORNADO/CRAZY, DISTURBING PEDRO LIBRE/LIBERATED

...'CAUSE, YOU KNOW, I FEEL KINDA SORRY FOR HER. I DUNNO...

END

JAMIE HERNANDEZ

PiPO

IN GLORIOUS ESPAÑOL BETO/93

I'M PIPO; PRONOUNCED PEE'-POE. I WAS BORN SOMEWHERE BELOW THE UNITED STATES BORDER IN A TOWN CALLED PALOMAR. AND DON'T YOU DARE ASK WHEN.

PAPA WAS KILLED IN PRISON A LITTLE WHILE AFTER I WAS BORN. MAMA NEVER RE-MARRIED, BUT ADOPTED CARMEN INSTEAD. MY REAL BROTHER AND SISTER ARE AUGUSTIN AND LUCIA.

I WAS FOURTEEN WHEN I HAD MY SON SERGIO. SERGIO'S FATHER WAS KILLED BY A JEALOUS LOVER. I DIDN'T WANT TO RAISE MY BOY ALONE, SO I MARRIED GATO.

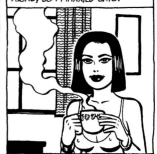

I HAD HEARD GATO WAS INFATUATED WITH ME SINCE I WAS TWELVE, BUT THAT'S NOT WHY I MARRIED HIM. I WAS USED TO OLDER BOYS WANTING ME SINCE I WAS LITTLE. GATO WAS DIFFERENT. HE WAS WILLING TO STAY, AND HE ACCEPTED SERGIO AS IF HE WERE HIS OWN.

GATO BOUGHT ME AND SERGIO A NICE BIG HOUSE OUTSIDE PALOMAR AND HE WORKED HARD AT THE PLANT TO KEEP IT UP. 'TIL THEN THE MOST IMPORTANT MEN IN MY LIFE HAD BEEN MURDERED. I HAD NIGHTMARES SERGIO AND GATO COULD BE GONE IN AN INSTANT, TOO.

I KEPT MYSELF IN REASONABLE SHAPE FOR FEAR GATO MIGHT ONE DAY TIRE OF ME. I LOAFED AROUND THE POOL A LOT WHEN HE WAS HOME FROM A LONG BUSINESS TRIP. I'M TOLD I'VE GOT PRETTY GOOD LEGS FROM PLAYING FÚTBOL SO MUCH AS A GIRL. GATO LOVED TO WATCH ME SHOW SERGIO HOW TO CHECK AND SCORE.

I WENT BACK TO SCHOOL TO LEARN TO READ AND WRITE BETTER IN CASE GATO DID TIRE OF ME, AND I EVEN TRIED TO LEARN ENGLISH BUT IT WAS SO AWFUL I LEARNED FRENCH INSTEAD.

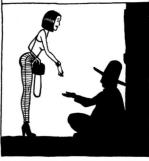

THEN ONE DAY GATO WAS TALKING ABOUT INVESTING MONEY IN STOCK SO HE MIGHT EVENTUALLY START HIS OWN BUSINESS. I ASKED HIM IF I COULD PUT SOME OF MY ALLOWANCE INTO SOME STOCK, TOO; JUST A LITTLE. OF COURSE, HE LAUGHED.

AFTER A FEW DRINKS GATO GAVE IN. IF IT AMUSED ME SO, WHY NOT? MIGHT TEACH ME SOMETHING. I DON'T EVEN REMEMBER THE NAME OF MY CHOICE, BUT IT DID TWICE AS GOOD AS GATO'S.

THIS HAPPENED AROUND THE SAME TIME NEW OWNERS TOOK OVER THE PLANT. GATO WAS FORCED TO FIRE A BUNCH OF MEN; SOME WHO WERE CLOSE ACQUAINTANCES. I'M SO GLAD SERGIO WAS AWAY AT SCHOOL BECAUSE GATO WAS VISIBLY DEPRESSED. SMASHED GLASSES, KICKED OVER CHAIRS.

THE GOOD SEX GATO AND I USUALLY HAD CAME LESS AND LESS WHEN THE STOCKS HE INVESTED IN FELL ALL THE TIME AND MINE ROSE AND ROSE. HE SAID I HAD A NATURAL FLAIR FOR IT, BUT REFUSED ME WHEN I WANTED TO INVEST FOR HIM.

I TRIED MY BEST TO CHEER HIM UP, EVEN TO THE POINT OF PROMISING TO GIVE UP INVESTING IN STOCK ALTOGETHER BUT WHEN EVEN THAT DIDN'T HELP, I CONTINUED MY INVESTING IN CASE GATO GOT TOO DEEPLY INTO DEBT.

WELL, THINGS HIT ROCK BOTTOM WHEN ONE DAY I TOOK SERGIO TO A FIESTA IN PALOMAR AND GATO CAME LATER AND SLAPPED ME IN FRONT OF EVERYBODY. NOT A WORD. JUST BANG!

GATO WAS FURIOUS WITH ME BECAUSE HE SUSPECTED I WAS HAVING AN AFFAIR WITH HIS BUSINESS PARTNER. RAUL AND I WERE FRIENDS AND I WENT TO HIM FOR COMFORT AND SUPPORT DURING THIS TIME BUT WE NEVER HAD SEX. NOT TECHNICALLY. I MEAN; WE ONLY··IT WASN'T SEX.

WE MANAGED TO KEEP OUR PROBLEMS FROM OUR RESPECTIVE FAMILIES AND GAVE IT ANOTHER GOOD TRY. FOR SERGIO'S SAKE. I'D NEVER FELT CLOSER TO GATO. I MAY HAVE EVEN BEEN FALLING IN LOVE WITH HIM AT THIS POINT.

PALOMAR-PAL'ON MAR / CARMEN - CAR'MEN / AUGUSTIN -AW GOOSE TEEN / LUCIA- LOU SEE'AH / SERGIO - SAIR'GEE OH / GAH-TOE / RAUL-RAH OOL'

THE DIVORCE WASN'T SO AWFUL AS DIVORCES GO, I SUPPOSE. SERGIO BEGAN TO WET THE BED AND FAILED TWO CLASSES BUT HE NEVER SAID A WORD. MY LITTLE SOLDIER.

I MOVED BACK TO PALOMAR. I HAD MONEY AND MEN FROM THE CITY AND A GOOD RELATIONSHIP WITH MY FAMILY, IF NOT SO MUCH WITH CARMEN'S HUSBAND HERACLIO. HE'S ARROGANT AND SELF-CENTERED AND CONDESCENDING.

I TRIED NOT TO GET INVOLVED WITH ANY MEN IN PALOMAR BECAUSE OF THE WAY GOSSIP CAN SPOIL EVERYTHING, BUT KHAMO WAS QUITE THE EXCEPTION. WHAT WAS THAT..? FACE OF AN ANGEL AND BODY OF THE DEVIL?

KHAMO BELONGED TO LUBA BUT THEY WERE BROKEN UP WHEN I STEPPED IN AND I WAS OUT AS SOON AS THEY MADE UP. I'M NO HOMEWRECKER, ESPECIALLY IF SOMEONE AS SAD AS LUBA IS INVOLVED.

291

THINGS GOT CRAZY IN PALOMAR DURING THAT TIME, I'LL TELL YOU. AN ARMY OF WILD MONKEYS ATTACKED THE TOWN AND A SERIAL KILLER WAS ON THE LOOSE, BUT WORST OF ALL, CARMEN'S BEST FRIEND TONANTZIN VILLASEÑOR BURNED HERSELF ALIVE IN SOME VAGUE POLITICAL PROTEST!

IT HAPPENED IN FRONT OF AN EMBASSY I DON'T REMEMBER WHERE. KHAMO WAS THERE AND TRIED TO SAVE HER BUT BARELY SURVIVED HIMSELF. LUBA TOOK GOOD CARE OF HIM AND HAS CONTINUED TO HAVE KIDS WITH HIM. THEY'RE HAPPILY MARRIED NOW.

WITH SERGIO AWAY AT SCHOOL I TOOK IN TONANTZIN'S SISTER DIANA AND TRIED TO KEEP HER MIND ON MORE POSITIVE THINGS LIKE HER EDUCATION AND HER LOVE OF RUNNING. DIANA FINISHED TOP OF HER CLASS WITH HONORS AND AT THE SAME TIME WON ALL THESE TRACK TROPHIES.

DIANA FIRST BECAME TOP FEMALE RUNNER IN HER SCHOOL; THEN IN NO TIME SHE COMPETED IN MEETS AROUND THE WORLD. ALL THIS AND MY BOY SERGIO WAS DOING EQUALLY WELL IN HIS SCHOOL WORK AND FÚT'BOL PLAYING.

DIANA'S LIFE CHANGED WHEN SHE HURT HER ANKLE IN A BIG TRACK MEET IN GERMANY. THE DOCTORS PUT HER ON STEROIDS TO HEAL IT AND DIANA GOT SO BIG AND MUSCULAR SHE SWITCHED HER CAREER OVER TO BODYBUILDING. JUST LIKE THAT, LIKE RUNNING NEVER MEANT MUCH.

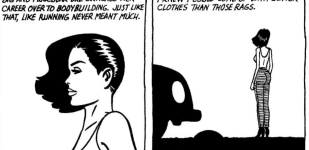

I BEGAN SEEING GATO'S EX-BUSINESS PARTNER AGAIN AND RAÚL WAS NOW HEAD OF A GARMENT DISTRIBUTOR. I WAS GOING THROUGH ONE OF HIS CATALOGUES WHEN I KNEW I COULD COME UP WITH BETTER CLOTHES THAN THOSE RAGS.

I HAD ALMOST FORGOTTEN MY BROTHER AUGUSTIN AND SISTER LUCIA WERE PRETTY GOOD DRAWERS. THEY'D HAVE CONTESTS ON WHO COULD DRAW THE OTHER UGLIER. I ASKED THEM BOTH IF THEY COULD DRAW SOMETHING I DESCRIBED, LIKE CLOTHES, OR BATHING SUITS.

LUCIA TATTLED AND SAID AUGUSTIN DREW GIRLS IN BIKINIS ALL THE TIME AND HIDES THEM UNDER HIS MATTRESS. MAMA OVERHEARD THIS AND CONKED HIM WITH A BROOMHANDLE AND PULLED OUT ALL THESE PAPERS. NO GIRL DRAWINGS, JUST CUT OFF HEADS OF PEOPLE. SIGH. BOYS.

I SPENT A LONG TIME DESCRIBING MY IDEAS TO THEM IN DETAIL AND AFTER A FEW TRIES THINGS STARTED COMING TOGETHER. THESE WERE THE TIMES I WAS HAPPY MAMA MADE ME LEARN TO SEW.

I HIRED THE BEST PHOTOGRAPHER FOR THE PRICE I COULD FIND AND MODELED MY FABULOUS CREATIONS MYSELF. I MADE HIM PROMISE NO SHOTS OF MY BUTT.

NEXT I GOT A PORTFOLIO PROFESSIONALLY MADE UP WITH THE PHOTOS AND TOOK IT IMMEDIATELY TO RAÚL. HE SAID HE'D SHOW IT AROUND AND GET BACK TO ME. RIGHT. I'M NOT THE WIDE-EYED TYPE.

I RENTED A LITTLE STORE FRONT IN THE CITY AND CALLED IT PIPO'S. I GOT A LICENSE AND GOT BEHIND THE COUNTER MYSELF. I HIRED A COUPLE OF RELIABLE SEAMSTRESSES AND PUT THEM TO WORK. THEY WERE OLD AND SLOW. AND FRANKLY, CHEAP.

2

HERACLIO- AIR AWK'LEE OH / KHAMO- KAH'MOE / LUBA- LOU'BUH / TONANTZIN VILLASEÑOR- TOE NONT ZEEN' VEE AH SEN YOR' / DIANA-DIE ANN'AH

GILBERT HERNANDEZ

NO MATTER HOW MUCH MONEY I PUT INTO ADVERTISING MY PRODUCT DIDN'T MOVE SO FAST. IT LOOKED LIKE I WAS FINISHED. I COULD NEVER SHOW MY FACE IN PALOMAR AGAIN. I WAS OUT OF DOUGH AND HAD TO BORROW TO SET UP SHOP CLOSER TO THE BEACH. AHA.

GOD BLESS TOURISTS. THE BEACH MOVE WAS A BIGGER SUCCESS THAN I HOPED, AND I WASN'T DOING ANYTHING MUCH DIFFERENT. EXCEPT THE RENT WAS DOUBLE SO I TRIPLED MY PRICES. DEMAND WAS SO GREAT I HAD TO FIRE MY OLD SEAMSTRESSES AND HIRE FASTER, YOUNG ONES. YEAH, I KNOW; BUT THAT'S ANOTHER STORY.

IT DIDN'T TAKE ME LONG TO DECIDE TO EXPAND AND MAKE MY MOVE TO THE U.S. POOR TONANTZIN VILLASEÑOR ALWAYS DREAMED OF COMING TO HOLLYWOOD SO I FELT AN OBLIGATION TO TREAT THIS WITH THE DEAD SERIOUSNESS SHE DID. I GOT THE PAPERWORK DONE AND I WAS SET.

I'D BEEN TO HOLLYWOOD BEFORE, BUT IT LOOKED DRAB AND CHEAP TO ME THEN. NOW IT STILL LOOKS DRAB AND CHEAP, BUT AT LEAST PEOPLE HERE HAVE MORE MONEY TO THROW AROUND. AND I'M TALKING ABOUT THE KIDS, THE SPOILED CRETINS.

THERE WAS TOO MUCH COMPETITION NEAR THE BEACH SO I SET UP SHOP ON THE TRENDIEST STREET POSSIBLE: NO PROBLEM. THE RENT IS THREE TIMES MORE THAN IT WAS BACK HOME, BUT SO ARE MY PROFITS. SOMEBODY SAID TINA TURNER COMES INTO THE SHOP ALL THE TIME, BUT I DON'T KNOW WHO THAT IS.

THREE OF LUBA'S GIRLS LIVE HERE NOW AND THEY HANG AROUND THE SHOP SO OFTEN I'M ALWAYS PUTTING THEM TO WORK. THE ELDEST, MARICELA, IS ALWAYS BRINGING HER GIRLFRIENDS AROUND. I DON'T SAY ANYTHING. BUT I THINK IT.

HER SISTER GUADALUPE IS MORE, WELL, LIKE ME BECAUSE SHE'S GOT A BABY BOY THAT HER MOTHER DOESN'T KNOW ABOUT AND GUADALUPE WON'T SAY WHO THE PAPA IS. HER SISTER DORALIS DOESN'T SAY MUCH OF ANYTHING. THAT'S ALL RIGHT. THE LYRICS AREN'T AS IMPORTANT AS THE MUSIC.

DIANA VILLASEÑOR CAME TO VISIT ME WHEN SHE WAS IN TOWN FOR A BODYBUILDING CHAMPIONSHIP. SHE WAS HAPPY TO ENDORSE MY GOODS, LEADING ME TO SPONSOR A SPANISH LANGUAGE MORNING EXERCISE SHOW WITH DIANA HOSTING. CABLE FIRST, MAYBE SYNDICATION LATER.

MY BROTHER-IN-LAW HERACLIO THINKS DIANA'S SELF-OBSESSED BECAUSE SHE FEELS HER SISTER TONANTZIN LOVED THE WORLD SO MUCH IT KILLED HER. HERACLIO'S GOT IDEAS ABOUT EVERYBODY AND SOMEDAY I'LL ASK HIM ABOUT ME.

JUST BEFORE THE CAMERAS WERE SET TO ROLL, DIANA'S MANAGER AND MY LAWYER STOPPED SEEING EYE TO EYE, SO DIANA WOUND UP ONLY BEING ABLE TO DO GUEST SPOTS. THAT LEFT ME TO HOST THE SHOW 'TIL I COULD FIND A REPLACEMENT. UGH. IN MY CONDITION.

I TAPED TWO WEEKS WORTH OF SHOWS SOLO, ALL THE WHILE SEARCHING LIKE MAD FOR A PERMANENT HOSTESS. I MUST ADMIT I FAKED MY ROUTINES ALL RIGHT. WE FINALLY FOUND INEZ PEREZ, A FIELD REPORTER ON THE LOCAL SPANISH NEWS. INEZ IS A NATURAL. HER GRANDMOTHER INVENTED THE MICROCHIP BUT FAILED TO REGISTER A PATENT, SO NO CREDIT DUE.

THEN THE MAIL CAME IN. EEP. THE CREEPIEST IS FROM PEOPLE WHO MASTURBATE TO THE SHOW. WE PUT KIDS ON TO DISCOURAGE IT BUT THEN, YOU NEVER KNOW...OH, WELL. EL SHOW DE INEZ SPONSORED BY PIPOWEAR! CATCH THE FEVER!

EXCEPT MOST STUPID AMERICANS CALL IT PIPE-OH-WEAR, OR PIPP-OH-WEAR. PEEP-OH, YOU DING DONGS! PEEP-OH! IT'S IN THE CONTRACT THAT THE HOST AND GUESTS MUST PRONOUNCE MY PRODUCT NAME CORRECTLY EVERY SHOW.

AND, WHERE DO NORTH AMERICANS GET THE NERVE TO CALL THEMSELVES AMERICAN AND EVERYBODY ELSE FROM THE SAME CONTINENT OR CONTINENTS CENTRAL AMERICAN OR SOUTH AMERICAN OR CANADIANS WHEN WE'RE ALL AMERICANS—EVERY ONE?

OK, THE CANADIANS CALL THEMSELVES CANADIANS, THE PERUVIANS PERUVIANS, ETC., BUT CENTRAL AND SOUTH AMERICA WERE ESTABLISHED LONG BEFORE THE U.S. WAS, BUT WE'RE NEVER CALLED AMERICANS WHEN WE COME UP LEGALLY TO MAKE A GOOD LIVING FOR OURSELVES JUST LIKE YOUR FOREFATHERS DID FOR YOU!

OK, WELL, THE U.S. IS ONE COUNTRY AND CENTRAL AND SOUTH AMERICA ARE SEVERAL DIFFERENT COUNTRIES, BUT IT'S JUST LIKE YOU TO TAKE THIS FROM HERE AND THAT FROM THERE AND PUT YOUR STAMP OR BRAND OR WHATEVER ON IT AND IT'S YOURS TO THE REST OF THE WORLD!

MARICELA-MAR EE SELL'AH/ GUADALUPE-GWAH DAH LOOP'EH/ DORALIS- DOOR AH LEESE"/ INEZ PEREZ"/ EE NEZ" PER EZ"

AND YOU KNOW WHO'S RESPONSIBLE? THE WHITE MEN. OK, MOSTLY THE RICH, EDUCATED WHITE MEN. OK, NOT RICH, BUT~ AND THE WHITE WOMEN JUST LET IT HAPPEN FOR YEARS, AND~ BLAMING BLAMING BLAMING IT ALL ON THE MEN LIKE YOU DON'T HAVE YOUR OWN BRAINS~

OK, SOME WHITE WOMEN ARE TRYING TO FIGHT THIS~ OK, MOST WOMEN, BUT THEN YOU WIND UP A LOT OF THE TIME FIGHTING AMONG YOURSELVES AND THERE'S BACK-BITING AND RIVALRIES AND EGOS~ YOU KNOW WHAT I'M TALKING ABOUT?!!

AND DON'T THINK I'M SAYING ALL THIS BECAUSE I'VE HAD SO MANY ROTTEN RELATIONSHIPS WITH WHITE MEN BECAUSE I HAVEN'T! SO THAT'S NOT IT AT ALL! I DON'T GO OUT WITH BUMS, ALL RIGHT? NO MATTER WHAT COLOR HE IS I WON'T TOLERATE ANY MACHO, PIG-HEADED, CRYBABY, COMPETITIVE, BULLSHIT FROM ANYBODY!!! OK?!!?

IF PEOPLE CAN'T COME TOGETHER AND UNITE FOR A COMMON CAUSE, OR~ OR WHATEVER BECAUSE OF PERSONALITY CONFLICTS, THEN I WILL CONTINUE TO PURSUE MY FUTURE AS I ALWAYS HAVE; AS AN INDIVIDUAL... AND WITH NEVER EVER EVER HAVING TO LEARN ENGLISH.

293

I'VE BEEN ACCUSED OF USING MY LOOKS TO GET TO WHERE I AM, LIKE SOME FAKE POP STAR; AS IF LOOKS HAD TO DO WITH MY SUCCESS IN CHOOSING THE RIGHT STOCK; OR THAT I MADE IT THROUGH SHEER DUMB LUCK, LIKE LUCK IS THE ONLY WAY A YOUNG IMMIGRANT WOMAN CAN MAKE IT. YOU GET WHAT YOU PAY FOR.

BACK HOME, SERGIO IS BECOMING QUITE A MAJOR FÚTBOL PLAYER AND THREE UNIVERSITIES WANT TO DRAFT HIM WHEN HE'S OLD ENOUGH. HE IS ONLY TOO GLAD TO SPONSOR MAMA'S PRODUCT, OF COURSE. HE'D BETTER.

RECENTLY GATO CAME ALL THE WAY UP HERE TO SEE ME AND ALMOST LITERALLY BEGGED ME TO LET HIM HELP ME MANAGE MY BUSINESS. HE WOULDN'T SAY, BUT I COULD SENSE THINGS WERE GOING BADLY FOR HIM.

WE DISCUSSED IT MORE AT DINNER, BUT I DIDN'T LEAD HIM ON. THAT'S ONE OF THE THINGS I LIKED ABOUT GATO; HE WASN'T A CRYBABY NO MATTER HOW FRANK I WAS WITH HIM. WELL, THERE WERE OTHER THINGS I LIKED ABOUT HIM, TOO. HE WAS SO PROUD OF SERGIO.

SERGIO'S FATHER AND GATO DISLIKED ONE ANOTHER QUITE A BIT. GATO WAS TERRIBLY JEALOUS OF HIM AND IT TURNED ME ON; EVEN THOUGH I DIDN'T KNOW IT AT THE TIME. MAYBE I DID. HEY, I WAS YOUNG...

AFTER OUR DINNER WE WENT BACK TO THE SHOP AND I SUCKED GATO'S COCK AND HE FUCKED ME NINE DIFFERENT WAYS AND I CAME THREE DIFFERENT TIMES. JUST LIKE THE OLD DAYS...

I'VE NEVER TOLD GATO HOW MUCH BETTER A LOVER HE IS THAN SERGIO'S FATHER EVER WAS. LOTS OF MEN LIKE TO KNOW THINGS LIKE THAT, BUT I DON'T THINK GATO NEEDS TO KNOW. HE WASN'T LIKE THAT. ISN'T.

I GO BACK TO PALOMAR NOW AND AGAIN TO SEE MY FAMILY AND I HAVE SUCH A WONDERFUL TIME. I'M NOT LIKE MOST PEOPLE; I LOVE MY MAMA AND MY SISTERS AND MY BROTHER DEARLY. OK, MY BROTHER-IN-LAW'S ALL RIGHT...

HERACLIO'S GOT A DRINKING PROBLEM BUT HE DOESN'T TAKE IT OUT ON CARMEN OR THEIR KIDS. AT LEAST IT DOESN'T SHOW. EXCEPT WHEN HE DISMISSES MY BUSINESS. HE USED TO ALWAYS DISMISS TONANTZIN WHEN SHE WAS ALIVE, TOO; BUT NOW HE TALKS ABOUT HER LIKE HE WAS IN LOVE WITH HER OR SOMETHING.

WHEN I DO VISIT PALOMAR, I TRY TO AVOID LUBA AND KHAMO WHENEVER POSSIBLE, THOUGH; LUBA, BECAUSE SHE'LL ASK ME A MILLION QUESTIONS ABOUT HOW HER THREE DAUGHTERS ARE DOING AND ITS SO HARD TO LOOK HER IN THE FACE WHEN I ANSWER HER; AND KHAMO, BECAUSE HE AND I STILL CAN'T SEEM TO KEEP OUR HANDS OFF EACH OTHER.

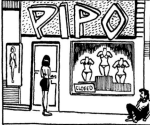

SOMETIMES WHEN I WAKE UP IN THE MORNING I'M STILL THAT FOURTEEN-YEAR-OLD GIRL SWEEPING THE STEP IN FRONT OF THE HOUSE; THAT GIRL WHO MAKES THE BEST RECIPE FOR SOPA DE GRAN PENA, THE SOUP THAT CAN CURE A BROKEN HEART BECAUSE IT TURNS YOUR HEART INTO STONE. I'VE NEVER HAD ANY MYSELF...

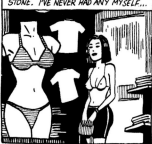

I STILL HAVEN'T GIVEN GATO A YES OR NO ABOUT HIS WANTING TO WORK WITH ME~ NEEDING TO WORK WITH ME. OH, I DON'T KNOW... WHAT'S TODAY? TUESDAY?

END

GILBERT HERNANDEZ

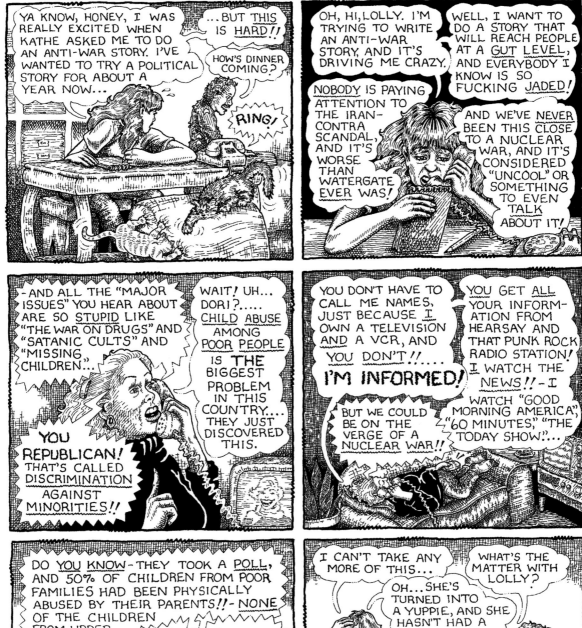

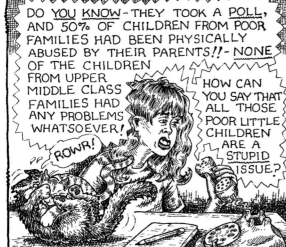

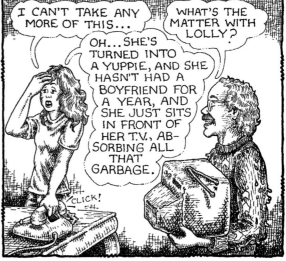

DORI SEDA

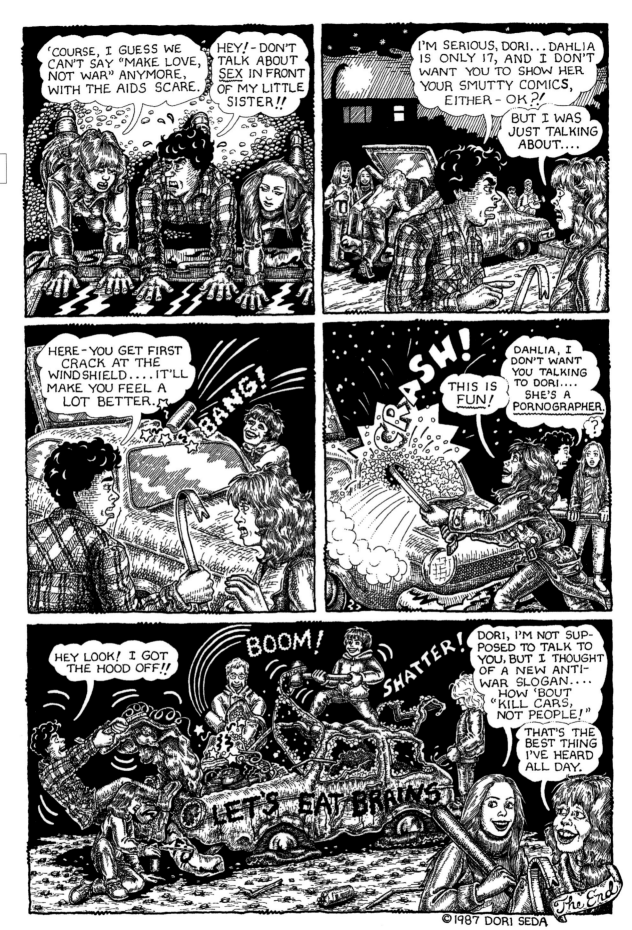

296

CARICATURE

I GUESS I SHOULD START OFF BY INTRODUCING MYSELF-- MY NAME IS MAL ROSEN. I SIGN MY DRAWINGS 'MAL'...I'M 39, DIVORCED, NO KIDS. I'VE ALWAYS BEEN INVOLVED IN ART AND ABOUT SIX YEARS AGO I STARTED TO REALLY GET INTO CARICATURING...

WHEN I WAS A KID MY MOM USED TO SAY "WHY DO YOU MAKE PEOPLE SO UGLY?" NOW THAT'S HOW I MAKE MY LIVING! I'VE BEEN DOING THE ART FESTIVAL / COUNTY FAIR CIRCUIT FOR TWO YEARS NOW, NON-STOP (BEFORE THAT I WORKED IN A SMALL GRAPHICS STUDIO FOR TEN YEARS). I'M NOT GETTING RICH (YET!) BUT I LOVE THE FREEDOM...

I DON'T REALLY HAVE A HOME ANYMORE (UNLESS YOU COUNT MOTEL 6)... MY MOM'S STILL ALIVE BUT SHE LIVES IN A NURSING HOME. I FEEL BAD THAT I NEVER GET TO SEE HER (SHE MAKES SURE OF THAT!) BUT I CAN'T AFFORD TO STOP WORKING RIGHT NOW...

IN SCHOOL I WAS A SCRAWNY, QUIET KID SO I STAYED AT HOME A LOT AND WORKED ON MY ART... AFTER A WHILE IT PAID OFF AND KIDS STARTED ASKING ME TO DO FUNNY DRAWINGS OF THE TEACHERS AND STUFF... THAT'S HOW IT ALL BEGAN...

TODAY IS DAY ONE (OF FIVE) OF THE TWIN LAKES CRAFT FESTIVAL. I SET UP EARLY BUT THERE WASN'T MUCH OF A CROWD SO I TOOK A WALK AROUND TO SEE WHO WAS THERE...

3.

DANIEL CLOWES

I SAT DOWN IN THE AFTERNOON AND DREW A FEW CUSTOMERS.... I TALKED THIS PAIR INTO A DOUBLE ...

YOU CAN LEARN A LOT ABOUT PEOPLE BY STUDYING THEIR FACES -- LIKE THIS GUY HERE IS THE HAPPY-GO-LUCKY TYPE, BUT HIS WIFE LOOKS LIKE SHE'S HAD A HARD LIFE ...

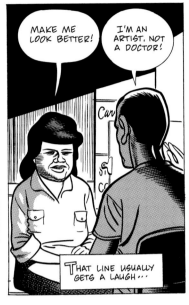

MAKE ME LOOK BETTER!

I'M AN ARTIST, NOT A DOCTOR!

THAT LINE USUALLY GETS A LAUGH ...

BEING ON THE ROAD ALL THE TIME I FIND MYSELF LONGING FOR FEMALE COMPANIONSHIP AND I HAVE TO WATCH WHAT I SAY TO THE PRETTY LADIES SO I DON'T APPEAR TOO FLIRTATIOUS ...

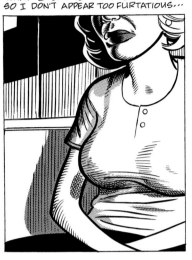

I CAN CUT THIS OUT IF THIS EVER GETS PRINTED, BUT SOMETIMES WHEN I'M DRAWING THEM, I IMAGINE WE'RE HAVING SEX ...

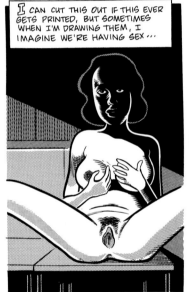

THE MAIN RULE YOU HAVE TO LEARN AS A CARICATURIST IS VERY SIMPLE AND BASIC: FLATTER THE CUSTOMER.

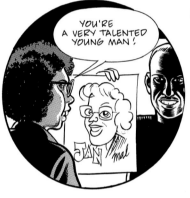

YOU'RE A VERY TALENTED YOUNG MAN!

YOU PRETEND TO EXAGGERATE THEIR FAULTS, BUT REALLY YOU DO ANYTHING BUT ...

ONCE, A RATHER LARGE WOMAN PAID FOR HER DRAWING AND THEN PROCEEDED TO RIP IT UP INTO LITTLE PIECES RIGHT THERE IN FRONT OF ME! I WANTED TO CRY!

THE PEOPLE STANDING AROUND SAID IT LOOKED JUST LIKE HER... TOO MUCH, I SUPPOSE ...

WHAT ELSE DO YOU NEED TO KNOW ABOUT ME? I'M AN OLD MOVIE BUFF; I LIKE MUSICALS AND MELODRAMAS.... I GUESS I'M A ROMANTIC AT HEART. WHAT ELSE? I LIKE ROCK (SOFT) AND COUNTRY MUSIC ...

BE NICE!

TWIN LAKES, DAY 2: I WAS WORRIED THAT TODAY WOULD BE AS SLOW AS YESTERDAY (ONLY EIGHT PAYING CUSTOMERS!). AUGUST WEEKENDS ARE TOO PRECIOUS TO WASTE!

4.

298

IT'S FUNNY... ONCE YOU START MAKING MONEY WITH YOUR ART YOU REALIZE HOW IMPORTANT IT IS... I WOULD NEVER ADMIT IT BUT I GUESS DEEP DOWN I WANT TO BE RICH AND FAMOUS AND LOVED BY ALL THE BEAUTIFUL WOMEN...

BELIEVE IT OR NOT, THAT'S JUST THE KIND OF STUFF I WAS THINKING ABOUT THIS AFTERNOON WHEN I HEARD THIS (IMAGINE A SQUEAKY TEENAGE GIRL VOICE):

LOOK AT THAT... THIS GUY'S A GENIUS!

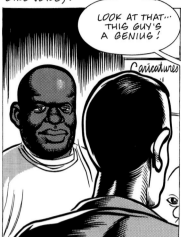

SHE WAS NO PRIZE---RATTY 'PUNK' HAIR-DO, SECOND HAND CLOTHES-- JUST AWFUL! BUT WHAT CAN I SAY? HER TASTE WAS IMPECCABLE!

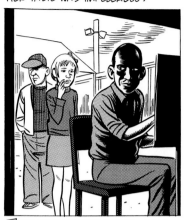

THEY WATCHED ME FOR A FEW JOBS... BELIEVE ME, MY HEAD WAS GROWING BIG- GER BY THE MINUTE OVER WHAT SHE SAID.

CAN I BE NEXT?

YOU'RE UP!

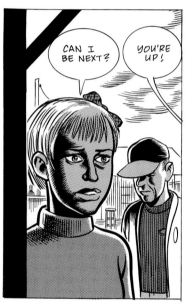

YOU... SHUT UP!

JUST DO AS I SAY!

DID I SAY SOMETHIN'?

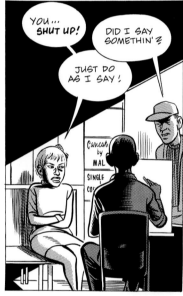

DON'T MIND HIM.

FO'GET CHOO, BITCH!

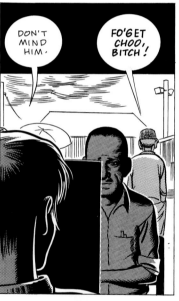

I THINK YOU'RE A GENIUS!

I FELT BAD FOR HER. SHE WAS 16 OR 17... A REAL CARICATURIST'S DREAM (I COULD GUESS WHO GAVE HER THAT BLACK EYE) BUT SHE SEEMED LIKE A TRULY NICE PERSON (THOUGH I COULDN'T HELP WON- DERING IF SHE HAD THE TWELVE BUCKS!)

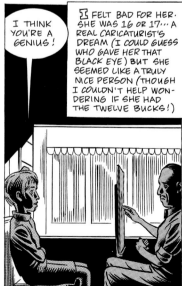

WHAT'S YOUR NAME?

THEDA!

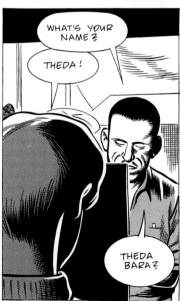

THEDA BARA?

YOU KNOW THEDA BARA?

NOT PERSONALLY, BUT SHE WAS A PRETTY FAMOUS ACTRESS...

MAL

SINGLE $ 12 00

COUPLE $ 15 00

I'M AMAZED! NOBODY KNOWS THEDA BARA ANYMORE!

5.

DANIEL CLOWES

ANOTHER IMPORTANT THING IS YOU HAVE TO BE FAST. MOST PEOPLE CAN'T SIT STILL FOR MORE THAN FIVE MINUTES, AND IF YOU TAKE LONGER YOU'RE LIABLE TO LOUSE IT UP ANYWAY...

IT'S SPECTACULAR, BUT YOU FORGOT MY BLACK EYE!

THEDA

DID YOUR BOYFRIEND GIVE THAT TO YOU?

HA HA HA!

I DON'T THINK SO!

IN HIS DREAMS, MAYBE!

I'M SO TIRED OF HIM I CAN'T TELL YOU...

OVER HERE, LITTLE MAN!

WHAT?!

TAKE A PICTURE OF ME AND MY GENIUS!

CLICK

SIR, IT'S BEEN AN HONOR AND A PRIVILEGE! I HOPE YOU NEVER STOP DOING THIS!

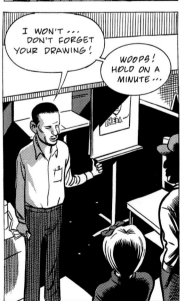

I WON'T... DON'T FORGET YOUR DRAWING!

WOOPS! HOLD ON A MINUTE...

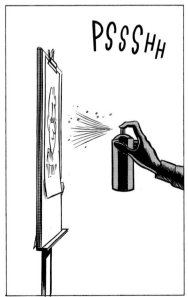

PSSSHH

6.

THE CONTEMPORARY EDGE

THE REASON I'M KEEPING THIS DIARY, OR WHATEVER IT IS, IS BECAUSE THERE AREN'T THAT MANY OF US AROUND WHO KNOW THE ROPES OF CARICATURING... I'D LOVE TO DO A BIG "HOW-TO" COFFEE TABLE BOOK SOMEDAY...

NINETY PERCENT OF ARTISTS ARE AMATEURS. YOU HAVE TO KNOW WHAT YOU'RE DOING TO MAKE A LIVING AT IT. MAYBE READING ABOUT MY LIFE WILL HELP INSPIRE SOMEBODY... (MAYBE NOT!)

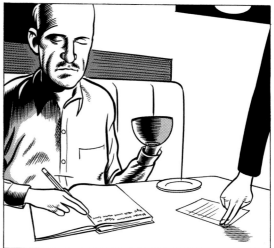

TWIN LAKES, DAY 3: IT RAINED ALL DAY SO I SLEPT IN. I WALKED OVER TO THE BOOTH IN THE AFTERNOON, BUT THEY HAD CLOSED THE FAIR AROUND NOON, I GUESS...

DAY 4: ANOTHER GLOOMY DAY... IT DRIZZLED ALL MORNING BUT I WENT OVER AND SAT THERE ANYWAY...

IT CLEARED UP AFTER LUNCH AND I STARTED TO GET A FEW PEOPLE...

BY LATE AFTERNOON, THE PLACE WAS PACKED AND I STARTED TO GET MORE BUSINESS THAN I COULD HANDLE...

I STARTED CUTTING CORNERS A LITTLE, TRYING TO GET EVERYBODY IN... I DID A FEW DRAWINGS IN LESS THAN TWO MINUTES! I GUESS I WAS GETTING A BIT GREEDY, BUT REALLY I FIGURED THIS MIGHT BE MY ONLY CHANCE TO CASH IN...

AFTER THREE HOURS, MY HAND STARTED TO BLEED AND I TOOK A BREAK. IT'S ONE OF THE HAZARDS OF THE TRADE--YOUR PINKY RUBS AGAINST THE ROUGH PAPER. (TIP: DON'T FORGET THE BANDAIDS!)

7.
DANIEL CLOWES

ANOTHER THING I SHOULD STRESS AT THIS POINT IS THAT DRAWING TAKES TOTAL CONCENTRATION. I SAY THIS BECAUSE TODAY A COUPLE WAS SCREAMING AT EACH OTHER NOT TWENTY FEET BEHIND ME AND I DIDN'T EVEN *NOTICE*... FINALLY, MY CUSTOMER STARTED LAUGHING AND I LOOKED UP. I COULDN'T SEE THE BOY, BUT THE SCREAMING GIRL APPEARED TO BE HEADED RIGHT FOR MY BOOTH.

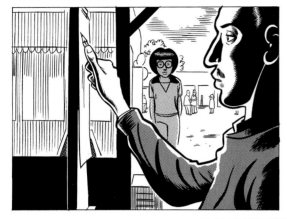

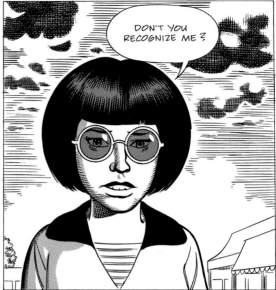

DON'T YOU RECOGNIZE ME?

IT WAS THAT SAME YOUNG LADY WHO CALLED ME A GENIUS (A WIG AND SUNGLASSES THIS TIME - NO BLACK EYE)

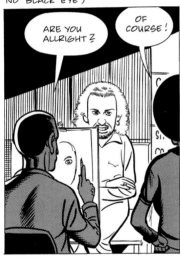

ARE YOU ALLRIGHT?

OF COURSE!

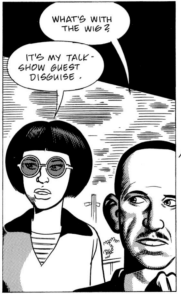

WHAT'S WITH THE WIG?

IT'S MY TALK-SHOW GUEST DISGUISE.

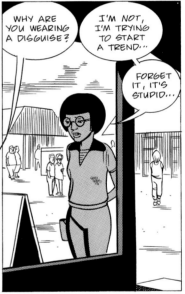

WHY ARE YOU WEARING A DISGUISE?

I'M NOT, I'M TRYING TO START A TREND...

FORGET IT, IT'S STUPID...

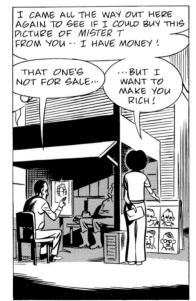

I CAME ALL THE WAY OUT HERE AGAIN TO SEE IF I COULD BUY THIS PICTURE OF MISTER T FROM YOU -- I HAVE MONEY!

THAT ONE'S NOT FOR SALE...

...BUT I WANT TO MAKE YOU RICH!

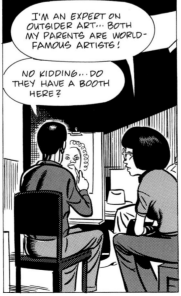

I'M AN EXPERT ON OUTSIDER ART... BOTH MY PARENTS ARE WORLD-FAMOUS ARTISTS!

NO KIDDING... DO THEY HAVE A BOOTH HERE?

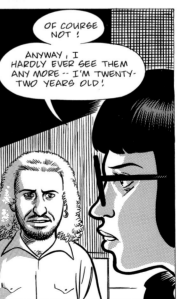

OF COURSE NOT!

ANYWAY, I HARDLY EVER SEE THEM ANY MORE -- I'M TWENTY-TWO YEARS OLD!

8.

THE CONTEMPORARY EDGE

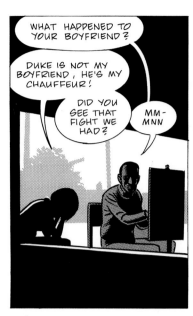

WHAT HAPPENED TO YOUR BOYFRIEND?

DUKE IS NOT MY BOYFRIEND, HE'S MY CHAUFFEUR!

DID YOU SEE THAT FIGHT WE HAD?

MM-MNN

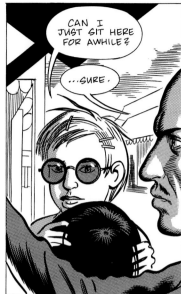

CAN I JUST SIT HERE FOR AWHILE?

···SURE.

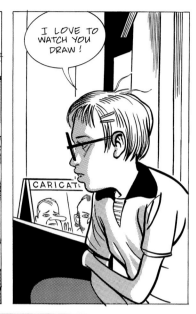

I LOVE TO WATCH YOU DRAW!

CARICAT

𝕋HIS I BELIEVE, BECAUSE ALL AFTERNOON SHE SAT THERE STARING AND MAKING SMALL TALK -- ASKING ME QUESTIONS AND STUFF... IT WAS GOOD FOR MY EGO TO HAVE A SMART YOUNG LADY TAKING SUCH AN INTEREST IN ME BUT, TO BE HONEST, SHE MADE ME A LITTLE NERVOUS···

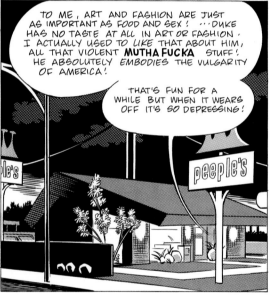

TO ME, ART AND FASHION ARE JUST AS IMPORTANT AS FOOD AND SEX! ···DUKE HAS NO TASTE AT ALL IN ART OR FASHION. I ACTUALLY USED TO LIKE THAT ABOUT HIM, ALL THAT VIOLENT **MUTHA FUCKA** STUFF! HE ABSOLUTELY EMBODIES THE VULGARITY OF AMERICA!

THAT'S FUN FOR A WHILE BUT WHEN IT WEARS OFF IT'S SO DEPRESSING!

peeple's

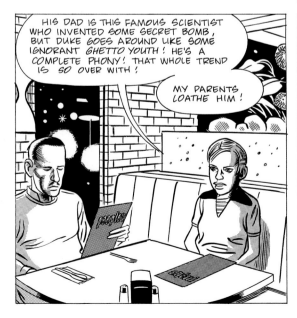

HIS DAD IS THIS FAMOUS SCIENTIST WHO INVENTED SOME SECRET BOMB, BUT DUKE GOES AROUND LIKE SOME IGNORANT GHETTO YOUTH! HE'S A COMPLETE PHONY! THAT WHOLE TREND IS SO OVER WITH!

MY PARENTS LOATHE HIM!

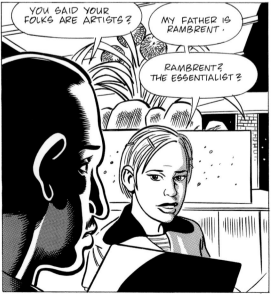

YOU SAID YOUR FOLKS ARE ARTISTS?

MY FATHER IS RAMBRENT.

RAMBRENT? THE ESSENTIALIST?

9.

DANIEL CLOWES

304

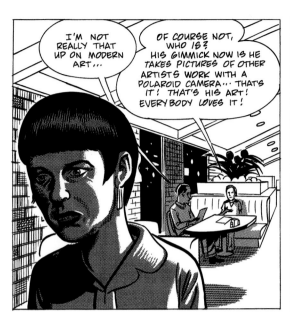

I'M NOT REALLY THAT UP ON MODERN ART...

OF COURSE NOT, WHO IS? HIS GIMMICK NOW IS HE TAKES PICTURES OF OTHER ARTISTS' WORK WITH A POLAROID CAMERA... THAT'S IT! THAT'S HIS ART! EVERYBODY LOVES IT!

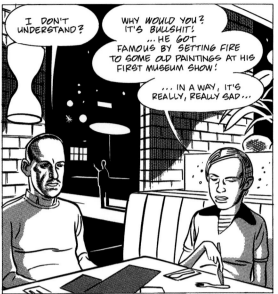

I DON'T UNDERSTAND?

WHY WOULD YOU? IT'S BULLSHIT! ...HE GOT FAMOUS BY SETTING FIRE TO SOME OLD PAINTINGS AT HIS FIRST MUSEUM SHOW!

...IN A WAY, IT'S REALLY, REALLY SAD...

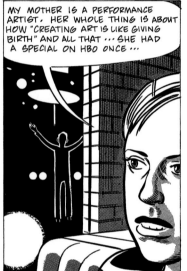

MY MOTHER IS A PERFORMANCE ARTIST. HER WHOLE THING IS ABOUT HOW "CREATING ART IS LIKE GIVING BIRTH" AND ALL THAT... SHE HAD A SPECIAL ON HBO ONCE...

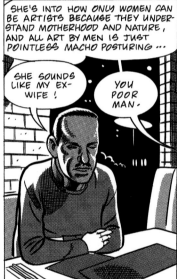

SHE'S INTO HOW ONLY WOMEN CAN BE ARTISTS BECAUSE THEY UNDERSTAND MOTHERHOOD AND NATURE, AND ALL ART BY MEN IS JUST POINTLESS MACHO POSTURING...

SHE SOUNDS LIKE MY EX-WIFE!

YOU POOR MAN.

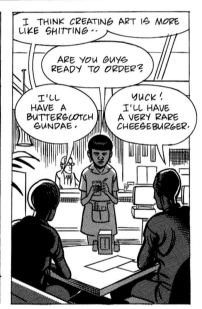

I THINK CREATING ART IS MORE LIKE SHITTING--

ARE YOU GUYS READY TO ORDER?

I'LL HAVE A BUTTERSCOTCH SUNDAE.

YUCK! I'LL HAVE A VERY RARE CHEESEBURGER.

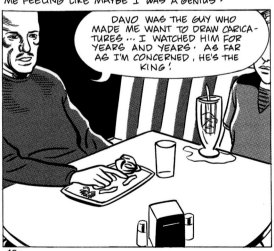

Most PEOPLE JUST ENDURE WHAT YOU HAVE TO SAY UNTIL IT'S TIME FOR THEM TO TALK, BUT THEDA MADE IT SEEM LIKE EVERYTHING I SAID HAD SOME DEEPER IMPORTANCE BEYOND WHAT I MEANT TO SAY. SHE HAD ME FEELING LIKE MAYBE I WAS A GENIUS.

DAVO WAS THE GUY WHO MADE ME WANT TO DRAW CARICATURES... I WATCHED HIM FOR YEARS AND YEARS. AS FAR AS I'M CONCERNED, HE'S THE KING!

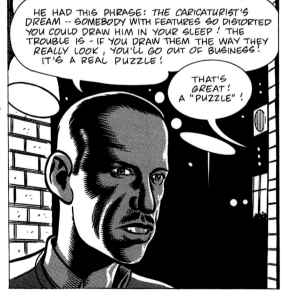

HE HAD THIS PHRASE: THE CARICATURIST'S DREAM -- SOMEBODY WITH FEATURES SO DISTORTED YOU COULD DRAW HIM IN YOUR SLEEP! THE TROUBLE IS - IF YOU DRAW THEM THE WAY THEY REALLY LOOK, YOU'LL GO OUT OF BUSINESS! IT'S A REAL PUZZLE!

THAT'S GREAT! A "PUZZLE"!

10.

THE CONTEMPORARY EDGE

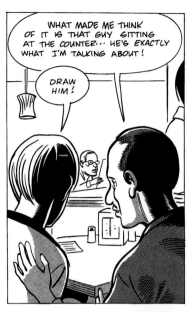
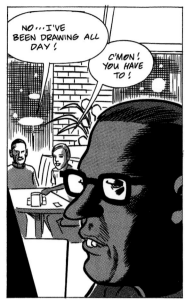
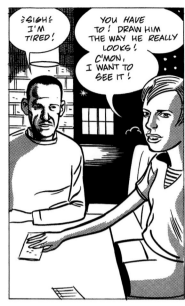

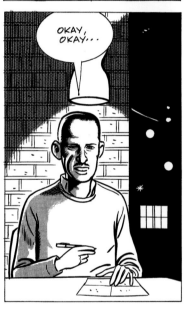
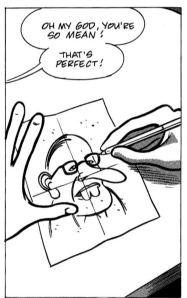
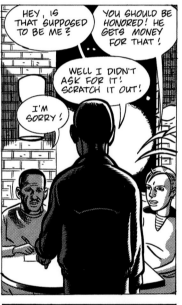

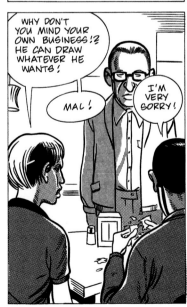
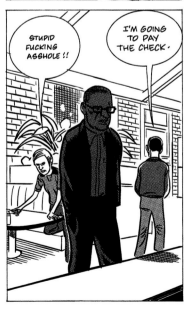
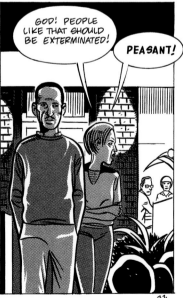

DANIEL CLOWES

306

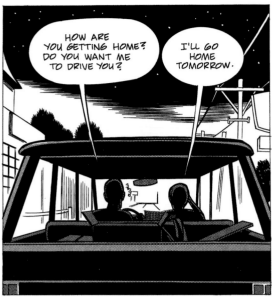

HOW ARE YOU GETTING HOME? DO YOU WANT ME TO DRIVE YOU?

I'LL GO HOME TOMORROW.

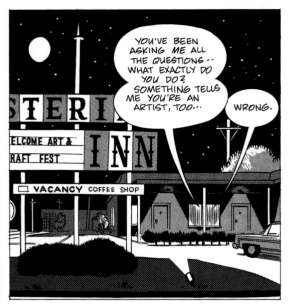

YOU'VE BEEN ASKING ME ALL THE QUESTIONS -- WHAT EXACTLY DO YOU DO? SOMETHING TELLS ME YOU'RE AN ARTIST, TOO...

WRONG.

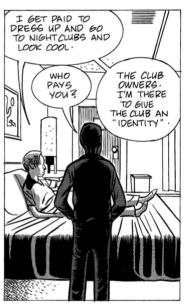

I GET PAID TO DRESS UP AND GO TO NIGHTCLUBS AND LOOK COOL.

WHO PAYS YOU?

THE CLUB OWNERS. I'M THERE TO GIVE THE CLUB AN "IDENTITY".

I SHOULD SAY I WAS THERE... AS OF LAST WEEK, I'M OFFICIALLY RETIRED.

SOUNDS WEIRD.

WELL, THAT'S THE IDEA.

I'VE MET HER... SHE'S A MAJOR COKE-HEAD!

PEOPLE LIKE HER ARE IMPOSSIBLE TO DRAW... NO OUTSTANDING FEATURES...

YOU'VE GOT A ONE-TRACK MIND!

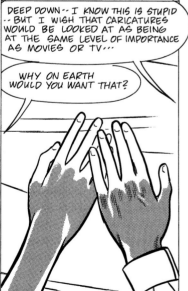

DEEP DOWN -- I KNOW THIS IS STUPID -- BUT I WISH THAT CARICATURES WOULD BE LOOKED AT AS BEING AT THE SAME LEVEL OF IMPORTANCE AS MOVIES OR TV...

WHY ON EARTH WOULD YOU WANT THAT?

13.

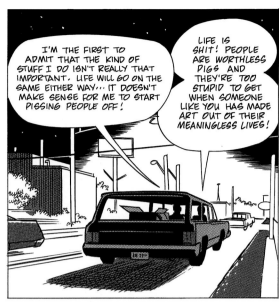

I'M THE FIRST TO ADMIT THAT THE KIND OF STUFF I DO ISN'T REALLY THAT IMPORTANT. LIFE WILL GO ON THE SAME EITHER WAY... IT DOESN'T MAKE SENSE FOR ME TO START PISSING PEOPLE OFF!

LIFE IS SHIT! PEOPLE ARE WORTHLESS PIGS AND THEY'RE TOO STUPID TO GET WHEN SOMEONE LIKE YOU HAS MADE ART OUT OF THEIR MEANINGLESS LIVES!

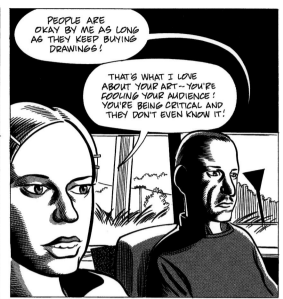

PEOPLE ARE OKAY BY ME AS LONG AS THEY KEEP BUYING DRAWINGS!

THAT'S WHAT I LOVE ABOUT YOUR ART -- YOU'RE FOOLING YOUR AUDIENCE! YOU'RE BEING CRITICAL AND THEY DON'T EVEN KNOW IT!

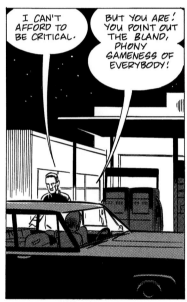

I CAN'T AFFORD TO BE CRITICAL.

BUT YOU ARE! YOU POINT OUT THE BLAND, PHONY SAMENESS OF EVERYBODY!

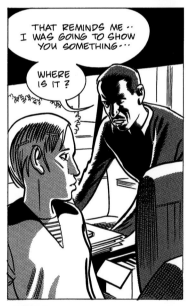

THAT REMINDS ME -- I WAS GOING TO SHOW YOU SOMETHING...

WHERE IS IT?

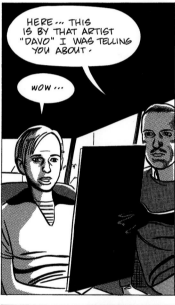

HERE... THIS IS BY THAT ARTIST "DAVO" I WAS TELLING YOU ABOUT.

WOW...

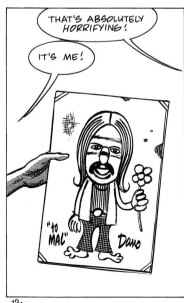

THAT'S ABSOLUTELY HORRIFYING!

IT'S ME!

"TO MAC" Davo

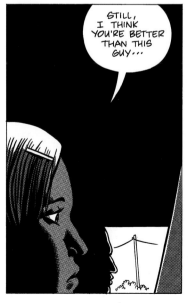

STILL, I THINK YOU'RE BETTER THAN THIS GUY...

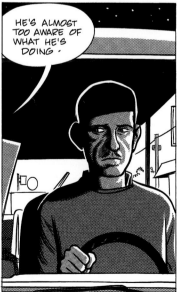

HE'S ALMOST TOO AWARE OF WHAT HE'S DOING.

DANIEL CLOWES

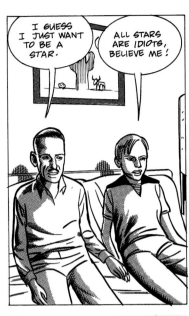

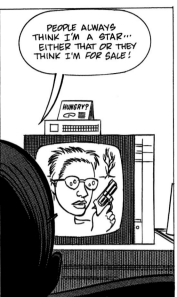

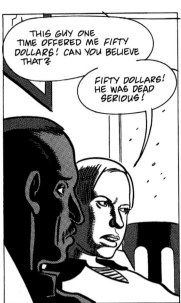

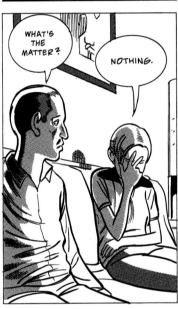

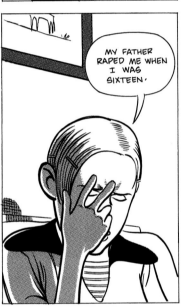

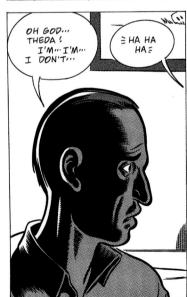

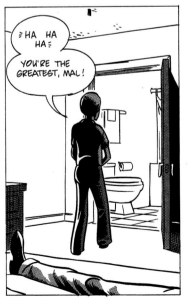

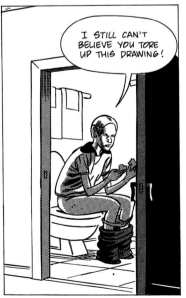

14.

THE CONTEMPORARY EDGE

FLUSH

And so, after all that, there she was, flushing over and over again; four, five, six times (trying to get me to look?). I wasn't going to fall for it.

FLUSH
FLUSH

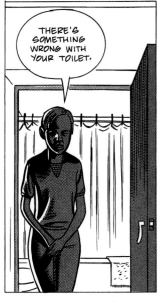

THERE'S SOMETHING WRONG WITH YOUR TOILET.

TURN THE LIGHT OFF.

I stayed there in that exact spot for a long time, trying not to move, or even breathe. I'm not sure why. The more I thought about it, the less natural each breath became.

I thought about Theda. Could she ever fall in love with me? (Had she already?) What would that be like?

I imagined us driving around the country together, really living it up. What an idea! Would she ever go for something like that? A few hours ago I might have been able to bring it up, but now I wasn't sure.

I started to think about that ripped-up drawing and what a mistake that had been... and then I thought of all the customers I had drawn and how they all seemed like the same person over and over ... and then about how, deep down, you know when someone is telling the truth or not.

DAY 5 (LAST DAY OF THE FAIR): THEDA AND I HAD BREAKFAST AT PABLO'S (CHEAP MEXICAN FOOD). YOU COULD TELL WE HAD BOTH SLEPT IN OUR CLOTHES.

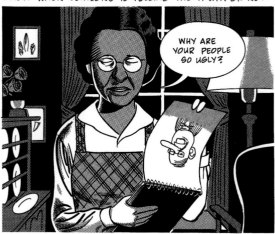

WHY ARE YOUR PEOPLE SO UGLY?

15.

DANIEL CLOWES

310

So...

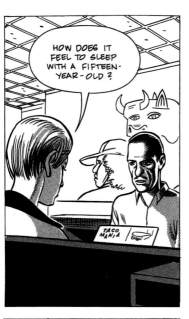

HOW DOES IT FEEL TO SLEEP WITH A FIFTEEN-YEAR-OLD?

TACO MANIA

I DON'T KNOW WHAT IT WAS WITH HER. I HESITATE TO CALL IT A GAME OR A JOKE BECAUSE IT MEANT MORE THAN THAT TO HER, BUT HOW WAS I SUPPOSED TO REACT TO SOMETHING LIKE THAT? (I DECIDED NOT TO).

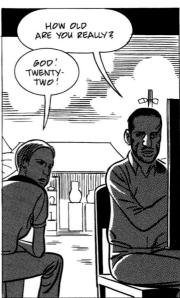

HOW OLD ARE YOU REALLY?

GOD! TWENTY-TWO!

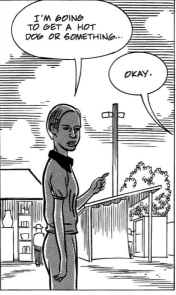

I'M GOING TO GET A HOT DOG OR SOMETHING...

OKAY.

NOW I KNOW I SHOULD HAVE SEEN WHAT WAS HAPPENING, BUT MY MIND ONLY WORKS SO FAST. BESIDES, I HAD OTHER PROBLEMS...

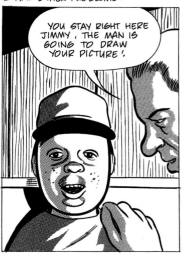

YOU STAY RIGHT HERE JIMMY, THE MAN IS GOING TO DRAW YOUR PICTURE!

I WAS REALLY NOT IN THE MOOD FOR THIS, BUT I TRIED TO BE A 'PRO'... WHAT KIND OF PERSON TAKES A DEFORMED CHILD TO A CARICATURIST?

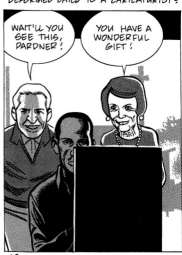

WAIT'LL YOU SEE THIS, PARDNER!

YOU HAVE A WONDERFUL GIFT!

I GAVE IT TO THEM FOR FREE (YOU SORT-OF HAVE TO, THOUGH USUALLY THEY INSIST ON PAYING)...

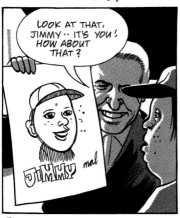

LOOK AT THAT, JIMMY··· IT'S YOU! HOW ABOUT THAT?

JIMMY mal

IT WAS OKAY, I DIDN'T WANT MONEY FOR SOMETHING LIKE THAT, AND ANYWAY I GOT BLOOD ALL OVER THE DRAWING -- VERY UNPROFESSIONAL.

MY HAND CAN'T TAKE TOO MANY MORE SHOWS LIKE THIS.

16.

I WENT TO THE JOHN TO PUT ON SOME MORE BAND-AIDS BUT I WOUND UP DRAWING A PICTURE OF MYSELF IN THE MIRROR INSTEAD.

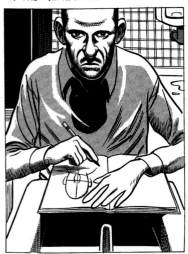

IT WAS THE FIRST SELF-PORTRAIT I REMEMBER EVER DRAWING AND I DIDN'T PULL ANY PUNCHES.

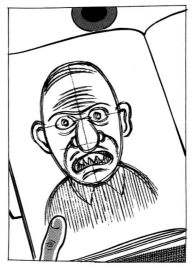

THERE WAS THAT DEPRESSING SUNDAY FEELING IN THE AIR. SOME VENDORS WERE ALREADY STARTING TO TEAR DOWN. SUDDENLY IT OCCURRED TO ME ·· I CAN'T REMEMBER EXACTLY WHAT ··· SOMETHING ···

311

HEY NELLA, HAVE YOU SEEN A TEENAGE GIRL WITH PINNED-BACK BLOND HAIR AROUND HERE AT ALL?

CAN YOU BELIEVE I HAVEN'T SOLD ONE SINGLE PAINTING ALL WEEKEND? WHY DOESN'T ANYBODY LIKE WHAT I DO?

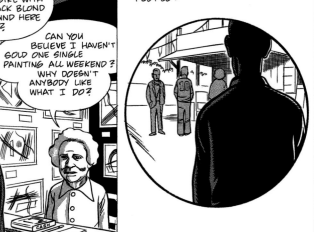

BACK AT THE BOOTH THERE WAS A SMALL CROWD WAITING. MY PEOPLE.

MAKE ME LOOK BETTER!

I'M AN ARTIST, NOT A DOCTOR.

SINGLE $12.00
COUPLE $15.00

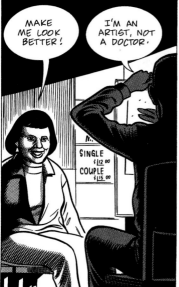

I WATCHED MY HAND MAKE A LARGE OVAL. IT WAS DRAWING BY ITSELF, BY REFLEX ALONE. THE MORE I THOUGHT ABOUT IT, THE MORE AWKWARD THE ACT OF DRAWING BECAME. THERE WAS A GENUINE STRUGGLE GOING ON HERE···

WHEN I FINISHED, I FELT NOTHING BUT RELIEF AND, I GUESS, A LITTLE TWINGE OF SADNESS···

IF YOU THINK I'M GOING TO PAY FOR THAT, YOU'RE CRAZY!

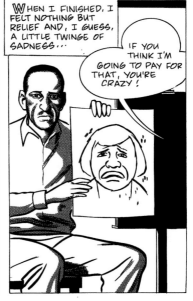

THAT'S NOT RIGHT, MAN··· THAT'S NOT RIGHT···

DANIEL CLOWES

17.

I WANTED TO GET A JUMP ON TRAFFIC SO I'D HAVE A CHANCE TO MAKE THE GARDENIA FESTIVAL BY TUESDAY. I STOPPED BY THE ROOM FOR A MINUTE TO SEE IF I'D FORGOTTEN ANYTHING.

WHEN I SAW THE MESSED-UP BED WE HADN'T SLEPT IN (NO MAID SERVICE ON SUNDAY?) I GOT HIT WITH A WAVE OF GRIEF -- LIKE FINDING OUT SOMEONE JUST DIED, ALMOST...

I WONDERED WHY I PICKED A CAREER LIKE DRAWING CARICATURES IN THE FIRST PLACE... I GUESS I MUST HAVE KNOWN THAT THE ONLY WAY I'D EVER MAKE IT AS AN ARTIST WAS TO LIMIT MY AUDIENCE TO STUPID PEOPLE.

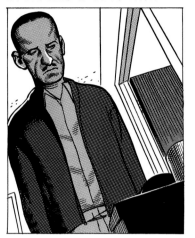

THAT'S ONE THING ABOUT ART: NO MATTER HOW ASHAMED YOU ARE OF WHAT YOU'VE DONE, THERE'S ALWAYS TOMORROW.

FOR A SECOND I FELT LIKE MAYBE I SHOULD CALL MY MOTHER; BUT WHAT WOULD I SAY TO HER? ANYWAY, I'M STARTING TO THINK SHE MIGHT HAVE ALZHEIMER'S...

WHAT WAS I THINKING WITH THIS DIARY? I HONESTLY THOUGHT I WAS SOMETHING SPECIAL; I JUST NEEDED OTHER PEOPLE TO EXPLAIN WHY. CAN YOU BELIEVE THAT?

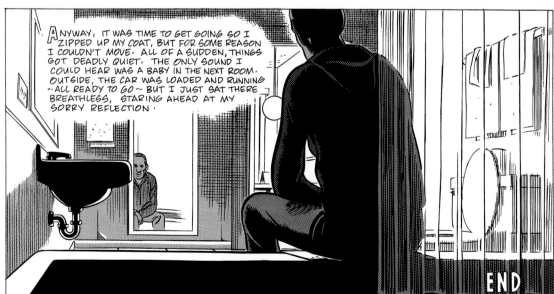

ANYWAY, IT WAS TIME TO GET GOING SO I ZIPPED UP MY COAT, BUT FOR SOME REASON I COULDN'T MOVE. ALL OF A SUDDEN, THINGS GOT DEADLY QUIET. THE ONLY SOUND I COULD HEAR WAS A BABY IN THE NEXT ROOM. OUTSIDE, THE CAR WAS LOADED AND RUNNING -- ALL READY TO GO -- BUT I JUST SAT THERE BREATHLESS, STARING AHEAD AT MY SORRY REFLECTION.

END

-18-

▷ Near·Miss ◁

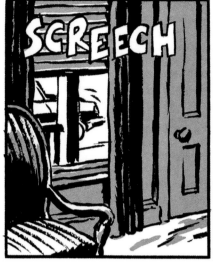

SCREECH

STEVEN? IS THAT YOU?

313

IS SOMETHING WRONG AT WORK?

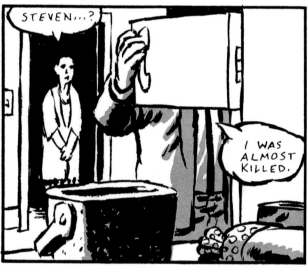

STEVEN...?

I WAS ALMOST KILLED.

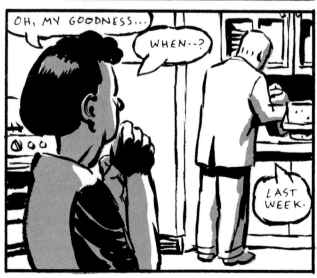

OH, MY GOODNESS...

WHEN--?

LAST WEEK.

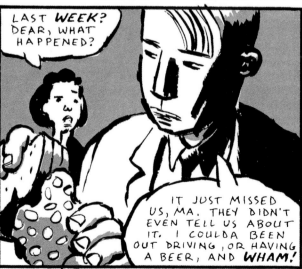

LAST *WEEK*? DEAR, WHAT HAPPENED?

IT JUST MISSED US, MA. THEY DIDN'T EVEN TELL US ABOUT IT. I COULDA BEEN OUT DRIVING, OR HAVING A BEER, AND *WHAM!*

DAVID MAZZUCCHELLI

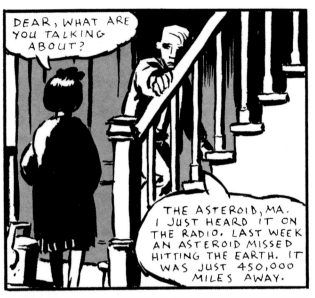

314

DAVID MAZZUCCHELLI

THE CONTEMPORARY EDGE

DAVID MAZZUCCHELLI

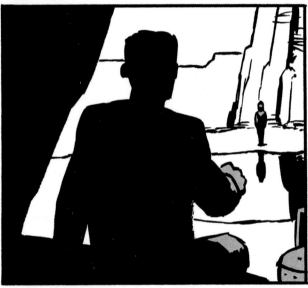
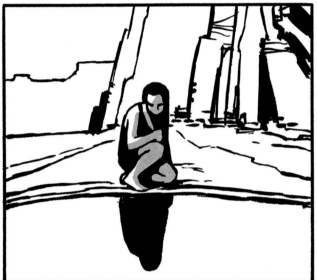

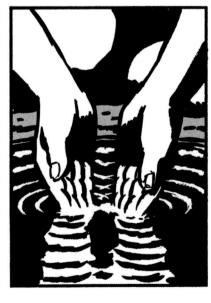

UH...

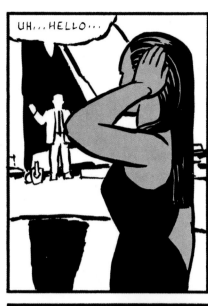

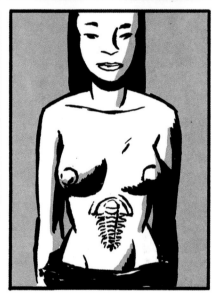

DAVID MAZZUCCHELLI

WOW, DID YOU SEE THAT?

...MA'AM?

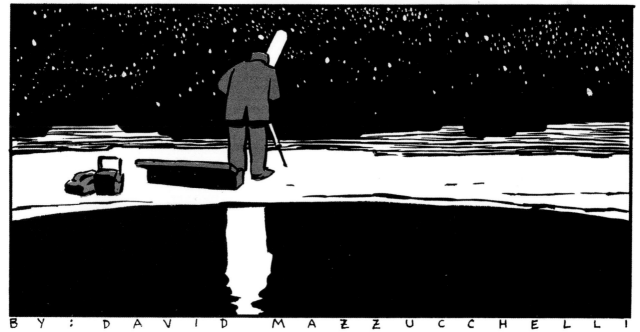

BY: DAVID MAZZUCCHELLI

DAVID MAZZUCCHELLI

*Nobody left
at the
Café Guerbois.*

*par
Edouard
Campbell
'02.*

In Paris we find ourselves in the *Père Lachaise* cemetery.

At first it's just a cold big place where the dead people live.

And then it warms, becomes much more than that.

How could so much genius wind up in the same boneyard?

I feel at home.

Enjoying the posthumous company.

Chatting over "Fred" Chopin's nocturnes.

Tipping my *chapeau* to Theodore Gericault, lolling smugly on his stone.

Père Lachaise - page 1

153

I'll blow a big kiss to Oscar Wilde.

I'll prance around with Isadora, blow a couple of choruses with Mezz Mezzrow, whose primary skill, they say, was in getting hold of marijuana.

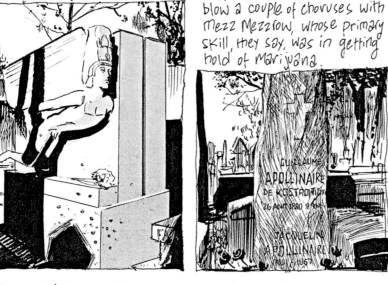

Georges Bizet, I've been meaning to ask... how far back does that tango rhythm go anyway?

Georges Melies, pardon me for using the moon-face in *Snakes and Ladders*.

Ah, Colette. 'L'Innocence monstrevese' indeed.

Rest well, Abelard et Heloise, together toujours.

Au revoir, Honoré Daumier, Jacques Louis David, Eugene Delacroix.

Sisley and Pisarro, au revoir to you all.

Au revoir. I have a plane to catch.

THE BARD MUST DIE!

LONDON 1608

When James Stuart became King of England on the death of Queen Elizabeth in 1603, William Shakespeare and his acting company were at the height of their popularity. For the first several years they performed regularly for the royal court, both new plays and old favorites, but His Majesty was not easily pleased.

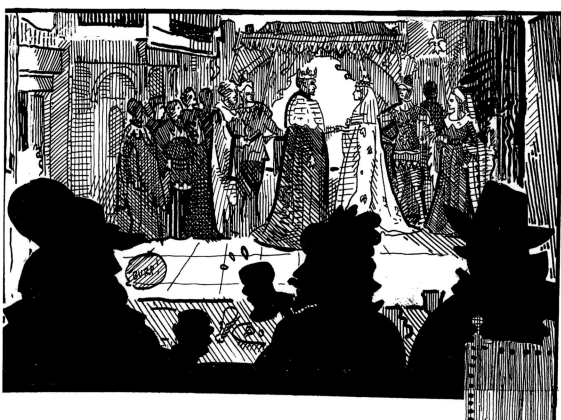

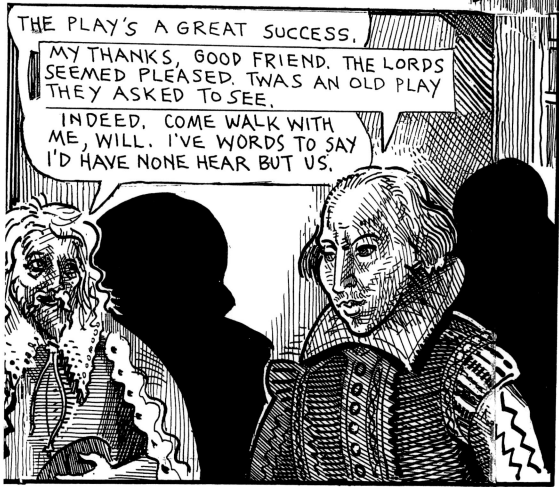

THE PLAY'S A GREAT SUCCESS.

MY THANKS, GOOD FRIEND. THE LORDS SEEMED PLEASED. 'TWAS AN OLD PLAY THEY ASKED TO SEE.

INDEED, COME WALK WITH ME, WILL. I'VE WORDS TO SAY I'D HAVE NONE HEAR BUT US.

FRANK STACK

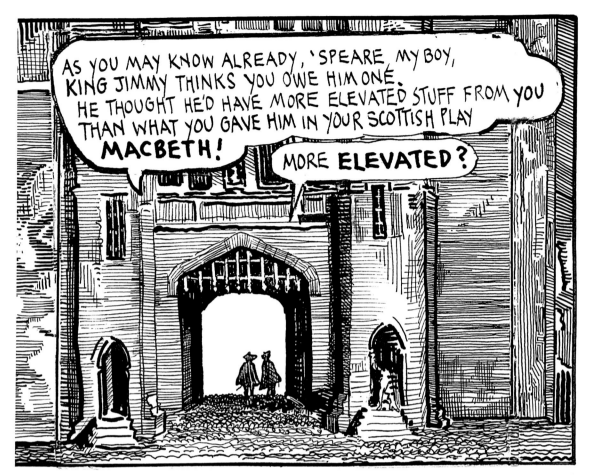

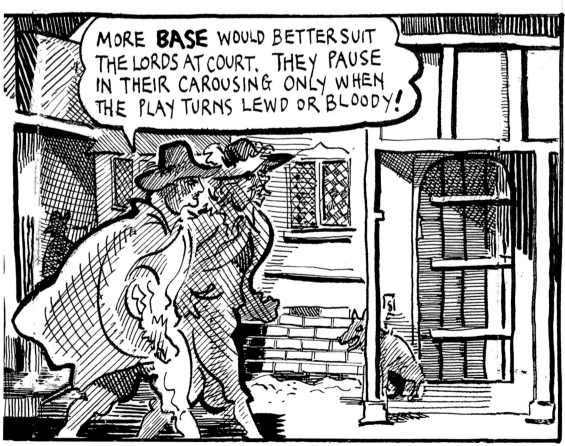

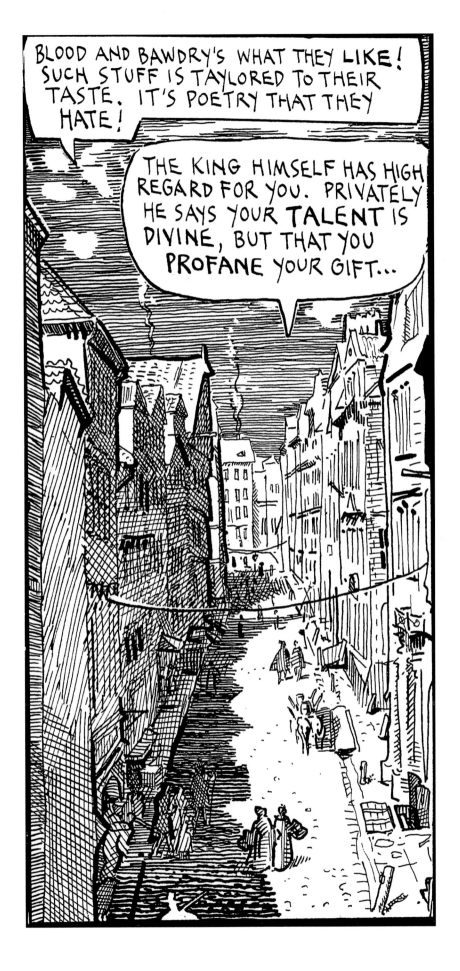

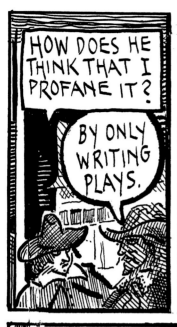

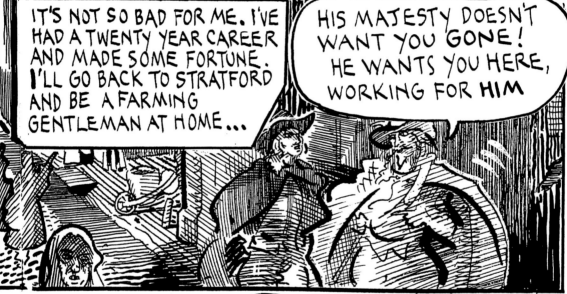

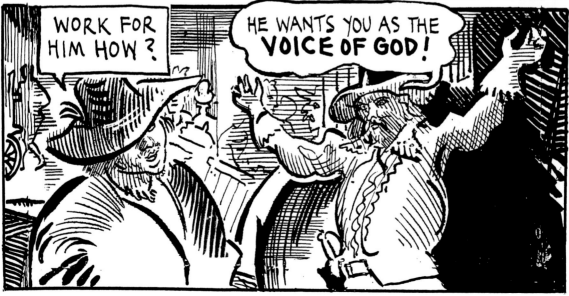

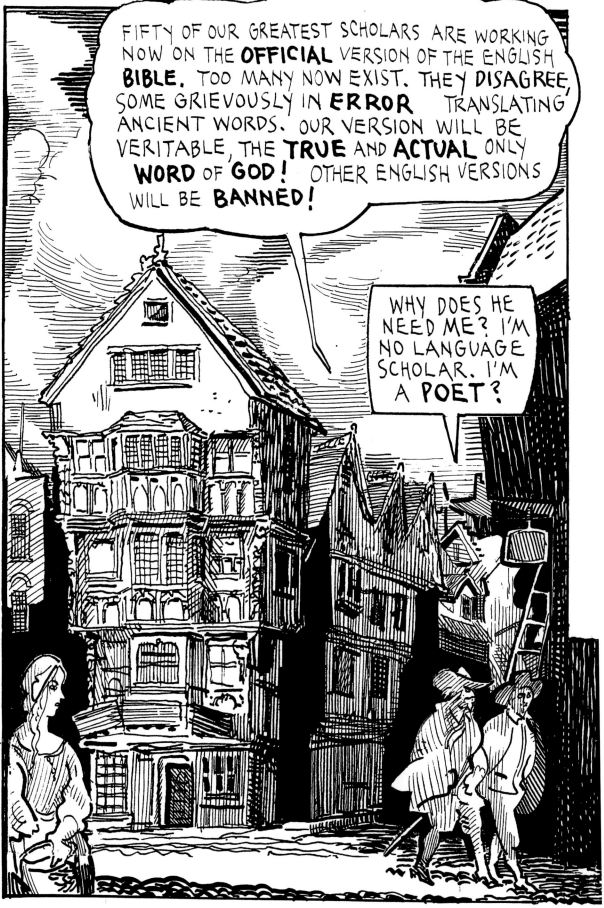

FRANK STACK

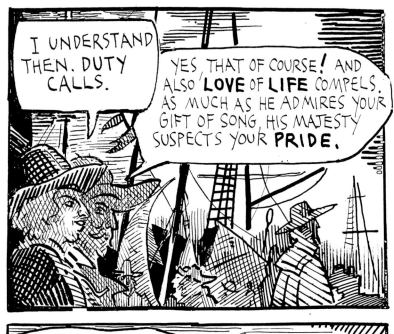

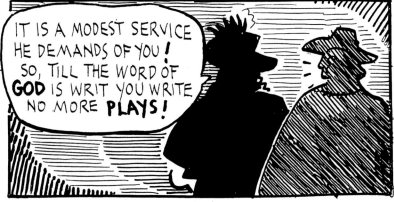

FRANK STACK

THE CONTEMPORARY EDGE

VAIN, ARROGANT AND LAZY IS HOW MY ENEMIES'LL PAINT ME.

THEY SAY THAT NOW. NEXT WEEK BE AT OXFORD!

A ROYAL ENVOY'LL INTRODUCE YOU TO THE SCHOLARS, THEY AREN'T PLAYGOERS, BUT MOST KNOW YOUR WORK IN PUBLICATION.

AND LIKE IT NONE, I HEAR.

335

OTHER POETS WILL BE THERE: CHAPMAN, JOHN DONNE, AND MARSTON...

MY FRIENDS AND RIVALS.

AND A CERTAIN MAN OF MYSTERY WHOM YOU KNOW, AND BEN JONSON.

YES.

FRANK STACK

WE'RE BROTHERS OF THE SWORD; TWENTY YEARS AGO, AS YOUTHS WE SERVED IN FLANDERS.

OUR **BLOOD** FLOWED THEN AS **INK** DOES NOW. YOUNG BEN AND I STOOD BY AS PHILIP SIDNEY DIED IN STAGES, WHEN HIS LEG WOUND FESTERED. I WAS SENT HOME WITH THE AWFUL NEWS TO TELL HIS MOTHER.

HM, I HAD NOT HEARD OF **THAT.** BUT NOW YOU HAVE GREAT WORK TO DO.

I DO INDEED!

AND I HAVE PRESSING BUSINESS, SO I'LL TAKE MY LEAVE.

AND YOU ARE WELCOME TO IT.

IF I HAD PLEADED FOR THIS TASK, MY LORD KING JAMES WOULD HAUGHTILY HAVE TURNED ME DOWN.
CAJOLERY THROUGH A MINION IS HIS ONLY METHOD OF PERSUASION. **IT IS** GREAT WORK, BUT I DOUBT I'LL BE **ALLOWED** TO DO IT.

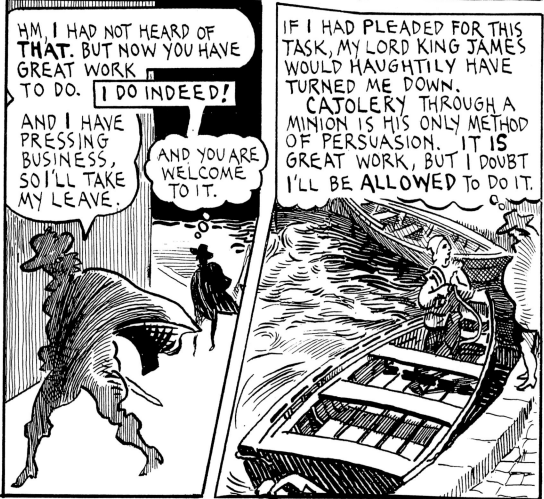

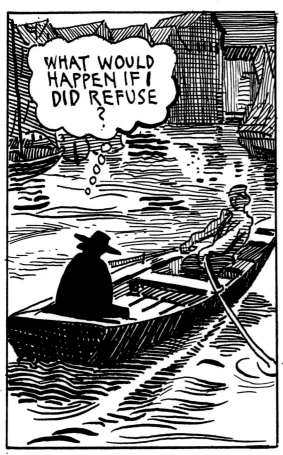

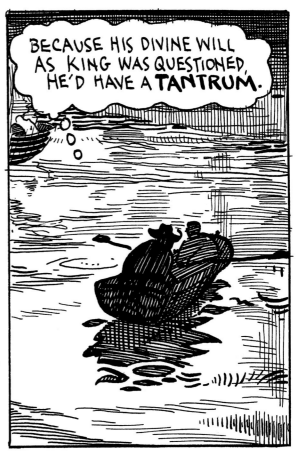

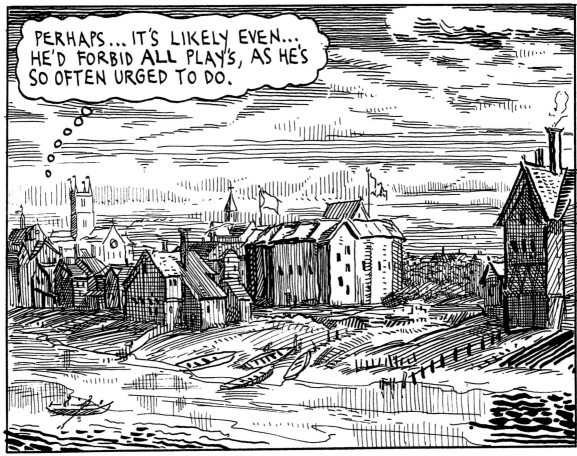

337

FRANK STACK

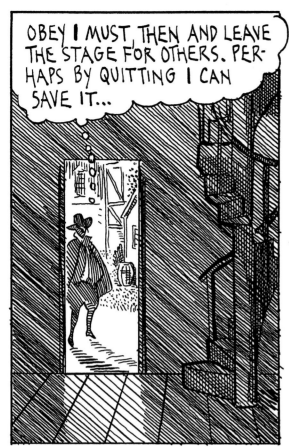

OBEY I MUST, THEN AND LEAVE THE STAGE FOR OTHERS. PERHAPS BY QUITTING I CAN SAVE IT...

I SPOKE TOO FREELY OF MY FAMILY TO THAT JACOBEAN BASTARD... BUT THE DANGEROUS GAME IS LONG SINCE **LOST!** PERHAPS OUR SECRETS NOW NO LONGER MATTER. **HA!** THAT **I** SHOULD TALK OF BASTARDS, WHO WAS 20 'FORE I KNEW MY FATHER...

AND NEVER FELT MY MOTHER'S LOVING TOUCH BEFORE SHE LET ME KISS HER AS SHE **DIED** FIVE YEARS AGO. BUT THE WORLD CANNOT KNOW MY STORY BECAUSE TO KNOW ABOUT **ME** IS TO KNOW TOO MUCH ABOUT PEOPLE WHOSE AFFAIRS CANNOT BE KNOWN...

Frank Stack 16

338

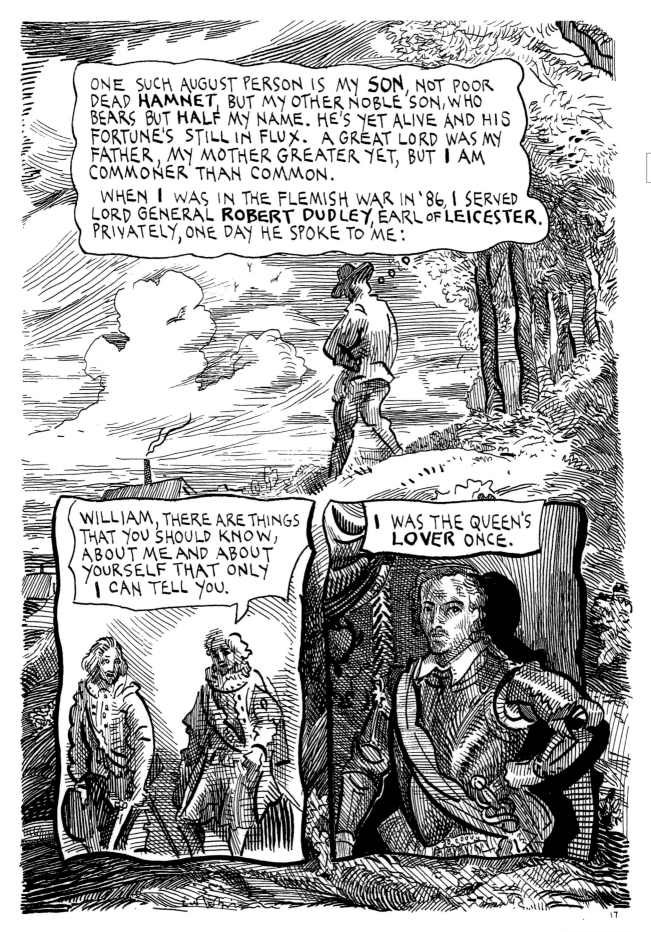

FRANK STACK

IT WAS SAID OF ME THAT WHAT I WANTED WAS THE CROWN, AND IT WAS THIS MUCH TRUE: WHAT I, AND ENGLAND, WANTED WAS AN ENGLISH MAN ON ENGLAND'S THRONE! NO SPANISH GRANDEE OR REGAL FROG AND CERTAIN NOT A THICK-TONGUE TOADY SCOT WHO'D ASK THE POPE FOR LEAVE TO TAKE A PISS! ANOTHER LORD OF ROYAL

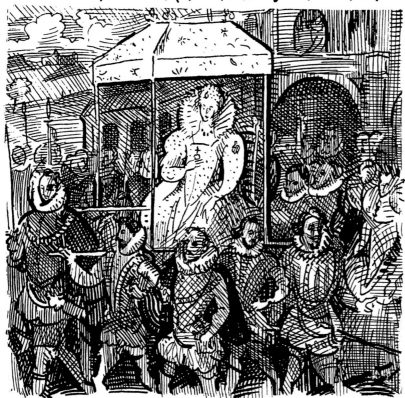

BLOOD WOULD HAVE SERVED AS WELL BUT WHO ELSE WAS THERE WHEN BESS WAS QUEEN AND YOUNG ENOUGH TO BREED AN HEIR? AS THERE WAS NO BETTER MAN ABOUT, I MADE MY SUIT. WE'RE BOTH GRAY NOW, BUT WE WERE SPLENDID THEN! AND SHE LOVED ME.

IT WAS DIFFICULT TO BE ALONE, BUT WE FOUND WAYS: MIDNIGHT RENDEZVOUS. ONE OF MY ACTORS IMPERSON-ATED ME, SO I MIGHT DISAPPEAR AND GO TO HER. SHE HAD DOUBLES TOO. IT MAY BE THAT FEW WERE FOOLED, BUT NO ONE DARED OBJECT. WE WERE READY TO BE MARRIED...

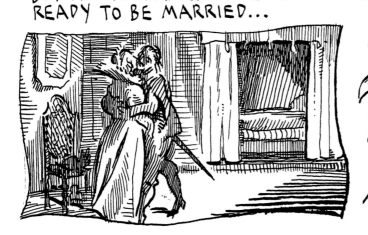

BUT I HAD A WIFE ALREADY

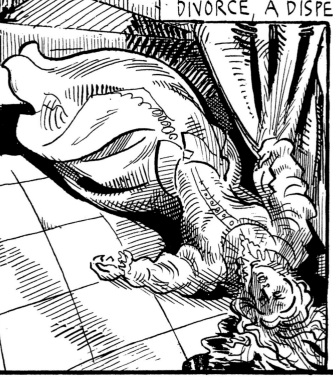

"NO MATTER. OUR PLAN CALLED FOR MY DIVORCE, A DISPENSATION FROM OUR CHURCH. GOOD QUEEN BESS AND I WOULD MARRY, GET AN HEIR AND HAVE UNCONTESTED OUR SUCCESSION TO THE THRONE."

"MY WIFE, AMY, SPOILED THE SCHEME. RATHER THAN ACCEDE AND STEP ASIDE FOR ENGLAND'S GOOD, SHE THREW HERSELF DOWN STAIRS AND BROKE HER NECK."

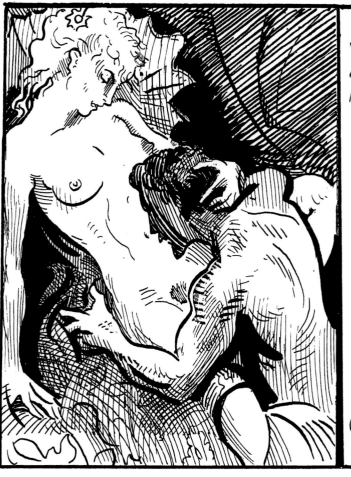

WE WED IN SECRET ANY WAY, AND CONSUMMATED THE MARRIAGE. WILD RUMOR SPREAD THAT I'D HAD AMY KILLED TO CLEAR MY PATH. IT WASN'T TRUE, BUT IN THE PUBLIC VIEW I WAS A SCHEMING VILLAIN. OUR **CHILD**, A BOY, WAS BORN IN SECRET, BUT **ELIZABETH** COULDN'T MARRY ME IN PUBLIC, OR EVEN **REAR** THE CHILD. BEFORE ANOTHER PLAN WAS RIPE BETH GOT **SICK** AND CAME OUT **STERILE**.

FRANK STACK

MY CHANCE WAS GONE, ALONG WITH ANY PLAN TO PASS SUCCESSION THROUGH THE TUDOR FAMILY LINE. OUR IMMEDIATE PROBLEM WAS THE CHILD! WHAT TO **DO** WITH HIM? WE MULLED THE PROBLEM SEVERAL WEEKS WHILE NURSING THE PUNY TOT TO HEALTH. WE FOUND A FOSTER HOME NEAR MY NEW ESTATE AT **KENILWORTH**. JOHN AND MARY **SHAKESPEARE** BAPTISED YOU AS THEIR SON **WILLIAM** AT **STRATFORD-ON-AVON** ABOUT A YEAR AFTER YOU WERE BORN. WHEN YOU HAD GROWN UP A BIT WE BROUGHT YOU TO THE CASTLE AS A PAGE.

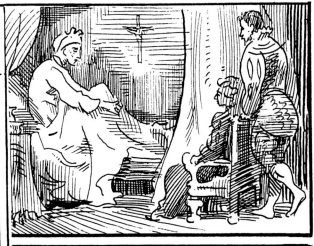

THE EARL (MY FATHER) WARNED ME ON MY LIFE TO KEEP THE SECRET. ALMOST NO ONE KNEW: ONLY HIS SISTER **MARY**, IN WHOSE HOUSE THE CHILD WAS BORN, THE FOSTER PARENTS AND A FEW RETAINERS.

AT THE TIME I WORKED WITH LEICESTER'S ACTORS, BUT THE COMPANY BROKE UP WHEN THE OLD LORD DIED IN 1588.

THE CONTEMPORARY EDGE

AFTER THAT, I ACTED WITH AND WROTE SOME PLAYS FOR PEMBROKE'S MEN. THAT ACTING TROUPE WAS PATRONIZED IN TRUTH BY LADY MARY, MY OLDEST, TRUEST FRIEND... I HAVE BEEN ASKED HOW I CAME TO BE A POET. IF I'M TO SPEAK OF THAT, I MUST TALK OF PHILIP AND MARY SIDNEY.

I MET THEM WHEN THEY CAME WITH THEIR MOTHER TO VISIT KENILWORTH. LEICESTER WAS HER BROTHER. THEIR FATHER WAS SIR HENRY SIDNEY, LORD HIGH CONSTABLE OF IRELAND. I, AS AN EXPERIENCED HOUSEHOLD PAGE, BECAME THEIR GUIDE AROUND THE GREAT HOUSE AND GROUNDS. I'D BEEN THERE SINCE THE AGE OF EIGHT, ACTING SOMETIMES WITH THE RESIDENT CHILDREN'S ACTING COMPANY.

PHILIP SIDNEY, THEN 19, WAS A RISING STAR AT COURT—HANDSOME, ATHLETIC AND WELL SPOKEN. JUST DOWN FROM OXFORD, HE WAS PREPARING FOR HIS TRIP TO EUROPE AS DIPLOMATIC ENVOY FOR HIS QUEEN.

I WAS ONLY TEN, TOO YOUNG TO INTEREST PHILIP, BUT I HIT IT OFF QUITE WELL WITH BOB HIS YOUNGER BROTHER, JUST MY AGE. I LATER LEARNED WE WERE BORN IN THE SAME HOUSE, TWO MONTHS APART.

AND I WAS INFATUATED BY THEIR
RADIANT SISTER **MARY**, THREE
YEARS OUR SENIOR. SHE WAS
WARM AND CLEVER, TOLERANT
OF OUR YOUTHFUL PRANKS. THE
BEST COMPANION, AND, THOUGH
ONLY 12, THE MOST BEAUTIFUL
WOMAN IN ALL THE REALM.

LATER, ROBERT SIDNEY ASKED
FOR ME TO JOIN HIS SERVICE AND
SERVE HIM AS A GENTLEMAN
COMPANION WHEN HE WENT UP
TO **OXFORD**. THOUGH LATER HE
WAS FAMOUS AS A SCHOLAR, I
WAS THE MORE APT STUDENT
AND HELPED HIM PASS HIS COURSES.

I WENT WITH HIM TOO ON HIS
CONTINTAL TOUR. IT WAS MY
ONLY TIME IN ITALY. ROBERT
STAYED ABROAD FOR SEVERAL
YEARS, BUT SENT ME BACK
WITH SECRET MESSAGES OF
STATE.

ON MY
RETURN I FOUND MY PROUD
COUSIN PHILIP SIDNEY
SORELY NEEDING FRIENDS.

HE'D BEEN BANISHED FROM THE COURT FOR ANGERING THE QUEEN. HE OFFERED HER ADVICE.

WHEN I JOINED HIM, HE WAS WORKING ON HIS POETRY, EXCITED AS HE WAS BY CONVERSATION WITH THE POET EDMUND SPENSER. I SERVED HIM AS I HAD SERVED HIS BROTHER.

HIS SISTER, LOVELY MARY, HAD GONE TO COURT WHERE SHE MET **HENRY HERBERT**, EARL OF PEMBROKE, A FORMIDABLE OLD GRAY SOLDIER LOOKING FOR A WIFE TO BEAR AN HEIR FOR HIM. HERBERT MADE HIS SUIT AND

IN DUE COURSE THEY WERE MARRIED.

THEY LIVED AT **WILTON HOUSE** IN WILTSHIRE. I TAGGED ALONG WITH PHILIP WHEN HE WENT THERE AS A GUEST FOR THE SPRING AND SUMMER **1580**.
MARY WAS BLOOMING, OVER-RIPE AT 19, MARRIED **THREE** YEARS TO A MAN **25** YEARS HER SENIOR, NO MORE PREGNANT THAN SHE WAS BEFORE. SHE WAS GLAD TO SEE US.

WILTON HOUSE NOW
FRANK STACK

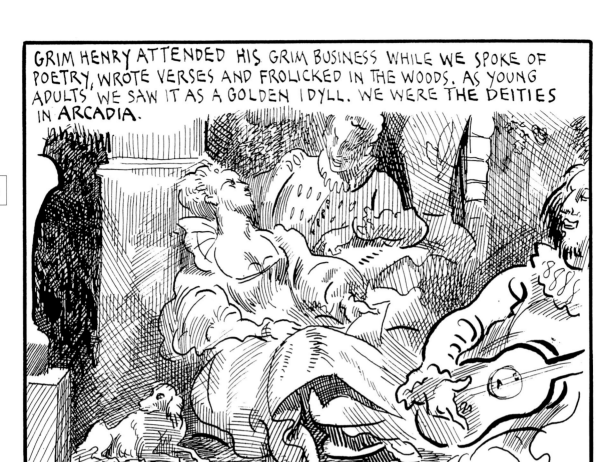

GRIM HENRY ATTENDED HIS GRIM BUSINESS WHILE WE SPOKE OF POETRY, WROTE VERSES AND FROLICKED IN THE WOODS. AS YOUNG ADULTS WE SAW IT AS A GOLDEN IDYLL. WE WERE THE DEITIES IN ARCADIA.

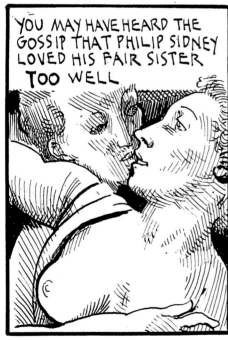

YOU MAY HAVE HEARD THE GOSSIP THAT PHILIP SIDNEY LOVED HIS FAIR SISTER **TOO WELL**

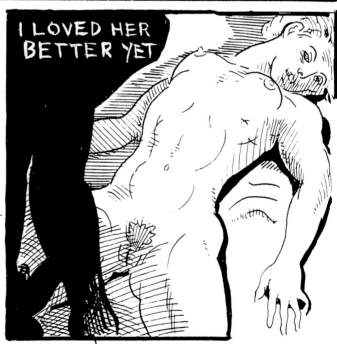

I LOVED HER BETTER YET

THE COUNTESS PEMBROKE BORE A CHILD **THAT FALL** . SHE NAMED HIM **WILLIAM**, SUPPOSEDLY FOR HIS GRANDFATHER, FIRST EARL OF PEMBROKE. HER NEXT CHILD'S NAME WAS **PHILIP!** MAKE WHAT YOU WILL OF **THAT**. MY **SONNETS**, PUBLISHED SOME YEARS **LATER** EXPRESSING LOVE FOR A YOUNG MAN, WERE WRITTEN, IN PART, TO MY **SECRET SON**, THIRD EARL OF PEMBROKE.

OLD HENRY HERBERT, IMPOTENT OF COURSE, ACCEPTED HIS WIFE MARY'S CHILD AS HIS. NONE THE LESS HE CAUGHT US BARE TOGETHER, CHASTISED ME SEVERELY AND SENT ME BACK TO STRATFORD IN DISGRACE...

... WHERE I FOUND JOHN SHAKESPEARE, MY GOOD FOSTER FATHER, HAVING DIFFICULTY WITH HIS BUSINESS.

WHILE WORKING FOR THAT HONEST MAN (TO WHOM I OWE MY FONDEST LOYALTY) I WAS IN THRALL TO MY RASH YOUNG PASSIONS. HAVING, AS IT SEEMED TO ME THEN, NO BETTER PROSPECTS, I MARRIED **ANN HATHAWAY**, THE BEST-LOOKING WOMAN IN THE COUNTY — AND SEVERAL YEARS MY ELDER. SHORTLY AFTER, IN 1582, LORD DUDLEY, EARL OF

LEICESTER, SUMMONED ME BACK INTO HIS SERVICE, PROBABLY AT THE URGING OF THE **QUEEN** WHO KEPT A WATCHFUL, THOUGH PERIODIC EYE ON MY FORTUNES, BECAUSE I WAS HER BASTARD BOY. BECAUSE I DIDN'T KNOW HE MEANT TO AID MY CAREER, I DID NOT UNDERSTAND LORD DUDLEY'S ANGER WITH MY MARRIAGE. ALWAYS TO PRACTICAL DETAILS MOST ATTENTIVE, I WAS EMPLOYED BY LEICESTER FOR MANY PRACTICAL SERVICES.

FRANK STACK

INCLUDING THE JOB OF ASSISTANT MANAGER (TO JAMES BURBAGE) FOR LEICESTER'S ACTING COMPANY, WHICH HE KEPT ALWAYS WITH HIM. IT WAS THEN THAT I FORMED MY LIFELONG BOND WITH THE FAMOUS STAGE **CLOWN**, WILL KEMPE, AND OLD **BURBAGE'S** SON DICK, BOTH ACTORS LATER IN **HAMLET** AND **MACBETH**.

I WROTE MY FIRST PLAYS FOR **LEICESTER'S** MEN. STUPID STUFF, I REALIZED WHEN I HEARD CHRIS MARLOWE'S LINES (MORE OF HIM SOME OTHER TIME).

WHEN LORD LEICESTER TOOK COMMAND OF THE ENGLISH EXPEDITIONARY FORCE TO AID THE **DUTCH** AGAINST THE SPANIARDS IN FLANDERS, WE ALL WENT WITH HIM AND PLAYED FOR **REAL** OUR PARTS AS SOLDIERS. THE SIDNEY NEPHEWS JOINED US TOO.

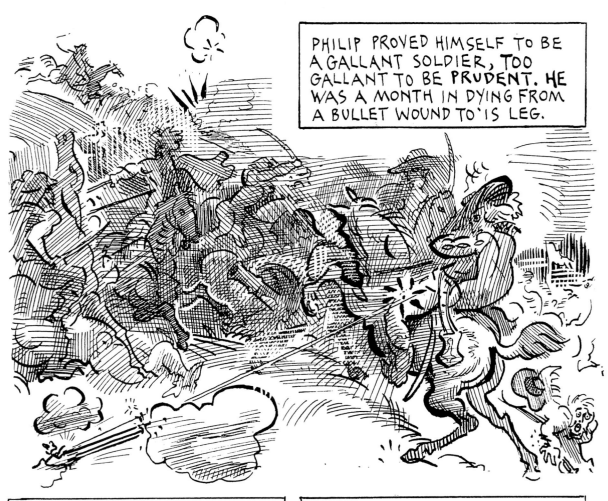

PHILIP PROVED HIMSELF TO BE A GALLANT SOLDIER, TOO GALLANT TO BE **PRUDENT**. HE WAS A MONTH IN DYING FROM A BULLET WOUND TO 'IS LEG.

I BECAME A MESSENGER AGAIN, RETURNED TO ENGLAND TO TELL PHIL'S FAMILY. IN GRIEF **HENRY HERBERT** FORGAVE HIS GRUDGE AGAINST ME.

THE WAR WAXED HOT TILL OUR VICTORY OVER THE SPANISH ARMADA IN 1588. ON **LEICESTER'S** SUDDEN DEATH THEREAFTER, AND DISPERSAL OF OUR ACTING COMPANY, OLD LORD PEMBROKE FORMED HIS OWN THEATER GROUP, OR ALLOWED HIS WIFE TO DO IT.

PEMBROKE'S MEN, (REALLY COUNTESS MARY) EMPLOYED MY SERVICES AS A WRITER AND AN ACTOR. AT FIRST I WROTE SOME SILLY THINGS — A COMEDY OF ERRORS, A BLOOD AND THUNDER PLAY, ANDRONICUS; BUT **THERE** WAS A GREATER PLAN WE HAD FOR PLAYS — TO DRAMATIZE OUR HISTORY HEROICALLY. IT WAS THEN I WROTE THE **HENRY SIXTH** PLAYS.

FRANK STACK

WHEN WE PERFORMED AT COURT **ELIZABETH TUDOR** FIRST SPOKE TO ME. SHE WAS IN HER **SIXTIES** THEN. SHE TALKED OF THE AWESOME RESPONSIBILITIES OF A PRINCE OF STATE, THE POTENTIAL OF A THEATER OF IDEAS AND ENCOURAGED ME TO WRITE ON PHILOSOPHICAL THEMES.

THE HOTSPUR YOUNG LORDS ASPIRED TO WEAR THE CROWN WHEN GLORIANA DIED. I WAS OF THE FAMILY OF EARLS **ESSEX** AND SOUTHAMPTON WHEN THEY MANUEVERED 'GAINST THE TIRED OLD QUEEN. SHE PLAYED A BETTER GAME OF CHESS AND SO DISMAYED US ALL BY NAMING **JAMES** OF SCOTLAND HER SUCCESSOR ONLY HOURS BEFORE SHE DIED IN 1603.

SCOTLAND

○ Glasgow ○ Edinburgh

JAMES I

CLUMSY DOUR JAMES STUART TOOK A LIKING TO THE PEMBROKE CLAN AND, AT COUNTESS MARY'S URGING, TOOK UP SPONSORSHIP OF MY COMPANY. WE BECAME THE **KING'S MEN**, AND, AS SUCH WE THRIVED...

...TILL NOW!

THE CONTEMPORARY EDGE

FRANK STACK

AND NO REPORT OF ANY OF OUR DISPUTATIONS MUST EVER BE RECORDED!

THE MUCH DISCUSSED AND CAREFULLY CRAFTED TEXT WAS FINALLY APPROVED BY SCHOLARS, THEOLOGIANS, GOVERNMENT OFFICIALS AND THE **HOLY KING** HIMSELF (ACTUALLY LITTLE CHANGED FROM WILLIAM TYNDALE'S ENGLISH TRANSLATION FROM ALMOST 100 YEARS EARLIER). THE AUTHORIZED VERSION APPEARED IN **1611**.

The original title page to the 1611 edition

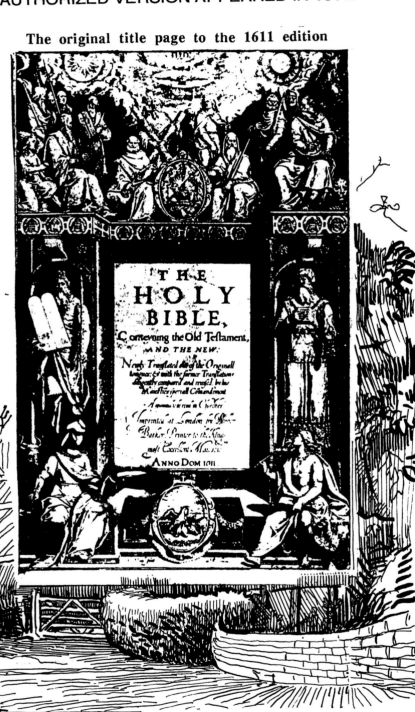

BY THEN, SHAKESPEARE WAS WEARY AND ILL. HE FINISHED A FEW FINAL PLAYS: **CYMBELINE, THE WINTER'S TALE** AND **THE TEMPEST**.

THEN HE RETIRED TO STRATFORD-ON-AVON.

VVINDSOR CASTLE
APRIL 1616

THE CHAMBERLAIN IS IN CONFERENCE WITH KING JAMES.

AS YOU MAY HAVE HEARD, MY LORD, WILLIAM SHAKESPEARE'S NOW ENGAGED AT HOME READYING HIS DRAMATIC WORK FOR PUBLICATION IN COMPLETE EDITION. HE WISHES TO INCLUDE A SECTION OF HIS VERSE.

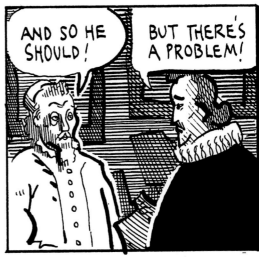

AND SO HE SHOULD!

BUT THERE'S A PROBLEM!

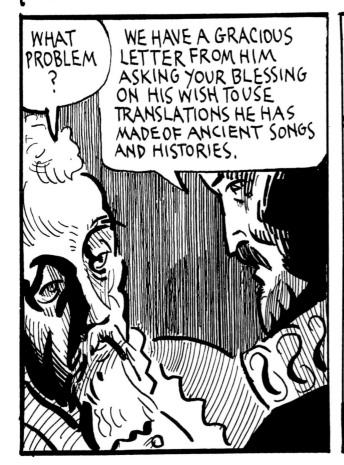

WHAT PROBLEM?

WE HAVE A GRACIOUS LETTER FROM HIM ASKING YOUR BLESSING ON HIS WISH TO USE TRANSLATIONS HE HAS MADE OF ANCIENT SONGS AND HISTORIES.

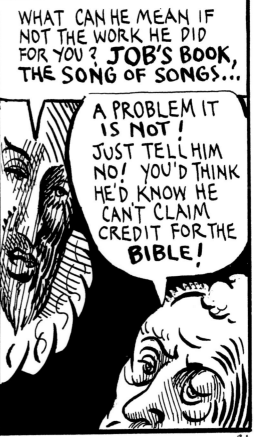

WHAT CAN HE MEAN IF NOT THE WORK HE DID FOR YOU? **JOB'S BOOK, THE SONG OF SONGS...**

A PROBLEM IT IS NOT! JUST TELL HIM NO! YOU'D THINK HE'D KNOW HE CAN'T CLAIM CREDIT FOR THE **BIBLE!**

FRANK STACK

GENTLE AS HIS REPUTATION IS, FOR THIS REFUSAL HE'LL BE ANGRY.

SO WHAT?

SO HE MAY, IN A HEATED MOMENT, EXPRESS HIS IRE IN PUBLIC, AND WORSE, GIVE REASONS...

...CALL AUTHORSHIP OF KING JAME'S BIBLE INTO QUESTION !!! HOLY WORD WAS WRITTEN BY THE BARD OF AVON!

THAT CANNOT BE! WHAT CAN WE **DO?** COOK UP A CHARGE? CONNECT HIM WITH A PLOT AGAINST MY LIFE? 'TIS SAD, HE'S SERVED US WELL 'TIL NOW, BUT I THINK IT BETTER FOR THE FAITH HIS VOICE BE STILLED 'FORE...

RUMOR OF HIS POET'S ROLE IN WRITING OF OUR BIBLE GETS ABROAD I HATE TO HAVE IT COME TO THIS! BUT, HOW CAN WE KNOW WHAT HE HAS SAID ALREADY?

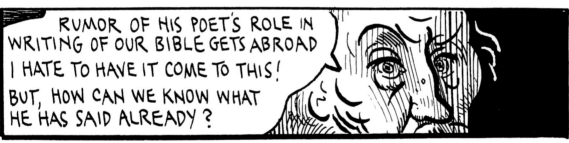

A PUBLIC TRIAL'S NOT WHAT WE WANT. **NOTHING** SAID IS BETTER.

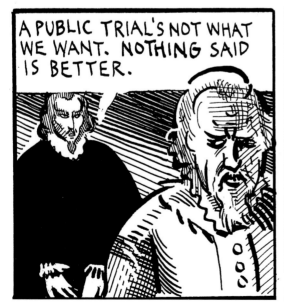

CERTAIN OF HIS FRIENDS REPORT TO ME, SO I KNOW MOST OF WHAT HE SAYS. BUT I CANNOT KNOW WHAT HE MAY **WRITE** IN PRIVATE.

AARGH !!!

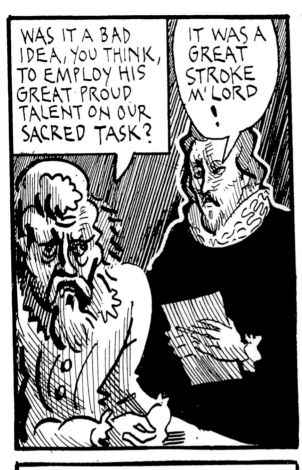

WAS IT A BAD IDEA, YOU THINK, TO EMPLOY HIS GREAT PROUD TALENT ON OUR SACRED TASK?

IT WAS A GREAT STROKE M'LORD!

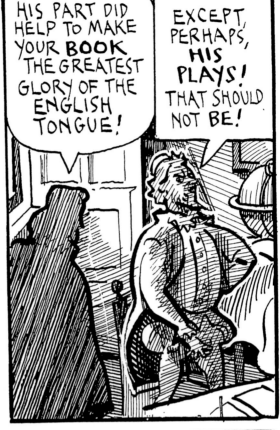

HIS PART DID HELP TO MAKE YOUR **BOOK** THE GREATEST GLORY OF THE ENGLISH TONGUE!

EXCEPT, PERHAPS, **HIS** PLAYS! THAT SHOULD NOT BE!

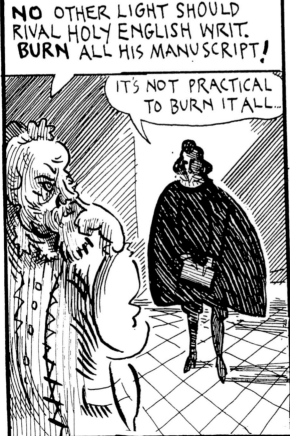

NO OTHER LIGHT SHOULD RIVAL HOLY ENGLISH WRIT. **BURN** ALL HIS MANUSCRIPT!

IT'S NOT PRACTICAL TO BURN IT ALL...

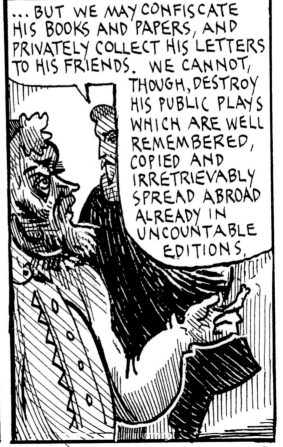

...BUT WE MAY CONFISCATE HIS BOOKS AND PAPERS, AND PRIVATELY COLLECT HIS LETTERS TO HIS FRIENDS. WE CANNOT, THOUGH, DESTROY HIS PUBLIC PLAYS WHICH ARE WELL REMEMBERED, COPIED AND IRRETRIEVABLY SPREAD ABROAD ALREADY IN UNCOUNTABLE EDITIONS.

FRANK STACK

ON APRIL 22, 1616, WILLIAM SHAKESPEARE RECEIVED AN UNEXPECTED VISIT FROM TWO WRITER FRIENDS.

THEY STAYED UP LATE TALKING OF OLD TIMES.

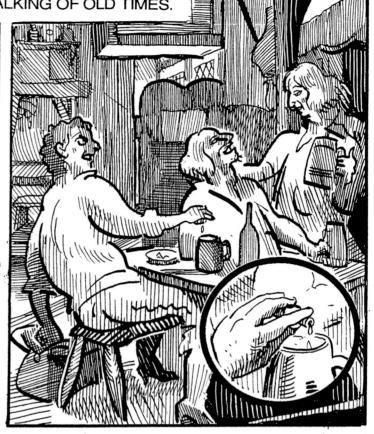

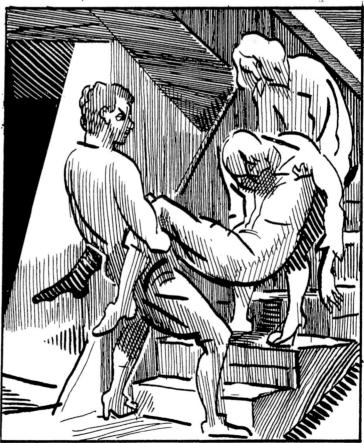

FRANK STACK

WILLIAM SHAKESPEARE DIED THE NEXT DAY, IT WAS SAID "OF A FEVER" CAUSED BY TOO MUCH DRINK.

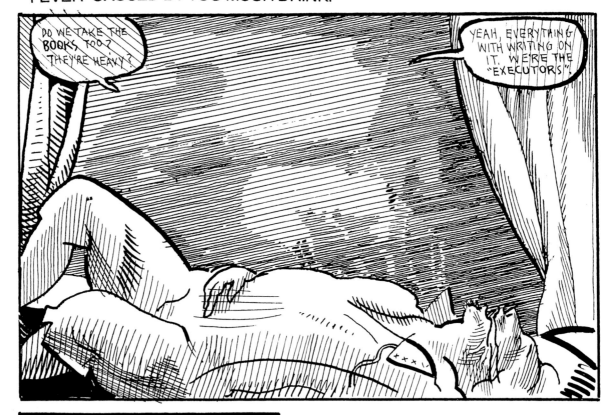

HIS PLAYS WERE PUBLISHED IN 1623 IN A DELUXE FOLIO EDITION DEDICATED TO, AND PERHAPS PAID FOR, BY **WILLIAM HERBERT**, EARL OF PEMBROKE (SINCE 1603).

NO LETTERS OR OTHER OF SHAKES-PEARE'S PERSONAL PAPERS HAVE EVER BEEN FOUND.

The End

PART SIX
A CONTEMPORARY FEAST

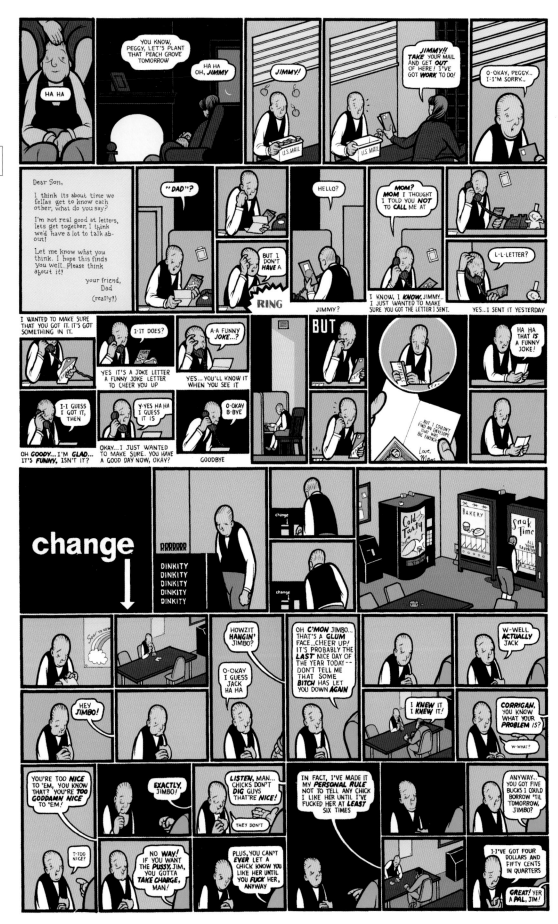

A CONTEMPORARY FEAST

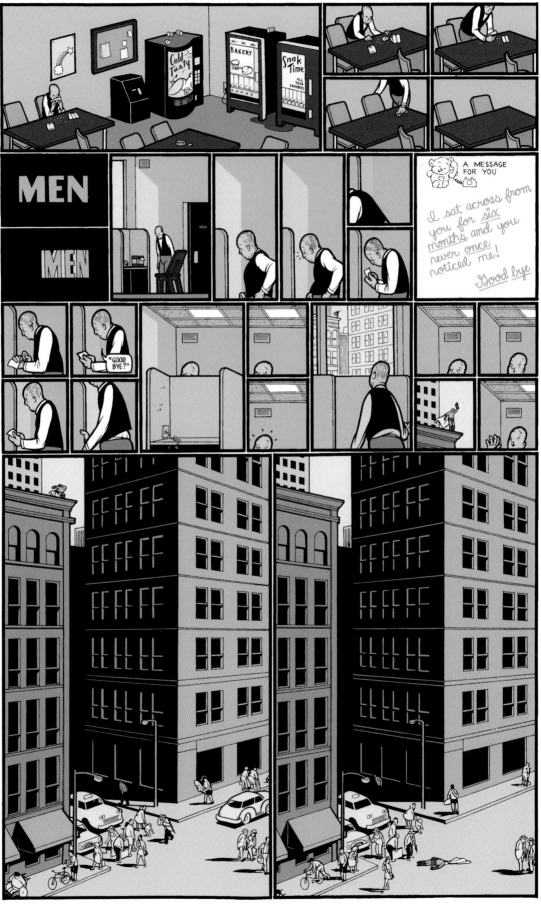

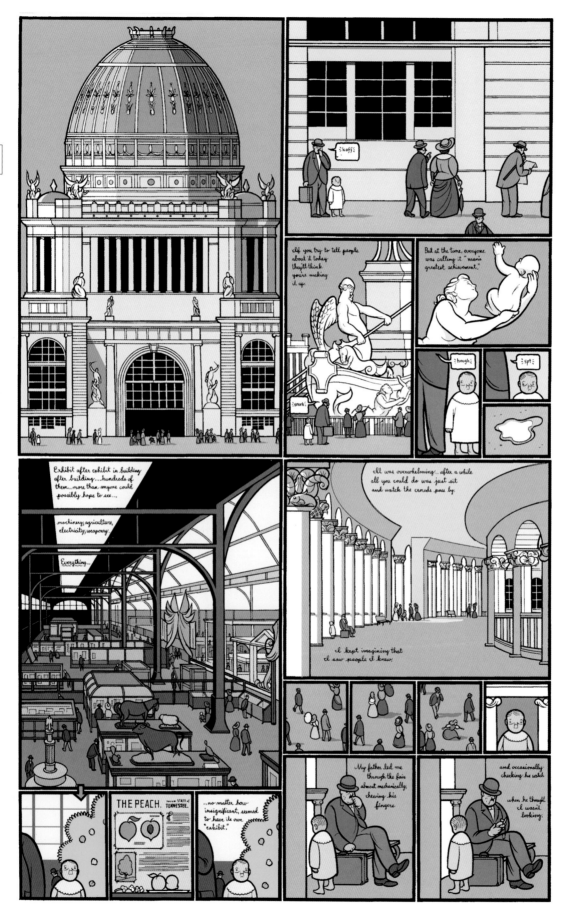

366

A CONTEMPORARY FEAST

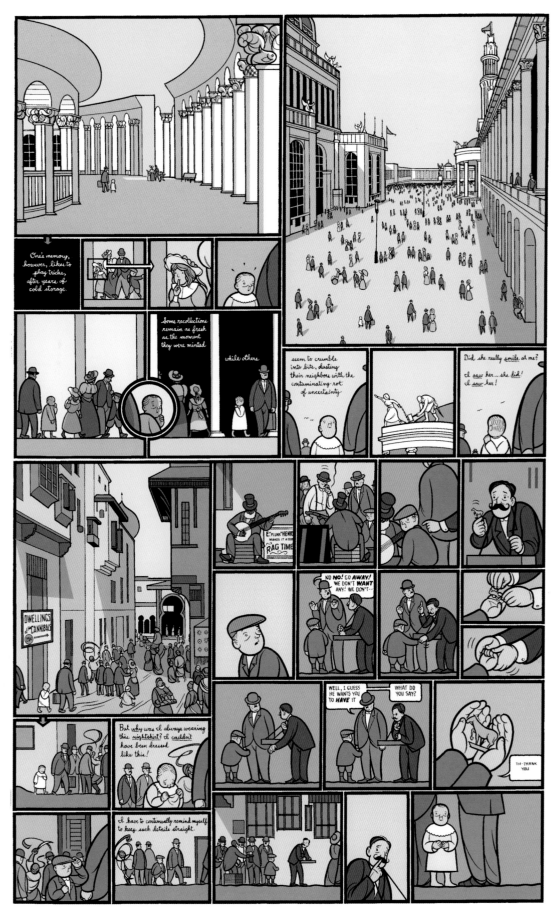

CHRIS WARE

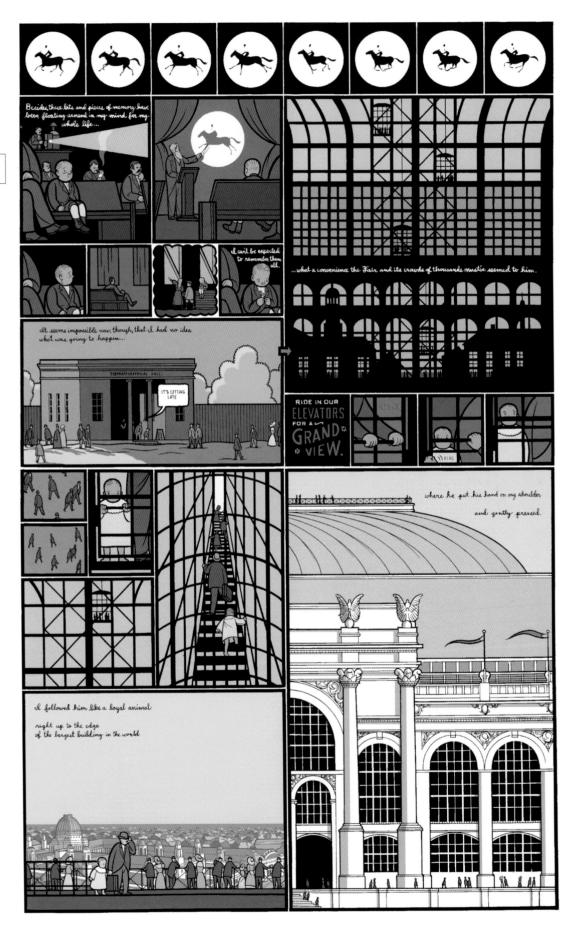

A CONTEMPORARY FEAST

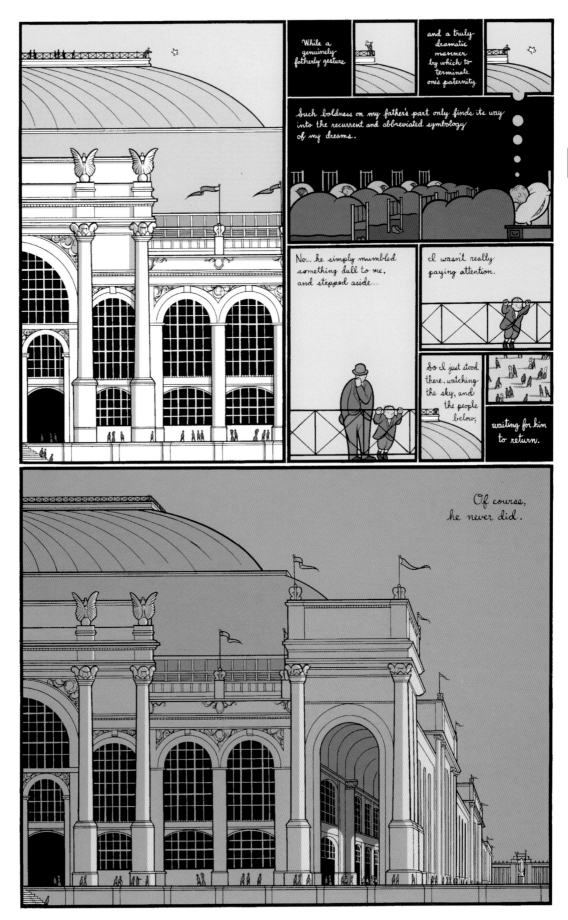

While a genuinely fatherly gesture

and a truly dramatic manner by which to terminate one's paternity.

Such boldness on my father's part only finds its way into the recurrent and abbreviated symbology of my dreams.

No... he simply mumbled something dull to me, and stepped aside...

I wasn't really paying attention.

So I just stood there, watching the sky, and the people below,

waiting for him to return.

Of course, he never did.

CHRIS WARE

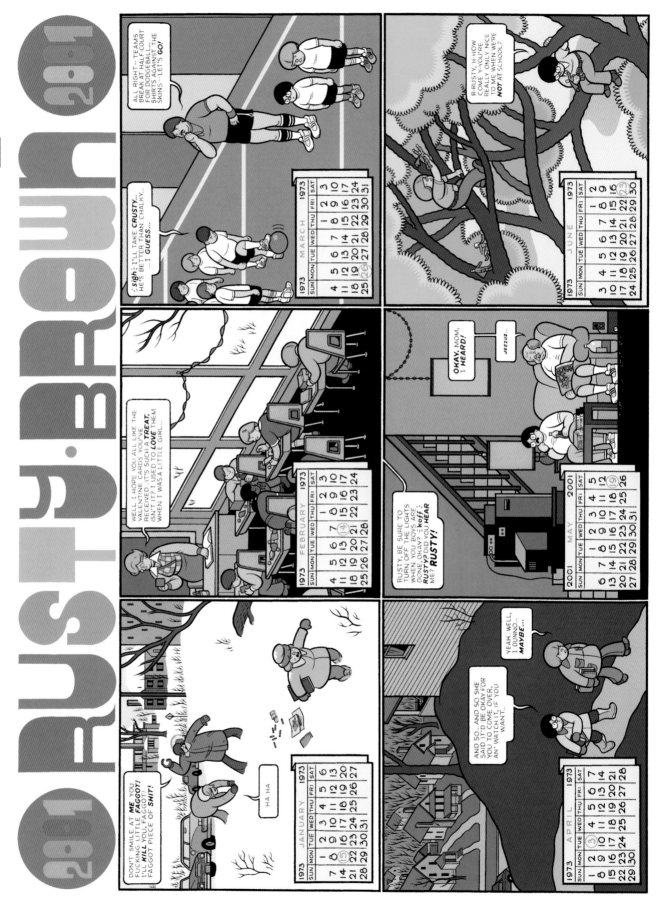

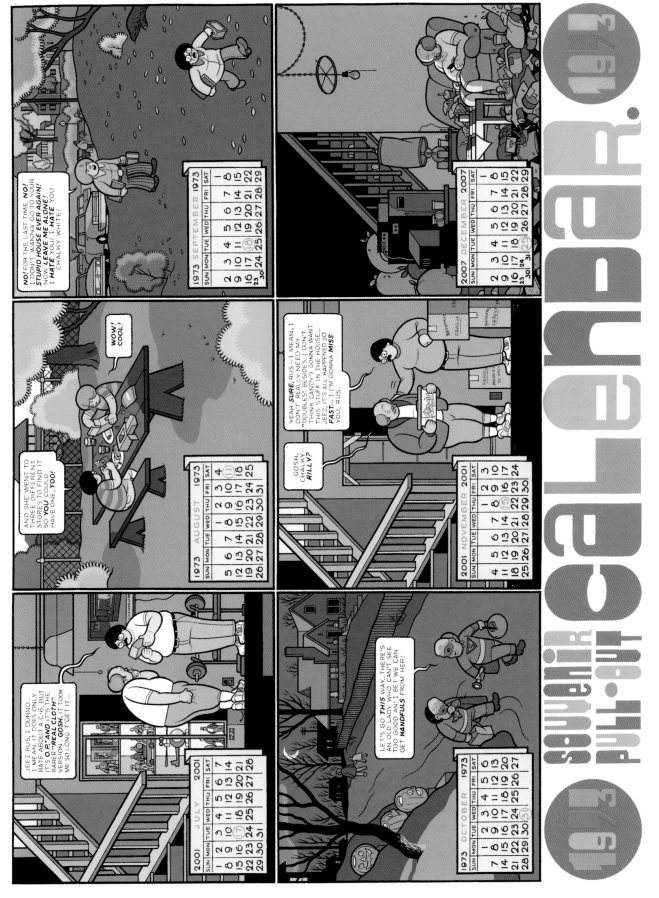

CHRIS WARE

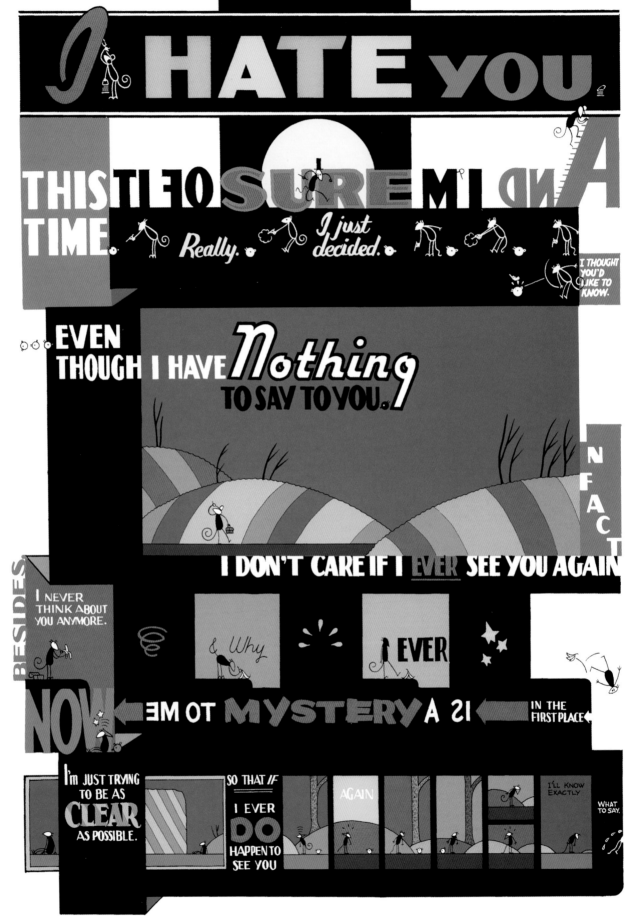

A CONTEMPORARY FEAST

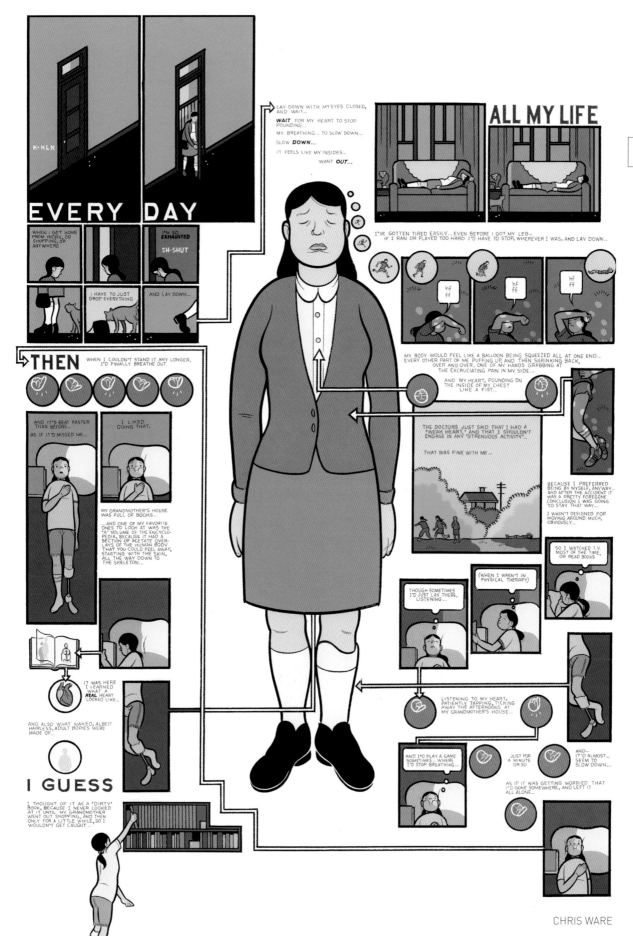

CHRIS WARE

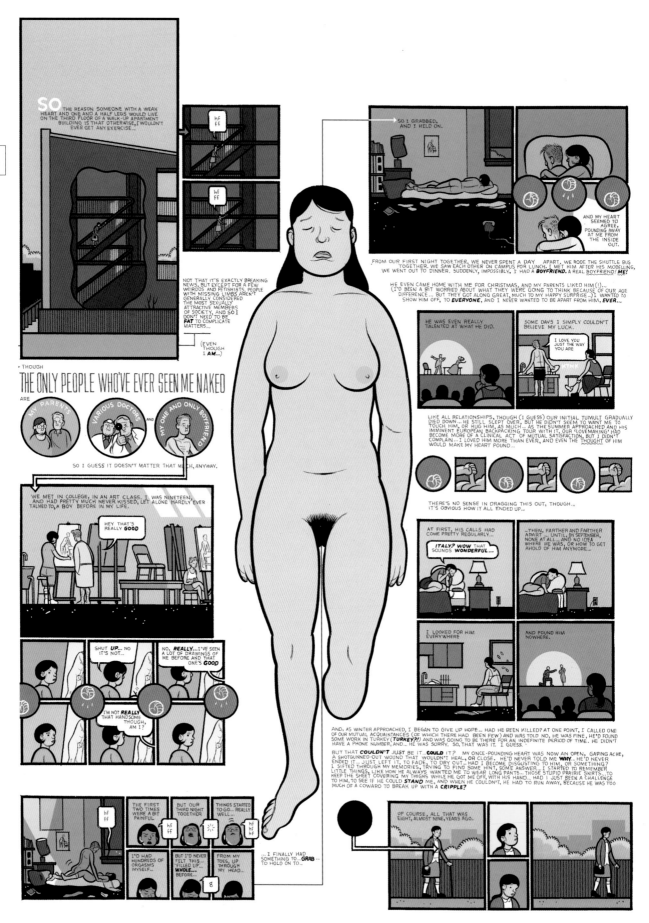

A CONTEMPORARY FEAST

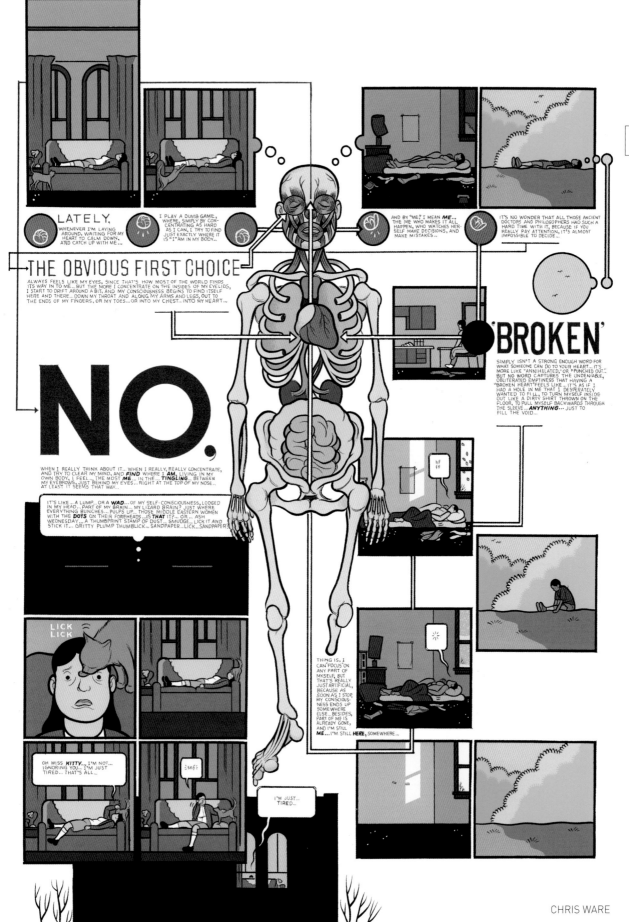

CHRIS WARE

TOWARD the END of each AUGUST THE "BACK-TO-SCHOOL" ADS BEGIN to APPEAR and THOUGH I AM WELL PAST SCHOOL age, THEY NEVER FAIL to GIVE ME A certain FEELING, a curious MIX OF ANXIETY, Dread AND excitement.

OH MAN!

ALREADY?

BACK TO SCHOOL SALE!

SCHOOL ALWAYS brought NEW things INTO MY LIFE, NEW PEOPLE, NEW ideas, NEW hope ABOUT NOT being SUCH A WEIRDO, ABOUT having a MIRACLE HAPPEN that WOULD GIVE ME STRAIGHT A's, straight HAIR, and a SUPER POPULAR YEAR.

LORD, PLEASE KEEP ME FROM HAVING TO GET HORRIBLE SHOES AGAIN THIS YEAR.

PLEASE KEEP MOM AWAY FROM SEAR'S JUNIOR BOOT SHOP.

Back to School SALE

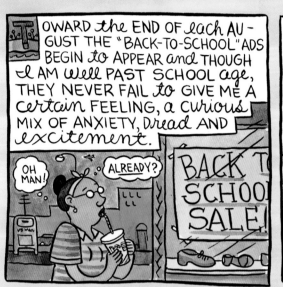

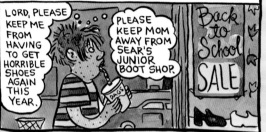

BUT it ALSO MEANT the END of summer. NO MATTER IF the HOT, PRETTY DAYS continued, once SCHOOL STARTED, SUMMER WAS over, AND WHOEVER I HAD been ALL that YEAR WAS over too. THE 6th GRADER DIES. THE 7th grader IS BORN.

13, 14, 15....

WHOA.

16 MORE DAYS, MAN.

MUTUAL FISH COMPANY AUGUST

'TIL WHAT? 'TIL YOU REALIZE YOU'RE ACTUALLY AN IDIOT?

That SUMMER, the one BEFORE 7th GRADE BEGAN, I DISCOVERED THE radio. IT HAD ALWAYS been there, BUT THAT summer IT STARTED TELLING ME THINGS, it WHISPERED to me ABOUT a WORLD OUT THERE, GAVE me CLUES in SONGS, GAVE numbers TO CALL, GAVE ME FEELINGS I COULDN'T resist.

BE THE FIFTH CALLER AND WIN TICKETS TO SEE THE TROGGS LIVE!

C'MON! ANSWER! C'MON, MAN!

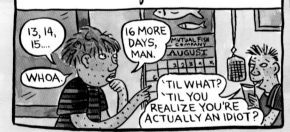

LYNDA BARRY

At NIGHT, ESPECIALLY, IN the PITCH DARK of MY BASEMENT BED room, the SONGS were POWERFUL, THE D.J. SEEMED TO be PLAYING MY FUTURE of fantastic MAGICAL encounters WITH PEOPLE WHO WOULD LEAD ME to SOMETHING I DIDN'T HAVE a name FOR YET.

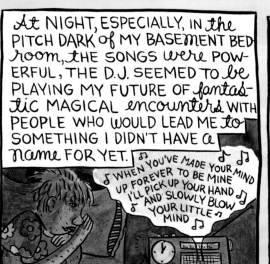

♪ WHEN YOU'VE MADE YOUR MIND UP FOREVER TO BE MINE I'LL PICK UP YOUR HAND ♪ AND SLOWLY BLOW YOUR LITTLE MIND ♪

OF course THERE WOULD be A GUY. A cute GUY, POSSIBLY a HIPPIE, POSSIBLY he'd HAVE A GUITAR, and HE'D FREAK out WHEN HE saw ME because our LOVE WOULD BE SO REAL. In THE darkness SUCH VISIONS OF MY FUTURE BLOOMED.

OH DONOVAN, I LOVE YOU TOO. BUT MY MOM HATES HIPPIES.

RUN AWAY WITH YOU? OH DONOVAN. PLEASE DON'T MAKE ME CHOOSE

DURING the DAY I WAS still A KID. I HUNG around THE USUAL PEOPLE, PLAYED the USUAL KICKBALL GAME, Drank THE USUAL GREEN KOOL-AID and waited FOR the ICE CREAM man.

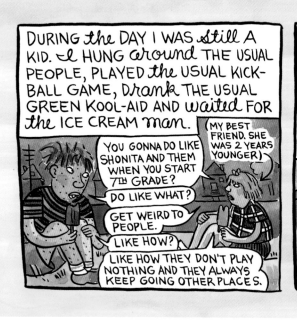

MY BEST FRIEND. SHE WAS 2 YEARS YOUNGER)

YOU GONNA DO LIKE SHONITA AND THEM WHEN YOU START 7TH GRADE?

DO LIKE WHAT?

GET WEIRD TO PEOPLE.

LIKE HOW?

LIKE HOW THEY DON'T PLAY NOTHING AND THEY ALWAYS KEEP GOING OTHER PLACES.

MY BEST FRIEND GLADYS was about TO START 5TH GRADE. SHE WAS a VERY cool PERSON and OUR AGE DIFFERENCE never mattered TO ME BEFORE. But DURING THOSE last WEEKS OF summer I WAS STARTING to FEEL SICK ABOUT it.

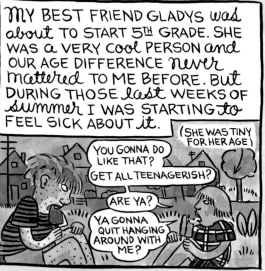

(SHE WAS TINY FOR HER AGE)

YOU GONNA DO LIKE THAT? GET ALL TEENAGERISH?

ARE YA?

YA GONNA QUIT HANGING AROUND WITH ME?

379

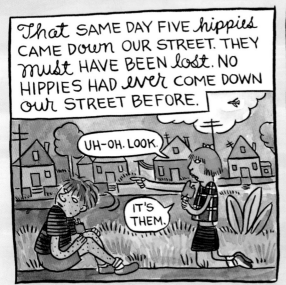

That SAME DAY FIVE *hippies* CAME DOWN OUR STREET. THEY *must* HAVE BEEN *lost*. NO HIPPIES HAD *ever* COME DOWN *our* STREET BEFORE.

UH-OH. LOOK.

IT'S THEM.

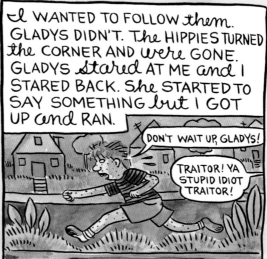

I WANTED TO FOLLOW *them*. GLADYS DIDN'T. *The* HIPPIES TURNED *the* CORNER AND *were* GONE. GLADYS *stared* AT ME *and* I STARED BACK. *She* STARTED TO SAY SOMETHING *but* I GOT UP *and* RAN.

DON'T WAIT UP, GLADYS!

TRAITOR! YA STUPID IDIOT TRAITOR!

GLADYS *was* THE ONLY *one* WHO *knew* I WANTED *to* BE A HIPPIE *I* TALKED *about* SAN FRANCISCO. *There* WAS A *song* ABOUT IT *that* PLAYED ON THE RADIO. IT *had* A *sad*, BEAUTIFUL MELODY. *I* SANG IT FOR GLADYS. I *didn't* KNOW WHY *she* SEEMED TO *hate* IT. I THOUGHT *she* WAS JUST TOO YOUNG.

YA UGLY, STUPID TRAITOR!

RUN! GO 'HEAD! RUN!

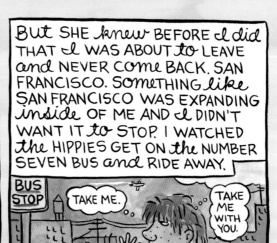

But SHE *knew* BEFORE *I did* THAT *I* WAS ABOUT *to* LEAVE *and* NEVER *come* BACK. SAN FRANCISCO. SOMETHING *like* SAN FRANCISCO WAS EXPANDING *inside* OF ME AND *I* DIDN'T WANT IT *to* STOP. I WATCHED *the* HIPPIES GET ON *the* NUMBER SEVEN BUS *and* RIDE AWAY.

BUS STOP

TAKE ME.

TAKE ME WITH YOU.

LYNDA BARRY

The LAST DAYS OF summer ARE ALWAYS SO SAD. FLOWERS lose THEIR PETALS and BECOME hARD SEEDS. I TOOK THE num-Ber SEVEN BUS in SEARCH OF THE HIPPIES. I AVOIDED GLADYS.

END OF THE LINE, SWEETHEART. YOU HAVE TO GET OFF.

WHAT DO YOU MEAN?

I DON'T GO NO FURTHER.

BUT WHERE'S THE HIPPIES?

I LISTENED to THE RADIO FOR LOCATIONS AND CHANGED buses downtown LOOKING out THE WINDOW FOR "THE HAPPENING," the PLACE WHERE the HIPPIES ALL GROOVED in THE sun. I knew IT WAS OUT THERE. ALL I NEEDED was TO FIND the RIGHT bus.

YOU RIDE THE #27?

EVERYDAY.

YOU EVER SEE WILD LOOKING PEOPLE ACTING MAGICAL WITH STICKING-OUT HAIR, MAYBE WEARING BOOTS AND POSSIBLY CAPES MADE FROM FLAGS?

YOU MEAN THE HALFWAY HOUSE?

BUS STOP

A LADY TOLD me TO GET OFF AT A certain STOP WHERE I'd FIND THE HALFWAY HOUSE. I ASKED her IF it WAS LIKE the HOUSE OF THE RISING SUN. SHE SAID IT was IF THAT WAS also A PLACE FOR PEOPLE who WERE OUT OF THEIR heads. IT SOUNDED right.

THOSE PEOPLE ARE LIVING IN ANOTHER WORLD.

YEAH, THEY'RE GETTING GROOVY.

WHATEVER THEY'RE GETTING, JUST DON'T GIVE ME NONE.

When I FIRST SAW the HALFWAY HOUSE, I THOUGHT I FOUND THEM. THERE were PEOPLE ON the FRONT STEPS. ONE HAD a GUITAR. ONE had A HAT made OF TIN FOIL. ONE GAVE ME THE PEACE SIGN and beckoned me OVER. THE sun WAS GOING DOWN. I WAS A LONG WAY FROM home.

HEY, LITTLE MAMA. GIMME A CIGARETTE AND I'LL WRITE A SONG ABOUT CHA.

YOU 'N' ME, DARLIN', BEEN WAITIN' FOR YA.

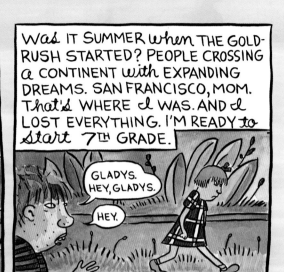

I NOTICED A PEE SMELL. I NOTICED their FREAKED-out DOG EYES. ONE GUY made SOME WEIRD FINGER GESTURES and STARTED vomiting. I RAN. IT was NIGHT WHEN I GOT BACK TO MY street. THE CORNER WAS DEAD. THE kickball GAME was OVER. MY MOM WAS on THE FRONT PORCH SCREAMING.

I'M GOING TO KILL YOU! WHERE HAVE YOU BEEN?! N'AKO, I'M GOING TO KILL YOU!

Was IT SUMMER when THE GOLD-RUSH STARTED? PEOPLE CROSSING a CONTINENT with EXPANDING DREAMS. SAN FRANCISCO, MOM. That's WHERE I WAS. AND I LOST EVERYTHING. I'M READY to start 7TH GRADE.

GLADYS. HEY, GLADYS.

HEY.

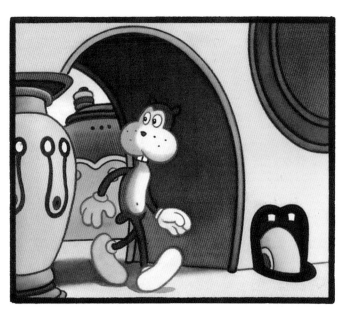

A CONTEMPORARY FEAST

JIM WOODRING

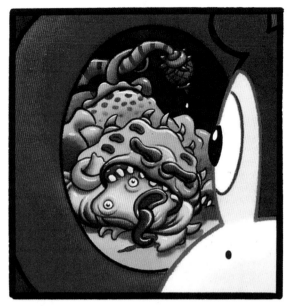
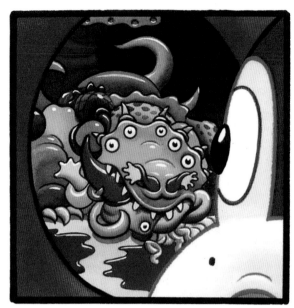

384

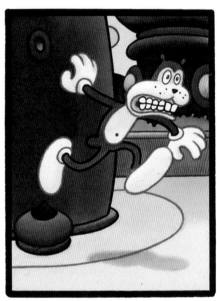
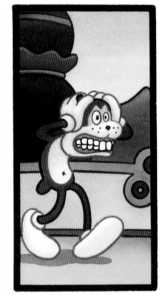

A CONTEMPORARY FEAST

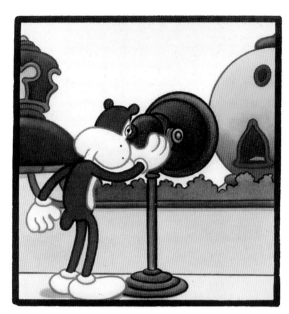

JIM WOODRING

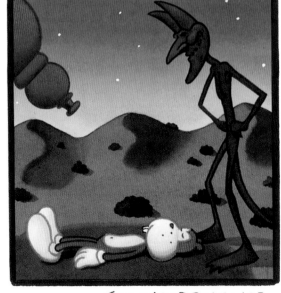

386

A CONTEMPORARY FEAST

JIM WOODRING '95

HOW THE MATERIAL COMPONENTS OF A BUILDING COALESCE INTO A MULTISTORIED STRUCTURE WITHOUT THE CONSCIOUS DIRECTION OF A CLIENT, ARCHITECT OR BUILDER.

TWO SMALL PANELED ROSES OCCUPY THE TYMPANUMS BENEATH EACH ARCH...

THE ARCHITECT, EARL ILIUM, LOST IN THOUGHT, STEPS OFF THE CURB AT A BUSY INTERSECTION.

AND REPEAT THE COMPARTMENTS OF THE CENTRAL ROSE-WINDOW.

A TRUCK CARRYING SHEET-ROCK SWERVES TO AVOID HITTING HIM AND COLLIDES WITH AN ICE-CREAM TRUCK.

NORTH POLE

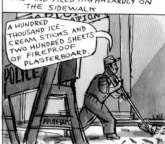

THE MATERIAL IS CLEARED FROM THE ROAD AND PILED HAPHAZARDLY ON THE SIDEWALK

A HUNDRED THOUSAND ICE-CREAM STICKS AND TWO HUNDRED SHEETS OF FIREPROOF PLASTERBOARD.

POLICE

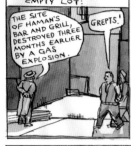

WHERE IT LIES FOR SEVERAL DAYS ALONGSIDE AN EMPTY LOT:

THE SITE OF HAMAN'S BAR AND GRILL, DESTROYED THREE MONTHS EARLIER BY A GAS EXPLOSION.

GREPTS!

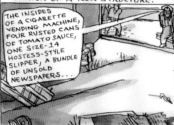

THE LOT, ALREADY FILLED WITH A RICH ASSORTMENT OF ILLEGALLY DUMPED DEBRIS, IS A FERTILE GROUND FOR THE ERECTION OF A NEW STRUCTURE.

THE INSIDES OF A CIGARETTE VENDING MACHINE, FOUR RUSTED CANS OF TOMATO SAUCE, ONE SIZE-14 HOSTESS-STYLE SLIPPER, A BUNDLE OF UNSOLD NEWSPAPERS...

TWO UNEMPLOYED LABORERS, PASSING BY, TAKE IT FOR A CONSTRUCTION SITE AND, TO DISPLAY THEIR WILLINGNESS TO WORK, CARRY IN SEVERAL SHEETS OF GYPSUM.

A DESPONDENT REGULAR OF THE VANISHED BAR IS MISTAKEN FOR THE FOREMAN.

OVER HERE, THERE WAS A WALL OVER HERE.

THE UNAUTHORIZED SITE ATTRACTS A NUMER OF UNSCRUPULOUS SUBCONTRACTORS AND NON-UNION WORKERS.

BY NOON, 300 ARTIFICIAL BAMBOO WINDOW FRAMES, 25 GRECO-ROMAN BATHTUBS, AND 100 CLIP-ON VAULT CEILING TILES ARE DELIVERED TO THE SITE.

SPONTANEOUS CONSTRUCTION

THE EAGER WORKERS TAKE THEIR DIRECTIONS FROM THE TEXT OF A BABYLONIAN BARBECUE TAKE-OUT MENU HANDED TO THEM BY A YOUNG BOY.

CHECK IT OUT. YOUR CHOICE, SOUP OR APPETIZER, MAIN COURSE AND DESSERT: $6.95.

FOLLOWING THE LEAD OF A STRAY DOG, A THOUSAND RETRACTABLE BALL-POINT PENS ARE BURIED, POINT DOWN, IN THE EARTH.

WITHOUT GLUE OR NAILS, THE WOODEN ICE-CREAM STICKS ARE LAID TO FORM A PARQUET FLOOR.

ONLOOKERS OFFER THEIR SUGGESTIONS:

A ZIGGURAT ON THE TOP FLOOR!

A BOWLING ALLEY IN THE BASEMENT!

AT 4 P.M THE LABORERS, REALIZING THAT THEY WON'T BE PAID FOR THEIR WORK, WALK OUT ON STRIKE.

HAPLOPIA CORPORATION

THE BUILDING STANDS UNOCCUPIED UNTIL NIGHTFALL,

A VODKA WITH GRAPEFRUIT JUICE.

WHEN ANOTHER "REGULAR" SHOWS UP AND, IN TRYING TO BUY A DRINK, CAUSES IT TO COLLAPSE.

BEN KATCHOR

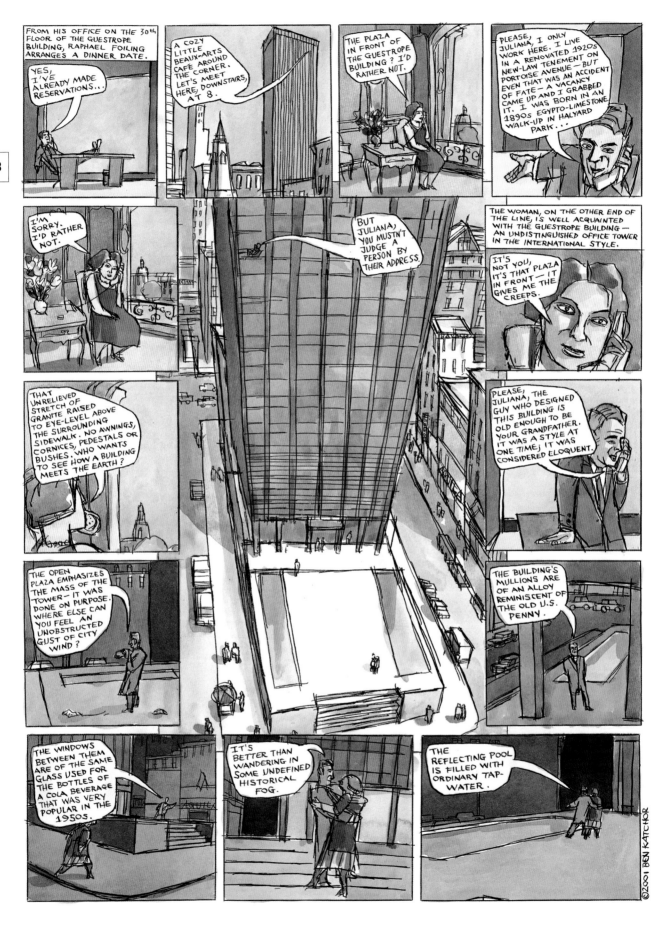

A CONTEMPORARY FEAST

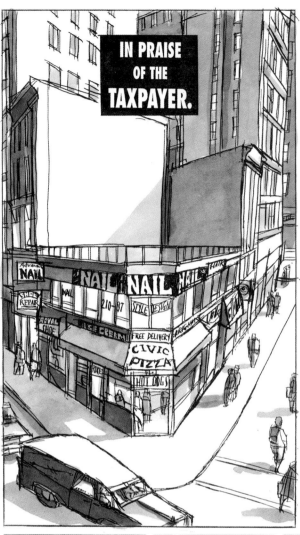

IN PRAISE OF THE TAXPAYER.

THAT SO MANY OF THE CITY'S MOST VENERABLE "TAXPAYERS" HAVE SURVIVED YET ANOTHER COMMERCIAL BUILDING BOOM IS CAUSE FOR CELEBRATION.

THESE ONE- OR TWO-STORY STRUCTURES, DESIGNED TO YIELD ONLY ENOUGH RENT TO DEFRAY THE TAXES ON THE PROPERTY ON WHICH THEY STAND, WERE NOT MEANT TO BE PERMANENT BUILDINGS.

YET FOR ONE REASON OR ANOTHER, THEY HAVE CONFOUNDED THE EFFORTS OF DEVELOPERS TO BE COMBINED INTO LOTS SUITABLE FOR HIGHRISE CONSTRUCTION.

ALTHOUGH THEY MAKE NO CLAIM TO ARCHITECTURAL BEAUTY, THEY ARE, IN THEIR PERFECT "TEMPORARINESS," A DELIGHTFUL ALTERNATIVE TO THE LARGE-SCALE STRUCTURES THAT MIGHT SOMEDAY TAKE THEIR PLACE.

THE MOST PERFECT EXAMPLES OCCUPY CORNER LOTS.

THEY OFFER A PLEASANT RESPITE FROM THE HIGH-DENSITY DEVELOPMENT AROUND THEM—A BREAK OF LIGHT AND AIR—AN ARCHITECTURAL BIDING OF TIME.

SO BURIED IN SIGNAGE ARE THESE STRUCTURES, THAT IT OFTEN TAKES A MOMENT TO DISTINGUISH THE MODERN, SPECIALLY CONSTRUCTED "TAXPAYER" FROM ITS NEIGHBOR:

THE SMALL COMMERCIAL BUILDING FROM AN EARLIER ERA WHOSE UPPER FLOORS HAVE BEEN SEALED AND WHOSE GROUND-FLOOR SPACE NOW FUNCTIONS AS A "TAXPAYER."

THE FEW SURFACES NOT COVERED BY SIGNS ARE OFTEN CLAD IN A DISTINCTIVE DARK, GREEN-GREY, STRIATED ALUMINUM SIDING.

OCCUPIED BY BUSINESSES OF AN EPHEMERAL NATURE...

TAKE-OUT SANDWICH SHOPS, FILM PROCESSING DROP-OFFS, PEEP-SHOWS AND NECKTIE STORES.

THESE PROVISIONAL STRUCTURES HAVE IN SOME CASES REMAINED STANDING FOR THE BETTER PART OF A HUMAN LIFETIME.

THE TEMPORARY BUILDING IS A TRIUMPH OF MODERN INDUSTRIAL ORGANIZATION,

A HEALTHY SUBLIMATION OF THE URGE TO BUILD,

AND PROOF THAT NOT EVERY ARCHITECTURAL IDEA SHOULD BE CAST IN STONE.

KAYO

RAYMOND OLIVER
ARCHITECT
1921-1998

© 1998 BEN KATCHOR

BEN KATCHOR

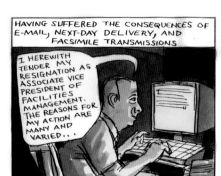

HAVING SUFFERED THE CONSEQUENCES OF E-MAIL, NEXT-DAY DELIVERY, AND FACSIMILE TRANSMISSIONS

I HEREWITH TENDER MY RESIGNATION AS ASSOCIATE VICE PRESIDENT OF FACILITIES MANAGEMENT. THE REASONS FOR MY ACTION ARE MANY AND VARIED...

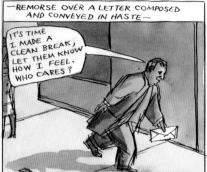

—REMORSE OVER A LETTER COMPOSED AND CONVEYED IN HASTE—

IT'S TIME I MADE A CLEAN BREAK, LET THEM KNOW HOW I FEEL. WHO CARES?

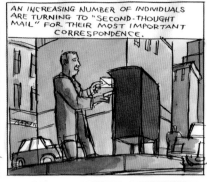

AN INCREASING NUMBER OF INDIVIDUALS ARE TURNING TO "SECOND-THOUGHT MAIL" FOR THEIR MOST IMPORTANT CORRESPONDENCE.

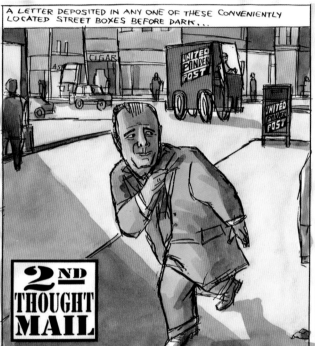

A LETTER DEPOSITED IN ANY ONE OF THESE CONVENIENTLY LOCATED STREET BOXES BEFORE DARK...

2ND THOUGHT MAIL

WILL BE COLLECTED AND BROUGHT TO A CENTRAL "PONDER-POST" DEPOT.

THERE, THE LETTER WILL BE HELD IN CONFIDENCE FOR TEN DAYS...

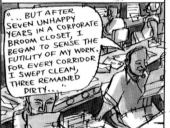

AT WHICH TIME, A BONDED CLERK WILL TELEPHONE THE SENDER TO REACQUAINT HIM WITH ITS CONTENTS.

"... BUT AFTER SEVEN UNHAPPY YEARS IN A CORPORATE BROOM CLOSET, I BEGAN TO SENSE THE FUTILITY OF MY WORK. FOR EVERY CORRIDOR I SWEPT CLEAN, THREE REMAINED DIRTY..."

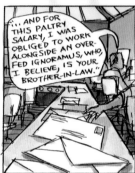

"... AND FOR THIS PALTRY SALARY, I WAS OBLIGED TO WORK ALONGSIDE AN OVER-FED IGNORAMUS, WHO, I BELIEVE, IS YOUR BROTHER-IN-LAW."

UPON HEARING HIS OWN WORDS, THE SENDER IS MOMENTARILY DUMBSTRUCK.

THIS MORNING WE CAN OFFER YOU OUR THREE STANDARD OPTIONS:

1) TO SEND THE LETTER ON AS ADDRESSED;

SO THAT'S HOW HE FEELS!

2) TO RETURN THE LETTER FOR REVISION:

I COULD WORK ON IT TONIGHT, OR OVER THE WEEKEND.

A CHANCE TO ALTER A SALUTATION, RETRACT A COMPLIMENT, QUALIFY AN OPINION, CANCEL A SUBSCRIPTION...

"TO HIS EXCELLENCY, THE RIGHT HONORABLE DR. AND MRS. H. FERBAM."

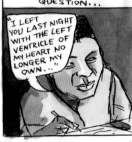

TEMPER A LOVE LETTER, MODIFY A NOUN, SQUASH A RUMOR, REPHRASE A QUESTION...

"I LEFT LAST NIGHT WITH THE LEFT VENTRICLE OF MY HEART NO LONGER MY OWN..."

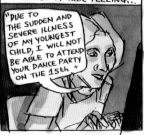

ALTER THE TRUTH, COUCH AN IDEA IN MORE PALATABLE TERMS, OBJECTIFY A STATEMENT, WITHHOLD A TRUE FEELING...

"DUE TO THE SUDDEN AND SEVERE ILLNESS OF MY YOUNGEST CHILD, I WILL NOT BE ABLE TO ATTEND YOUR DANCE PARTY ON THE 15th."

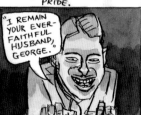

PUT SOMETHING IN A BETTER LIGHT, CONSIDER THE OTHER SIDE OF AN ARGUMENT, EXPUNGE AN OBSCENITY, MINCE ONE'S WORDS, AND SWALLOW ONE'S PRIDE.

"I REMAIN YOUR EVER-FAITHFUL HUSBAND, GEORGE."

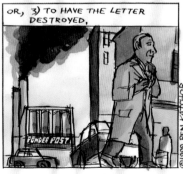

OR, 3) TO HAVE THE LETTER DESTROYED.

PONDER POST

A CONTEMPORARY FEAST

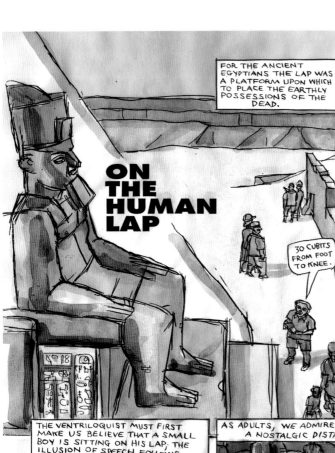

BEN KATCHOR

THE FAULTY SWITCH

ANOTHER BEAUTIFULLY DESIGNED, NEW BUILDING RUINED BY THE SOUND OF THE COMMON WALL LIGHT-SWITCH.

IT'S FINE DURING THE DAY, WHEN THE MAIN ROOMS ARE FLOODED WITH SUNLIGHT.

BUT AT DUSK, EVERYTHING CHANGES.

THE ARCHITECT SPENT HUNDREDS OF HOURS DESIGNING BURNISHED BRASS SWITCH-PLATES FOR HIS NEW OFFICE TOWER

AND THEN LEFT IT TO A CONTRACTOR TO INSTALL THESE 79¢ SWITCHES BEHIND THEM.

WE KNOW INSTINCTIVELY WHERE TO REACH WHEN WE ENTER A DARK ROOM.

WE AUTOMATICALLY THROW THE LITTLE NUB OF PLASTIC UPWARD,

BUT THE SOUND WE ARE GREETED WITH—AS THE ROOM IS BATHED IN THE SIMULATED GLOW OF LATE-AFTERNOON LIGHT—

RECALLS TO MIND A DIRTY MEN'S ROOM IN THE REAR OF A BABYLONIAN COFFEE SHOP.

THIS SOUND COLORS OUR FIRST IMPRESSION OF ANY ROOM—IT CAN'T BE HELPED. BUT WHERE DOES THIS SOUND, COMMONLY DESCRIBED AS A "CLICK," COME FROM?

IS IT SIMPLY THE BY-PRODUCT OF A CRUDE MECHANICAL ACTION?

OR, IS IT AN IMITATION OF ONE-HALF THE SET OF SOUNDS WE MAKE TO EXPRESS DISAPPOINTMENT: THE ORPHANED DENTAL CONSONANT OF NO INDO-EUROPEAN LANGUAGE?

TSK, TSK.

OR, IS IT THE AMPLIFIED SOUND OF A SYNAPSE FIRING IN THE BRAIN OF A COCKROACH?

IN THE 1950s THEY TRIED THEIR BEST TO MUFFLE THIS SOUND WITH MERCURY SWITCHES AND SILENT KNOB CONTROLS, BUT TODAY THESE "IMPROVEMENTS" SEEM SOMEHOW UNAUTHENTIC.

IT IS THE MODERN TRIUMPHAL CLARION PRECEDING US THROUGH LIFE, ANNOUNCING OUR ENTRY INTO EVERY LIGHTLESS ROOM.

THE SOUND MADE FLICKING A WALL-SWITCH OFF IS OF A COMPLETELY DIFFERENT NATURE. IT HAS A DEEP, MELANCHOLY RING.

CHILDREN DON'T LIKE IT—IT'S WHY THEY LEAVE LIGHTS ON AROUND THE HOUSE—ADULTS FIND IT COMFORTING.

BUT WOULDN'T IT BE AN EASY MATTER TO WIRE A WALL-SWITCH SO THAT IT TRIGGERS THE MUTED HORN OF A STEAMSHIP?

OR THE RECORDED CROWING OF A ROOSTER?

OR THE DISTANT PEAL OF THUNDER?

THOMAS EDISON WENT THROUGH THOUSANDS OF UNLIKELY SUBSTANCES BEFORE HE CAME UPON THE RIGHT ONE FOR THE FILAMENT OF HIS ELECTRIC LIGHT BULB.

SISAL, DANDELION GREENS, JUTE, OPOPANAX, BITUMEN, LICORICE, TAFFY, KAURI GUM...

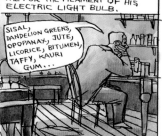

WHY HAVE WE SETTLED SO QUICKLY FOR THE SOUND OF ITS SWITCH?

©1998 BEN KATCHOR

A CONTEMPORARY FEAST

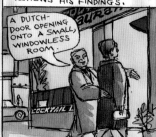

MARCUS YULE, A STUDENT OF CLOAK- AND HAT-CHECK ROOM DESIGN FOR THIRTY-FIVE YEARS, REVIEWS HIS FINDINGS.

A DUTCH-DOOR OPENING ONTO A SMALL, WINDOWLESS ROOM.

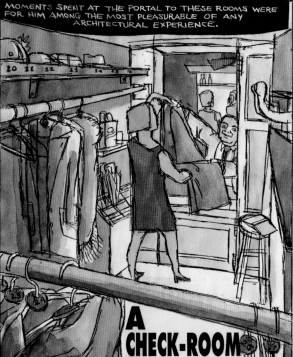

MOMENTS SPENT AT THE PORTAL TO THESE ROOMS WERE FOR HIM AMONG THE MOST PLEASURABLE OF ANY ARCHITECTURAL EXPERIENCE.

A CHECK-ROOM ROMANCE

HE'D LINGER TO WATCH THE ATTENDANT HANG HIS COAT

THE WALLS LINED WITH HOOKS AND A STOOL FOR THE ATTENDANT.

$2⁰⁰

AND THEN RETURN WITH A CLAIMCHECK.

A DISTINCTIVE NUMERICAL TAG SYSTEM.

A BOX OF CIGARS, FOR SALE INDIVIDUALLY.

NOT RESPONSIBLE FOR ARTICLES LEFT...

IN THE HOT SUMMER OF 1981 HE TOURED THE CAPITALS OF EUROPE, HAT AND COAT IN HAND.

HE LINGERED IN THE GREAT PUBLIC BUILDINGS JUST LONG ENOUGH TO CHECK AND RECLAIM HIS BELONGINGS ... BUT WAS NOT IMPRESSED.

CONCURRENTLY, HE AMASSED A LARGE COLLECTION OF CLAIMCHECKS.

I DON'T KNOW WHAT I DID WITH IT. NUMBER 42. THE CALF-LENGTH CAMELHAIR WITH A CAN OF SARDINES IN THE RIGHT-HAND POCKET.

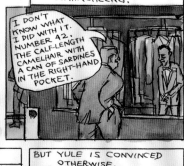

IN THE BACK OF HIS MIND WAS A PLAN TO INCORPORATE THE ESSENCE OF THESE CHECK-ROOMS INTO HIS OWN HOME.

I'LL USE THOSE HEXAGONAL, RED PLASTIC TAGS WITH THE GOLD-EMBOSSED NUMBERS.

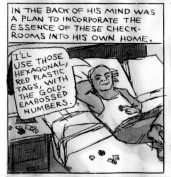

AN ARCHITECT TRIES TO DISSUADE HIM...

IN ANTICIPATION OF A MEAL, CONCERT, OR ART EXHIBITION WE'RE SIMPLY HAPPY TO BE RELIEVED OF OUR HAT AND COAT. THERE IS NOTHING INHERENTLY SATISFYING ABOUT THIS PARTICULAR ARCHITECTURAL ARRANGEMENT.

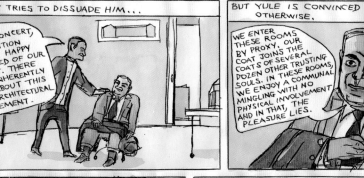

BUT YULE IS CONVINCED OTHERWISE.

WE ENTER THESE ROOMS BY PROXY. OUR COAT JOINS THE COATS OF SEVERAL DOZEN OTHER TRUSTING SOULS. IN THESE ROOMS, WE ENJOY A COMMUNAL MINGLING WITH NO PHYSICAL INVOLVEMENT AND IN THAT, THE PLEASURE LIES.

IN THE AUTUMN, HE BUILT A SMALL CHECK-ROOM OFF THE FRONT FOYER OF HIS APARTMENT.

WE BRICKED-UP THE WINDOWS OF WHAT WAS OUR DAUGHTER'S BEDROOM. SHE NOW SLEEPS ON A CONVERTIBLE SOFA IN THE LIVING ROOM.

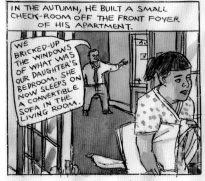

MY WIFE WENT BACK TO WORK FULL-TIME SO THAT WE COULD AFFORD A DECENT SALARY FOR THE PART-TIME ATTENDANT.

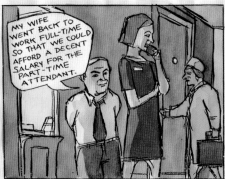

BUT HE LACKED THE NUMBER OF FRIENDS, RELATIVES, AND ACQUAINTANCES TO FILL THE ROOM ON A NIGHTLY BASIS.

SLOW TONIGHT.

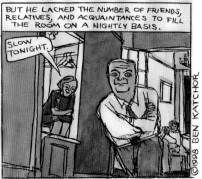

©1998 BEN KATCHOR

BEN KATCHOR

In addition to the stories contained in this volume, the editor suggests that the reader look at the work of the following artists and illustrators for the recent history of the American comic book. In the underground era, while Bill Griffith and Dan O'Neill have become known primarily as newspaper serial strip cartoonists, and await a new Smithsonian book of comic-strip serials to properly survey their work, both have written numerous early comic book stories worth reading. Griffith's best are found in the magazine *Arcade,* which he coedited with Art Spiegelman, and in *Young Lust,* which was his own contribution to the underground revolution. O'Neill, however, engaged in a mad little snit with Walt Disney during most of this period, which has been beautifully brought back to life in Bob Levin's book *The Pirate and the Mouse* published by the invaluable Fantagraphics.

Among the undergrounds, one should also mention the masterful works of S. Clay Wilson, Victor Moscoso, and Robert Williams, whose defiantly non-PG offerings nonetheless do not hide the masterful talents admired and respected by all of their comrades.

On the opposite end of the spectrum, Trina Robbin's *Go-Go Girl* and Lee Marrs's *Pudge, Girl Blimp* were among the first works to take on the sexual stereotypes that undermined so much of the underground effort. Other great books to look for from this period include Jack Jackson's *Comanche Moon,* Jay Lynch's comic book serial *Nard 'n' Pat,* and almost anything you can find by Hal Robins, especially his more recent "Dickeyland" pages for the *LA Weekly.*

In the Silver Age era, Carmine Infantino's work with The Flash, Gil Kane with Green Lantern, Murphy Anderson with the Hawkman, Neil Adams with Green Arrow, Gene Conlan with Sub-Mariner, and John Byrnne and Chris Claremont with the X-Men also make them candidates for this very same Hall of Fame. Russ Heath's Sea Devils series for DC in the early sixties and most of Alex Toth's stories for James Warren's *Eerie and Creepy* belong in this company.

The list of truly wonderful comic book stories from the Spiegelman/later Crumb era would have to include David Sandlin's various and amazing Sinland tomes; the brilliant design found in Mark Beyer's syndicated strip *Amy & Jordan*; Warren Pleece's work from Velocity Comics; Carol Lay's vari-

ous *Weirdo* and other pre-syndicated stories; Mark Zingarelli's tales from his own *Real Life*; Howard Cruse's wonderful graphic novel *Stuck Rubber Baby*; and any number of Sue Coe's remarkable political comic books, especially *How to Commit Suicide in South Africa*. Peter Bagge's ongoing serial Hate and Chester Brown's *Ed, The Happy Clown* date back to this period as well. Peter Kuper's work also began to appear regularly in this era. His adaptation of Upton Sinclair's *The Jungle* remains one great early success for the growth of the new graphic novel.

The age of the comic noir, which Alan Moore and Frank Miller helped to issue in, would later grow to include Bill Sienkiewicz's *Stray Toasters*, Matt Wagner's *Mage*, Ted McKeever's *Metropol*, David Lapham's *Stray Bullets*, and a number of challenging Vertigo titles, including Warren Ellis's *Transmetropolitan*, many of Grant Morrison's books, and most recently Brian Azzarello and Eduard Risses's *100 Bullets*.

Comics published today are for the first time truly aware of the entire history of this medium. In addition to the artists featured in this book, I would also like to recommend the ongoing comic book serial, Optic Nerve, by Adrian Tomine; anything by Seth, especially *It's a Good Life, If You Don't Weaken*; Ho Che Anderson's multivolume *King;* Phoebe Gloeckner's amazing novel *A Child's Life*; Debbie Dressler's haunted *Summer of Love*; Dylan Horrock's *Hicksville*; Craig Thompson's *Blankets*; Richard Sala's *Maniac Killer Strikes Again; Jars of Fools* and *Berlin* by Jason Lutes; and *Artbabe* by Jessica Abel.

There is much more, but that ought to hold you for a while.

NOTES ON THE NEW SMITHSONIAN BOOK OF COMIC-BOOK ARTISTS

THE UNDERGROUNDS
Robert Crumb, "I Remember the Sixties," from *Weirdo*, copyright (c) R. Crumb, reprinted by permission of the author. Crumb currently lives in the south of France.

Gilbert Shelton and Paul Mavrides, "The Death of Fat Freddy," from *The Fabulous Furry Freak Brothers*, copyright (c)1996 Gilbert Shelton. From the cartoon series "The Fabulous Freak Brothers" as originally published by Rip Off Press, Inc., in California USA. Reprinted by permission of Gilbert Shelton. Both men are currently collaborating on a future issue of *Zap Comics*, the vanguard underground comic book still setting the gold standard after all these years.

Kim Deitch, "Karla in Kommieland," from *Raw*, vol. 2, no. 1, copyright (c) Kim Deitch. Simon Deitch also contributed to the story. *The Boulevard of Broken Dreams*, a wonderful book-length work by Deitch, was published to much acclaim (New York: Pantheon Books, 2002). Reprinted by permission of Kim Deitch.

Spain Rodriguez, "Down at the Kitty Kat," from *Blab* #6, 1991. One of the best of the author's "Growing up on the Streets of Buffalo" stories. Copyright (c) Spain Rodriguez, reprinted with the author's permission. Co-created with Bob Callahan, the first volume in Spain's *Tales from The Dark Hotel* has recently been published.

Justin Green, "Sweet Void of Youth," from *Sacred and Profane* (Last Gasp, 1976). Reprinted by the permission of the author. The story is one of a series of "Binky Brown" tales, a series that culminated in the first great graphic novella of at the modern age, *Binky Brown Meets the Blessed Virgin Mary*.

Carol Tyler, "Labor," from *The Job Thing* (Seattle: Fantagraphics, 1993), copyright (c) Carol Tyler, reprinted with permission. The story is a compilation of a comic strip series on the subject of job abuse that first appeared in *Street Music* magazine. Tyler currently lives in Cincinnati.

Harvey Pekar, "Jack the Bellboy and Mr. Boats," from *American Splendor* (artwork by R. Crumb), story copyright (c) Harvey Pekar, reprinted with the author's permission. First appearing in Pekar's now legendary magazine, it was later reproduced in the first Doubleday anthology featuring stories from that magazine. *American Splendor*, a recent multiple narrative film biography of Pekar and *American Splendor* is broadly considered one of the finest movies of 2003, and is now available in video and DVD.

SILVER AGE SUPERHEROES
Stan Lee and Jim Steranko, "The Strange Death of Captain America," from *Captain America* #113 (May 1969). Copyright (c) Captain America and 2004 Marvel Characters, Inc. Used with permission. Both Lee and Steranko continue to make major contributions to this field.

Stan Lee and Jack Kirby, "The Hate Monger," from *Fantastic Four* #21 (1963). Copyright (c) Fantastic Four and 2004 Marvel Characters, Inc. Used with permission. Kirby is widely regarded as big graphic boss of the action field, an artist on a par with Alex Raymond and Hal Foster.

Bob Kanigher and Joe Kubert, "Enemy Ace," from *Our Army at War* #151 (1965). Copyright (c) 1965 DC Comics. All rights reserved. Reproduced with permission. Joe Kubert continues to write and draw at the cutting edge of the comics field today.

Stan Lee and Steve Ditko, "The Final Chapter," from *The Amazing Spiderman* #33 (February 1966). Copyright (c) Marvel Comics. Reprinted with the permission of the publisher. One by one, many of the characters first created by Stan Lee have been transformed into box office hit movies in recent years.

A RAW GENERATION
Will Eisner, "Izzy the Cockroach and the Meaning of Life," from *A Life Force* (Kitchen Sink Press, 1988). Copyright (c) Will Eisner, reprinted with the permission of the author. Eisner is widely considered "the chairman of the board" in terms of the entire field of independent comics.

Rick Geary, *Farewell to Charlie Chaplin* copyright (c) by Rick Geary, reprinted with permission of the author. In recent years Geary has focused his charming drawing on the retelling of some of the most violent murders of the Victorian age.

Melinda Gebbie, "My Three Swans," from Gebbie's first comics collection, *Fressca's* (Last Gasp, 1979). One of the truly great artists of the underground era, Gebbie has for the last twenty years lived in England, where with her partner Alan Moore she has been creating *Lost Girls*, a major graphic novel to be published this year.

Art Spiegelman, "Nervous Rex: The Malpractice Suite," first appeared in *Arcade, the Comics Review* (summer 1976), copyright (c) Art Spiegelman, reprinted with permission of the author. Spiegelman's work on a poetics for the comics may, in the end, prove every bit as important as his accomplishment with *Maus*.

Kaz (Kazimieras Prupulolenis), "Dream of the Pork Rinds Fiend," from *Buzzbombs* (Fantagraphics Books, 1987), copyright (c) Kazimeieras Prupulolenis), reprinted by permission of author and publisher.

Charles Burns, "Robot Love," from *Hard-Boiled Defective Stories*, (New York: Pantheon/Raw, 1983), copyright (c) Charles Burns, and is reprinted with the permission of both the publishers and the author.

Gary Panter, "Jimbo," from *Raw* #6 (1984), copyright (c) Gary Panter, reprinted with permission of the author and publisher.

Art Spiegelman, "The Honeymoon," Chapter 2 of *Maus*, first published in chapter form in *Raw*, and then gathered into the Pulitzer Prize winning "memoir" *Maus: A Survivor's Tale*. From *Maus I: A Survivor's Tale / My Father Bleeds History* by Art Spegelman, copyright© 1973, 1980, 1981, 1982,1984,1985, 1986 by Art Spielgelman. Used by permission of Pantheon Books, a division of Random House, Inc.

DARK FICTION AND DEEP FANTASY
Frank Miller with Klaus Jackson and Lynn Varley, "Born Again," from the opening sequence to *Batman: The Dark Knight Returns* #1. Copyright (c) 1986 DC Comics. All rights reserved. Reproduced by permission of publisher. Miller's Dark Knight, Alan Moore's Watchmen, and Spiegelman's Maus are often considered the peak moments in this new comics age.

Alan Moore and Dave Gibbons, "Dr. Manhattan," from *Watchmen* #4. Copyright (c) 1986 DC Comics. All rights reserved. Reproduced with permission of publisher.

Neil Gaiman, with art by Charles Vess and Malcolm Jones III, "A Midsummer Night's Dream," from *The Sandman* #19. Copyright (c) 1990 DC Comics. All rights reserved. Reproduced with permission of publisher.

THE CONTEMPORARY EDGE
Joe Sacco, "Hebron," from *Palestine* #2 (Fantagraphic Books, 1993). Copyright (c) Joe Sacco. All rights reserved. Reproduced with permission of author and publisher. Following the "permission" afforded by Spigelman's *Maus*, Sacco had opened up the field of graphic journalism wide with his studies in the Balkans, Israel, and Palestine.

Jaime Hernandez, "Locos," from *Love & Rockets* #7 (Fantagraphic Books, 1984). Copyright (c) Jaime Hernandez. All rights reserved. Reproduced with permission of author and publisher.

Gilbert Hernandez, "Pipo," from *Love & Rockets* #43 (Fantagraphic Books, 1994), has recently been magnificently reprinted in the book-length *Palomar: The Heartbreak Soup Stories* by Fantagraphics (2003). Copyright (c) Gilbert Hernandez. All rights reserved. Reproduced with permission of author and publisher.

Dori Seda, "The Do-Nothing Decade," from *Dori Stories: The Complete Dori Seda* (Last Gasp, 1999). Copyright (c) Don Donahue. Reprinted by permission of Don Donahue. Seda's premature death brought to a sudden end the life and career of one of comics' most promising young artists.

Daniel Clowes, "Caricature." from *Eightball* #15 (Fantagraphic Books, 1995). Reproduced with permission of author and publisher. Clowes was nominated for an Academy Award for his screenplay for the film *Ghost World*.

David Mazzucchelli, "Near Miss," from *Rubber Blanket* (no. 1, 1991). Copyright (c) David Mazzucchelli. Reprinted with the author's permission. Mazzucchelli's art for Paul Auster's *City of Glass* is one of the greatest accomplishments in short history of the graphic novel.

Eddie Campbell, " Nobody Left at the Café Guerbois," from *After the Snooter*, copyright (c) Eddie Campbell. Reproduced with permission of author.

Frank Stack, "The Bard Must Die," from *Blab!* (no. 7, 1992). Copyright (c) Frank Stack. Reproduced with permission of publisher and author. Stack's story, along with that by Neil Gaiman, is further proof of how the spirit of Puck has reclaimed this medium after all.

A CONTEMPORARY FEAST
Chris Ware, "Jimmy Corrigan and Rusty Brown adventures were selected from the larger Jimmy Corrigan corpus by the author especially for this collection. The author would like to thank *Nest* magazine, where "Every Day When I Get Home" first appeared. All stories (c) copyright Chris Ware.

Lynda Barry, "San Francisco," from *One Hundred Demons* (Seattle: Sasquatch Books, 2002). Copyright (c) Lynda Barry, reproduced with permission of the author.

Jim Woodring, "Peeker," from *Jim* (vol. 2, no. 5, 1995). Copyright (c) Jim Woodring. Reproduced with permission of publisher and author.

Ben Katchor, "Architectural Curiosities," from *Metropolis*. Copyright (c) 2004 Ben Katchor. Reproduced with permission of the author.